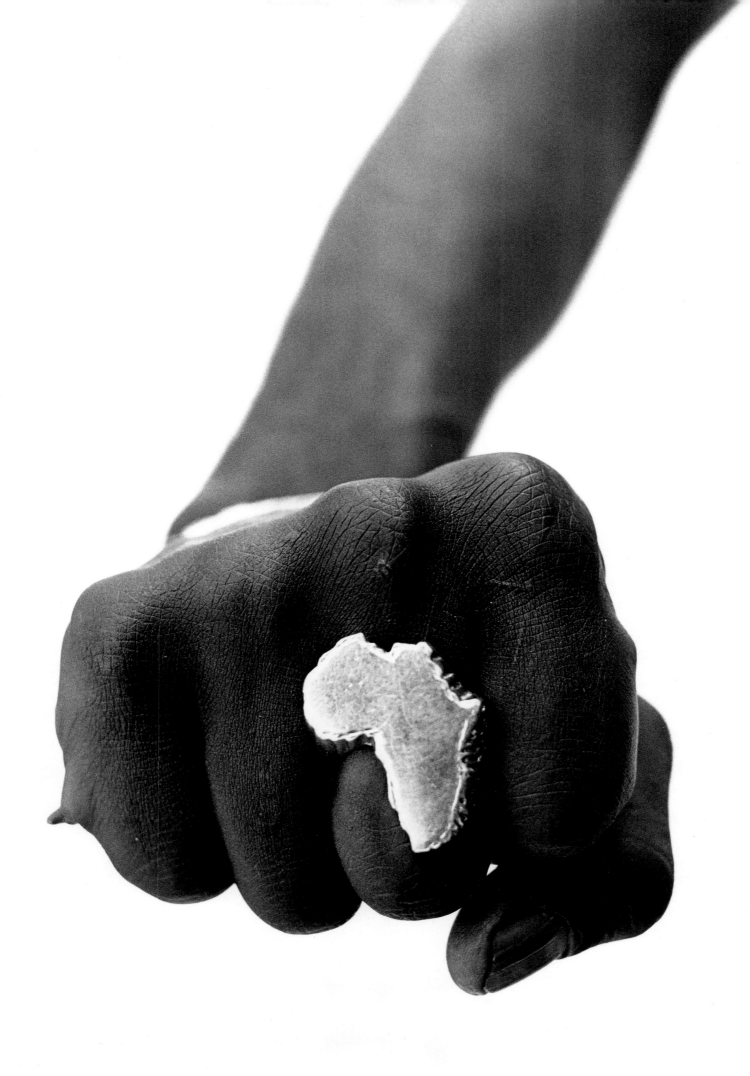

001. Buju Banton by Christian Witkin

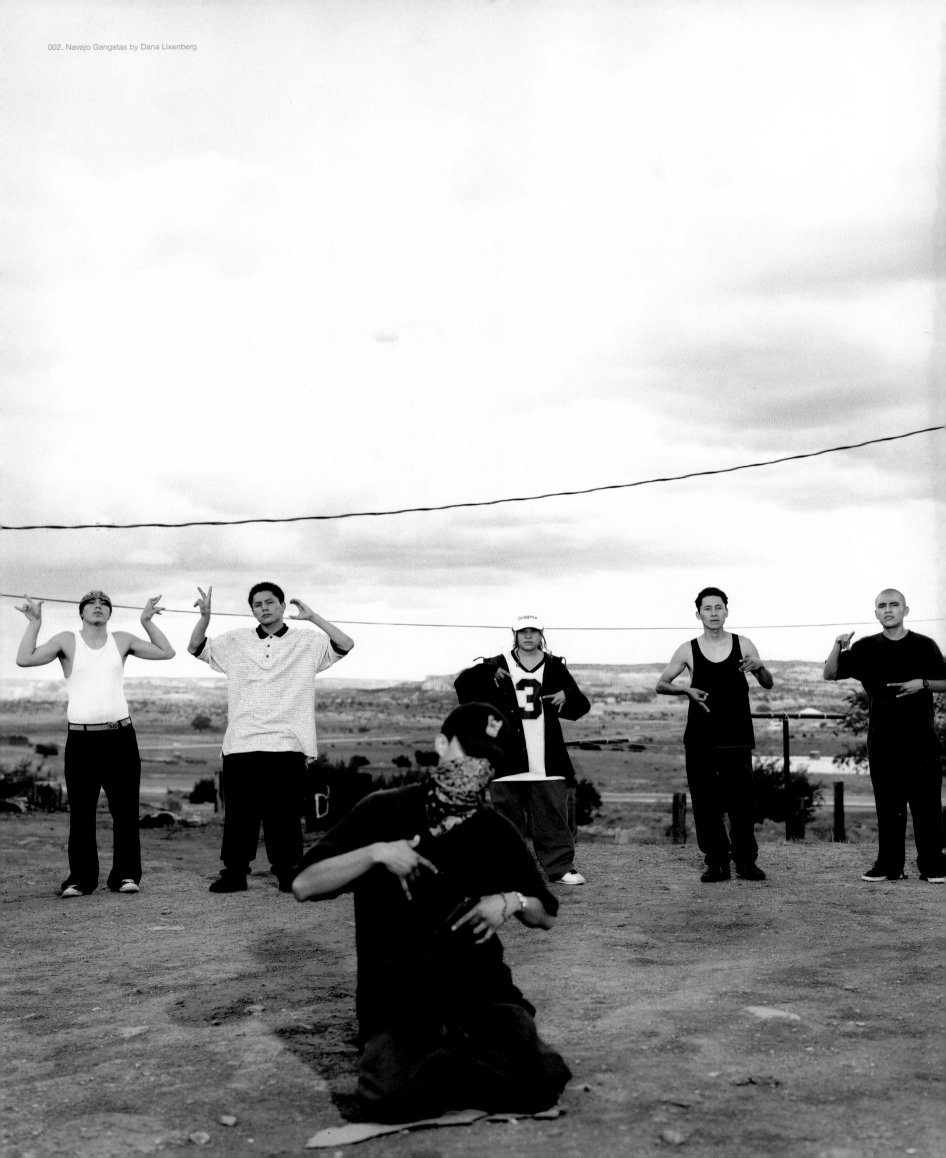

VXBe

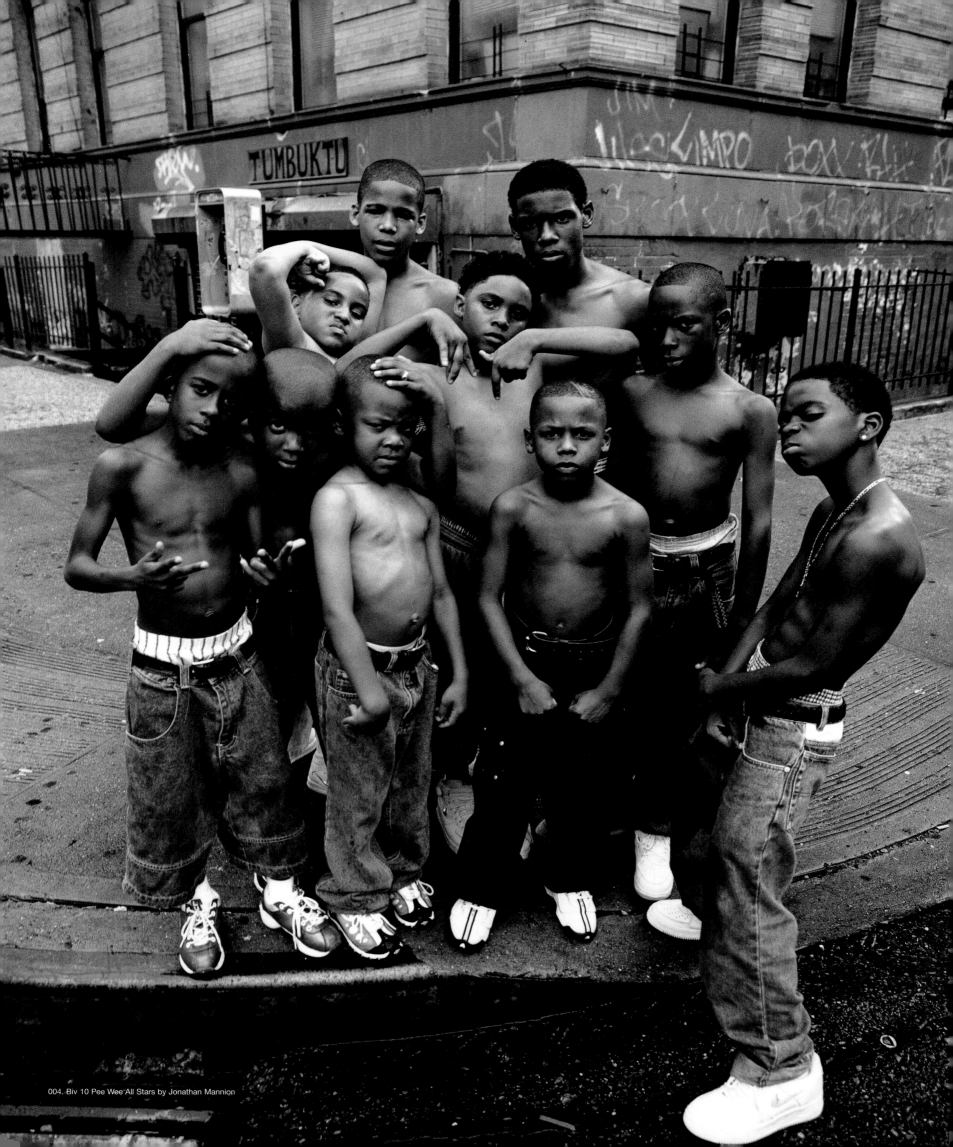

004. Biv 10 Pee Wee All Stars by Jonathan Mannion

10 YEARS OF VIBE PHOTOGRAPHY

BY ROB KENNER & GEORGE PITTS

WITH A FOREWORD BY QUINCY JONES

DESIGN BY GARY KOEPKE FOR MODERNISTA!

PUBLISHED BY VIBE BOOKS IN ASSOCIATION WITH HARRY N. ABRAMS, INC., PUBLISHERS

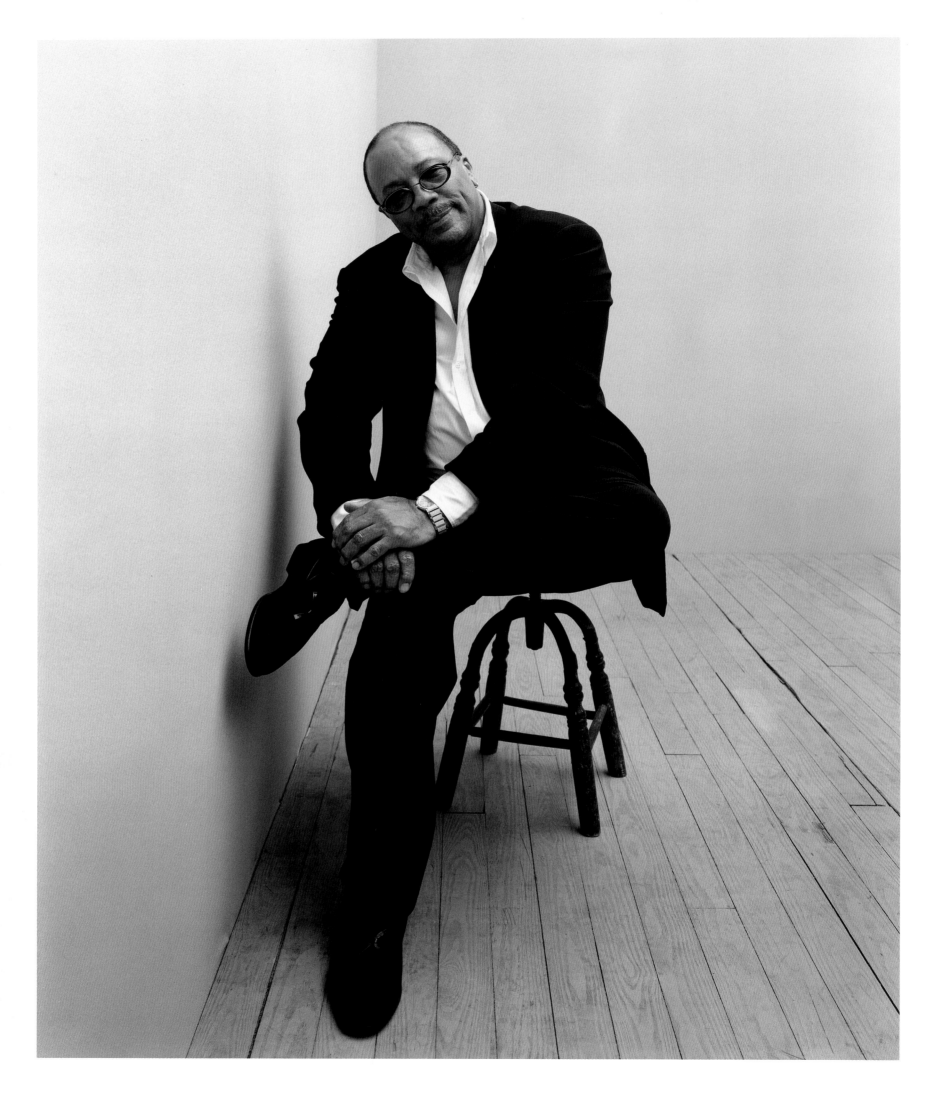

006. Quincy Jones by Christian Witkin

For 60 of his 70 years on earth, Quincy Jones has been making music—not just any music, but culturally defining, life-changing, beautiful music. He's worked with the likes of Ray Charles, Sarah Vaughn, Frank Sinatra, Count Basie, Dinah Washington, Miles Davis, Dizzy Gillespie, and Michael Jackson. He's written books, produced and scored movies, revitalized the Montreux Jazz Festival, organized the famine relief project We Are The World, formed the philanthropic Listen Up! foundation, executive produced the 1993 Presidential Inauguration and the 1996 Academy Awards, and received an honorary Oscar for his humanitarian work to go with his 27 Grammys. He even found time to come up with an idea for a magazine called VIBE, which officially launched in 1993. Ten years later, VIBE is the fastest growing music magazine in history, boasting millions of readers. With the help of the late Steve Ross, Bob Miller, Gil Rogin, Jane Pratt, Jonathan Van Meter, Alan Light, Danyel Smith, and myself, Quincy's bright idea—to give hip hop and urban culture a respectful, critical voice—has blossomed: in 2002, VIBE won the National Magazine Award for General Excellence. Led by Director of Photography George Pitts and founding Creative Director Gary Koepke, VIBE has won dozens of photographic and design awards. And so, to mark our 10th anniversary, we give you VX. As with hip hop itself, many player haters predicted that VIBE wouldn't be around this long. But thanks to Quincy, the maestro who set the tone for this musical, multicultural, in-your-face periodical, VIBE is still here and getting better with age.

AS TOLD TO EMIL WILBEKIN, EDITOR IN CHIEF:

It took us a minute to discover that the secret of any magazine is the cover. That's the Holy Grail. It's all about selecting the right picture that maintains its integrity and has an edge to it. You almost have to peer into the future when you choose a magazine cover. Like Stravinsky said, it's always a choice of one out of many. And your future rides on what that choice is. How do you know that's it? That is the most important question I ask myself the older I get. How do you know? It's got something to do with God's whispers. Making that selection is not a science. It's based on how perceptive you are, being a great observer and having an overview of what's going on—not only in your genre, but what the tenor of the world is at that time. It's about being ripe, instead of almost ripe. It's about being guided by something bigger than human beings, being connected to a divine source. I know that sounds cosmic, but it's true. It's like music; it's very elusive. But you know you're on it when you get the goosebumps.

Which covers stick in my mind? Well, let's get real. Tupac. And Biggie. And Aaliyah. That hurt, man. A lot of them hurt. It was all very personal. Pac was engaged to my daughter Kidada when he was killed. We took Aaliyah to Fiji one Christmas with some of my kids. As we were leaving a cyclone was coming. We were getting ready to go to our raggedy plane and saying goodbye to all the kids on the island. They were crying and we were crying and Aaliyah got back out of our car and started singing "Amazing Grace." *So* beautiful. I'll never forget that. We got on the plane in 150 mile-per-hour winds and the cyclone bounced us around in the air until we landed safely on a bigger island. Tupac, Aaliyah, and Biggie were all important covers for VIBE. It's not just about saying that we lost these great artists. They represent a culture, they represent a socio-political aspect, they represent a lot of things. Like Miles, Tupac has a significance that is stronger than music. They're like a collage of the totality of our humanity. Black music always comes from the soil and it never misses. It's the only music I know that's the whole voice of one people. I hear it in the slang—Lester Young and Basie were using terms like "homie" and "homeboy" more than 50 years ago. Hip hop is our latest black baby. It needs to be nurtured and respected and evolved. And it's not just a sound; it's a sensibility; it's a state of mind. It's about being hip and being aware and paying attention to everything. It's an attitude, a look. The bebop thing was like that too: so much style and flavor, from the music to the way you walked and talked and dressed. So there are roots there, and that's always fascinated me. The lightning bolt hit in 1979 with "Rapper's Delight." If you go back, there's always been some kind of rap in black music. To me, it's all reminiscent of the griots (oral historians) and the imbongi (praise shouters) of ancient Africa, and many other ways that cultures have communicated with the power of the drum. I love this music. My kids love this music. But I also know and love our history. The gangster lifestyle that is so often glorified in this music is not always about "keeping it real." The Last Poets and Melle Mel were serious street poets *and* revolutionaries. It's not about being soft. Stay hard, but you can still lay some things down that will enlighten people. And I'm not talking about anything wack or lame. Let's try to split the difference between mind pollution and mind solution. And let's connect the generations so we can learn from each other. The past is the foundation of the future. That's why we did that cover with me, Stevie Wonder, Babyface, and Coolio. And it was fun to be on the cover with Puffy, Wyclef, Babyface, and T-Boz too. I'm happy to see all these new people like Alicia Keys and 50 Cent on the cover. lMy love and grateful props to all the creative souls who came together to make VIBE what it is today. VIBE covers are meaningful now. Remember when there was a song called "I Wanna Be On The Cover Of *Rolling Stone*"? We'll be hearing a song soon, I'm sure, called: "I Wanna Be On The Cover Of VIBE."

—*Quincy Jones, Founder*

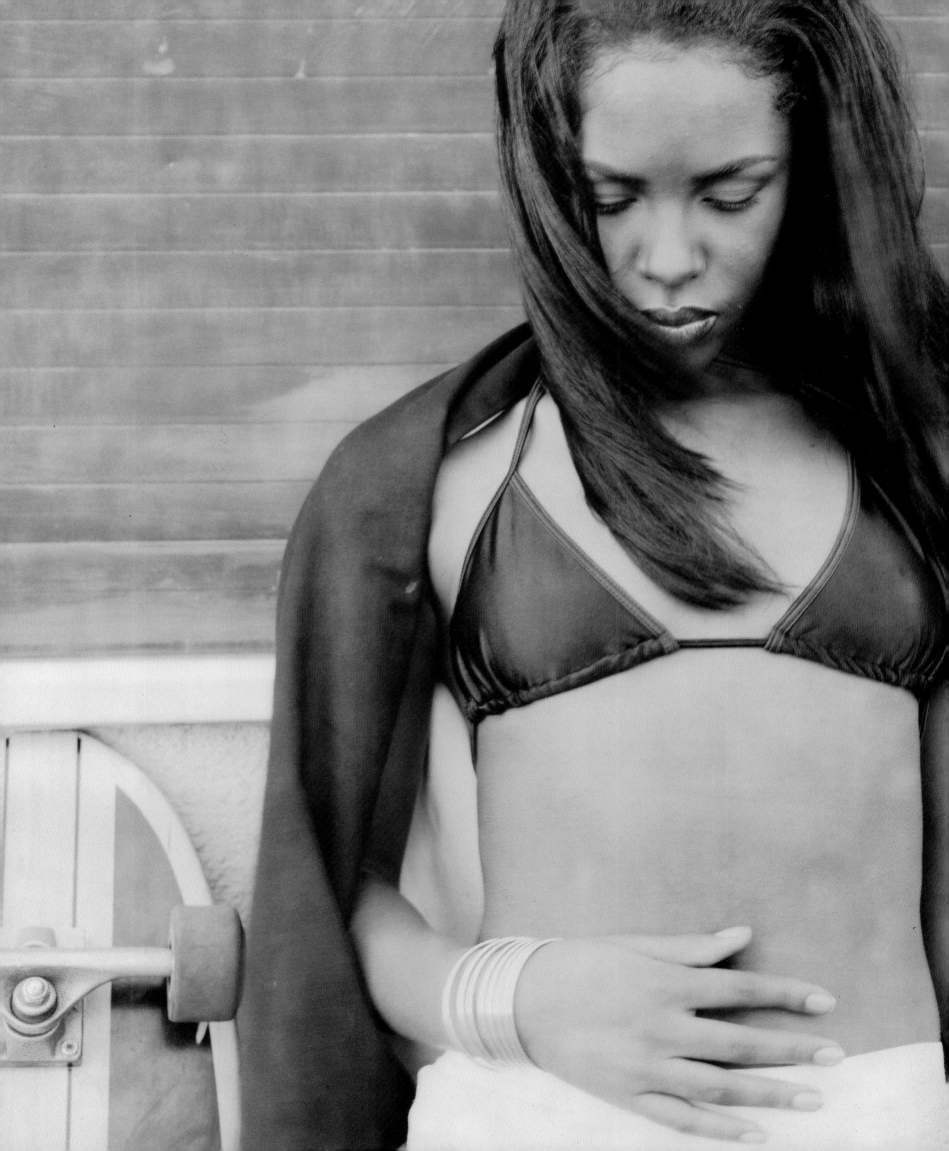

VX Mindstorm by George Pitts

Beats, attitude, politics, soul, style, fashion, skills, flow, sex, race, electronics. Homegirls, big dogs, old school, cash rules, glamour, MCs, glory, DJs, word battles, beef. The street, the truth, the breaks, the funk. Smoke, sparks, juice, dark. Cutting, scratching, bumpin', banging. Two-ways, Pro Tools, sound-bytes, samples. Jams, trance, skits, slams. Sound clash. Culture clash. Non-stop death bulletins. Ghetto CNN. Sonic landscapes, urban mindscapes. 24/7 nightlife. Thug realism. La Familia. Ghetto fabulous. Say it loud. Keep it real. Southern cookin', porkless diets, bottled water, Cristal. Bodegas, strip clubs, churches, cribs. Projects, mansions, summer homes, yacht clubs. Hotel, motel, Holiday Inn. Compton, Bronx, Hollis, the Hamptons. London, Miami, St. Louis, Milan. Harlem, Hollywood, Bristol, St. Barts, Oaktown. Kingston, Paris, Tokyo, Navajo. Queensbridge, D.C., Capetown, Dallas. Rio, Bombay, Illadelph, The ATL. Toronto, Amsterdam, Detroit, New Orleans. Strong Island, Chitown, Morocco, El Segundo. Mexico City, Brick City, Ibiza. Is Brooklyn in the house? Without a doubt. Mercedes Benz, Harley Davidson, BMW, Bentley. Rolex, Lexus, Escalades, Hummers, hoopties, Nikes, Chucks, shell-toes, hoodies, Kangols, Clarks, Phat Farm, Fubu, Prada, Gucci, Versace, D&G, Burberry, Polo, Sean John, Roca Wear, Tommy, Timberlands, T-shirts, wife beaters, furs. Taxis that do and taxis that don't stop. Gypsies, hustlers, playas, pimps, thespians. Overnight fashionistas, nouveau riche moguls, undercover intellectuals, haters. Most alluring boo, most hard, most deft, most notorious, menace to society. Fronts, blunts, forties, shorties. Scars, bars, tattoos, piercings. Extra extra large, pinky rings, ice. Big ups, shoutouts, posses, props. Attitude on overdrive. Back in the day. Can I kick it? Pour out a little liquor. Throw ya hands in the air. One love. Such is the mission of VIBE: to make sense of every cultural utterance and decisive noise assaulting the urban ear, teeming through the urban spirit, extending its reach beyond cities into the suburbs, and finally, into humanity's collective consciousness. Such is the challenge of VIBE: to document the hip-hop explosion, as far as its influence extends, with as many faces and places and races as it takes to sustain it, define it, enlarge and challenge it. For the past 10 years, I have overseen the original photography at VIBE. Sometimes what we do feels like cultural anthropology. Sometimes it feels like a bad acid trip, a cartoon, or a horror movie without monsters. Mostly it is a voyage of discovery. We take our responsibility seriously because we are recording the defining moments in a cultural adolescence, a never-to-be-repeated chapter taken from the big book of humankind. VX collects some of the most memorable photographs from the first ten years of that journey.

Among the many pieces of paper hanging on the walls of my office at VIBE is a quote from an interview with Toni Morrison. "I would like my work to do two things," she says. "Be as demanding and sophisticated as I want it to be. And at the same time be accessible in a sort of emotional way to lots of people just like jazz. That's a hard task but that's what I want to do." When we do our job best, that's what we achieve at VIBE. It's a synthesis that's only possible through the clashing tastes of opinionated people. That's why we've worked such long hours for the last decade. That's why we have argued so often, even when we swore we were going to keep our cool. Some of the photographs we have published have won awards, and some of the best photographs we took were never published. This book makes up for some of that; some of the photographs here have never been seen before. Others are already for sale on bootleg T-shirts in a 'hood near you. Others have been reprinted in a diversity of magazines without those readers noticing the original source of the images. Others have been imitated to the point where you could comfortably say the VIBE look has broadened the sphere of magazine photography. But that's okay, imitation is the sincerest form of appropriation. The contemporary taste for authentic, extreme, brazenly sexy, off-handedly cool imagery has enabled VIBE to explore a documentary approach to photography not unlike the old LIFE magazine (whose leftover paper the first issues of VIBE were printed on). It's an empathetic, non-pandering style characterized by graphic intensity and disarming realism. At VIBE we have always taken chances on behalf of brutal honesty. We try to witness the truth without all the pedagogy. Sometimes people criticize the magazine for "objectifying" women. I tend to believe that objectification is inherent in the act of photographing anything or anyone. At VIBE we strive to be emotionally honest. We admit that sexist thinking is part of the culture without dressing it up. If a star is sexy and revels in that definition of them-

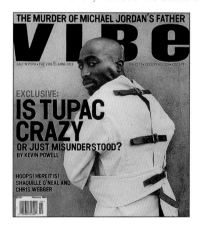

selves, we consider photographers who can capture that sensation effortlessly. The challenge in addressing an artist like Lil' Kim or Kool Keith is to make images that are not literally but figuratively sexist. The real question is whether the photographer has any genuine regard for the subject as a human being, or whether he or she is merely a catalyst for somebody's voyeuristic pleasure. We hope you can feel the love that motivates VIBE photography, even when the picture hurts.

With the catalyst of a great subject—that being the hip-hop explosion—VIBE's photographers have explored a generous vocabulary of visual possibilities that jumpstart the intensity of picture making. Our photography runs the gamut of styles and tastes from glamourous fashion shoots to harshly realistic portraiture and documentary work. It's a rare photographer who is truly suited for every story. Finding the right photographer for any given subject is a dare that we accept with love, acute attention to detail, and a competitive zeal to exceed all previous depictions. The right photographer can reveal the presence of an artist and weave a narrative that is built picture by breathtaking picture. We may buy into the mythology that encircles a star—their work, their look, their entourage, all refracted through the distorting lens of celebrity—while at the same time seeking to discover the person packaged inside the media image. Although pop imagery is considered disposable by cynics, an inspired editor can aim high, and assume there is a discerning audience for discerning images. Although I didn't always harbor this kind of idealism on behalf of magazine visuals, I do now; and I labor to impress it upon anyone within earshot. It's a relief that at VIBE we're encouraged to pursue beauty in our photography. Too many music pictures are sight gags, with no other reason for existing than to fit some half-assed idea—commonly known as a "concept." Beauty implies that the photograph will warrant being looked at again and again. Beauty entails enough visual and psychological and emotional resonance that one wants to see deeper into the image. Beauty can also be so simple, and so purely (and so rigorously) on the surface, that one isn't motivated to look harder; one can just rest with the sheer spectacle of the visual feast, which may be enough. But this is a problematic sort of beauty because it is an end in itself with no fear of being perceived as shallow. This brand of beauty is evident in virtually every magazine today. Newstands are overflowing with ravishing, expensive-looking images that pander to the alleged sophistication of their audience. Such images are destined to evaporate into the pop culture ether, only to be replaced by yet another set of beautiful, interchangeable images. But there is always the possibility that an image will outlive prevailing taste and lodge itself in the cultural archive, maybe ending up on a museum wall with the work of Avedon and Newton and Van Der Zee. One can only hope for such things.

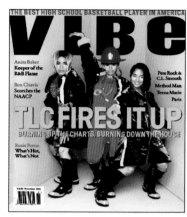

To paraphrase the artist Francesco Clemente, words often divide people, while images unite them. But that has not always proved to be the case at VIBE. When we published a picture of Tupac on the cover wearing a strait jacket, the effect was like an electric shock. Love it or hate it, the issue broke all our previous sales records, dispelling rumors that the magazine might fold. When we photographed TLC in firemen's coats after Lisa "Left Eye" Lopes was accused of burning down her boyfriend's mansion, that image ignited a firestorm of controversy. Sadly that film is now lost, so those November 1994 issues and this book are the only surviving records of that landmark shoot. VIBE blissfully has a wide enough aesthetic/cultural reach that it can include diverse musical genres, underground practices, outré creative stylists, and humane, carefully observed ethnic tableaux. Musicians such as Toni Braxton can use the occasion of their appearance in VIBE to alter the reading of their image. When Miss Braxton appeared on our cover wearing only a sheet, the reaction was so volatile that she ended up discussing the picture on *Oprah*. The presence of authors such as Toni Morrison, Walter Moseley, Bell Hooks, or Zadie Smith both as writers and subjects has added complexity to VIBE's reputation as fundamentally a music magazine. VIBE is a place where Ja Rule can flirt with his other career (as an actor) and where Wesley Snipes can tap into the ancestral look of his forebears. It's a place where athlete Tracy McGrady can step outside his profession, and put across the man. VIBE's decision to put a sober, confrontational, non-accommodating portrait of the Notorious B.I.G. on the cover isn't necessarily commercial suicide—as conventional magazine marketing wisdom dictated in the days before VIBE came along. To this day, the unspoken policy of most magazines is to avoid putting "threatening images" of black men on their covers, a policy justified on the grounds that they won't sell. VIBE recognized the strategy of marrying the image with the lyrical agenda, and the lack of bullshit in Biggie's own persona. Such pairings of the artless visual with the artless glamour of the subject has often worked extraordinarily well for us. Although it may not be a strategy other magazines can use as effectively, it's been a winning formula for *VIBE*, especially with regard to hardcore male rappers, who have a disdain for looking too cute.

I realize now, in retrospect, that my dad was a big influence on my choice of professions. George Pitts, Sr. was the entertainment columnist for the groundbreaking black newspaper, *The Pittsburgh Courier*. And so, during the 1950s, black royalty passed through our modest living room. As a child, I wasn't especially mindful of the celebrity of Harry Belafonte, Dinah Washington, Nat King Cole, or Hazel Garland, but the photos that lined the walls of our basement den—of my parents in their best clothes, conversing with stars—kind of predicted my means of survival. Some of those pictures were taken by Teenie Harris, a black photographer whose work is coming to be appreciated as a kind of visual diary, a document of extraordinary times— which is one way to think about our first decade at VIBE. Growing up in the Pitts household also gave me an awareness of and comfort with the real people who also happen to be black celebrities. The childlike, bespectacled, Sammy Davis Jr., was a personal favorite of mine because he was funny. I knew his records, and sometimes when he babysat me I would ask him to do impressions of Marlon Brando or Jerry Lewis. But in my kid's way, I understood that he mostly just wanted to chill, so we ate soul food and snacks and watched *Dennis The Menace* on TV. Other formative influences include a lifelong practice (and study) of painting, which afforded me a means of putting all my concerns—sensual, emo- tional, psychological, cultural—onto the canvas. This facility and intimacy with the pigment is as creative to me as holding a microphone. And contemplating the compositions of Vermeer, Degas, Manet, and Balthus has had *more* than an indirect influence on how I look at magazines. The first time I worked passionately in publishing was in the books section of *Entertainment Weekly*, where I had the opportunity to arrange sit- tings with writers I'd long admired, such as Harold Brodkey and Susan Sontag (whose essay "On Pornography" was a significant influence on my thinking). The medium closest to my heart is probably cinema, which has enthralled and transported my sensibility even as it taught me how one medium can draw on all existing art forms. Learning about film also taught me how many individuals are involved in the construction of a single image, which is a humbling and invaluable insight for a photography editor. The interdependence of different specialists working in concert is at the core of what we do. Although I'm not particularly enamored of populist definitions of quality, I do enjoy the opportunity to infect the world with funky, elegant, and compassionate visual images. It's a privilege I never take for granted.

Someone from another publication who perceived our magazine to be their rival once told me "VIBE was for fags, and [the rival publication] was for real niggas." Since I do have a sense of humor, I relished the wack absurdity of this remark. (As if those were the only two modes of existence! As if anyone's life could be reduced to such simple-minded extremes!) I also understood that the remark was illustrative of deep rifts within the black community. The ascension of a certain kind of rap has marginalized the profoundly valid voices found in jazz and other musical expressions. There is much to criticize within what can now be called "mainstream" rap culture: the crass commercialism, the unexamined macho entitlement, the vicious homophobia. I recognize of course that the bad-ass pose is a sort of cultural defense, the flip side of Ralph Ellison's *Invisible Man*. But even this "unchained" persona can become a sort of prison. My own cultural vendetta has been to get across that there is otherness even in the so-called "black community." Also that there is a history of trading ideas between black and white people. In the '60s the cultural gap was much wider than it is today, hence the big differences between Motown style and that of, say, The Rolling Stones—both entities theoretically devoted to the same thing: black music. Artists like Jimi Hendrix, Sly Stone, and Arthur Lee of the group Love bridged the style gap by dressing more in rock or "hippy" mode than the typical black performer. With hip hop, a cultural reversal has taken place; white urban and suburban kids have adopted black street style. This narrowing of the style and taste gap helps account for the success of VIBE—or vice versa. VIBE has had the good fortune to work with photographers who hail from all over the world, and we've turned them loose on subjects whose musical talent has also allowed them to travel the world. The reciprocity and exchange of transcultural perception discloses an obvious awareness of difference, as when Dutch-born Dana Lixenberg made it her mission to document the residents of Watts, L.A., but it also reveals how little difference there is in the core of our beings. We travel across distances and across streets. We connect, or resist connection, as a result of these differences, these distances, these streets. For many years, hip hop has been isolated in a sort of media penal colony. But really it's an epic film that demands a cast big enough to bridge the distance between generations and cultures. At VIBE, we strategize over how to represent this culture to the fullest: with love, with flair, with wit, and with glamour—or without it.

—*George Pitts, Director of Photography*

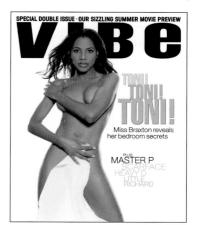

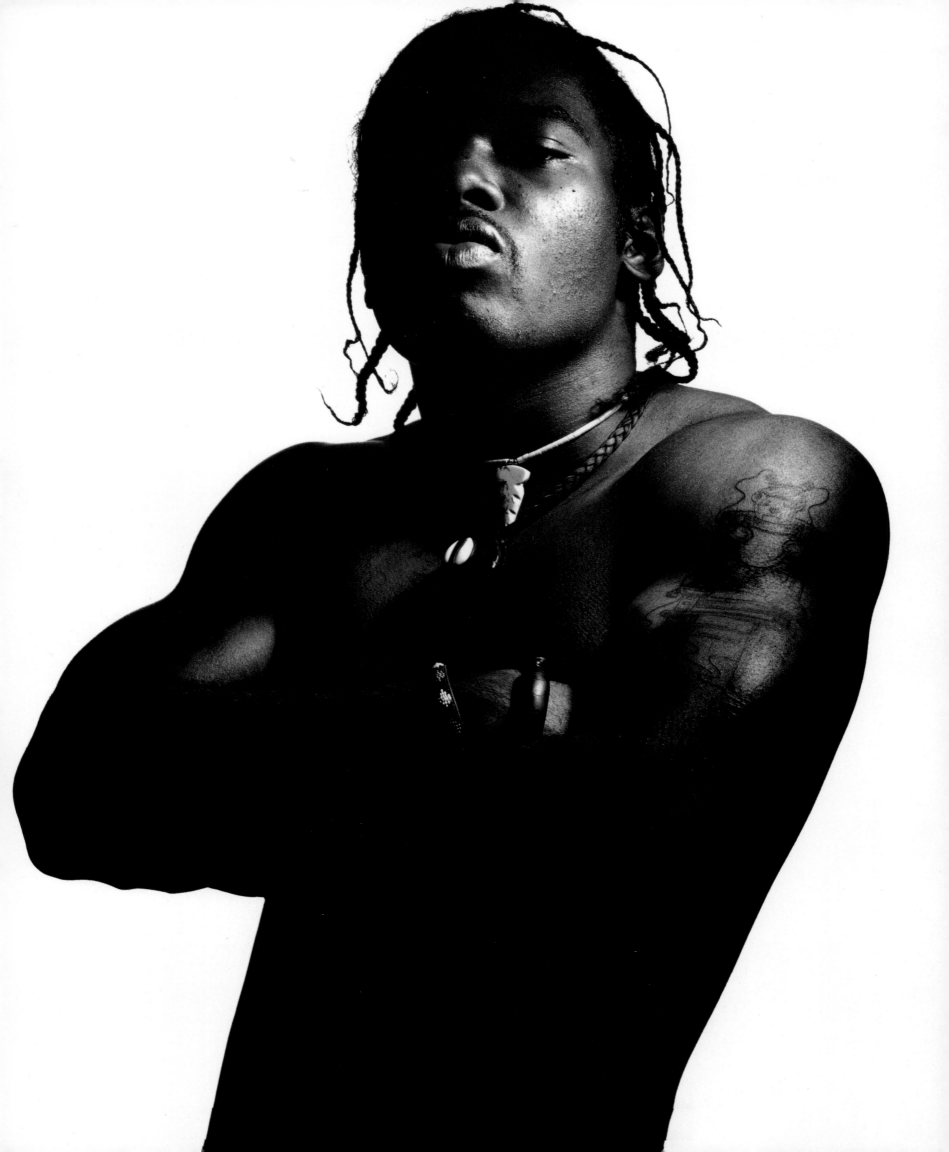

Treach glides across the stage like a panther: Black, lean, his narrowed eyes riveted on his prey; he grips the mike tightly in one hand while the other slashes the air with his ever-present machete. He's one of the rare brothers who knew he could when everyone and everything around him told him he couldn't. His success comes from the ability to control the rage and cultivate the creativity.

—*from "Native Sons" by Kevin Powell*

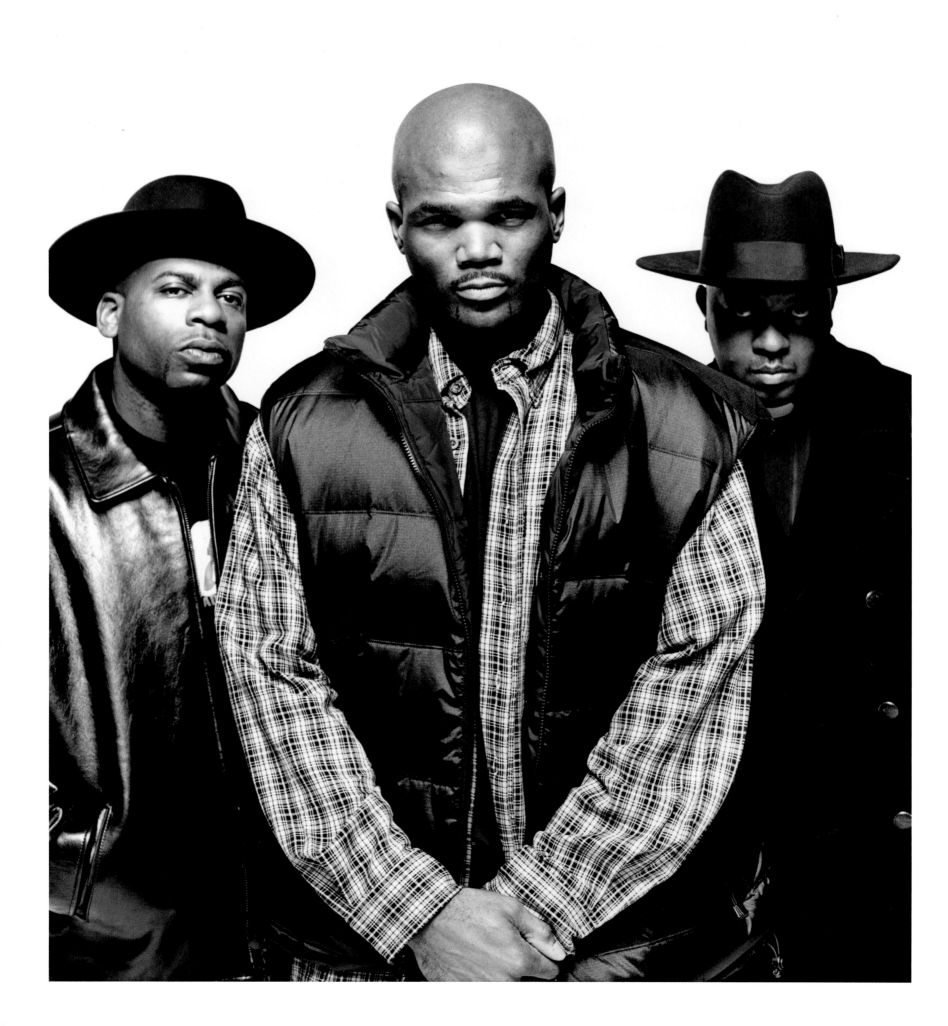

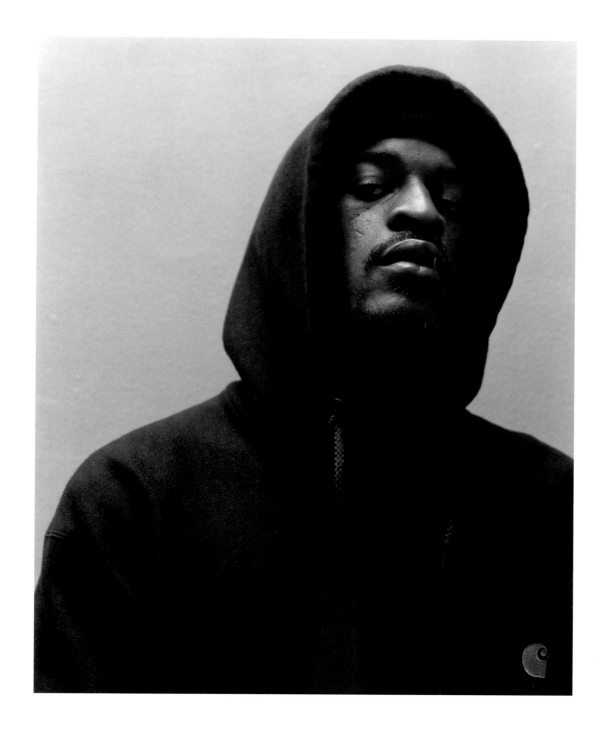

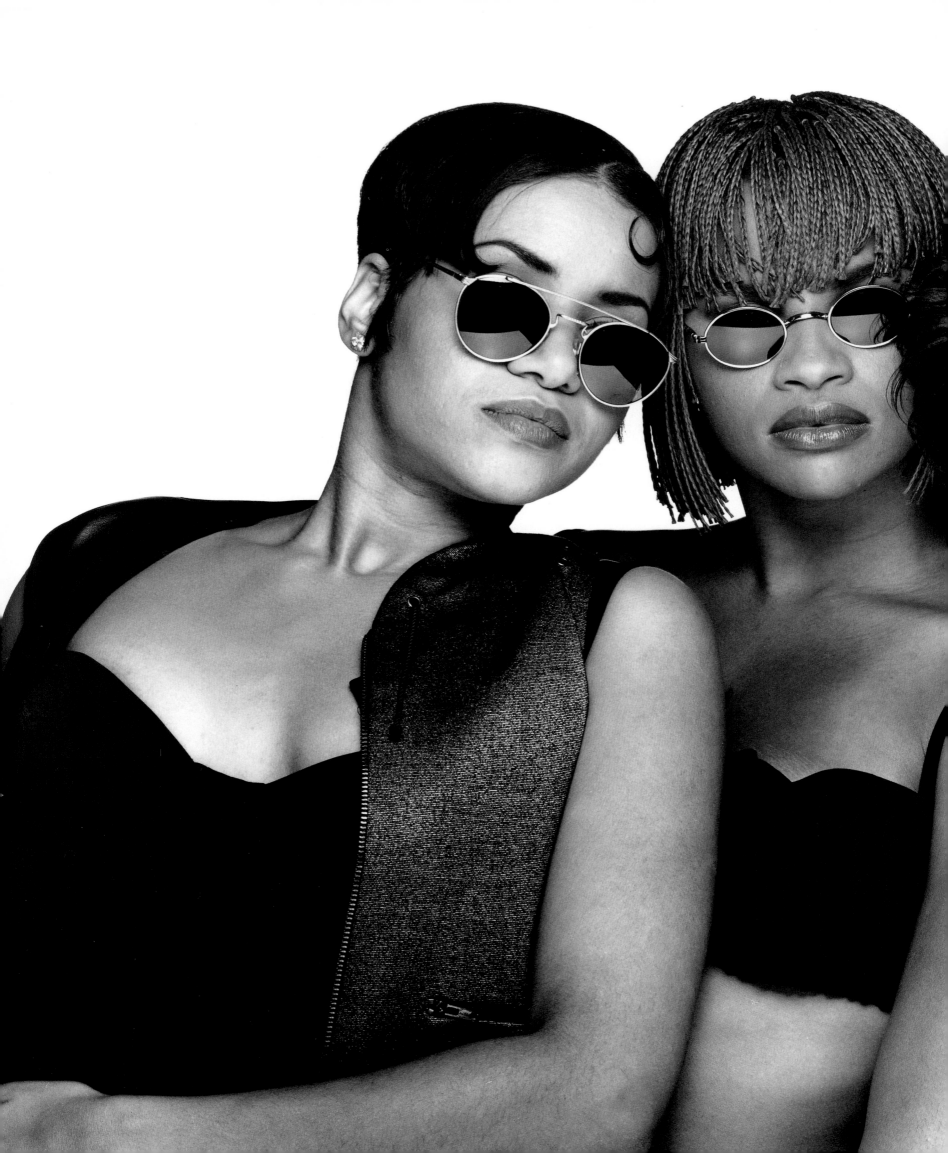

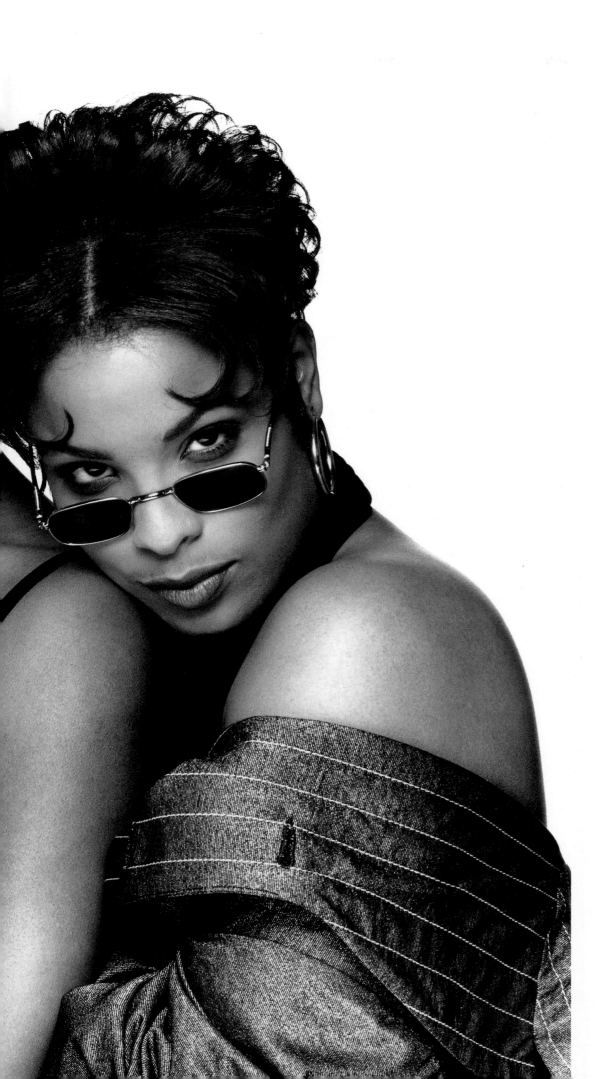

020. Salt-N-Pepa by Albert Watson

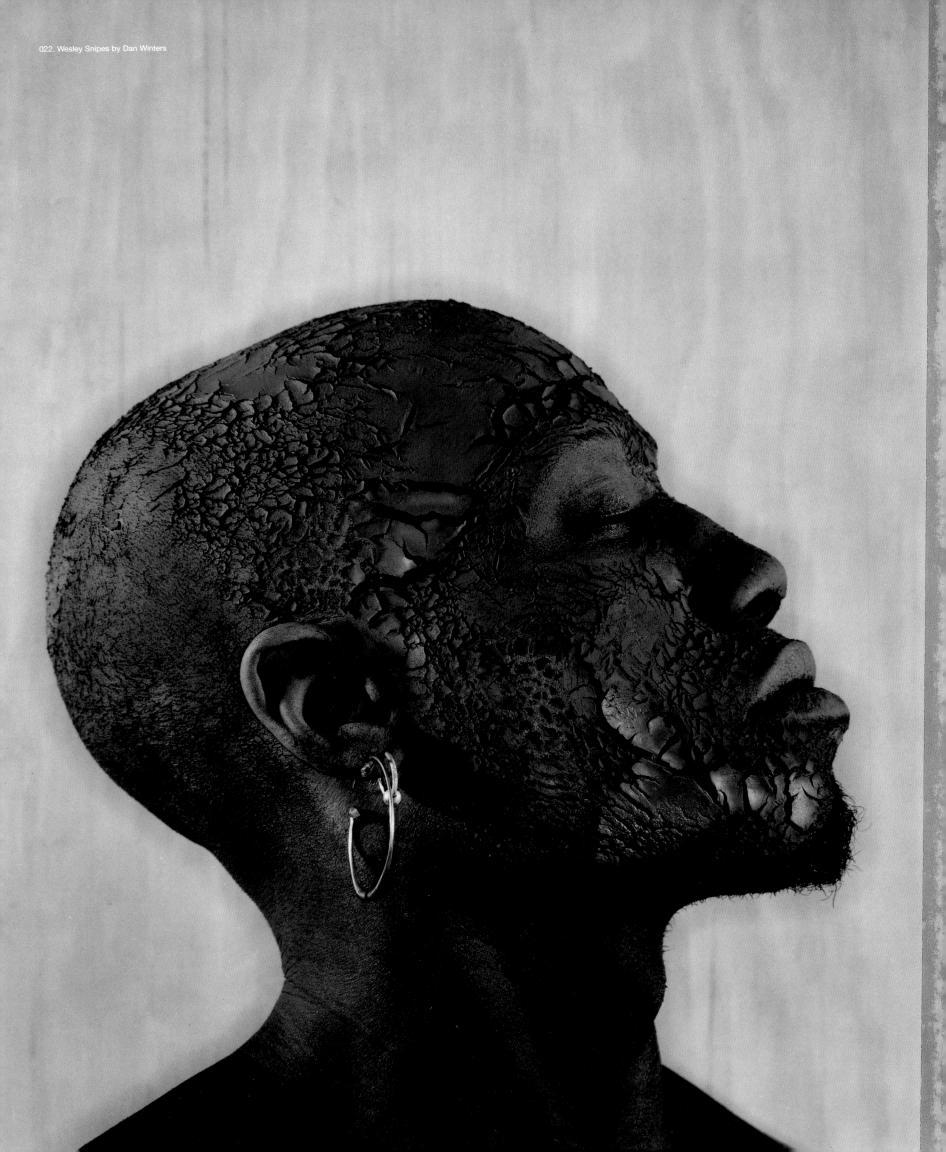

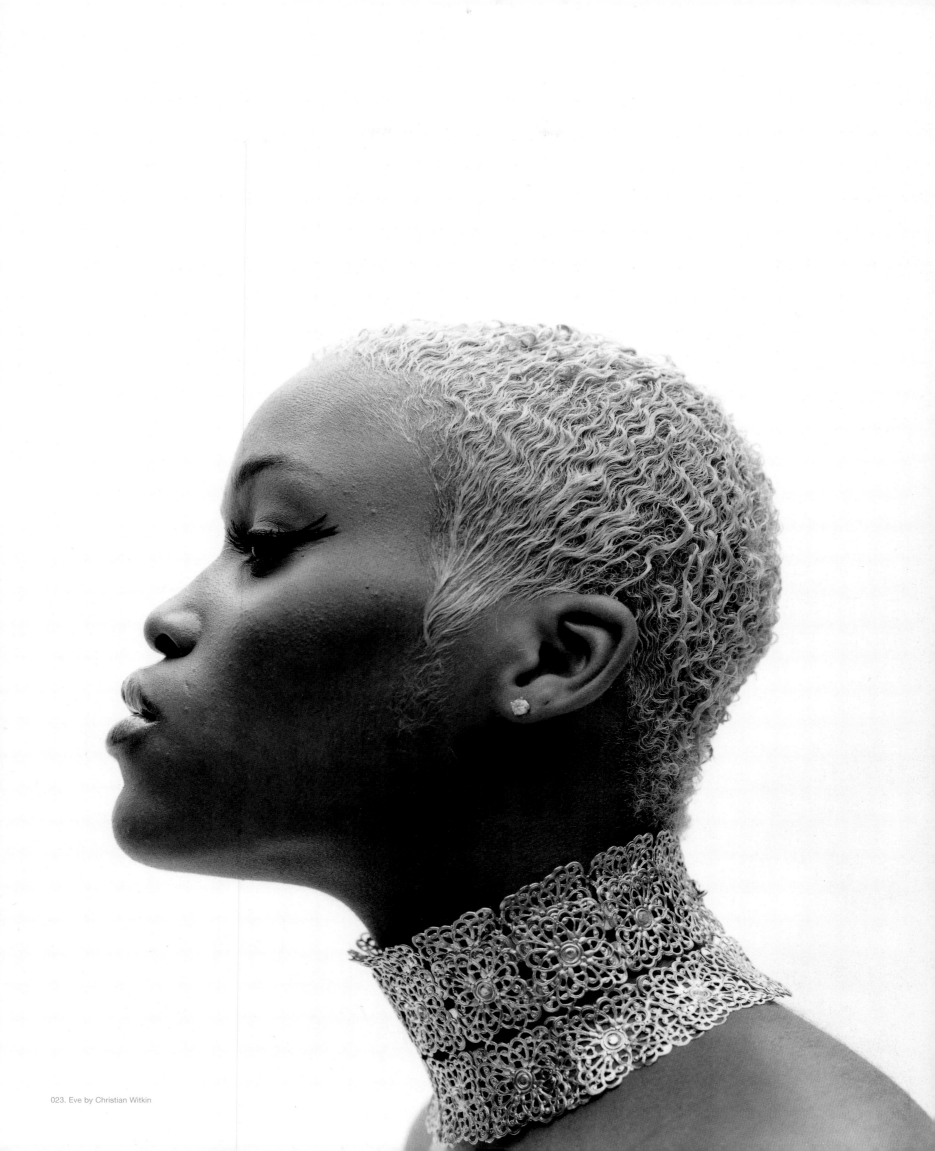

023. Eve by Christian Witkin

On *AmeriKKKa's Most Wanted*, Cube emerged as the sonic personification of unmitigated black rage. It was violent, sexist, powerful, relentless, funny, and painful. It was also seductive as hell. For white America, it was a voyeuristic look into the world where racism causes its equality-starved victims to feed upon themselves. For black folks, it was a long, cold, hard look in the mirror. There we were, ass-out for the world to see, and all the Brooks Brothers/kente cloths, relaxers/dreadlocks, embarrassment/denial in the world were not going to change a thing.

—from *"The Devil Made Me Do It" by Joan Morgan*

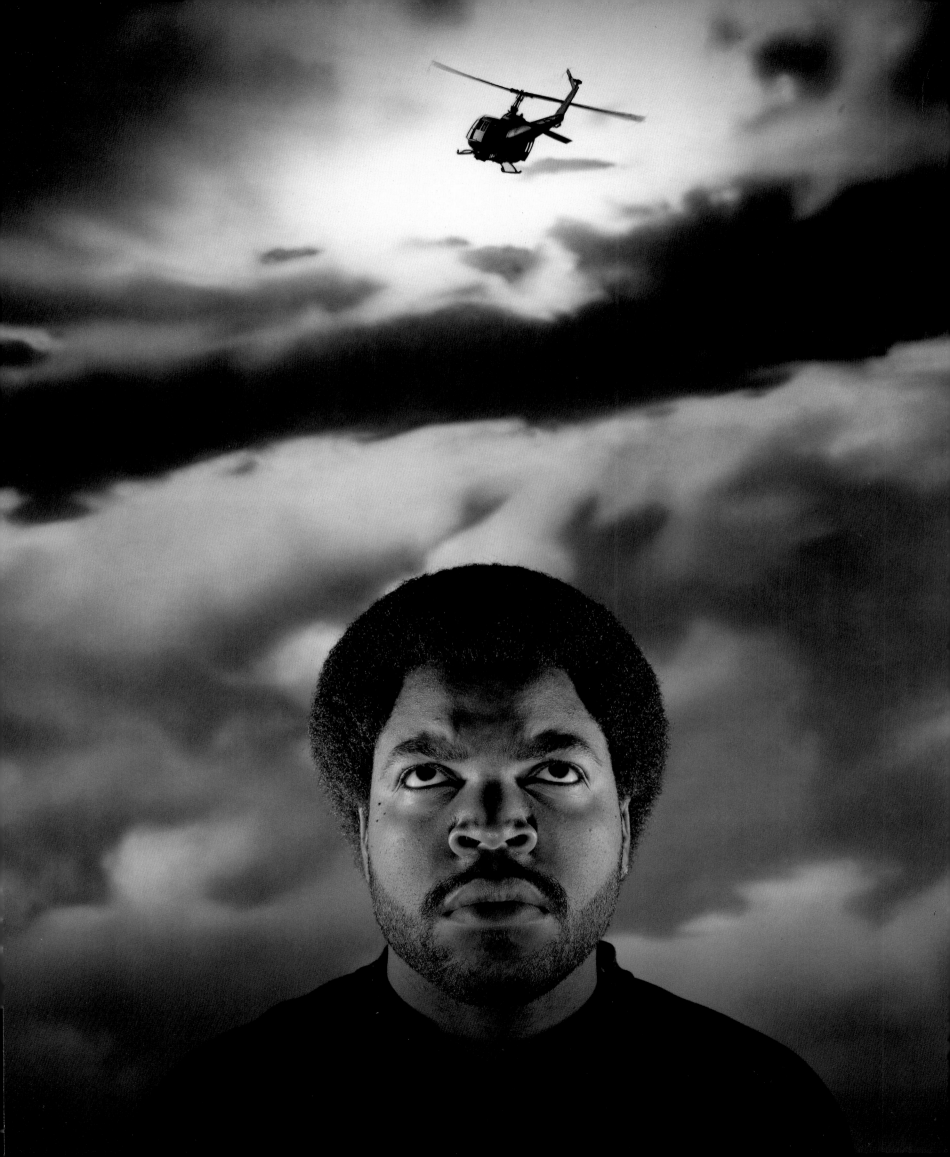

All right, Chaka, you gorgeous 50-year-old recording star, our star of stars, with your flat, freckled, not to say triangular nose (powdered) and small firm handshake (nails: red) and kooky like Elsa Lanchester in *The Bride of Frankenstein* grin and that mane of (what color is it?) hair that keeps shifting back and forth from your face, exposing its seam, which circles your circular face as so many hairpieces and wigs have done before; Chaka, you gorgeous kid you, eat your food!

—from "Better Days" by Hilton Als

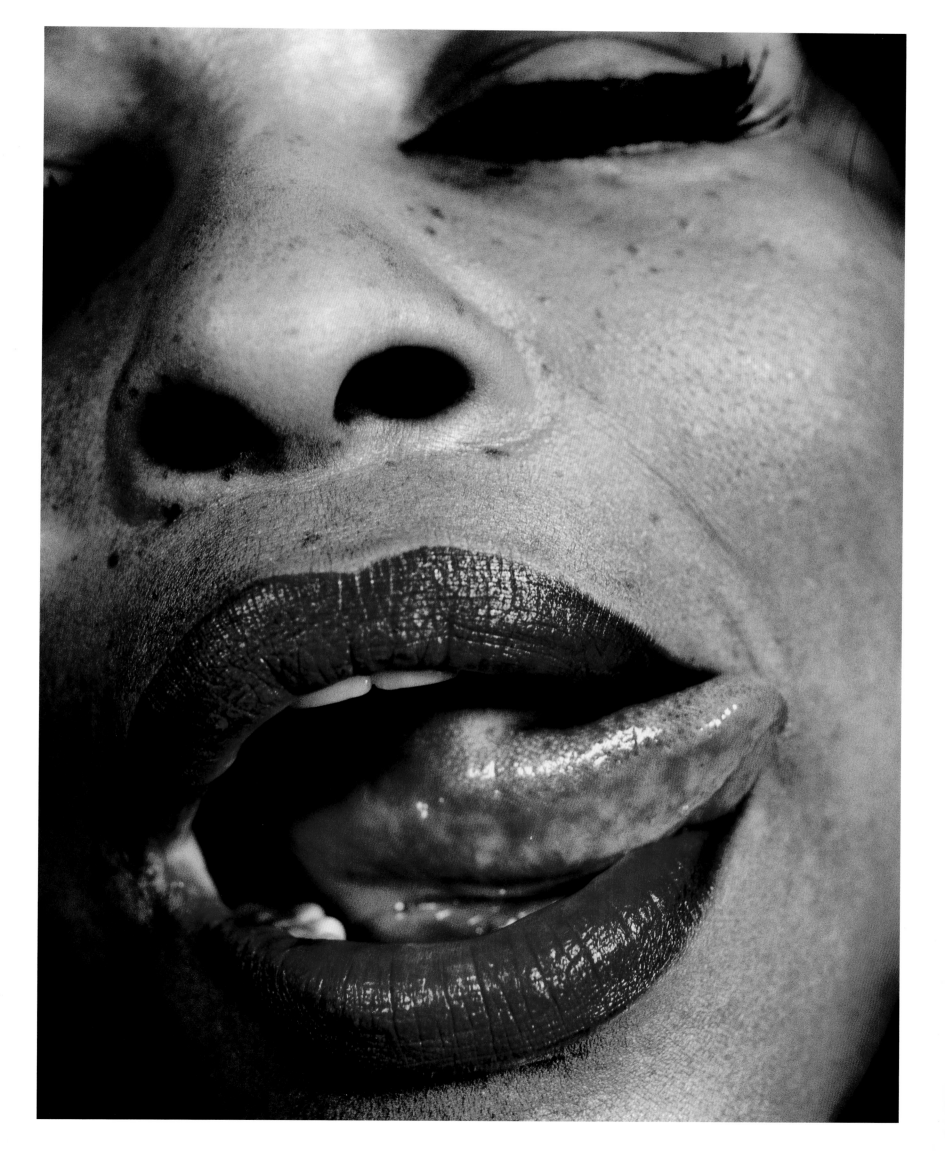

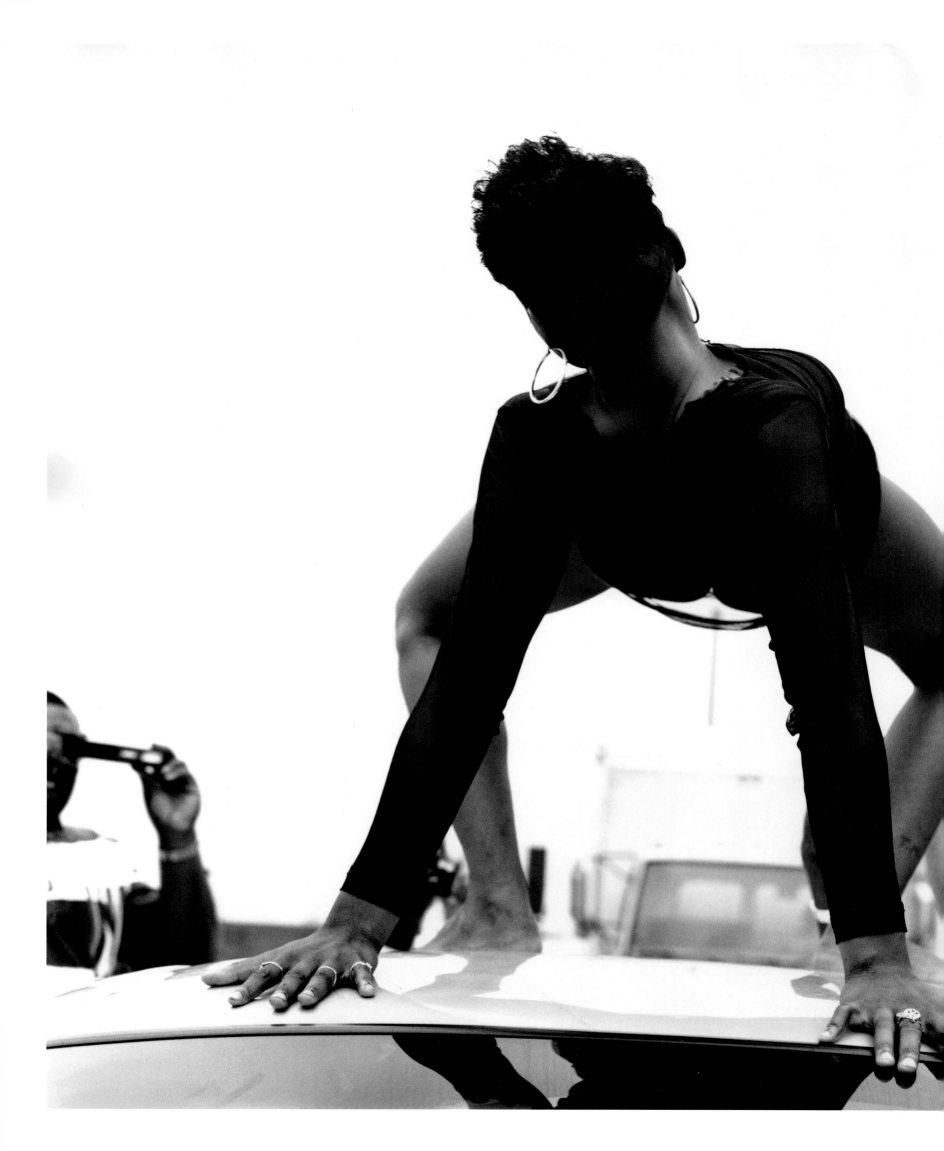

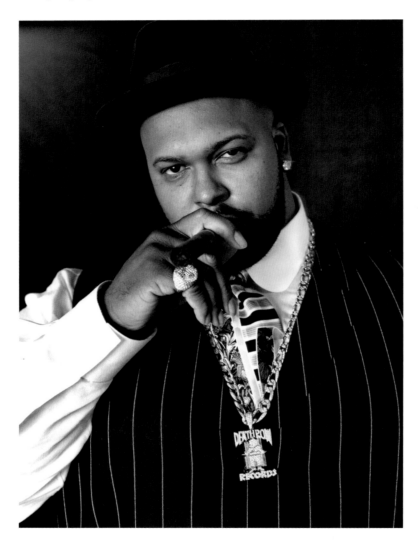

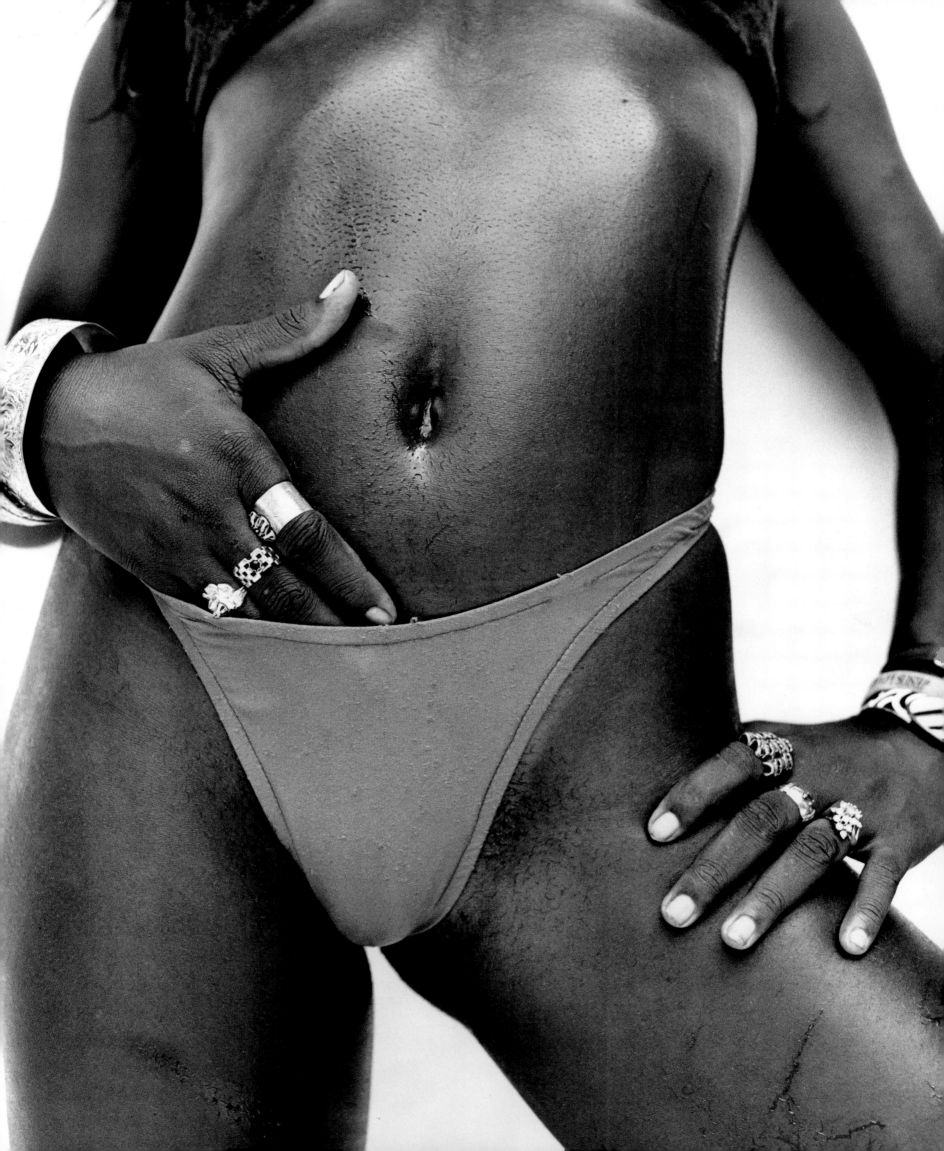

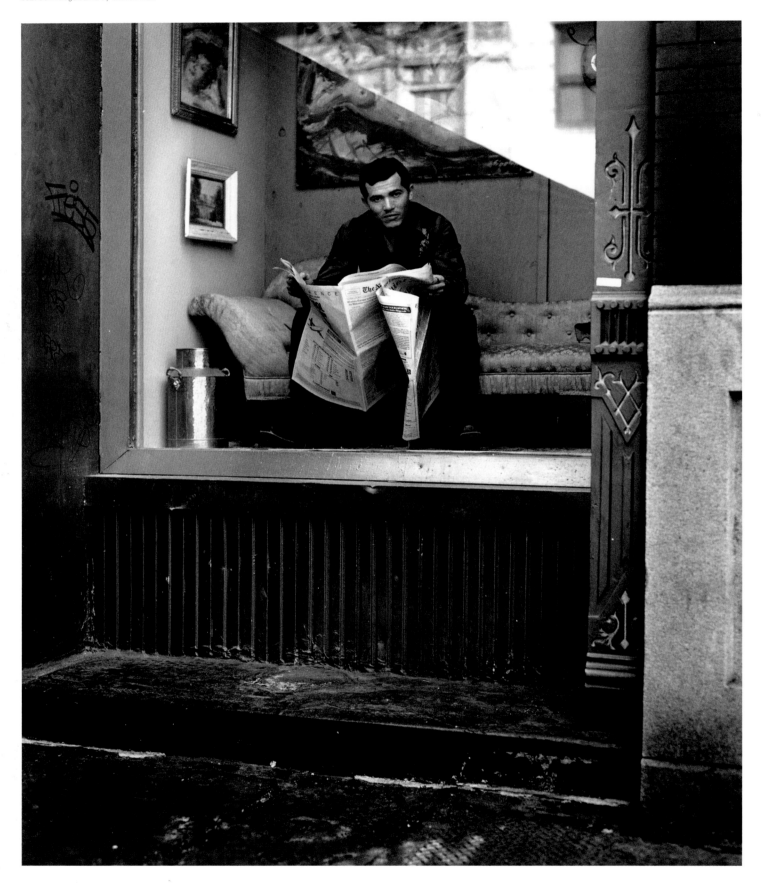

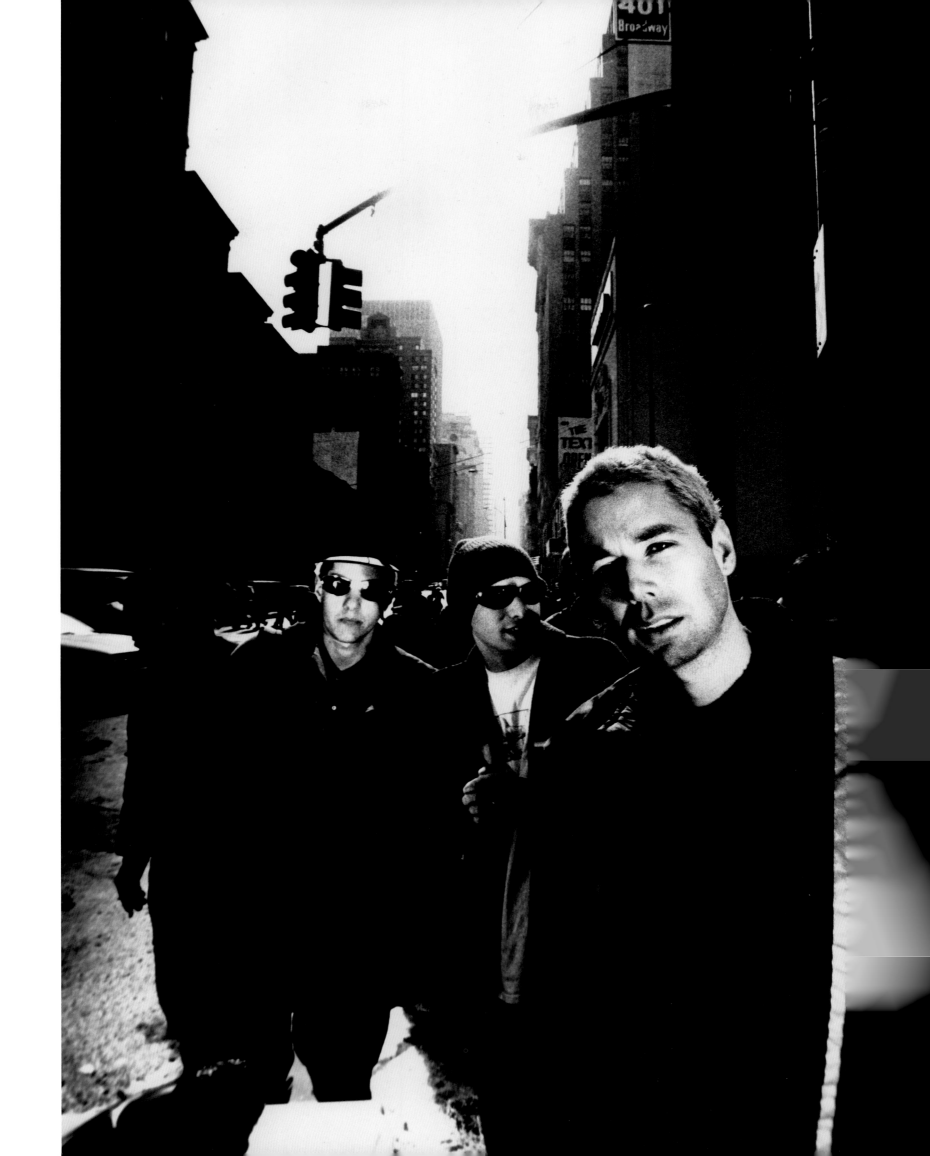

So here he is—21 years old, six-foot-four, pencil thin, and quite obviously only one generation removed from his family's Mississippi roots. Snoop's just a regular kid from the block who happens to have a rhyme virtuosity that's the envy of rappers on both coasts. He still packs two guns and he never roams without the Dogg Pound and other friends from the 'hood. So he doesn't even worry about the static that inevitably results from walking a fine line between ghetto life and life as a rap star.

—from "Hot Dogg" by Kevin Powell

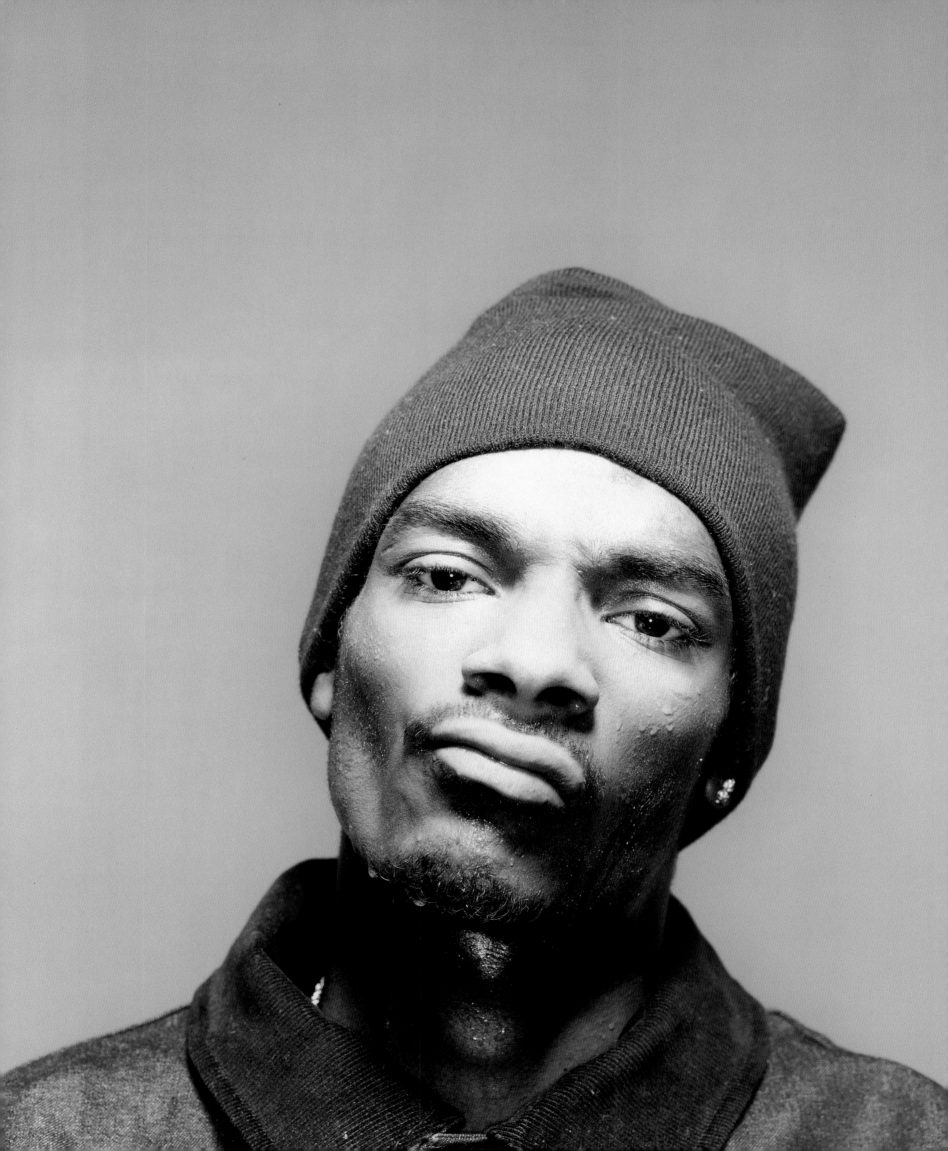

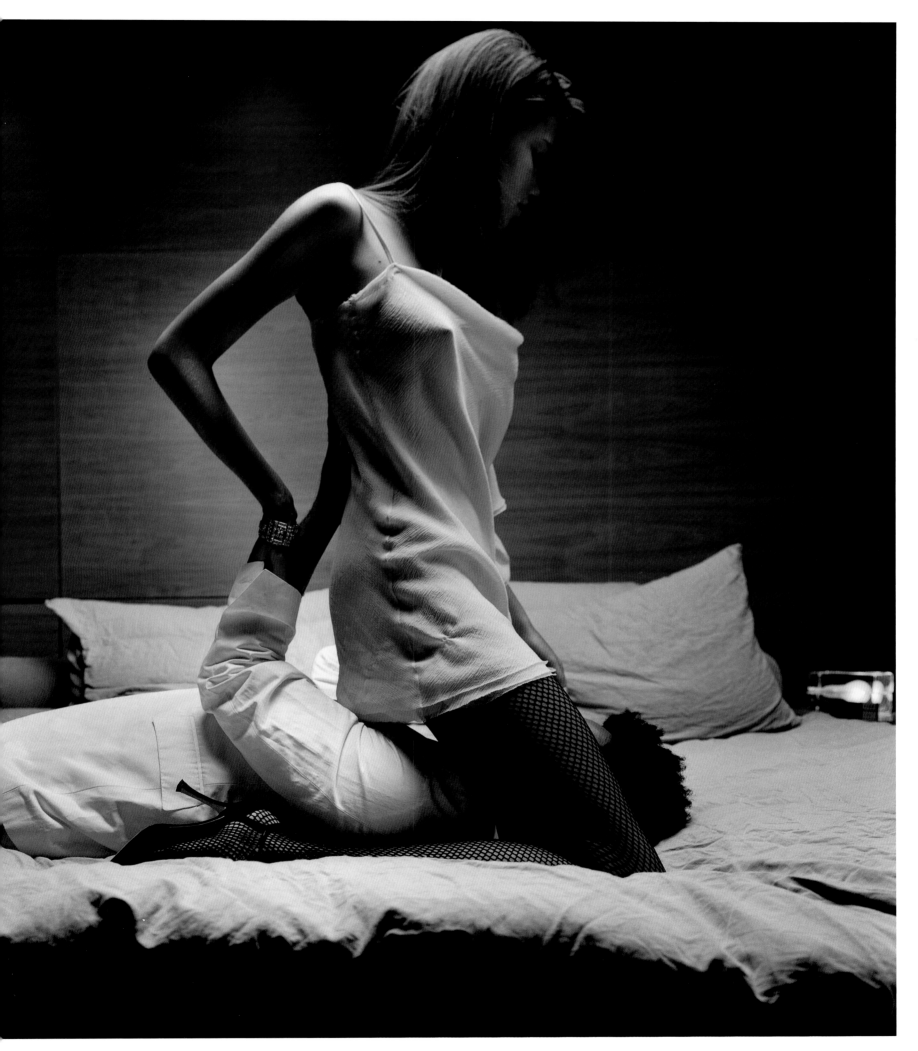

037. Lenny Kravitz by Robert Maxwell

After shooting a scene, Macy Gray retreats to her trailer and strips down to a pair of hot pink terry-cloth bell-bottoms, a black girdle, and an ill-fitting bra. "I'm a big fan of mixed drinks," she says. "I like to be drunk and out of my mind a little bit. I think it's good for the soul."

—*from "Wild Thing" by Margeaux Watson*

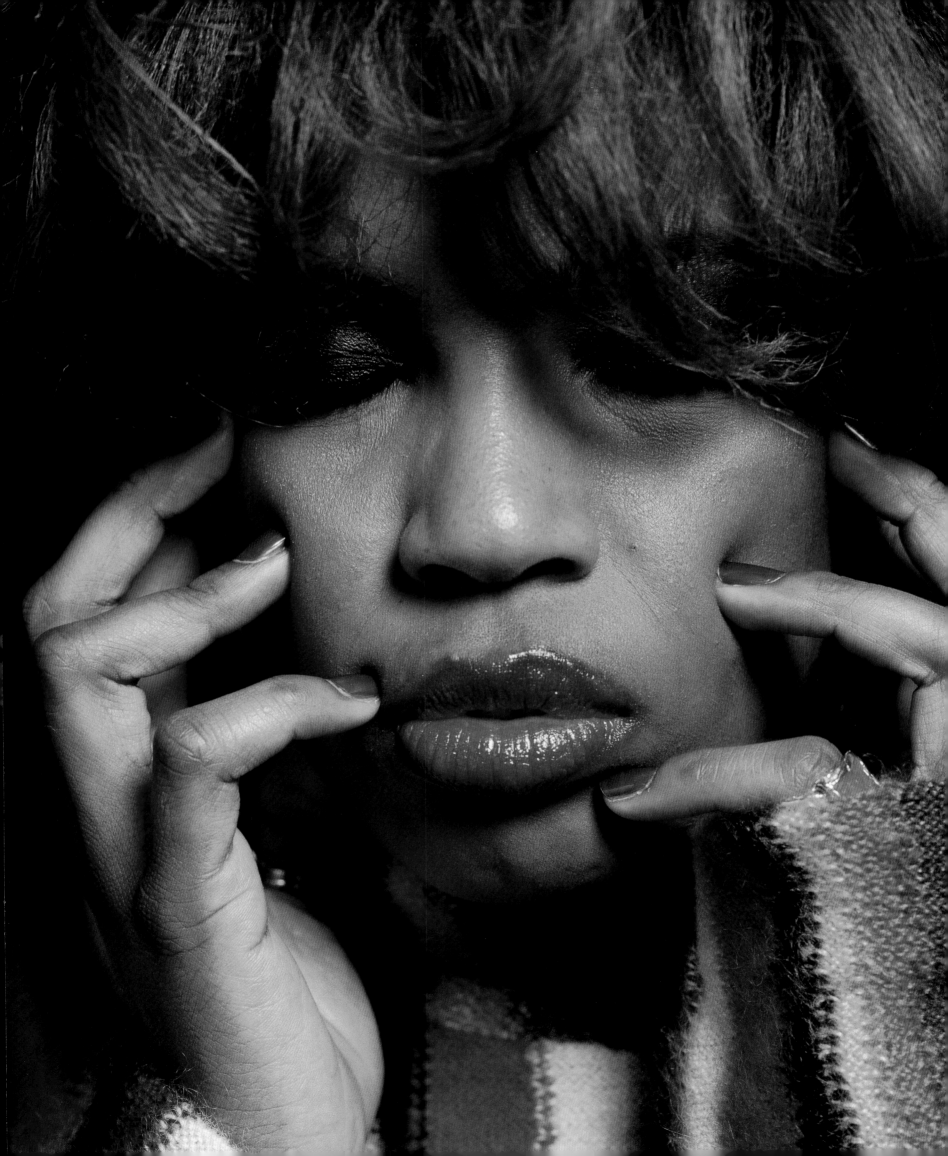

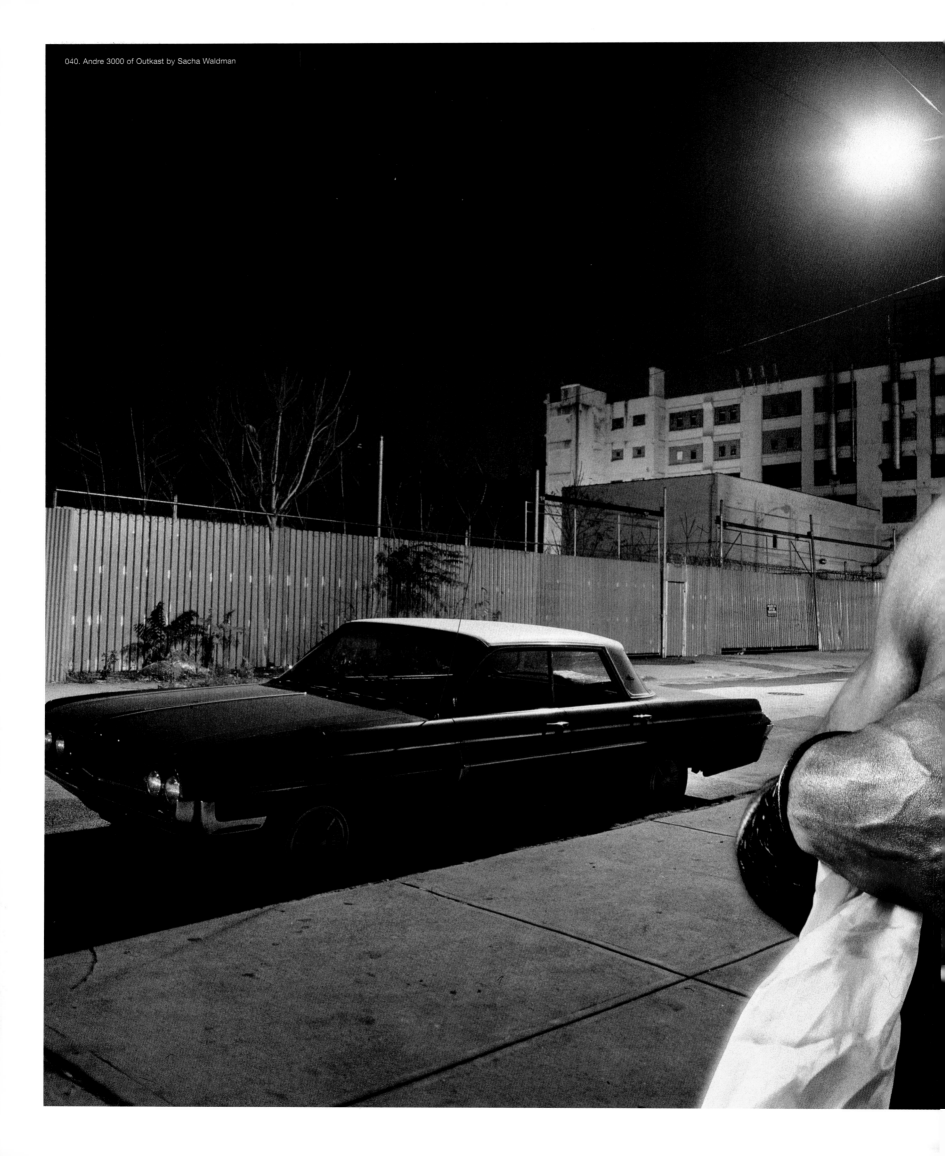

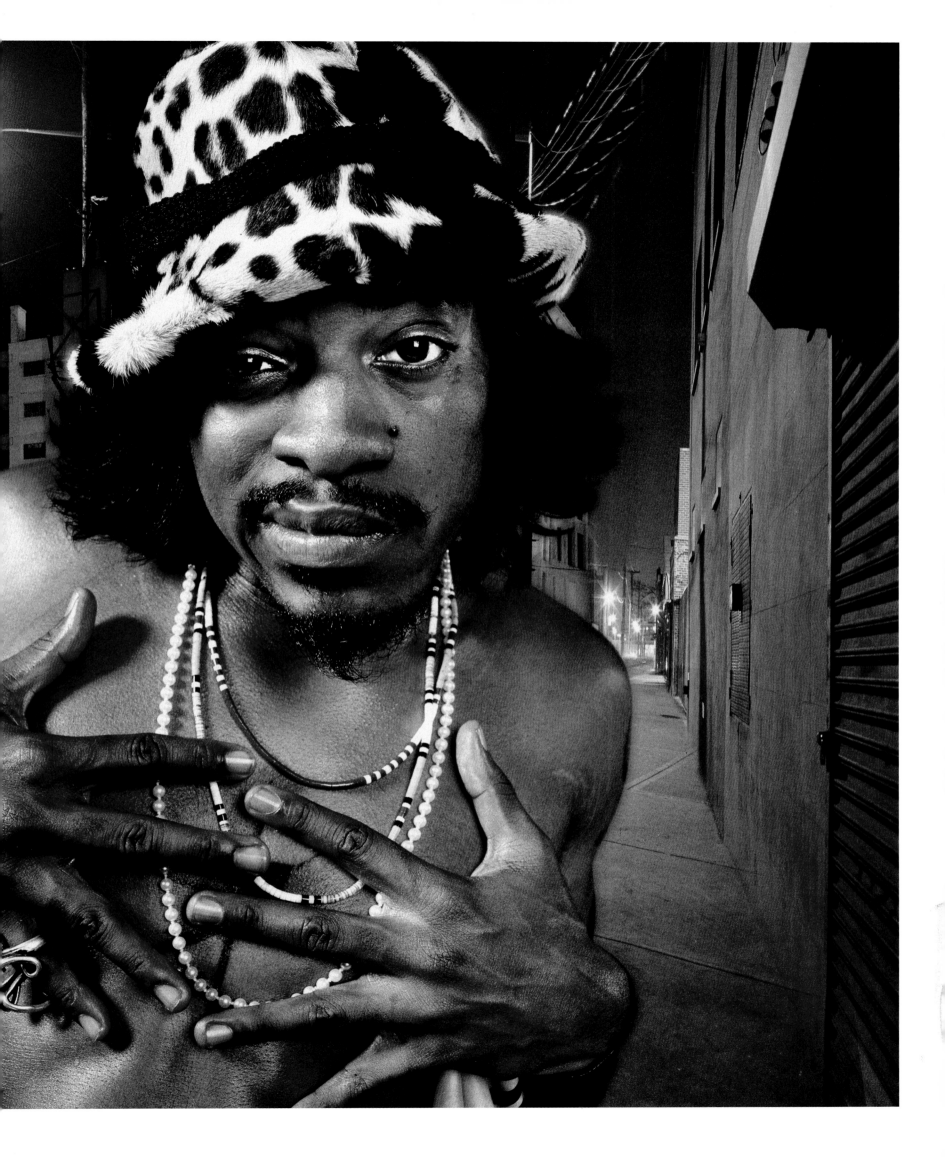

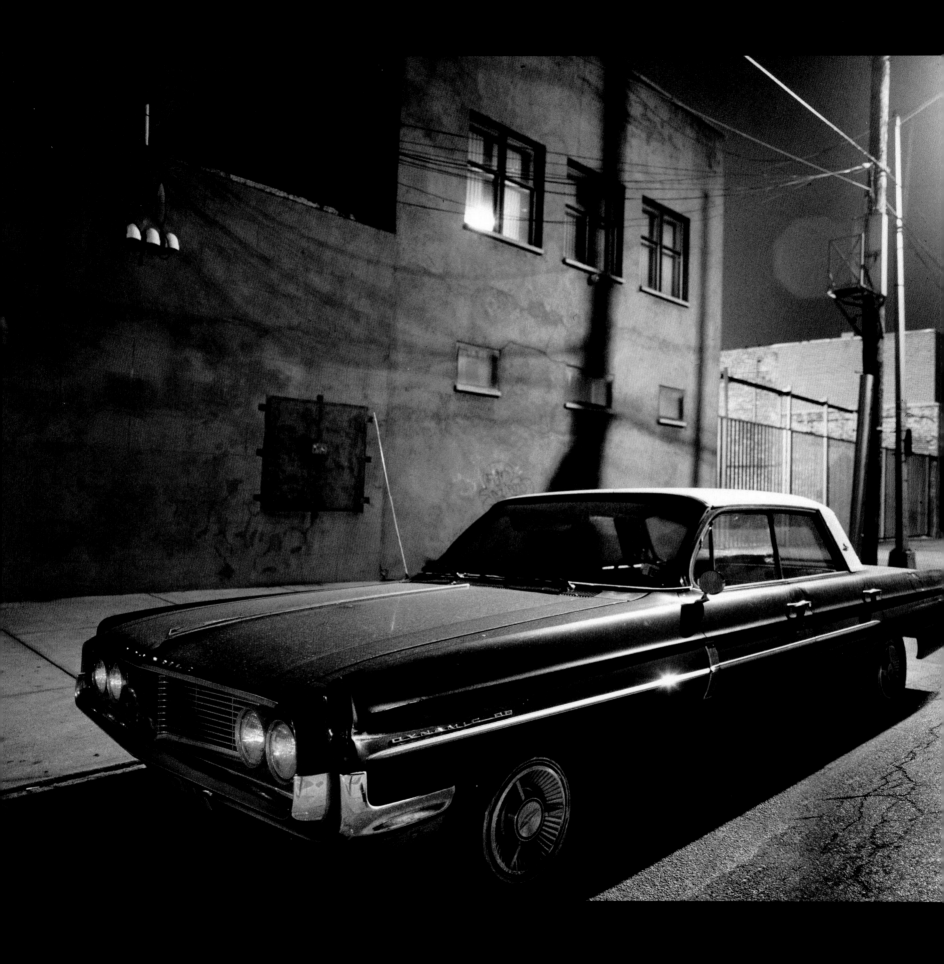

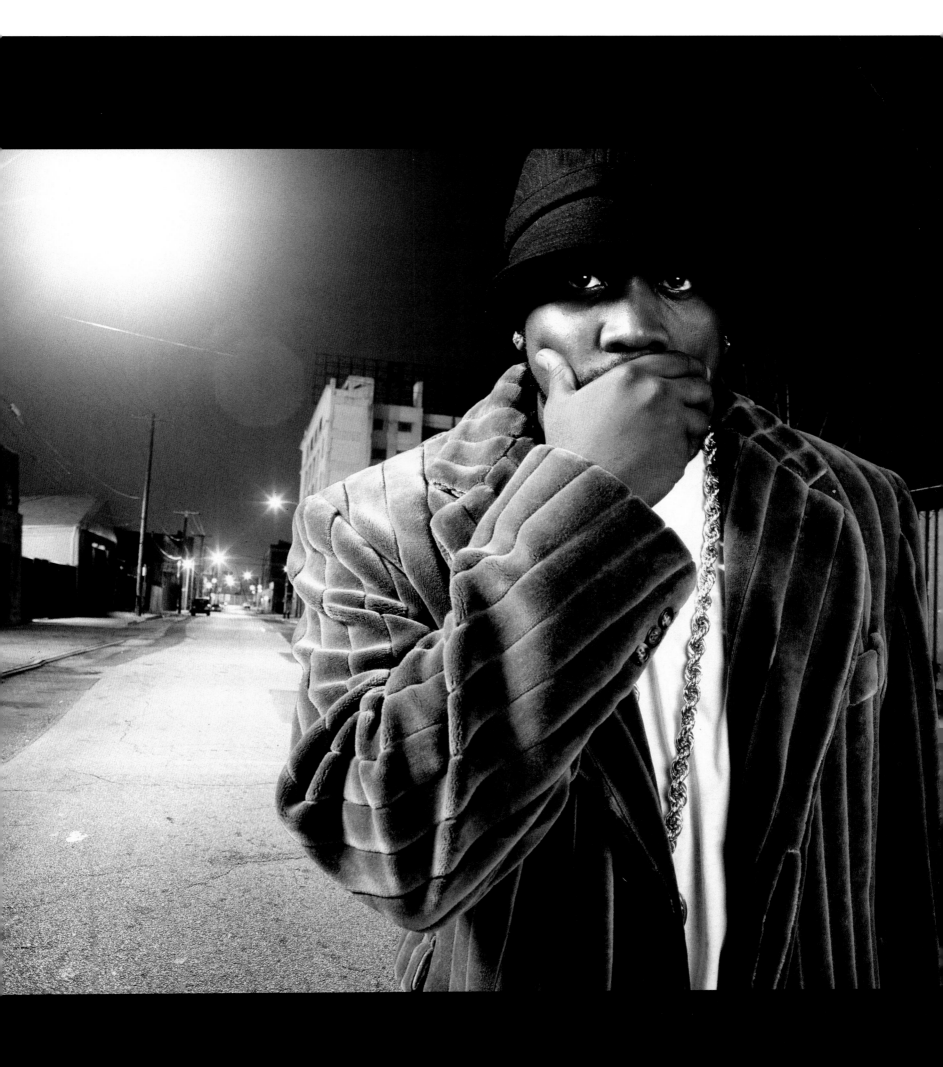

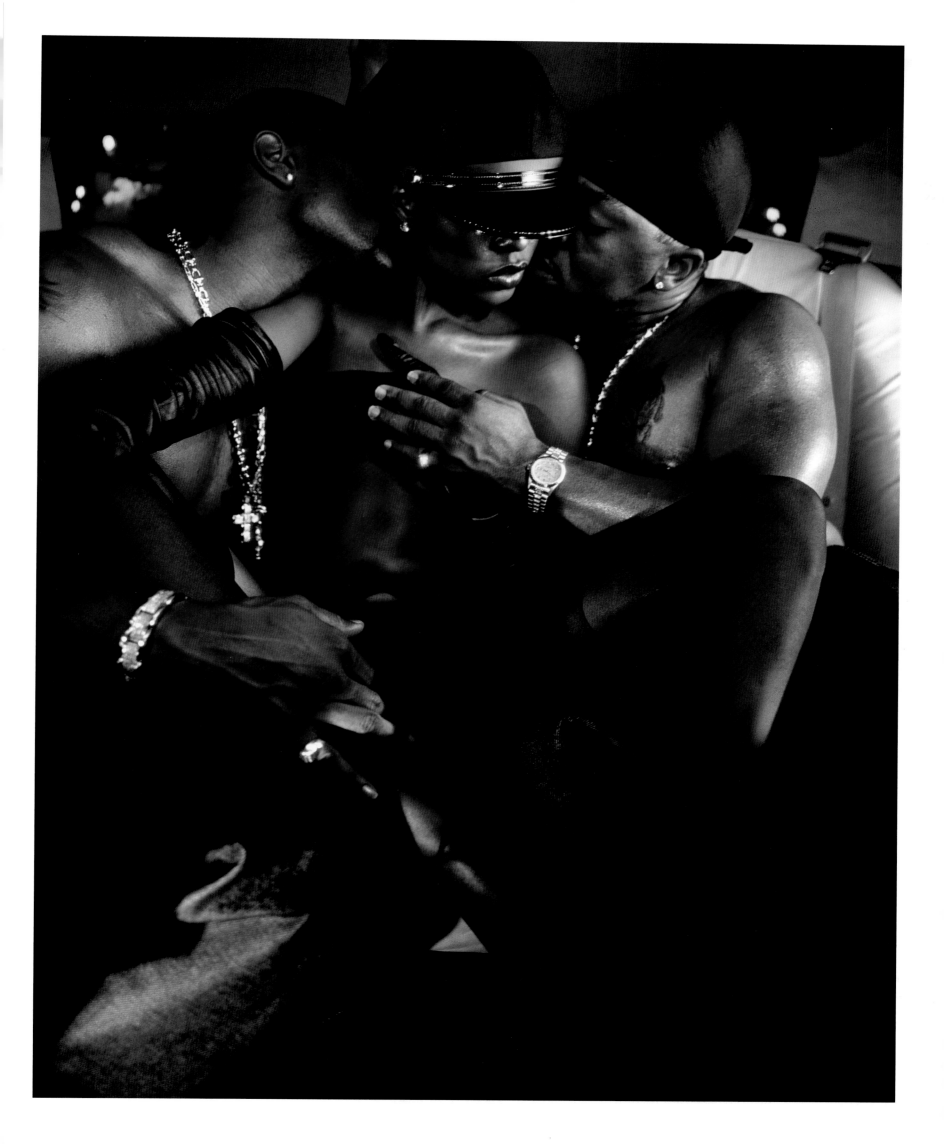

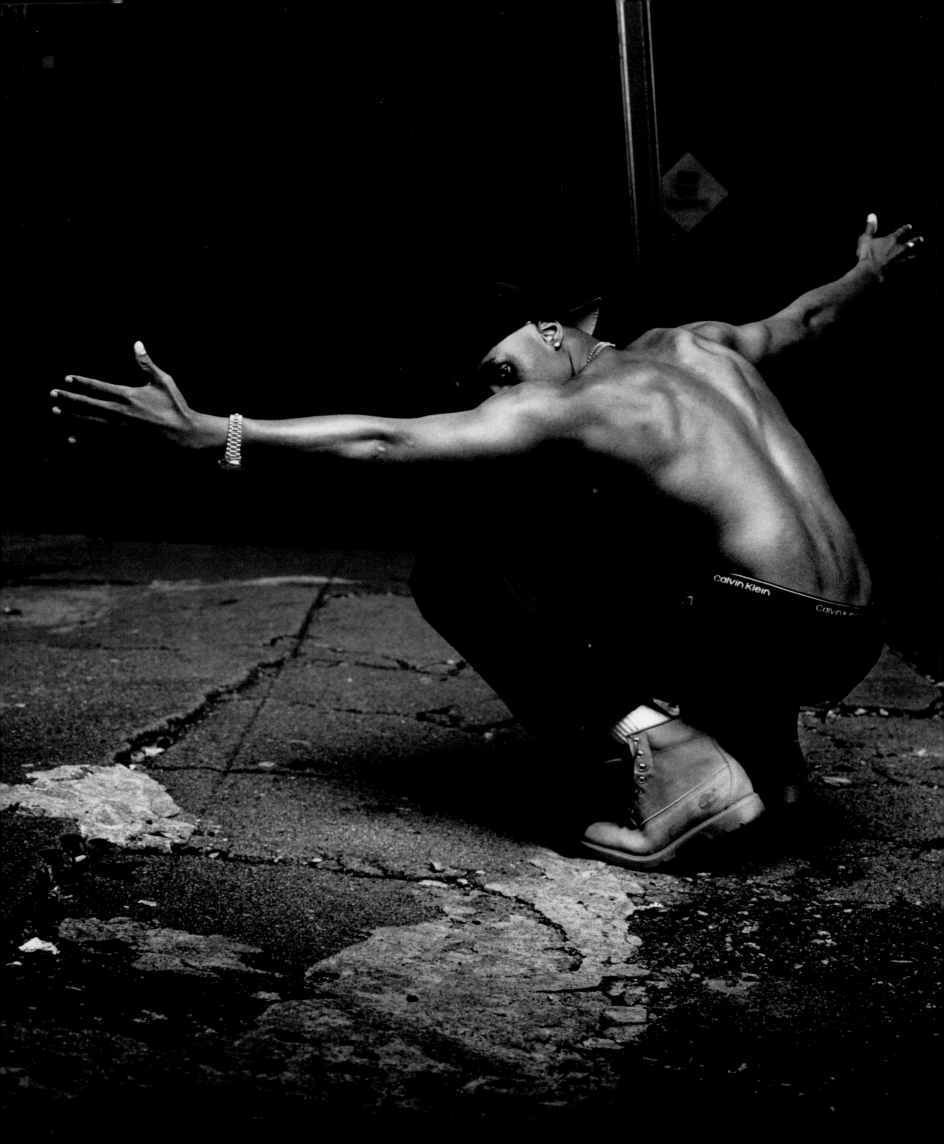

"I'm trying to run a business," says Sean "Puffy" Combs. "I ain't trying to run no young, reckless black man type of situation." At age 26, this fudgey Thurston Howell III definitely has a situation on his hands. Puff Daddy has mutated into a monster bigger than hip hop, bigger than rock 'n' roll, bigger than comet-worshipping cults and Bigfoot sightings. He's became a franchise, a brand name—a plastic-and-rubber action figure who dances like Savion Glover, golfs like Tiger Woods, and flies like R. Kelly believes he can."

—*from "Koo Koo for Cocoa Puff" by Sacha Jenkins*

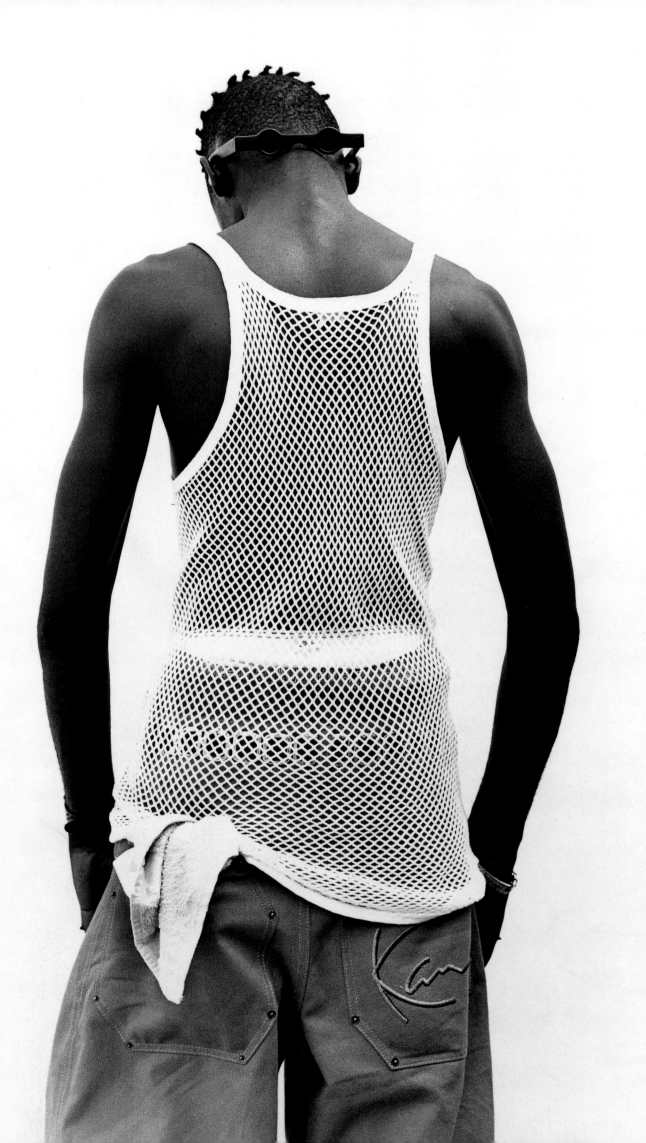

048. Buju Banton by Christian Witkin

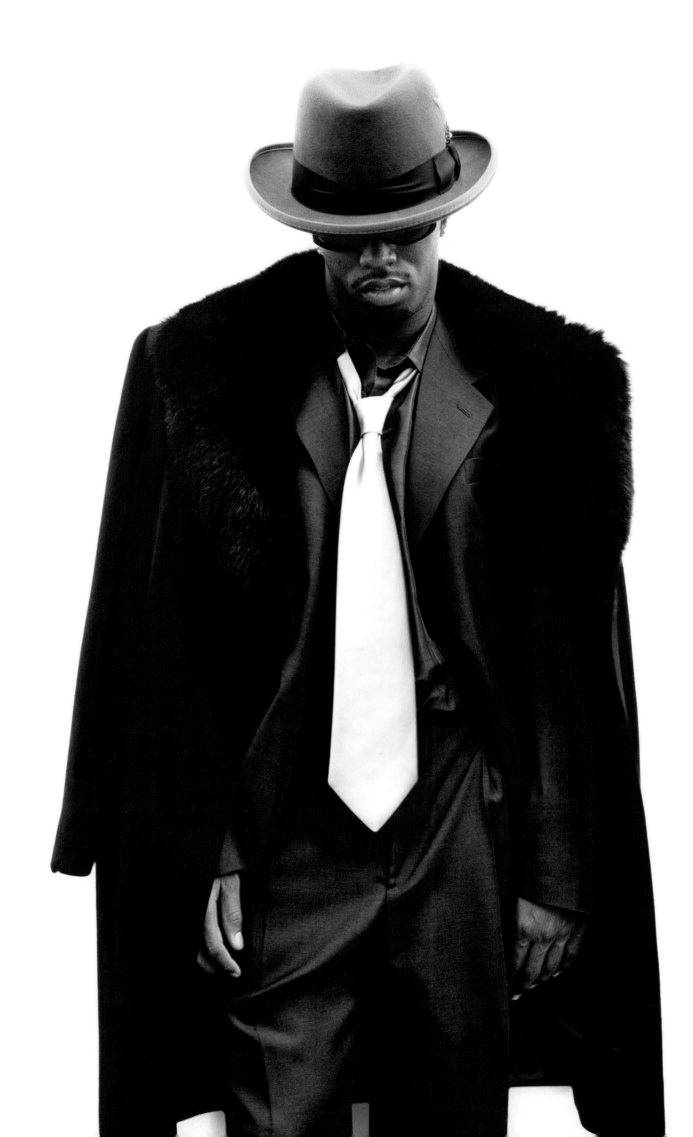

049. Puff Daddy by Piotr Sikora

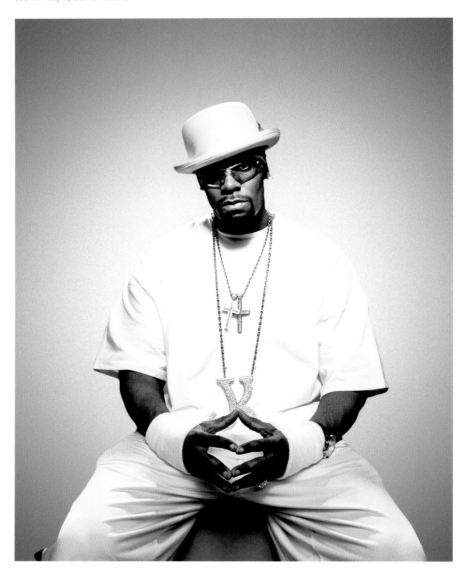

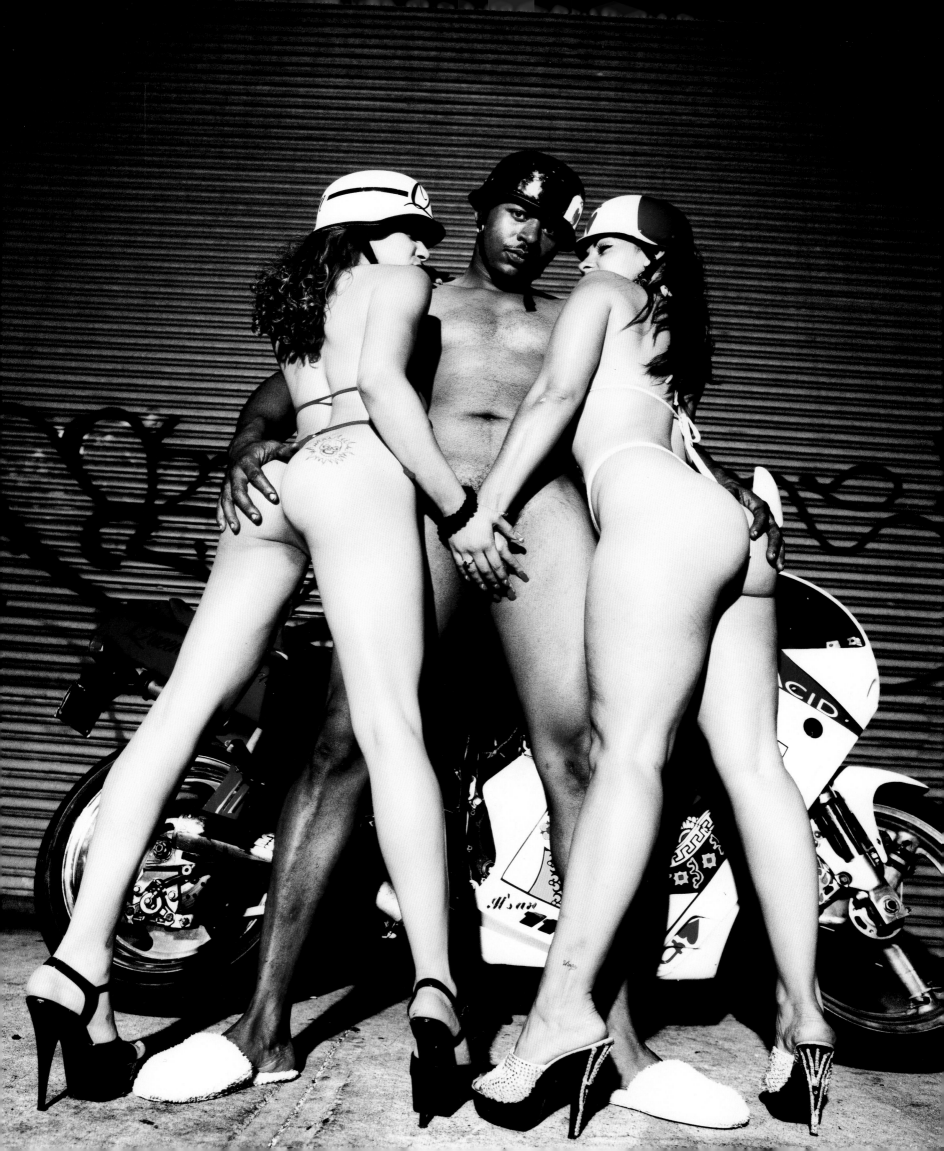

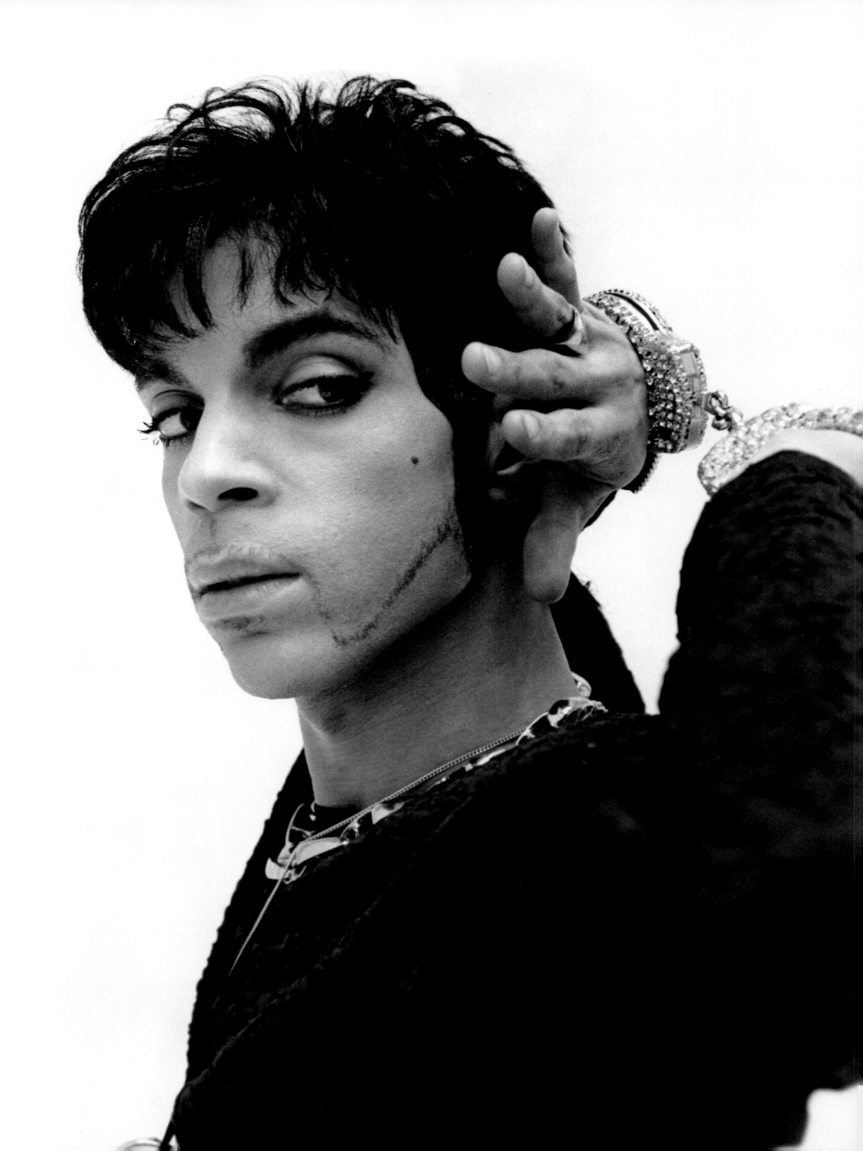

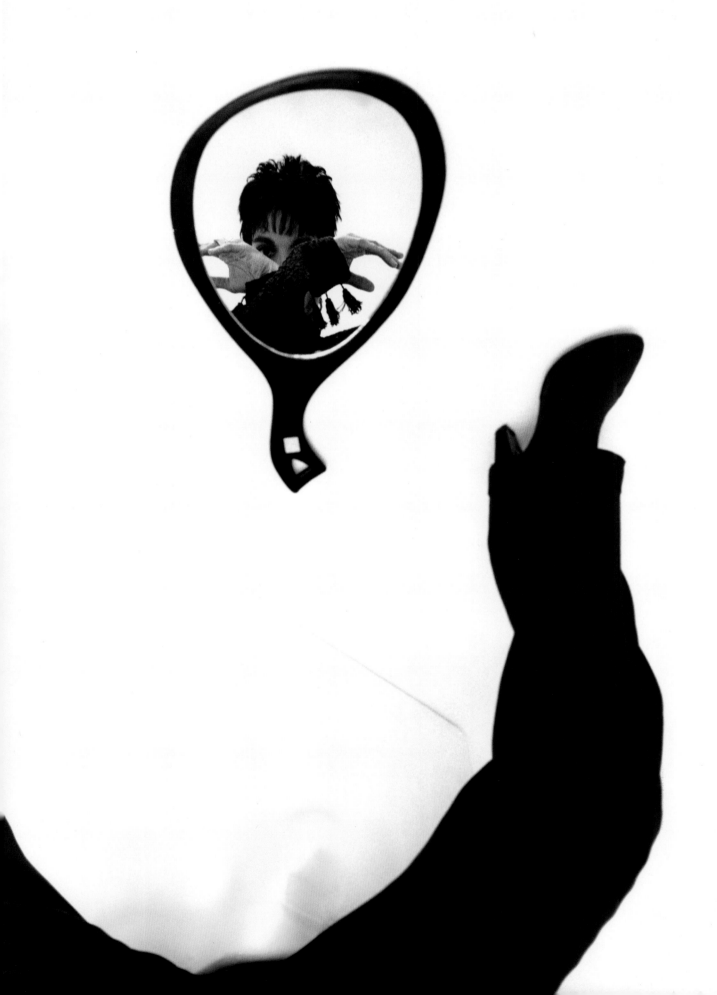

052. Prince by Dana Lixenberg

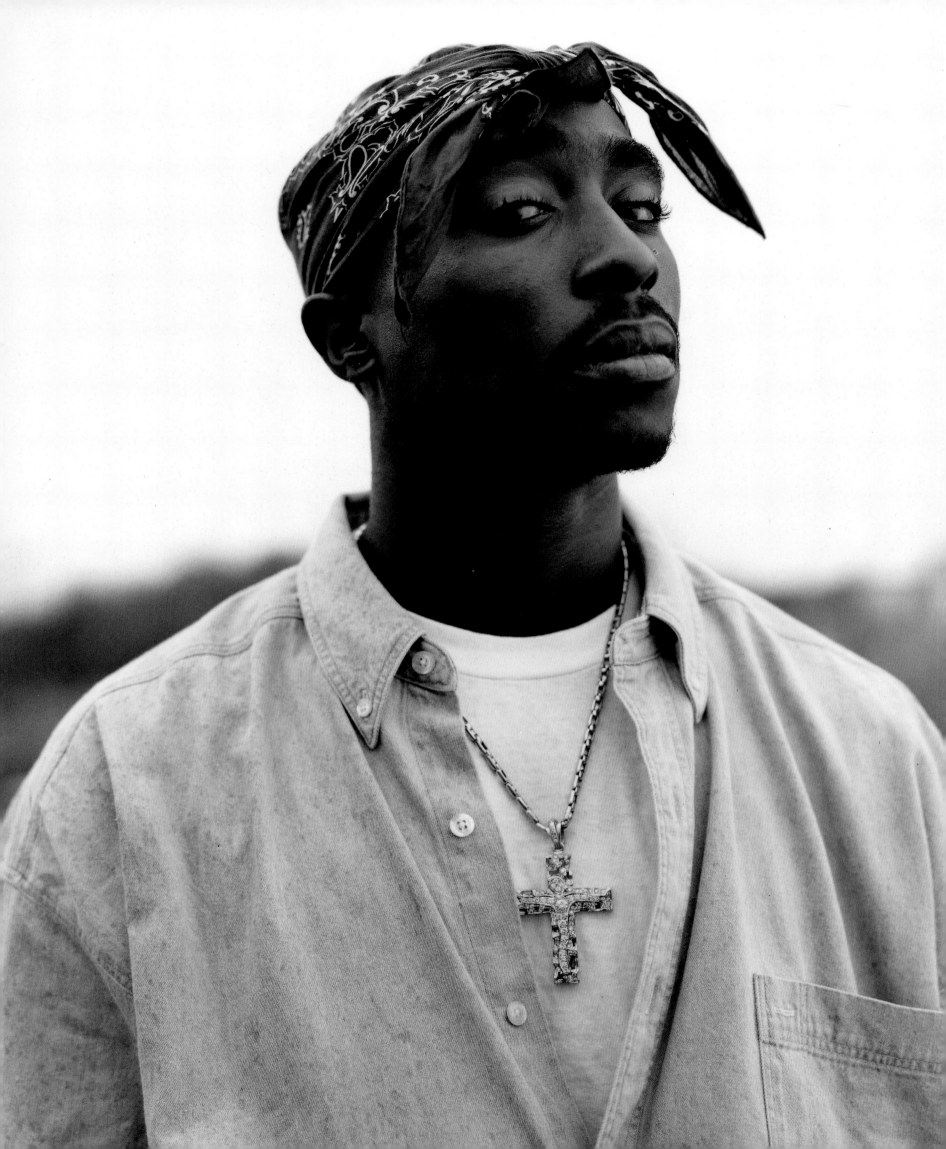

"We're all soldiers, unfortunately. Everybody's at war with different things. I'm at war with my own heart sometimes. There's two niggas inside me. One who wants to live in peace, and the other won't die unless he's free."
—Tupac Shakur

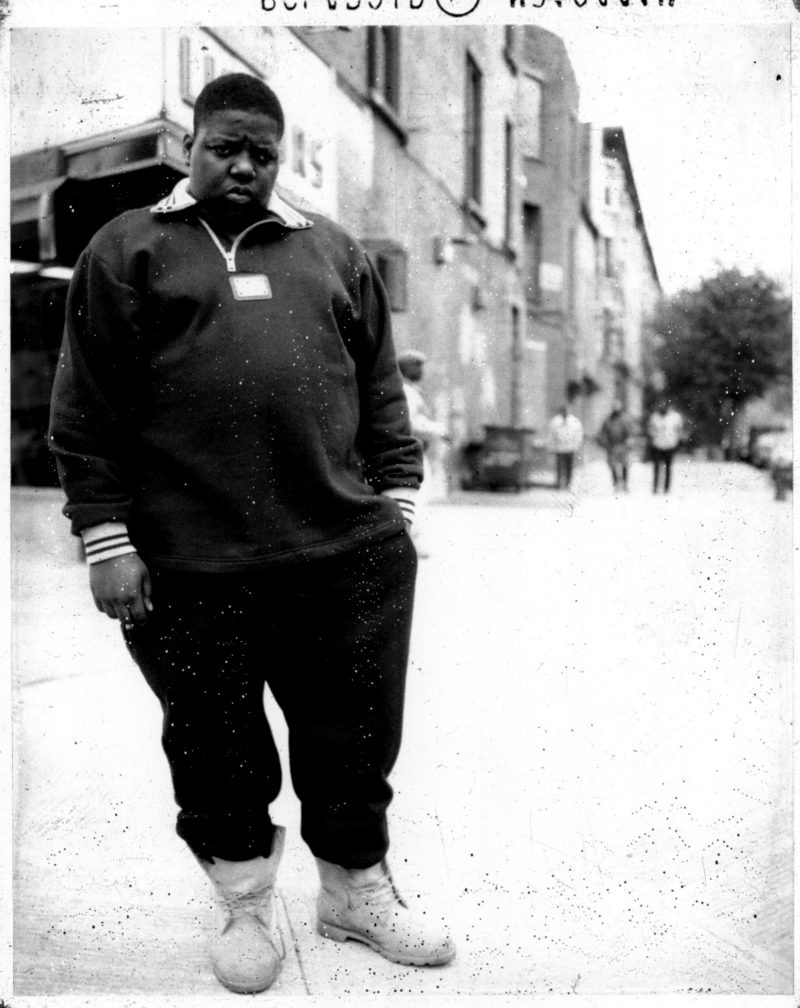

There's Biggie picking up the dice with his right hand, taking a wide step backwards, shaking his hand furiously—and with a twist of his wrist, the dice spill onto the concrete as he snaps his fingers and lets out a satisfied Hah! Rolling out a 4-5-6, he wins the bank of $6. "Ain't no nigga I know that been hustlin' or been fucked up in the street shit that can tell me they ain't never wish they was fuckin' dead," he says. "I know plenty of nights I laid down and wished it was just over."

—from "Notorious" by Mimi Valdes

"If I was the type of person who got in it for the money, I would have quit after the first album."

 —*Eminem*

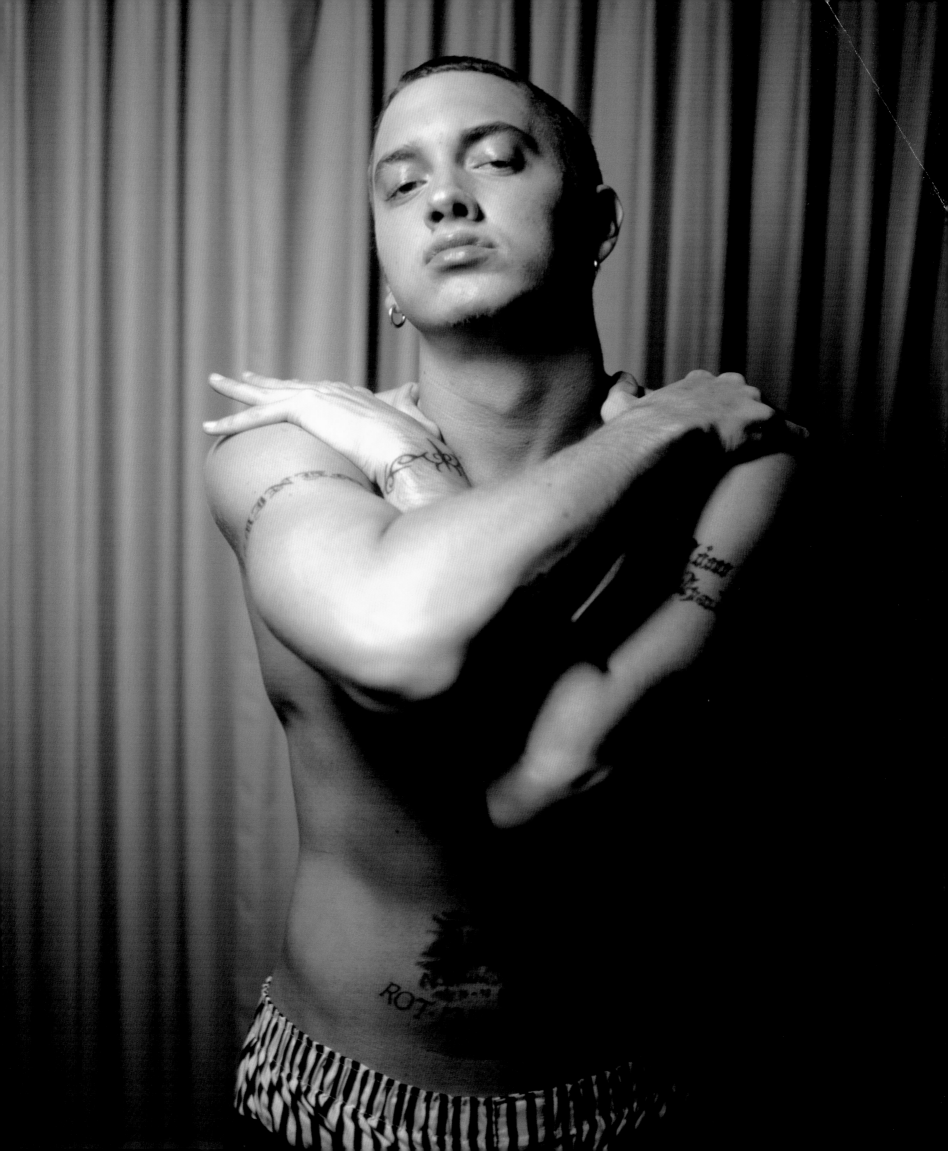

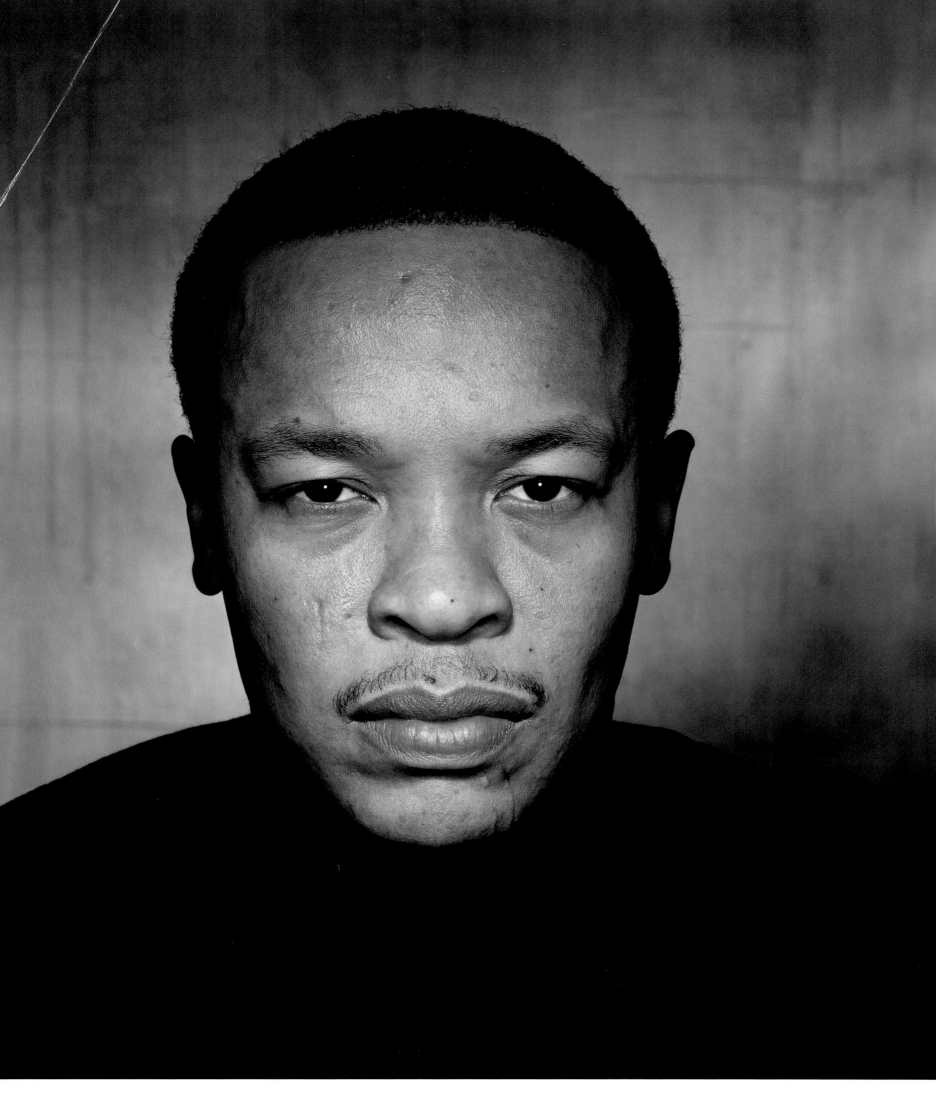

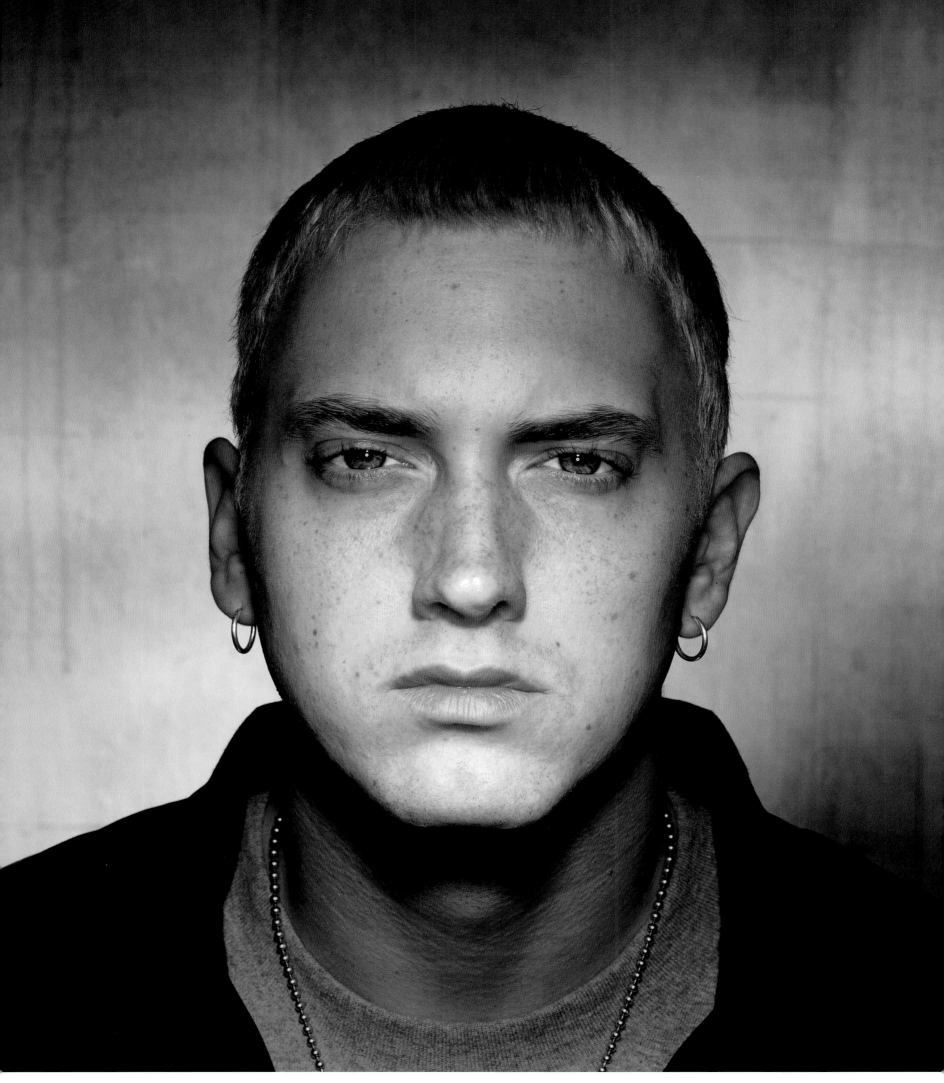

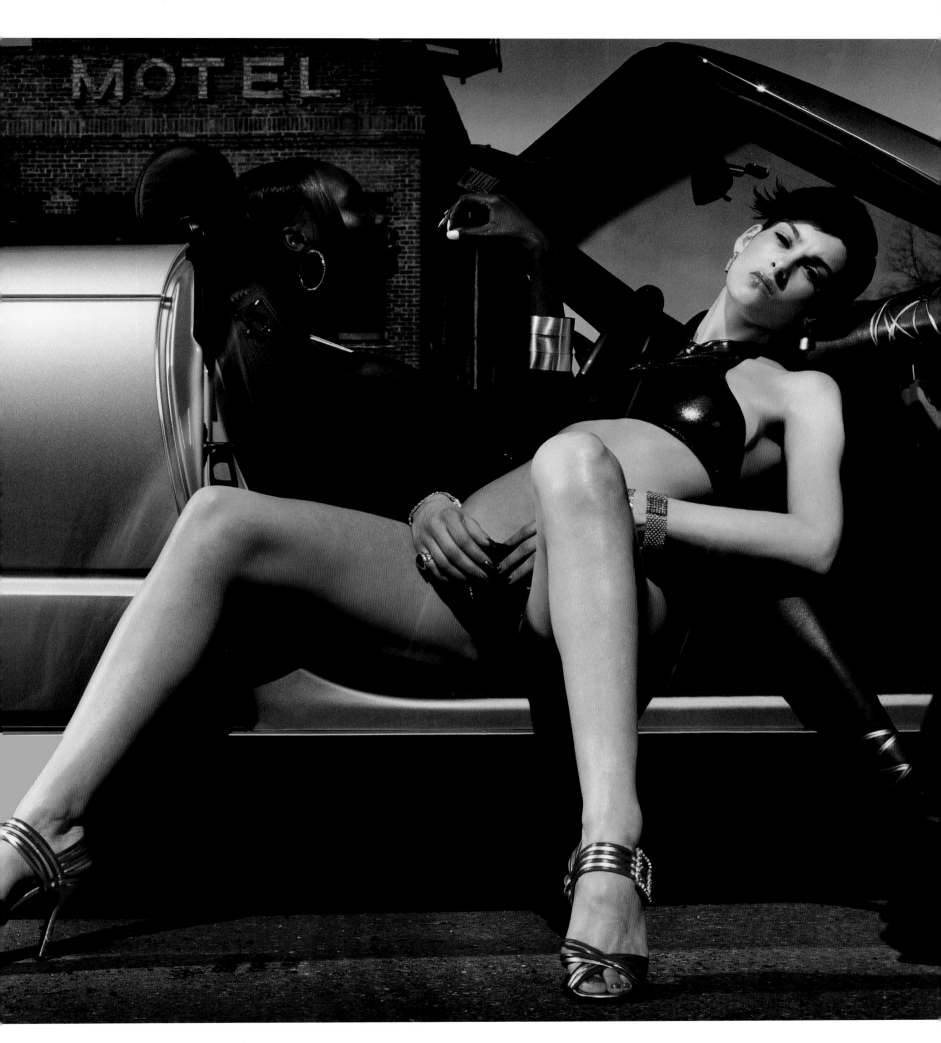

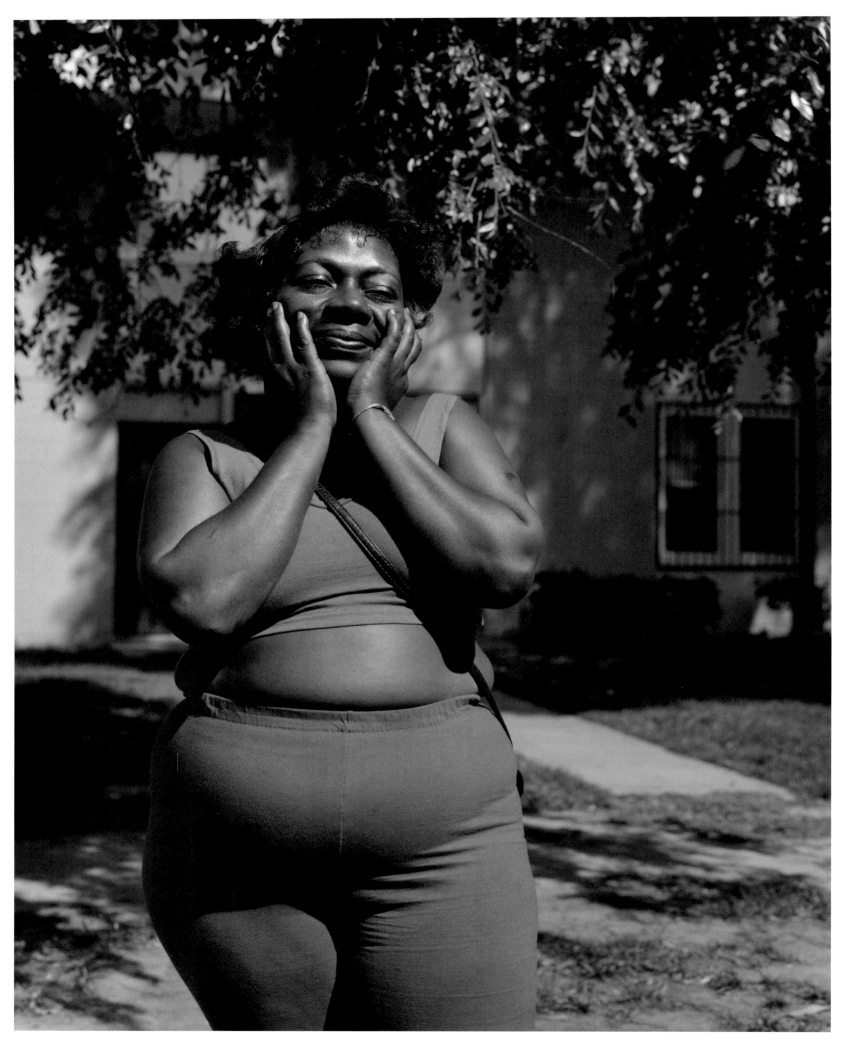

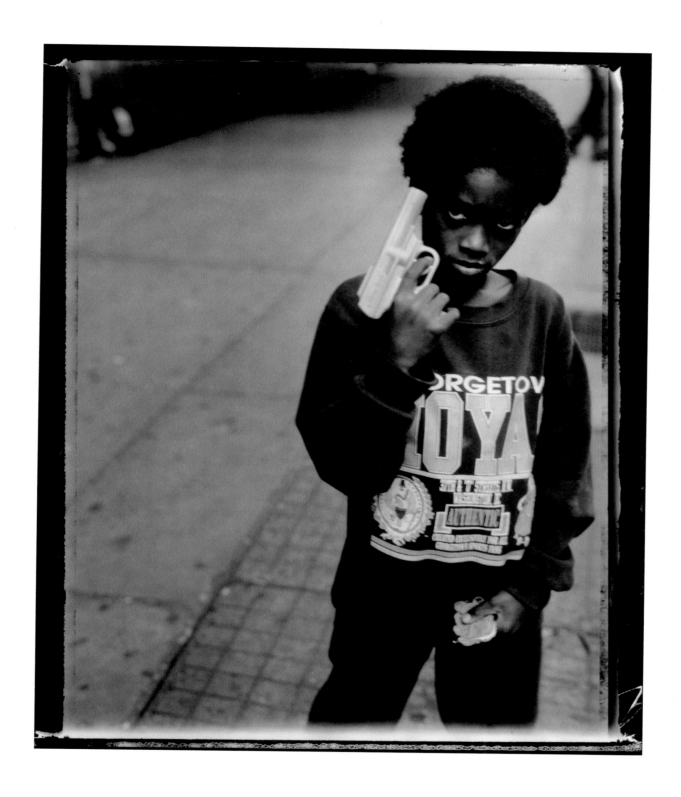

067. Alicia Keys by Michael Thompson

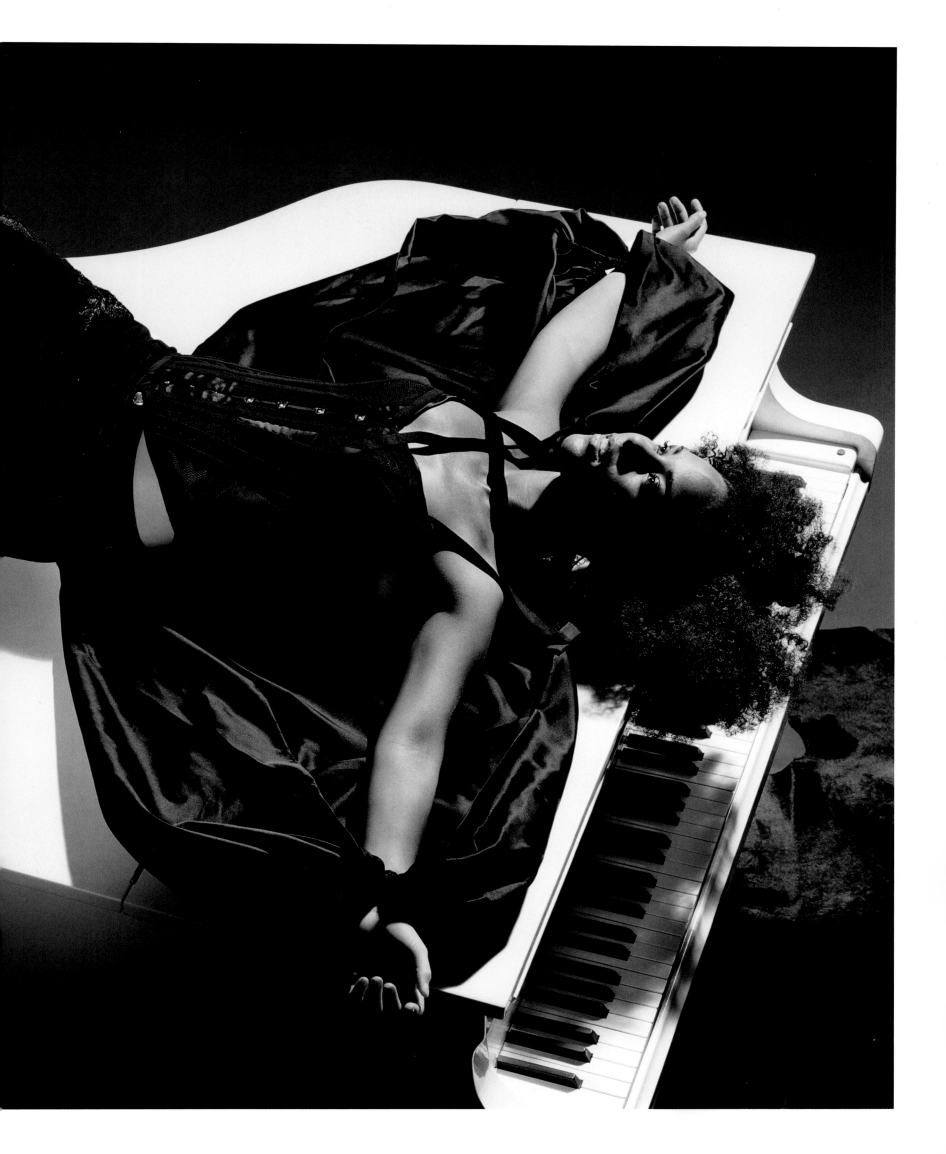

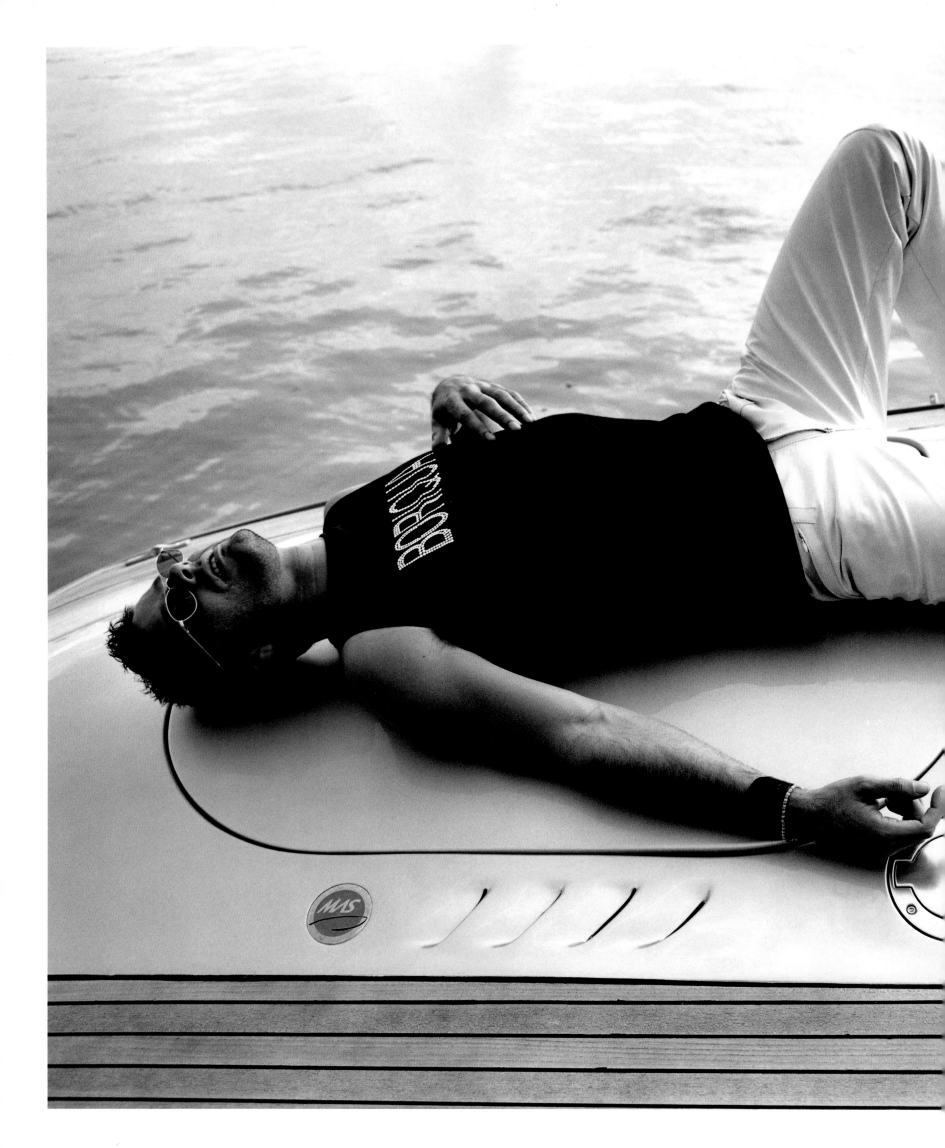

Kim's capacity to calculate what you want her to be and then become it—a skill she honed in the streets of Brooklyn—makes her damn near interactive. Raunchy, vulnerable, demure. Mae West. Bessie Smith. Lady Godiva. Blue-eyed Barbarella, aqua-haired ghetto mermaid—she's the virtual black girl staring at you from billboards and magazine covers in a dazzling array of guises.

—*from "Blowin' Up" by Robert Marriott*

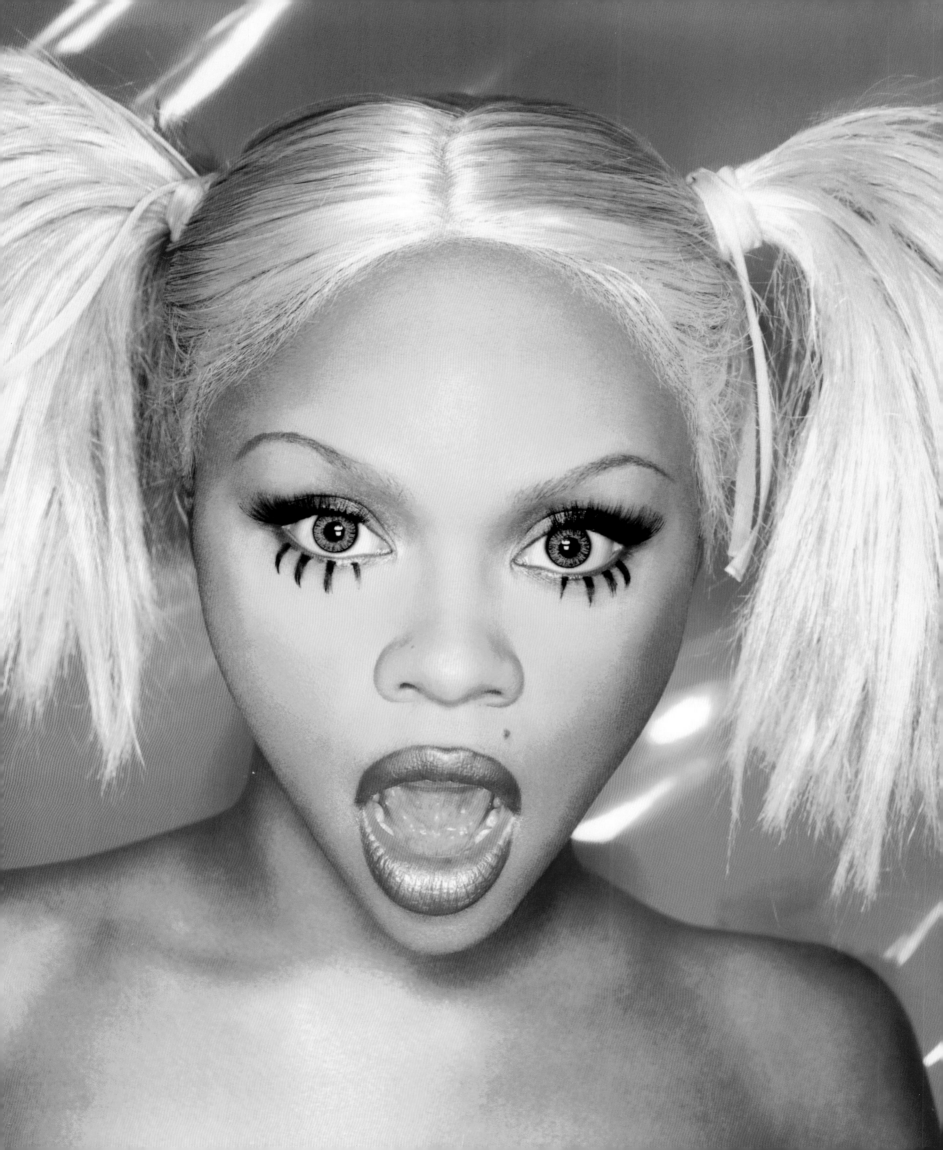

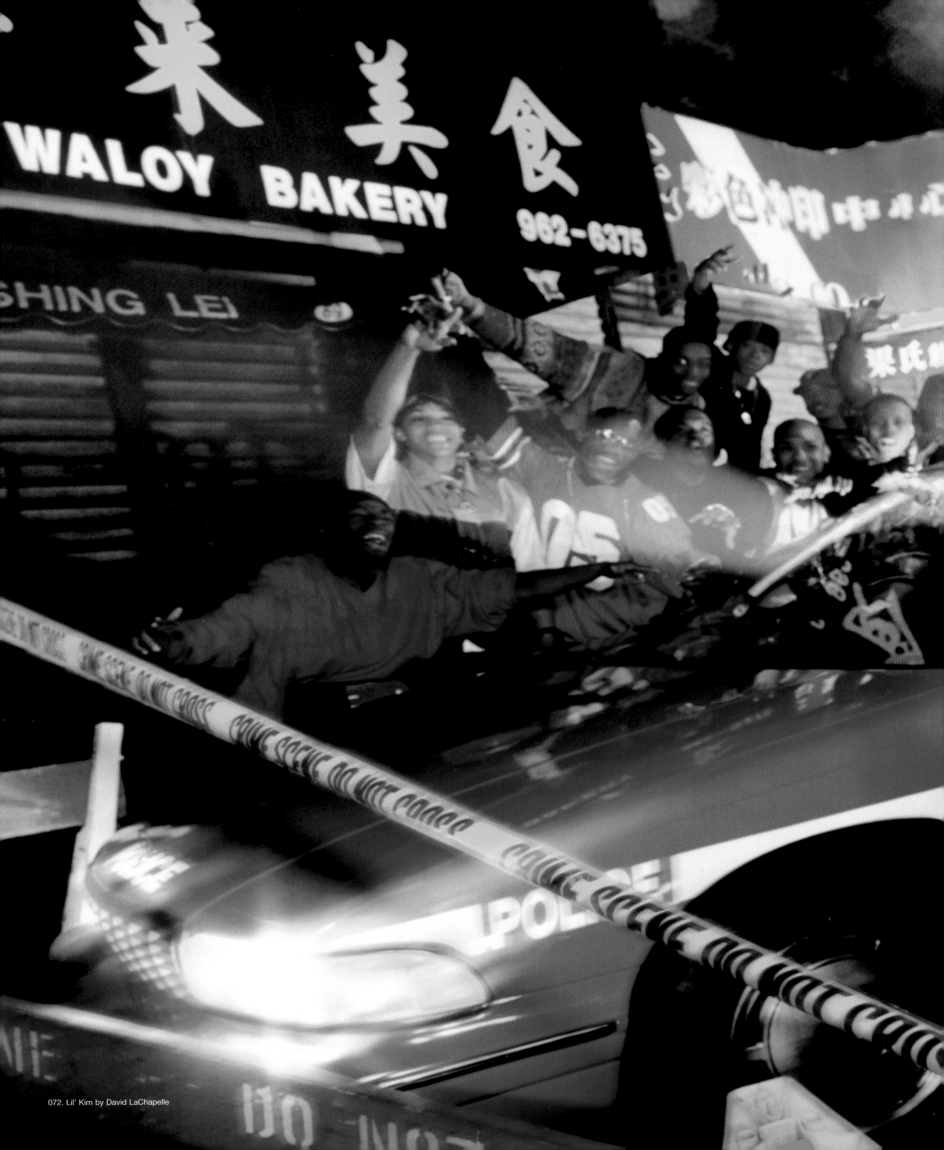

072. Lil' Kim by David LaChapelle

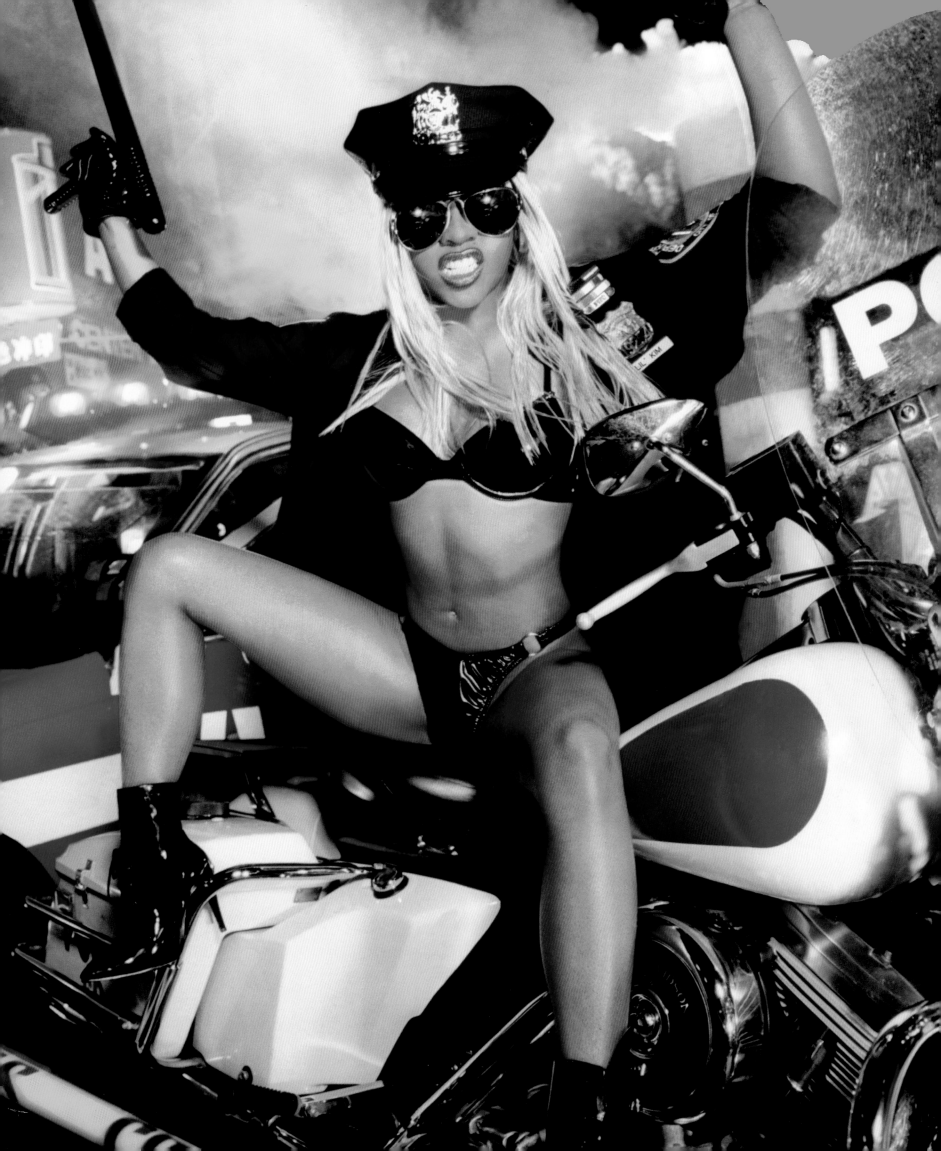

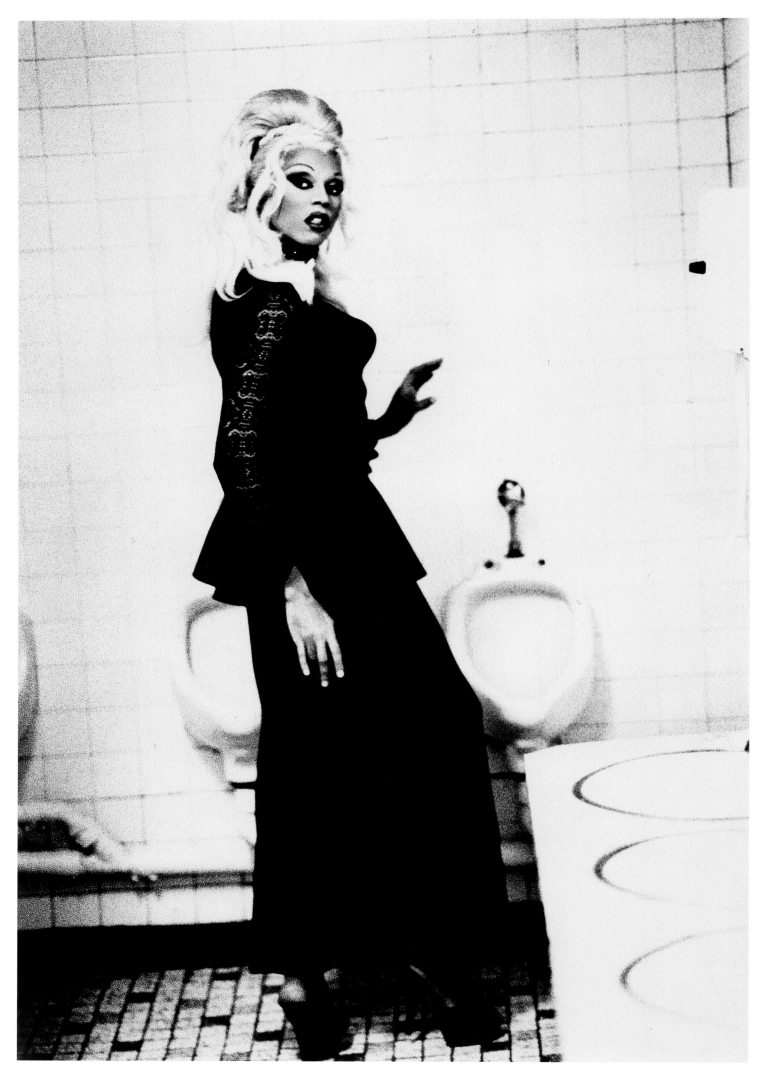

074. RuPaul by Ellen von Unwerth

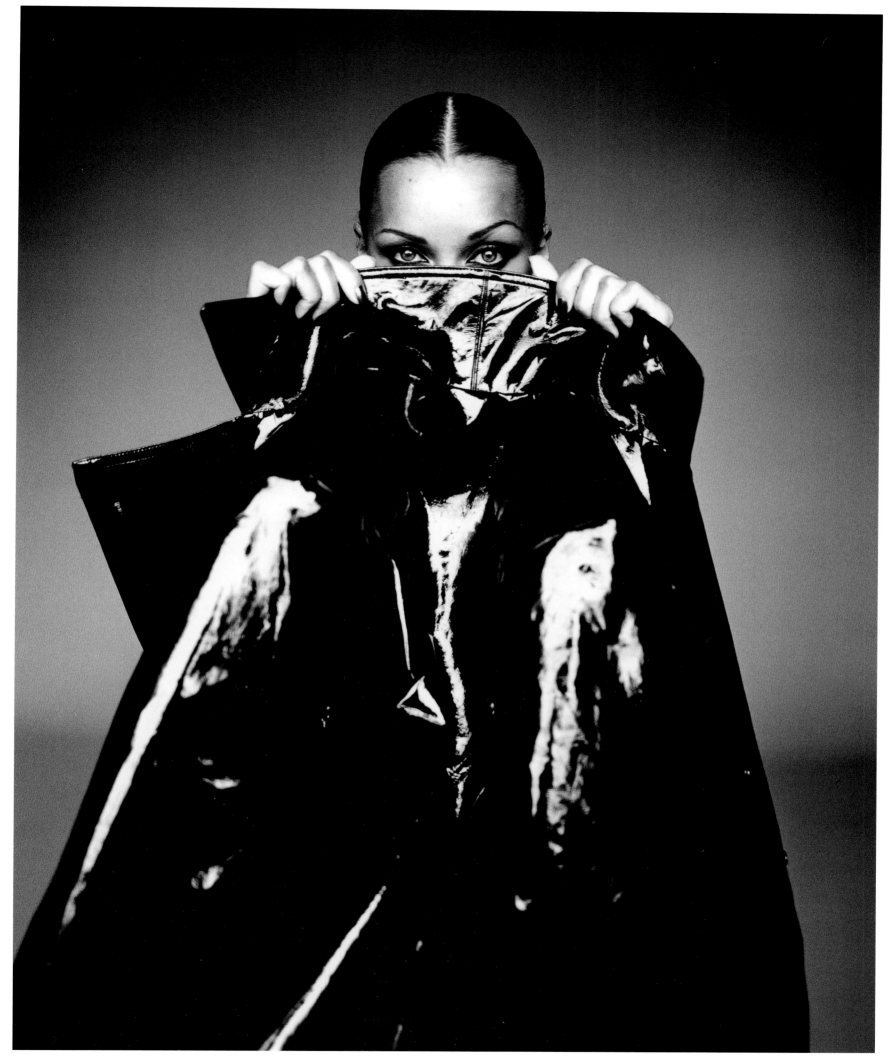

075. Vanessa Williams by Ruven Afanador

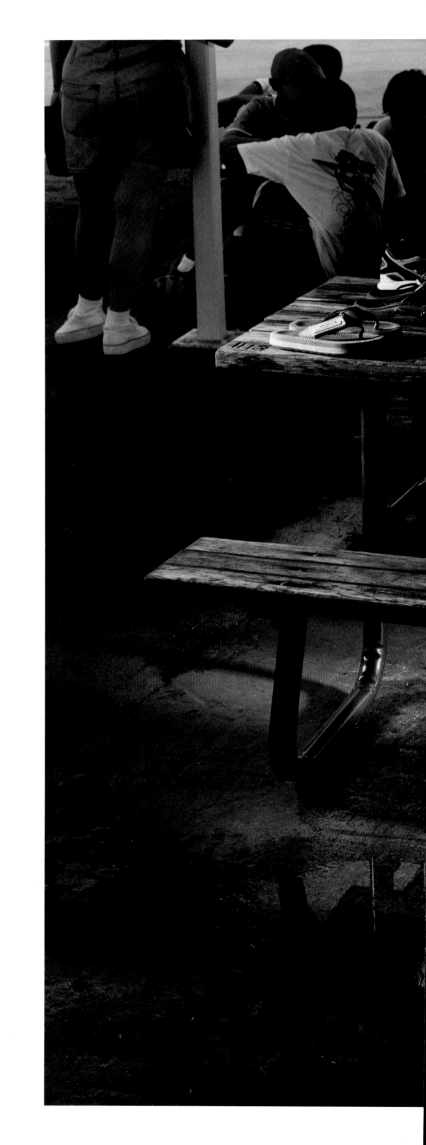

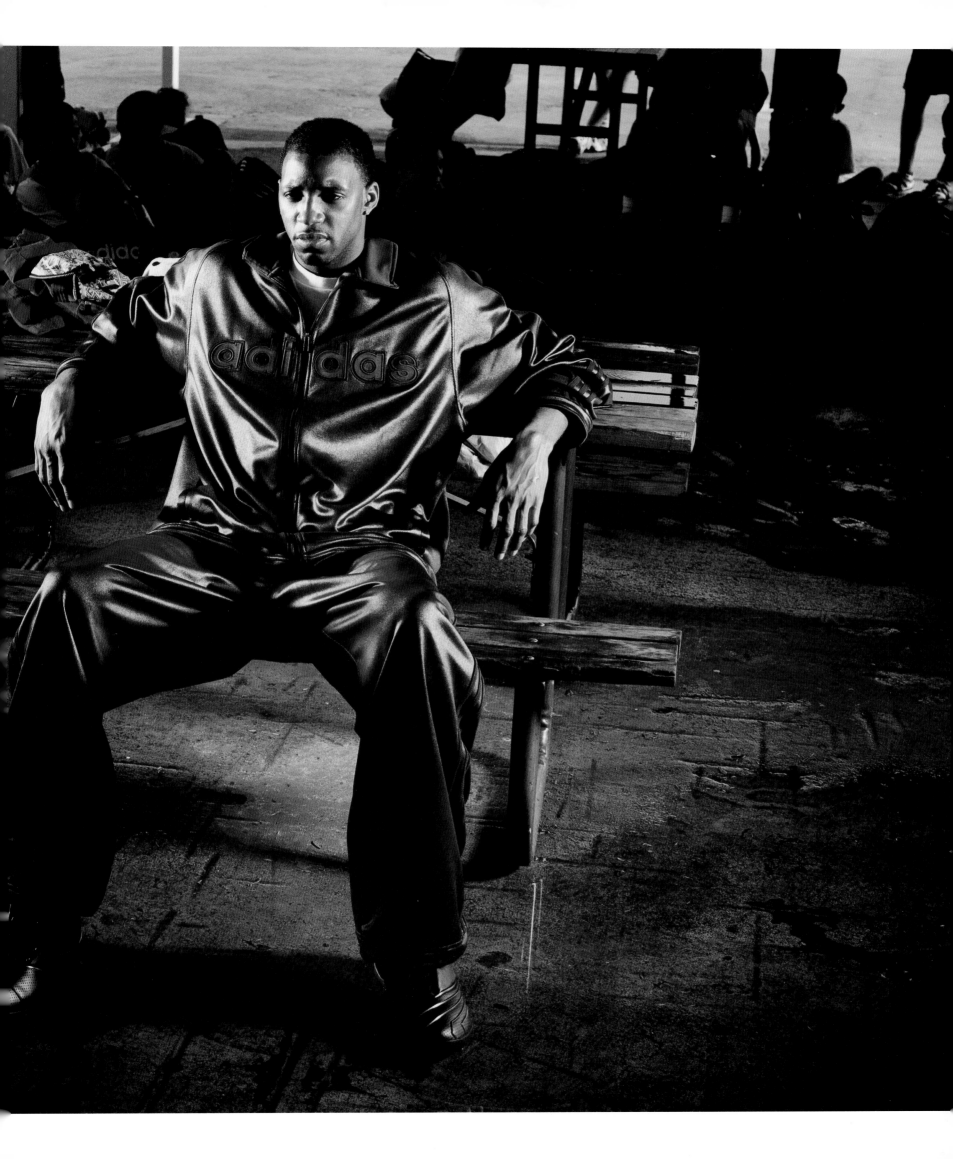

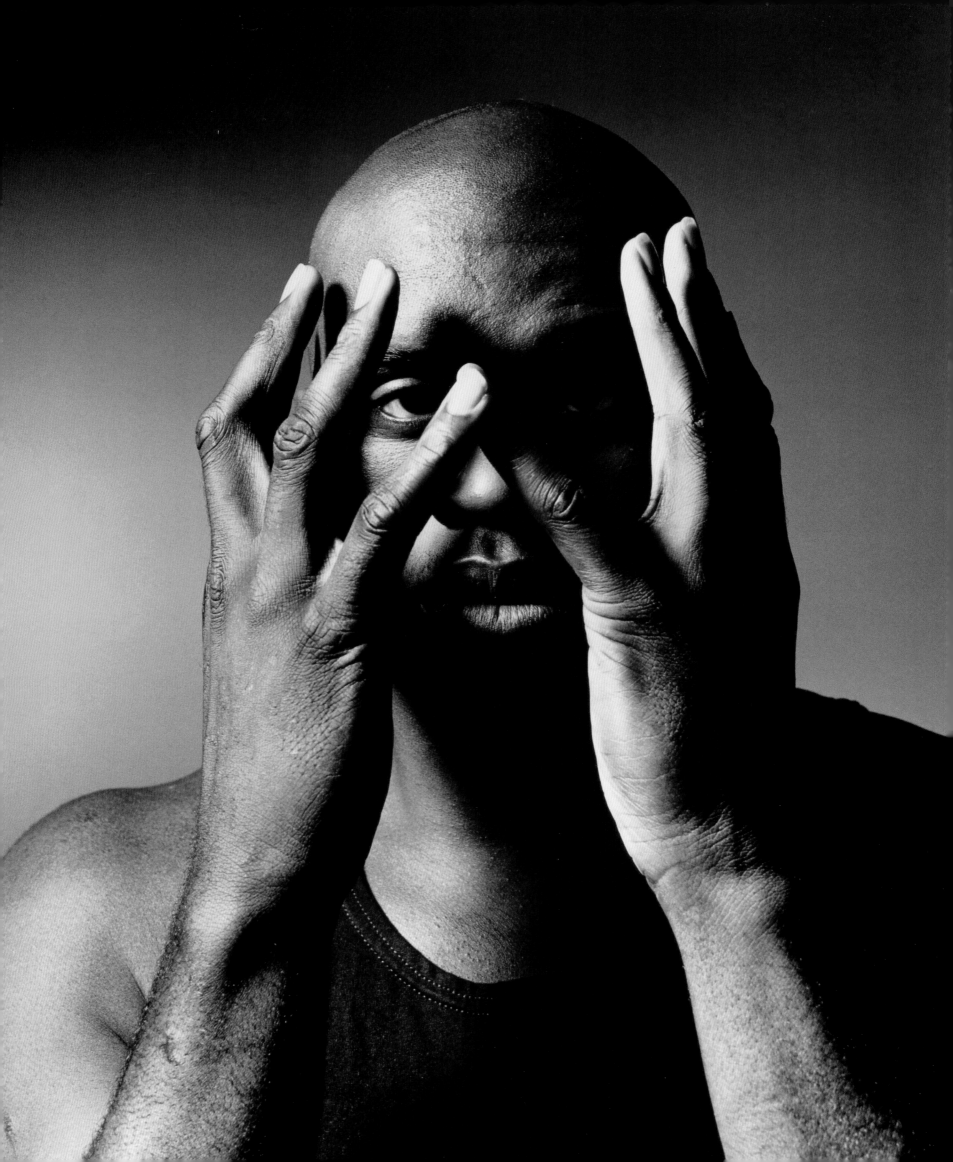

079. Stephon Marbury by Xavier Guardans

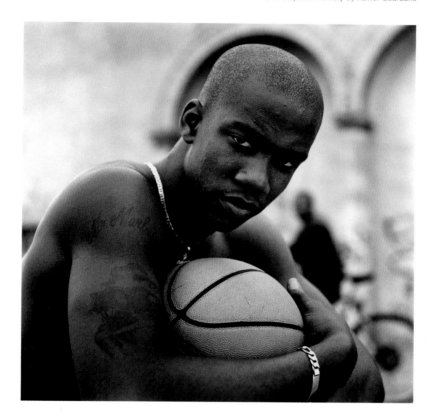

078. Shaquille O'Neal by George Holz

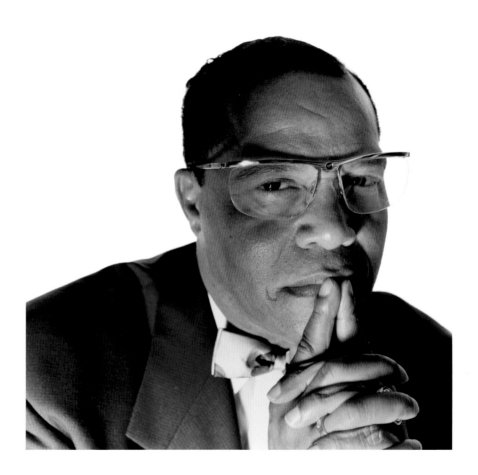

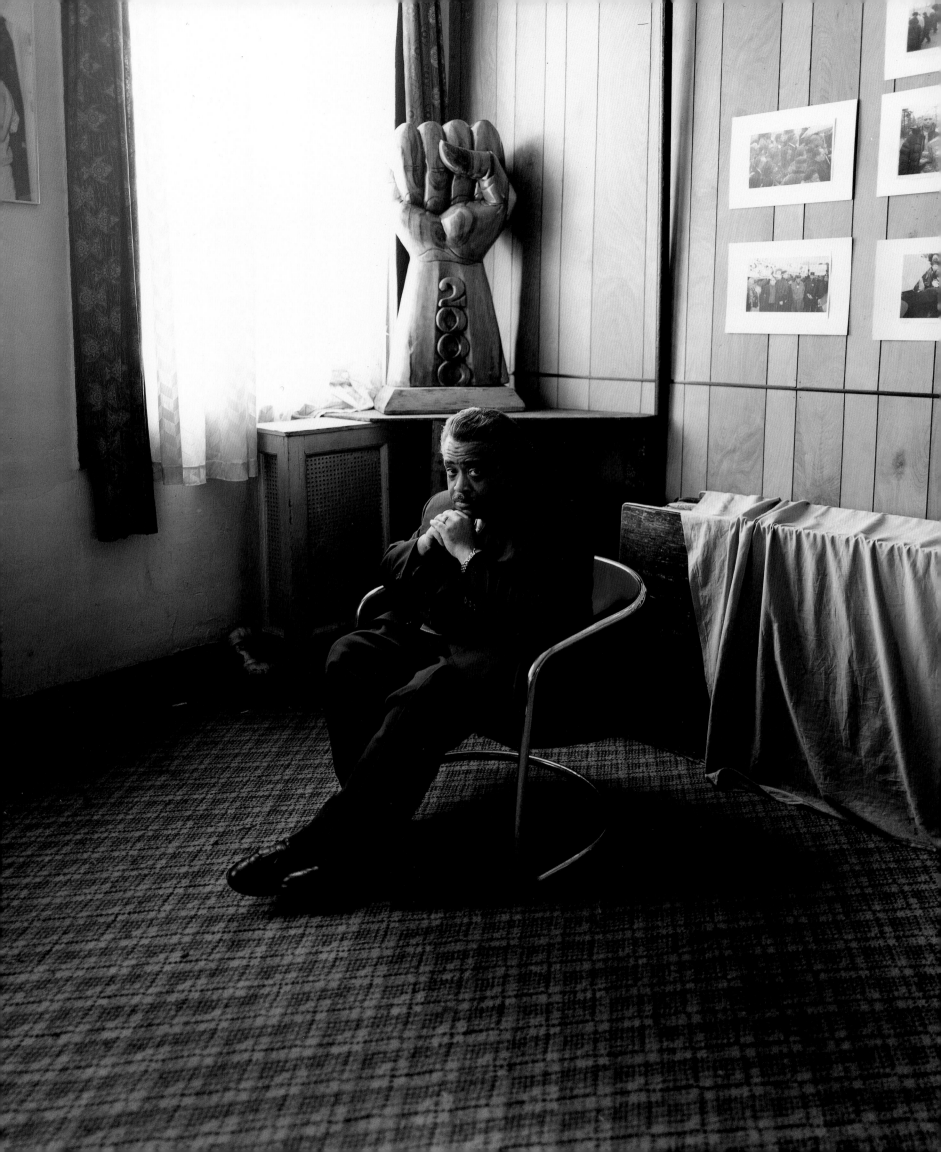

082. Moroccan Boy by Dana Lixenberg

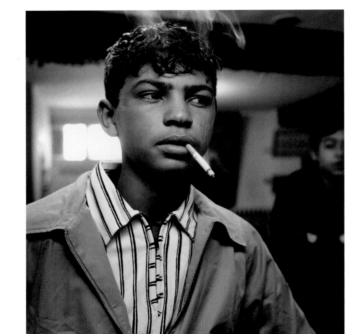

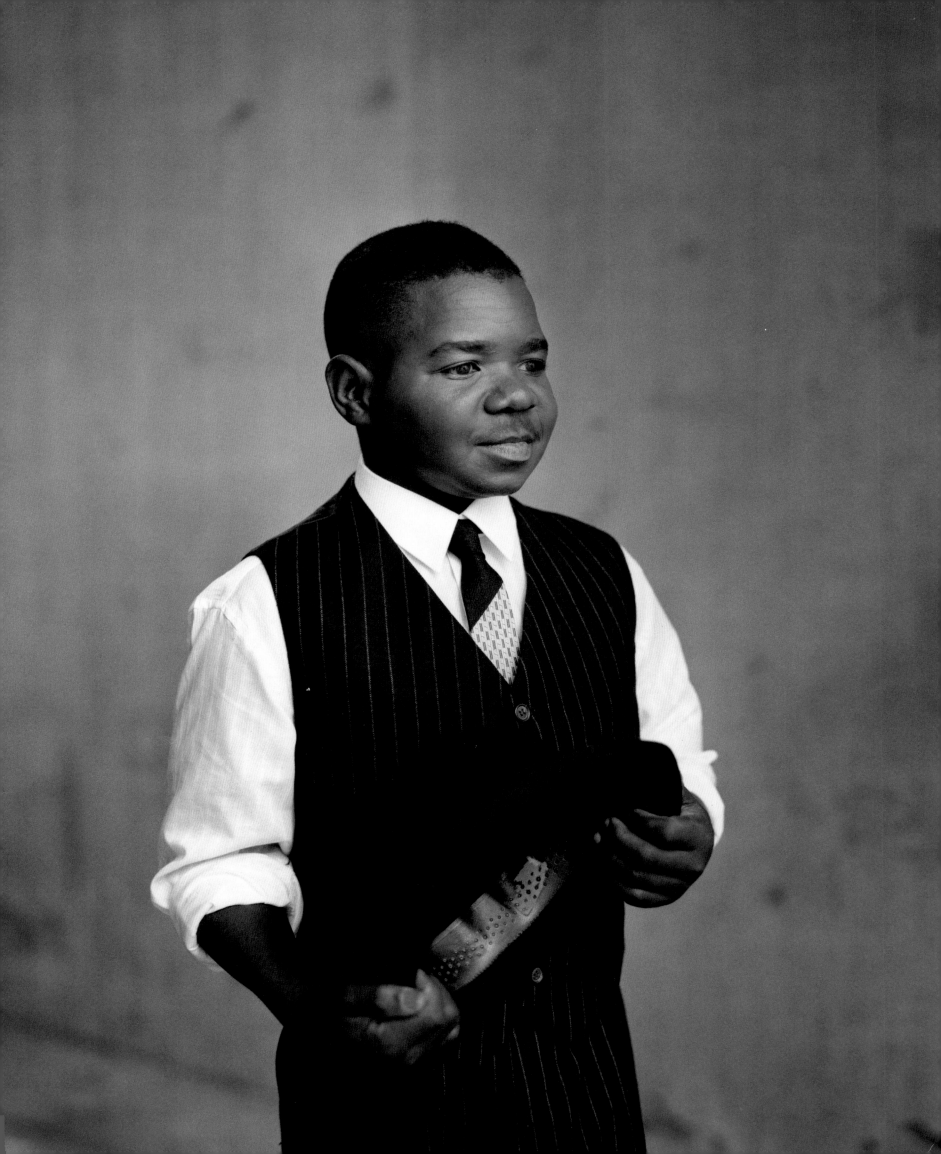

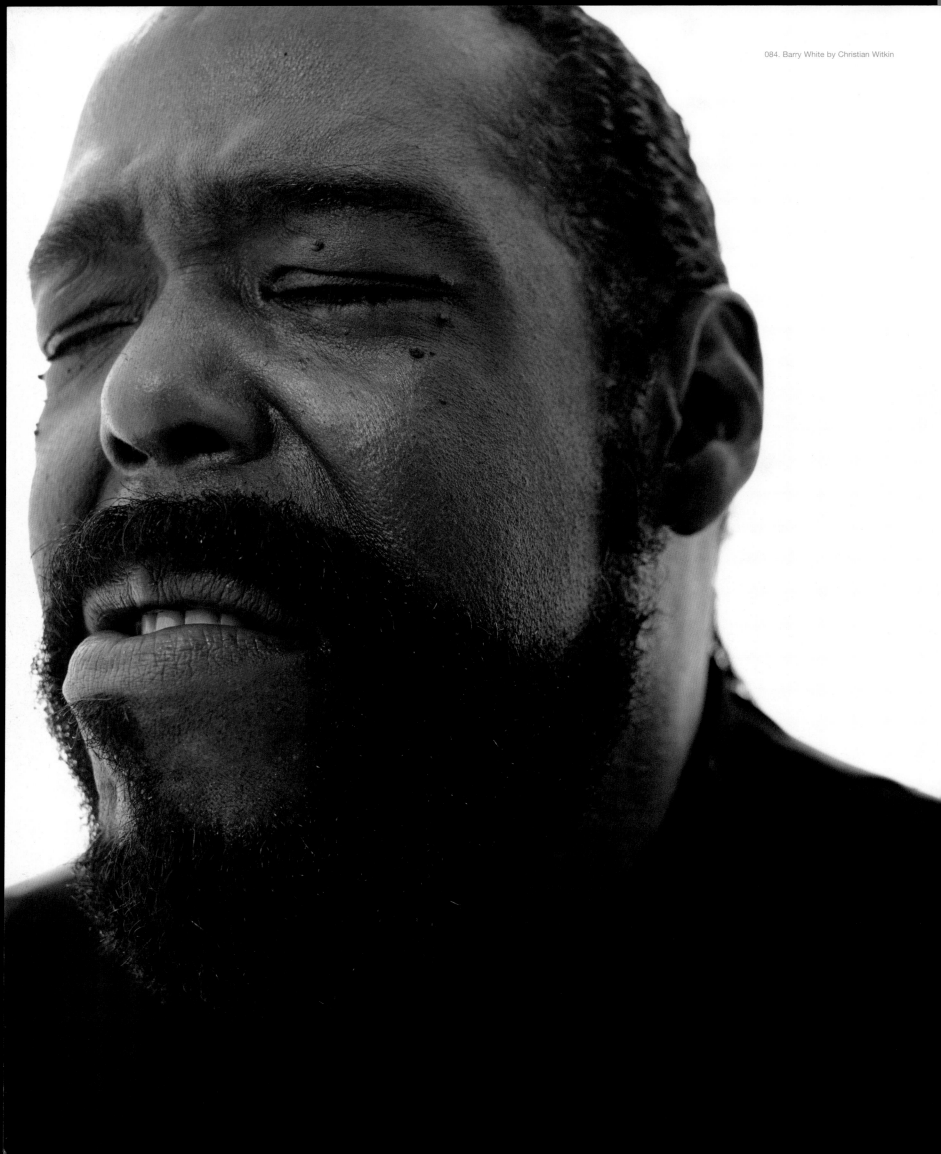

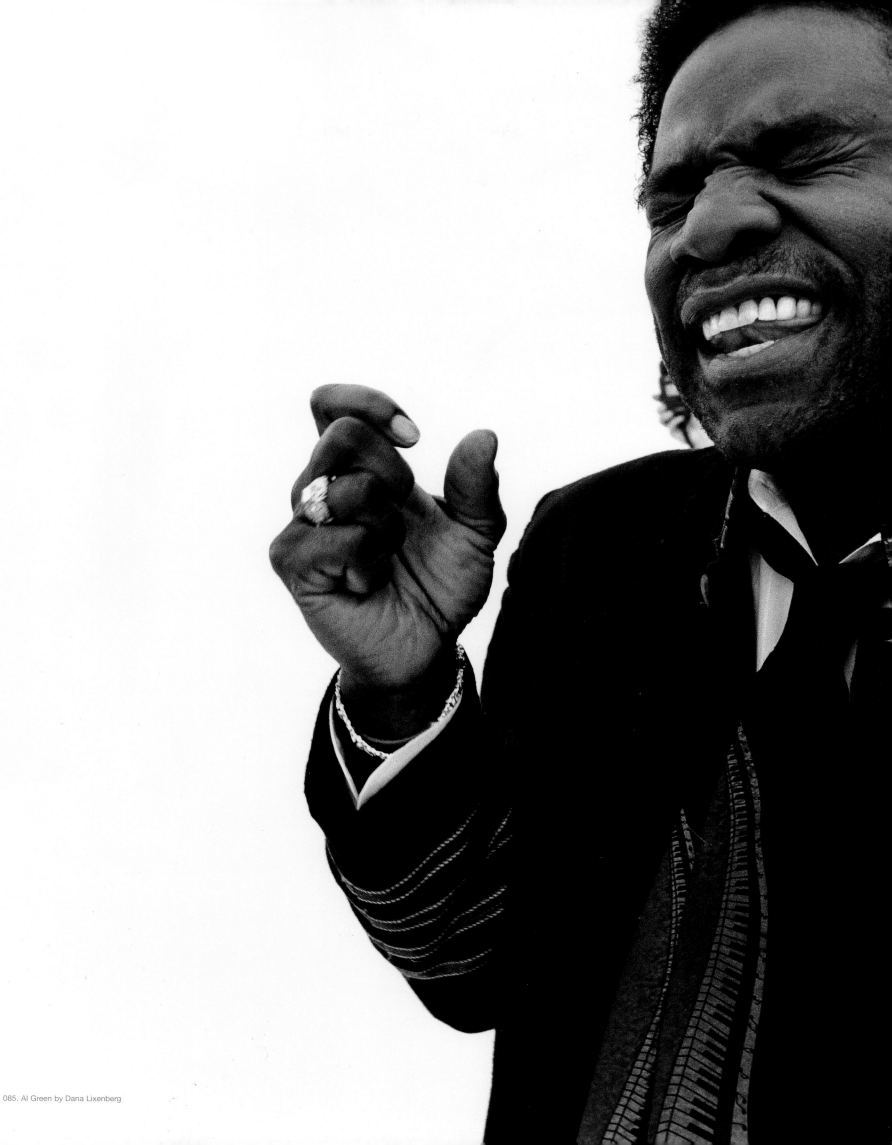

085. Al Green by Dana Lixenberg

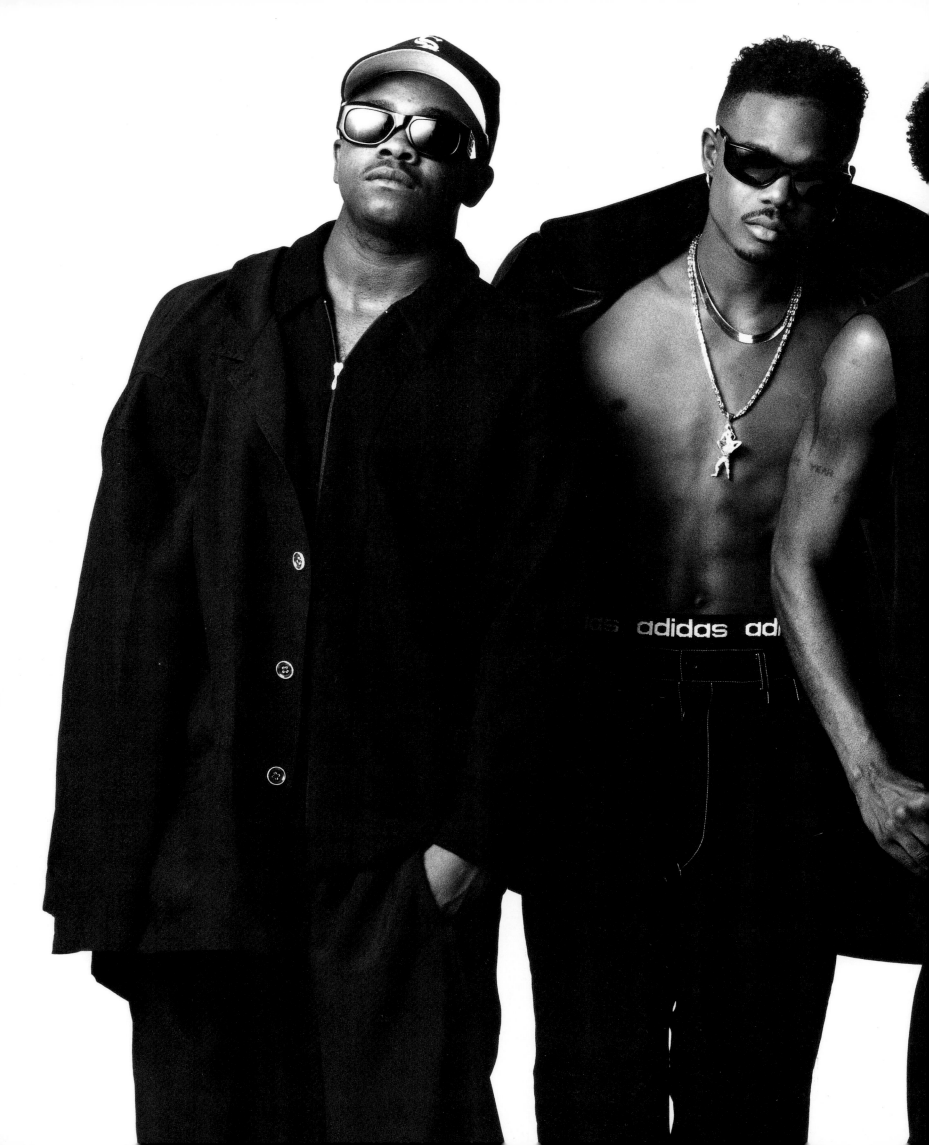

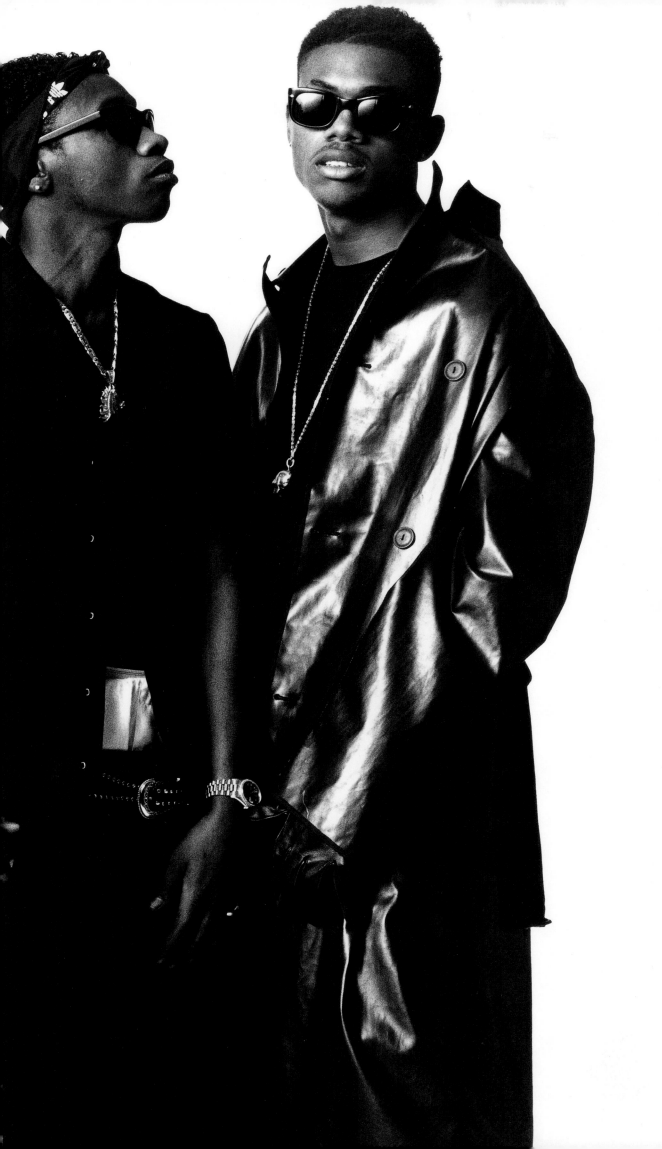

086. Jodeci by Albert Watson

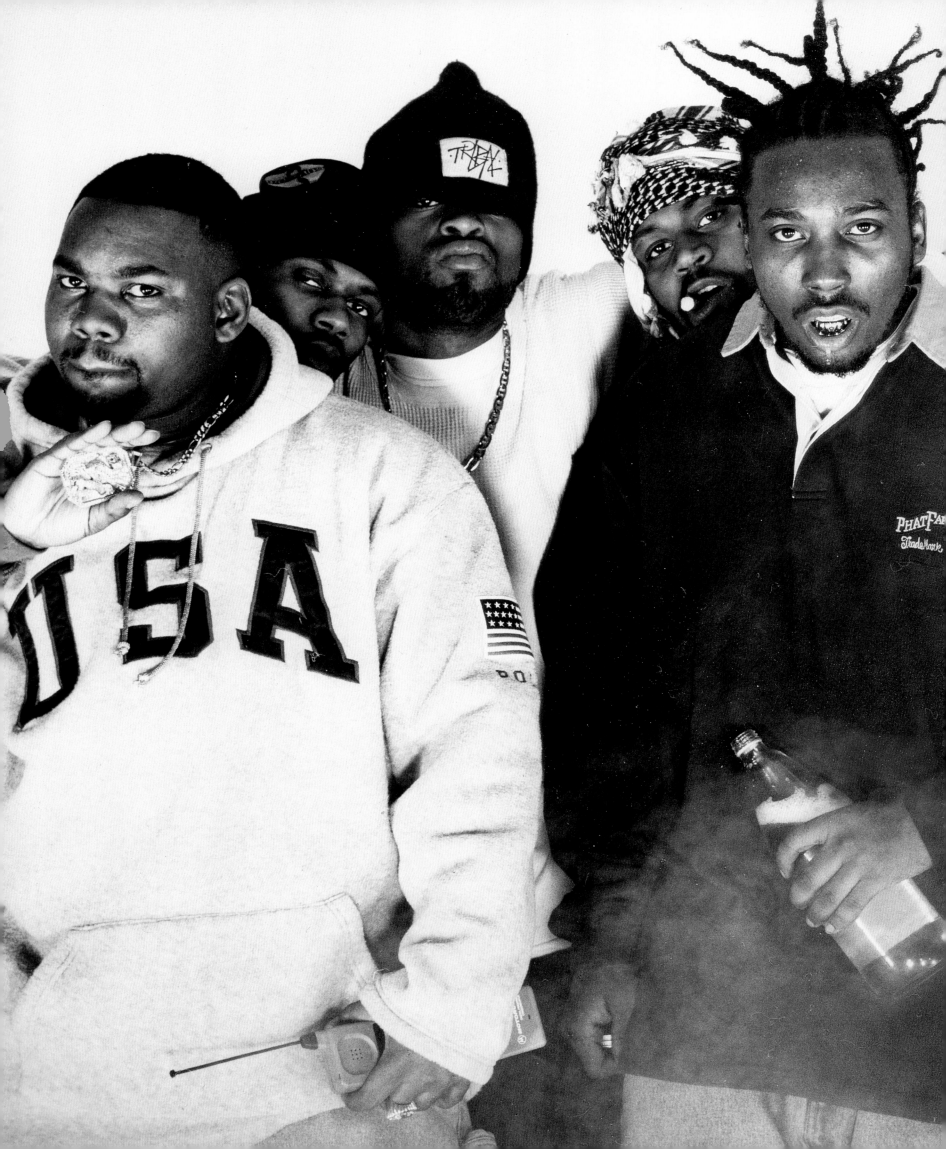

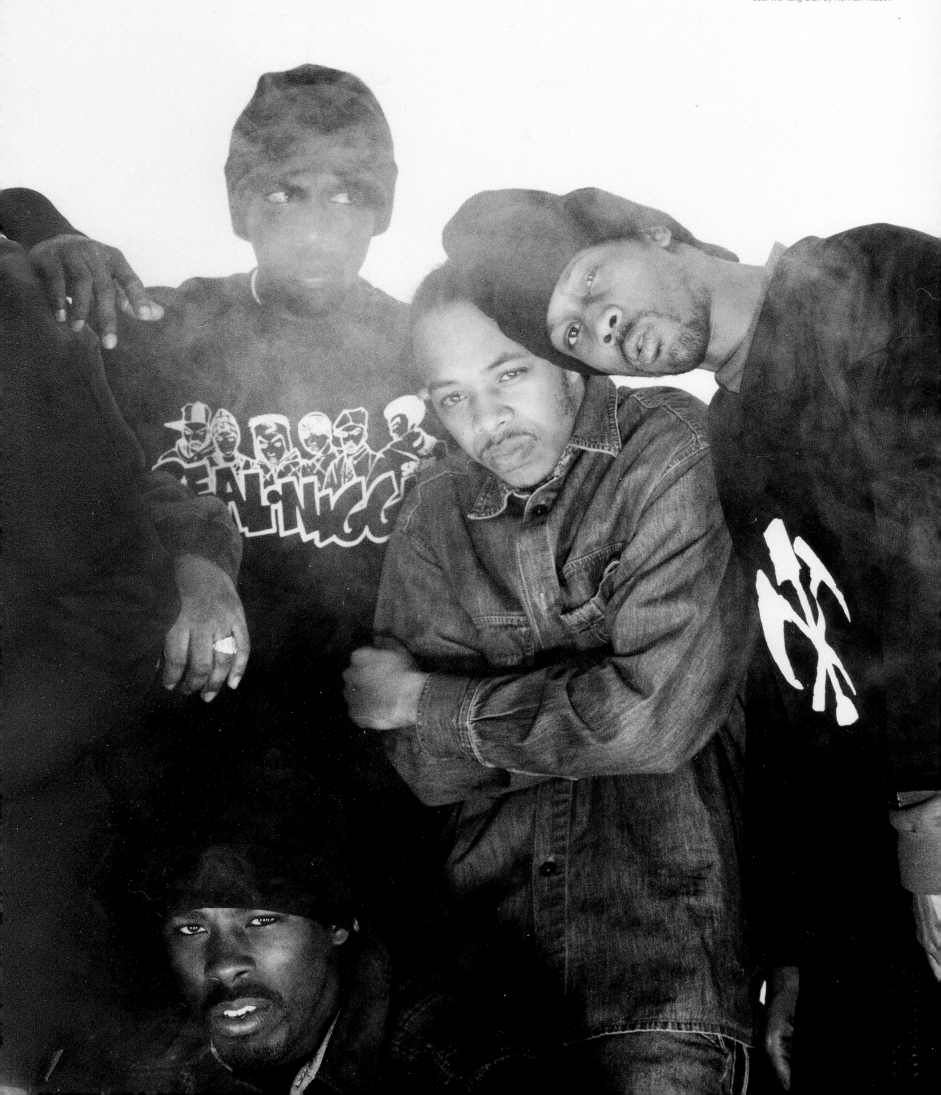

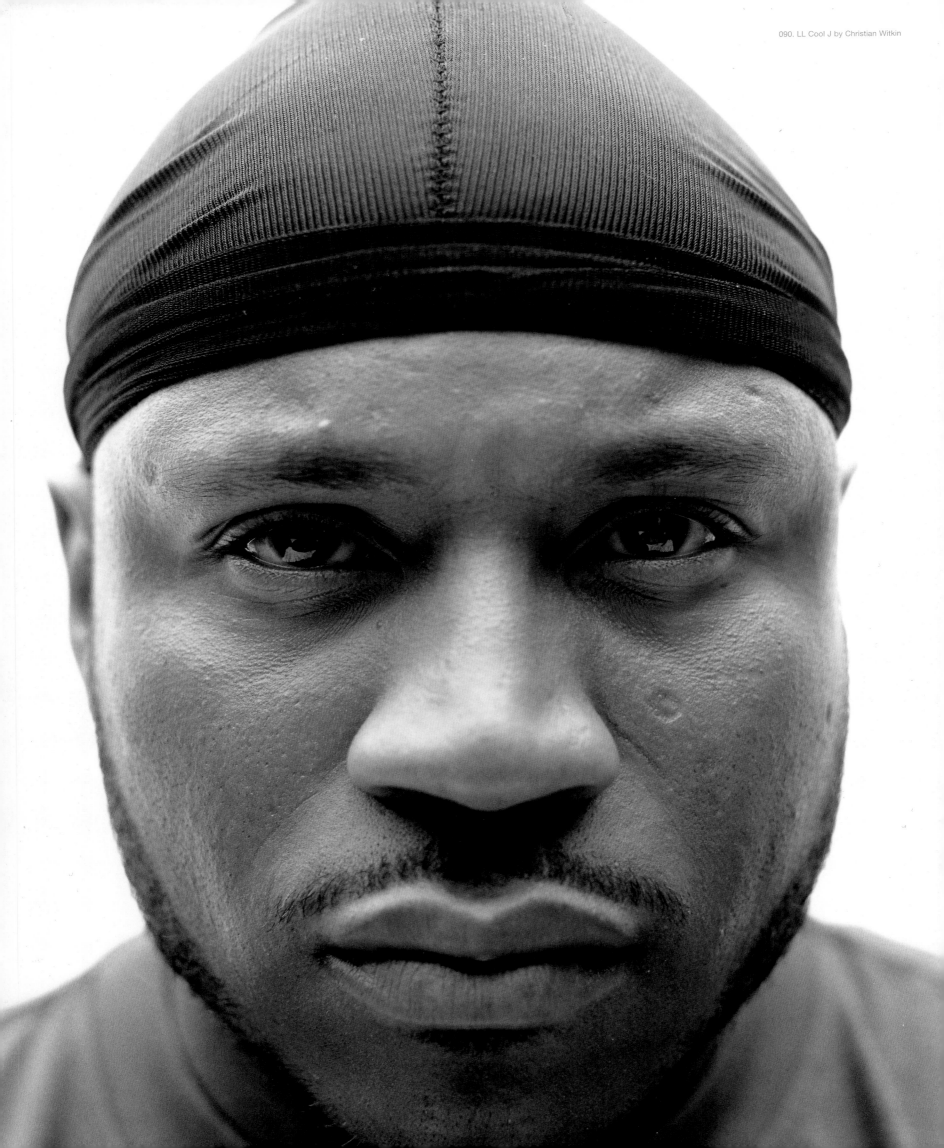

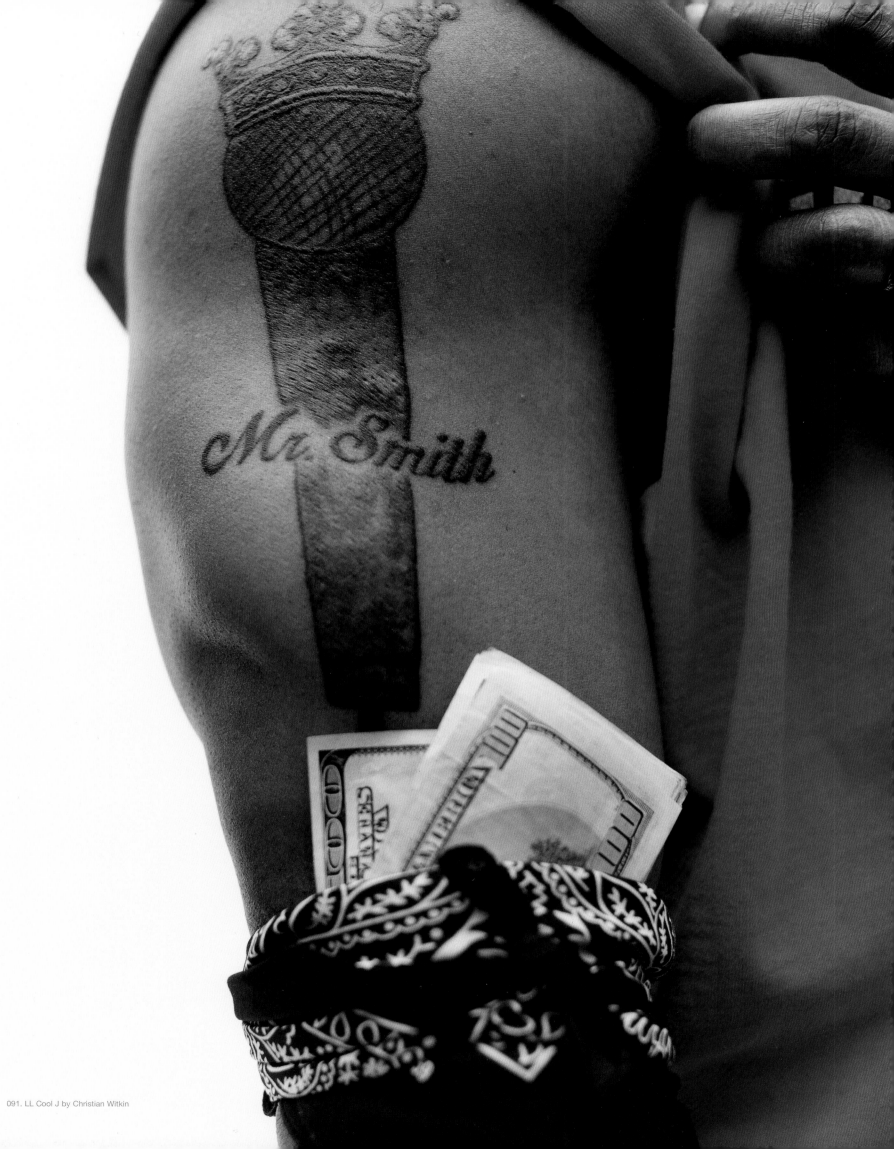

091. LL Cool J by Christian Witkin

Jay-Z's history as a New York baller is complicated by his own closed, defensive, sometimes mysterious demeanor. Here's a guy who called his first album *Reasonable Doubt* and named his label after the billionaire architect of New York's ultra-tough drug policy. Folks who keep this kind of lore running are divided on his Eighties status. He was either the nigga next to the nigga, but not that nigga, or he's simply telling other people's stories. Or his past is far darker than he tells it and grudges over bodies and monies are still held.

 —from "The Life" by dream hampton

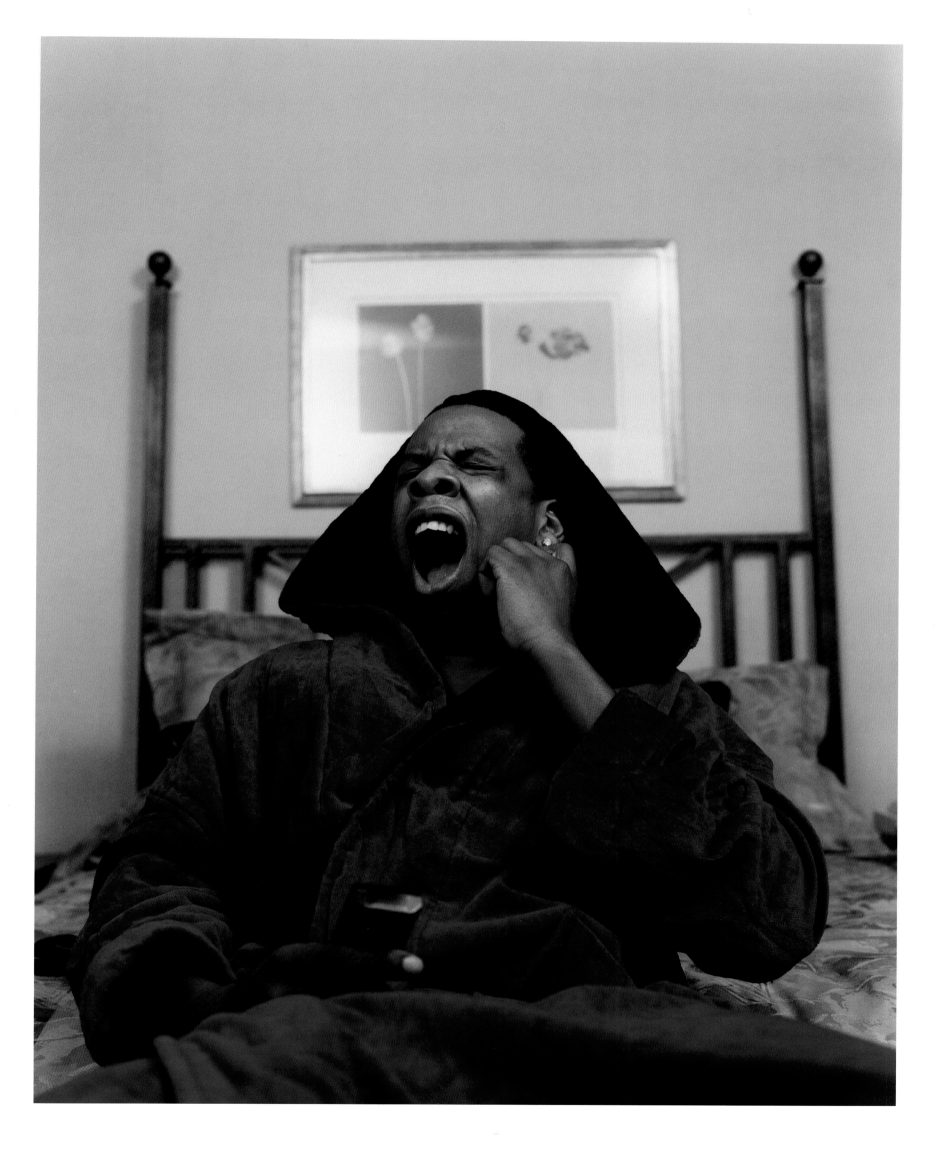

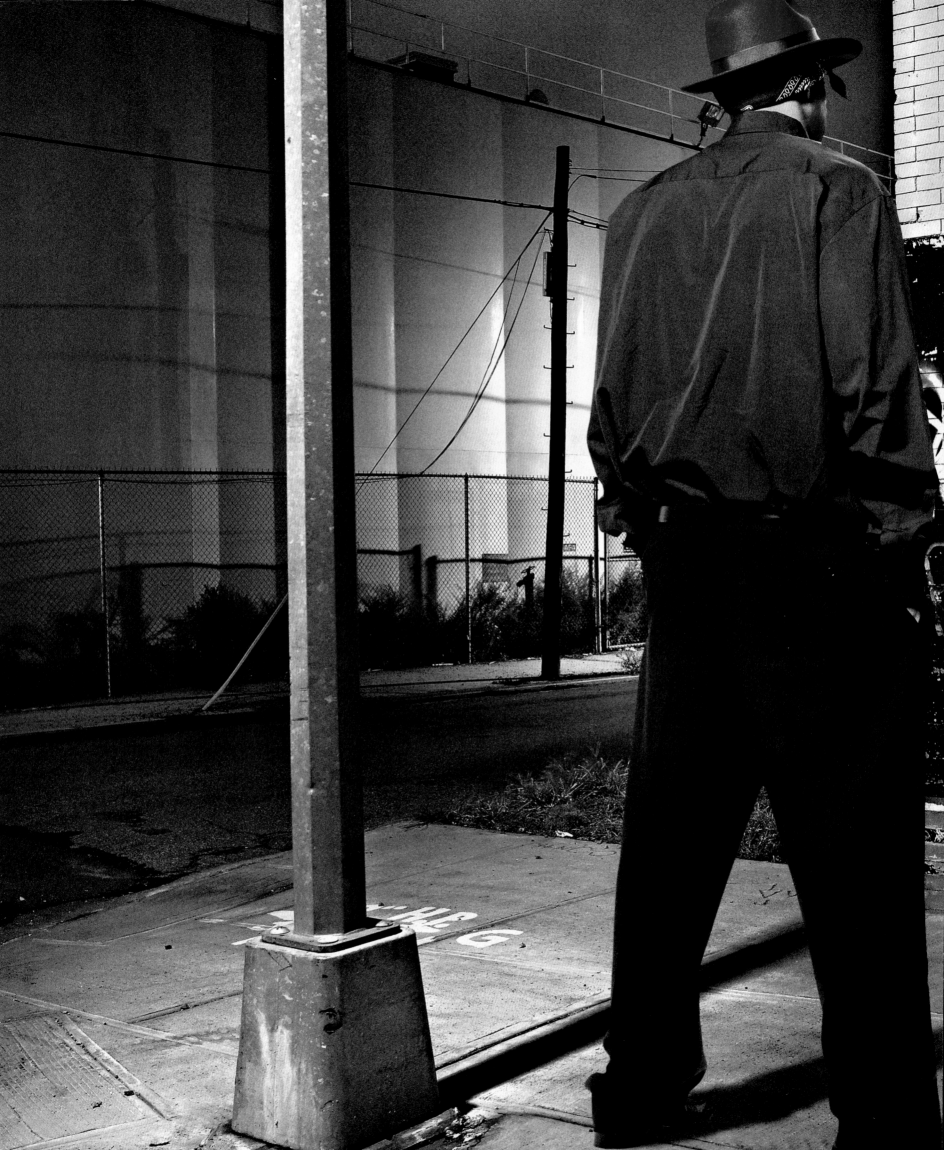

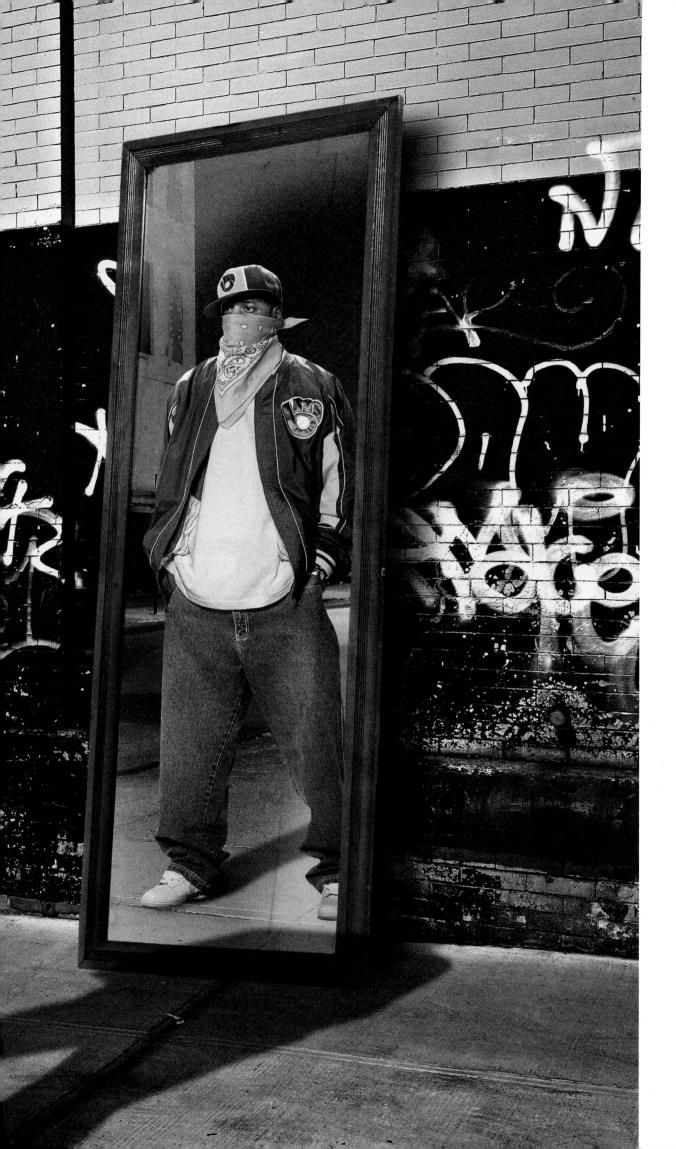

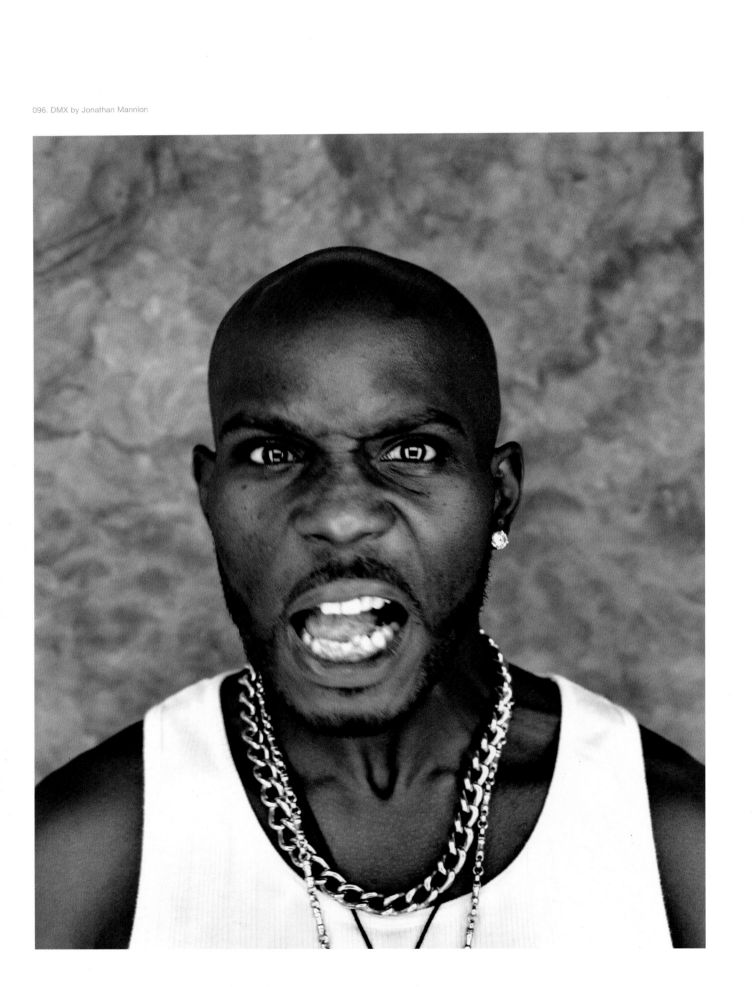

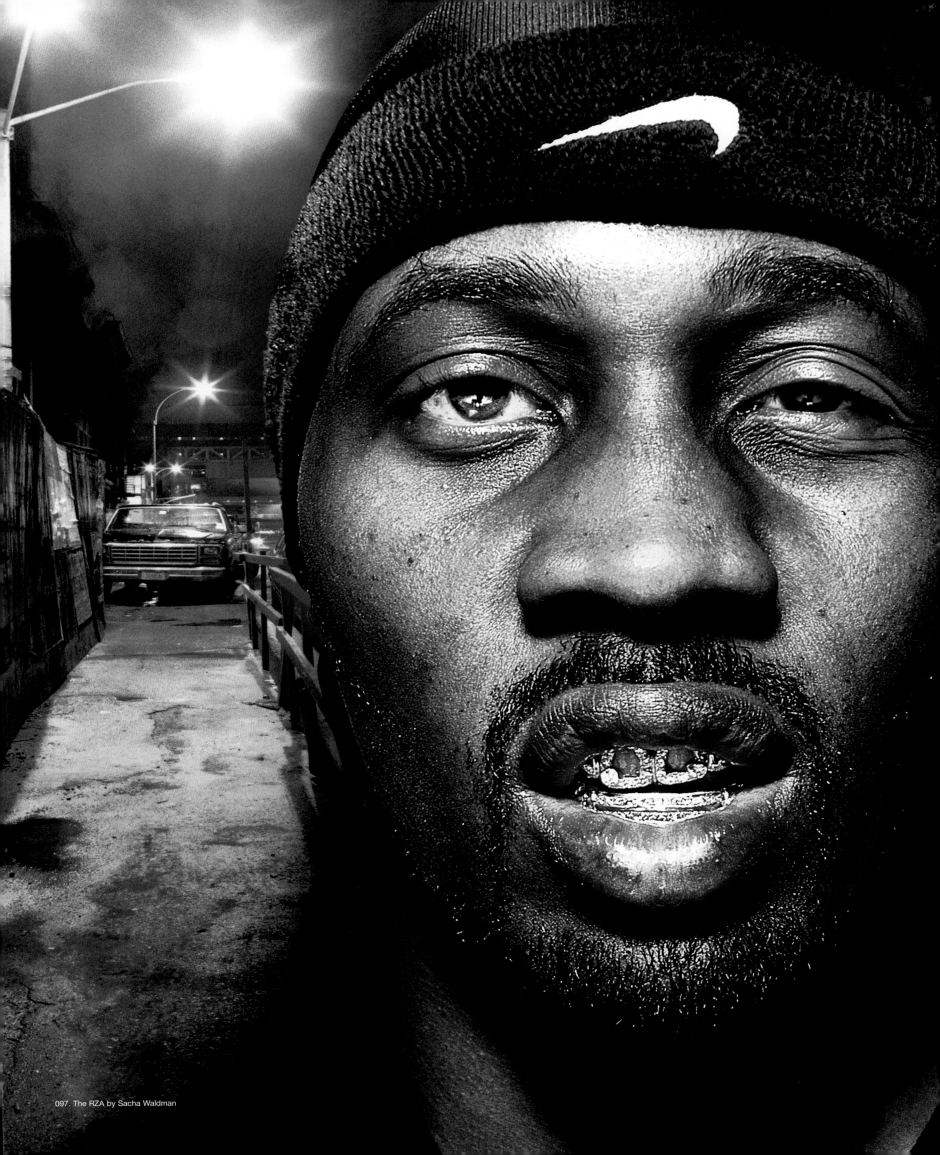

097. The RZA by Sacha Waldman

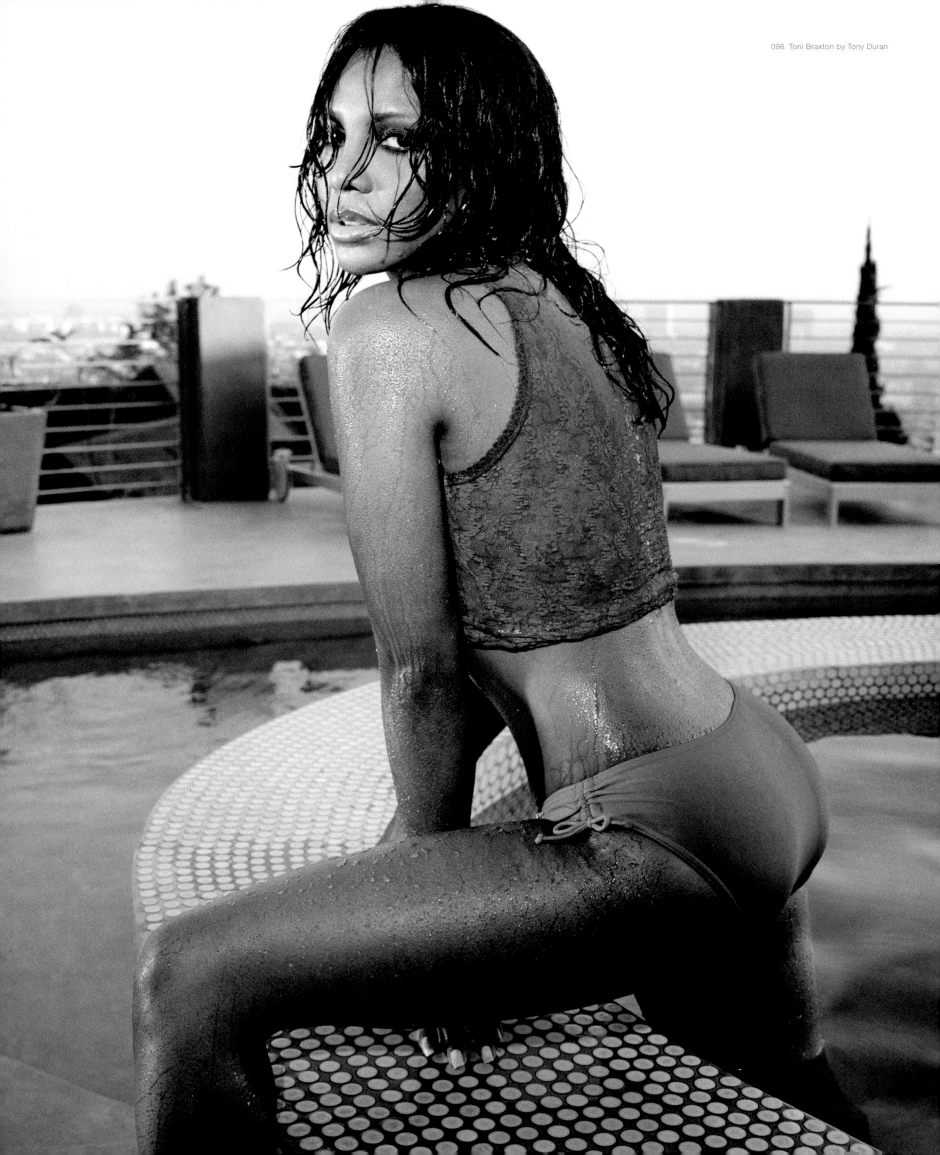

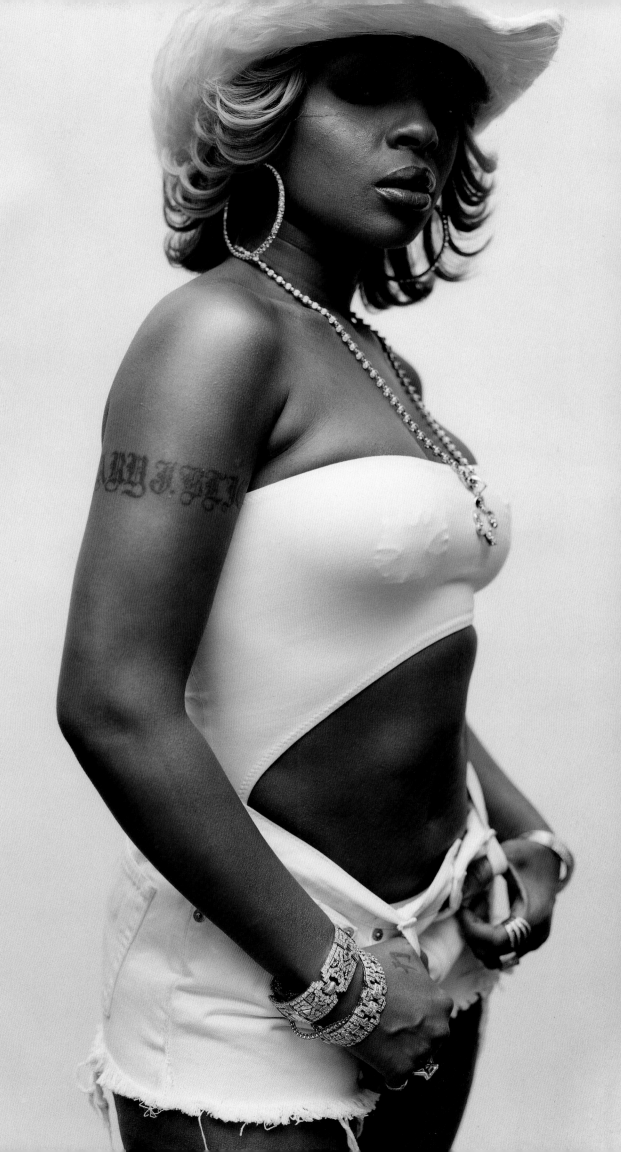

099. Mary J. Blige by Christian Witkin

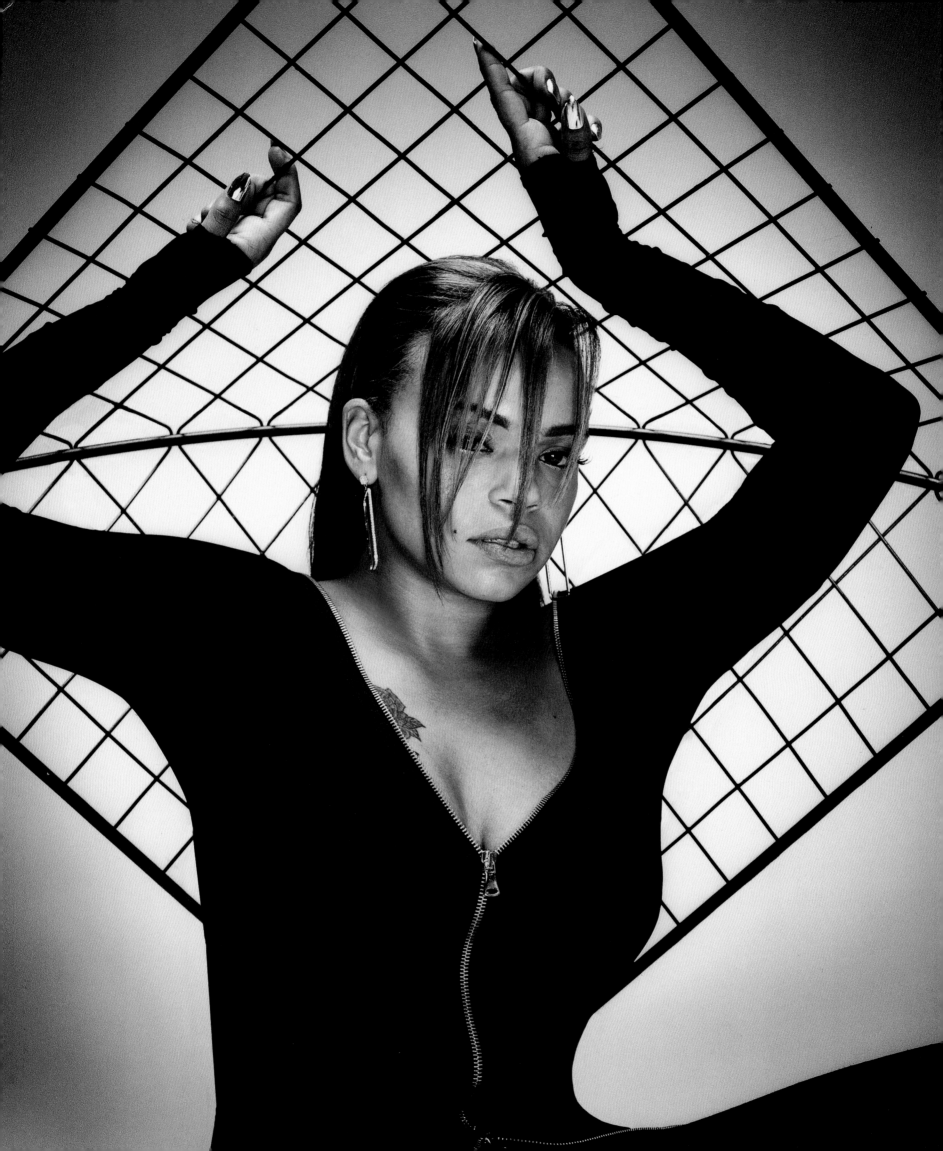

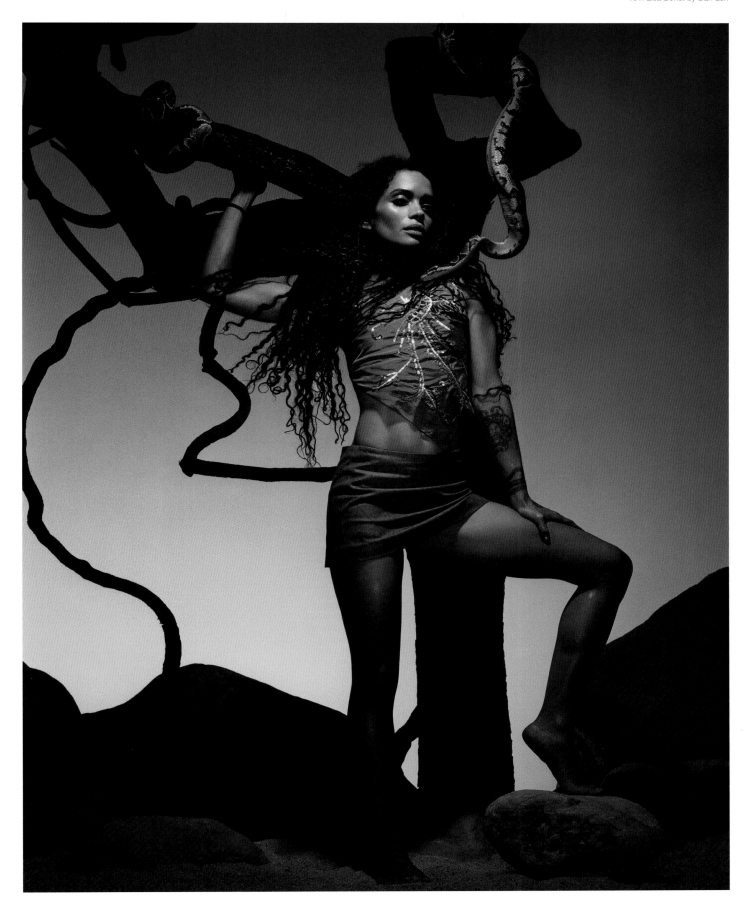

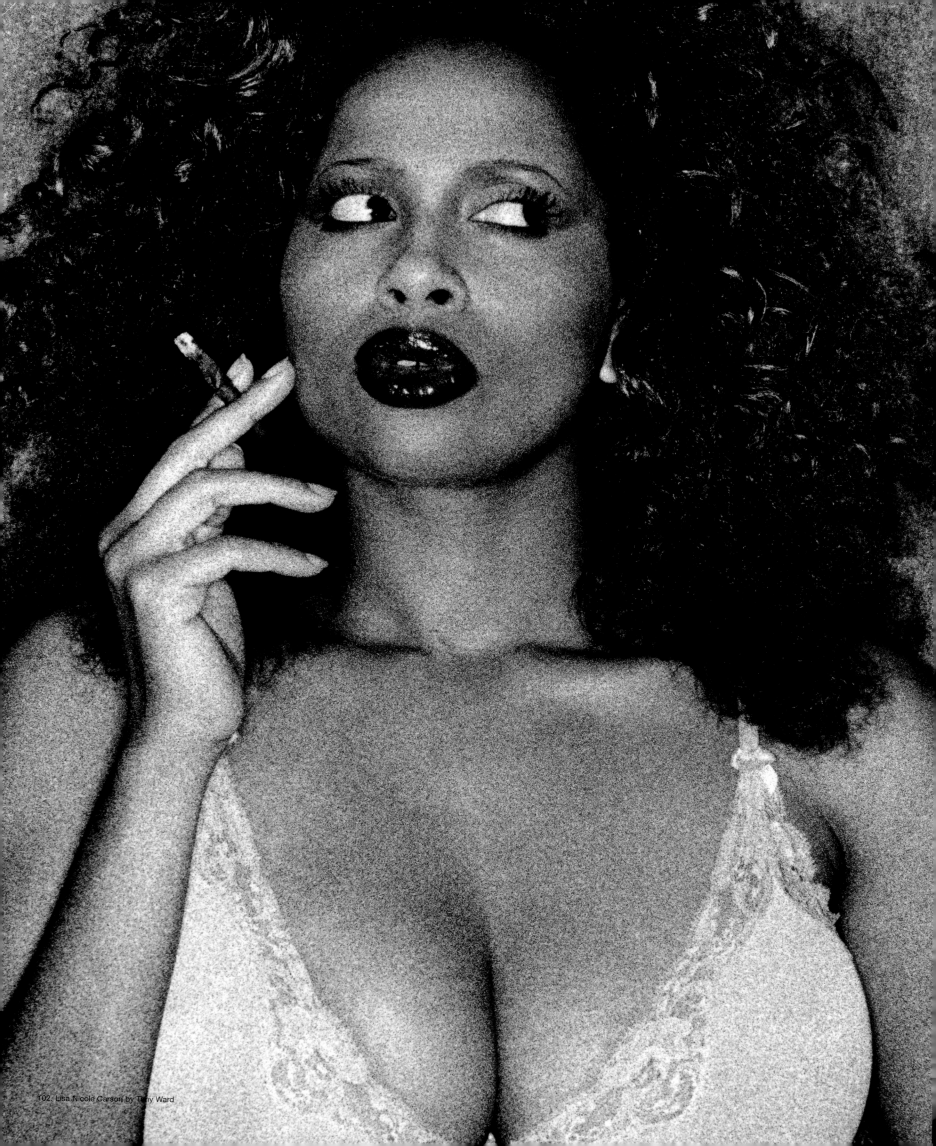

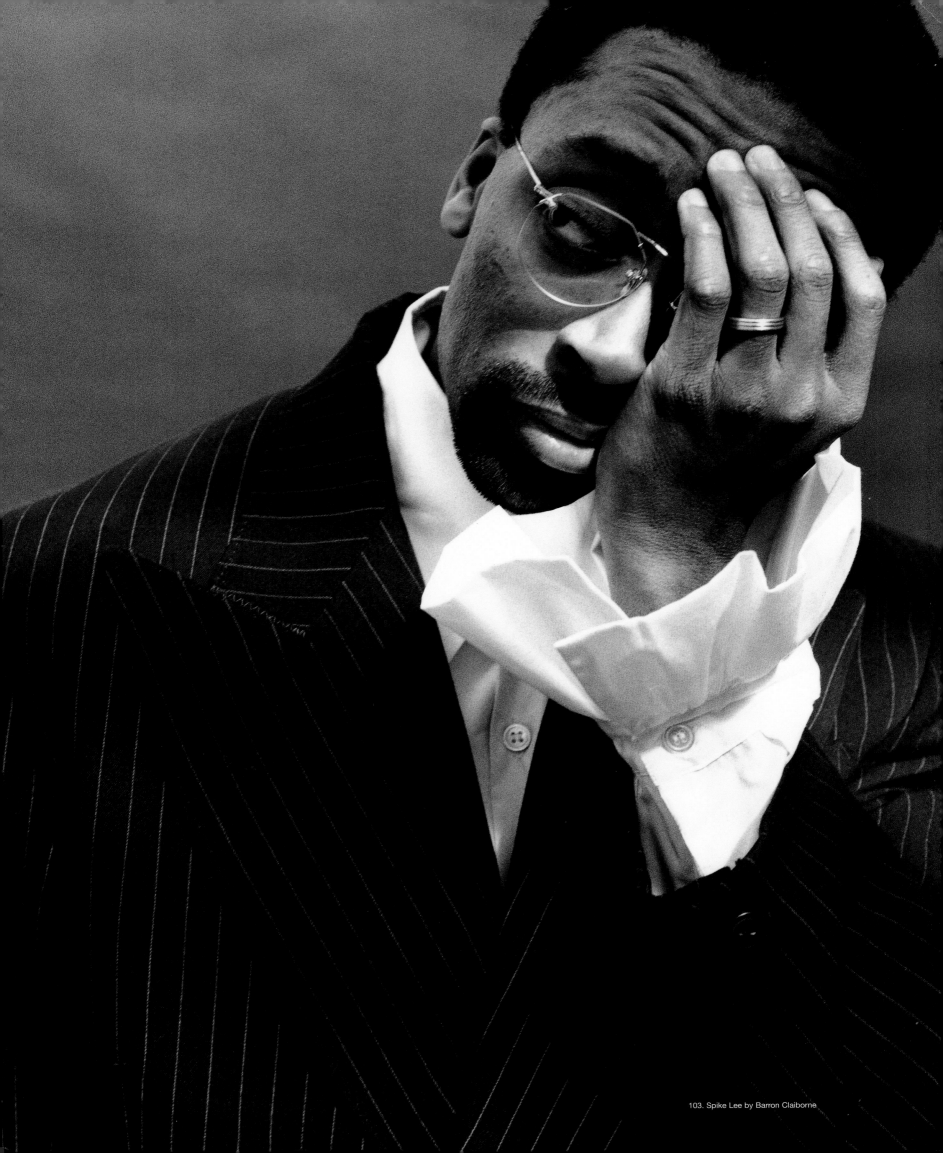

103. Spike Lee by Barron Claiborne

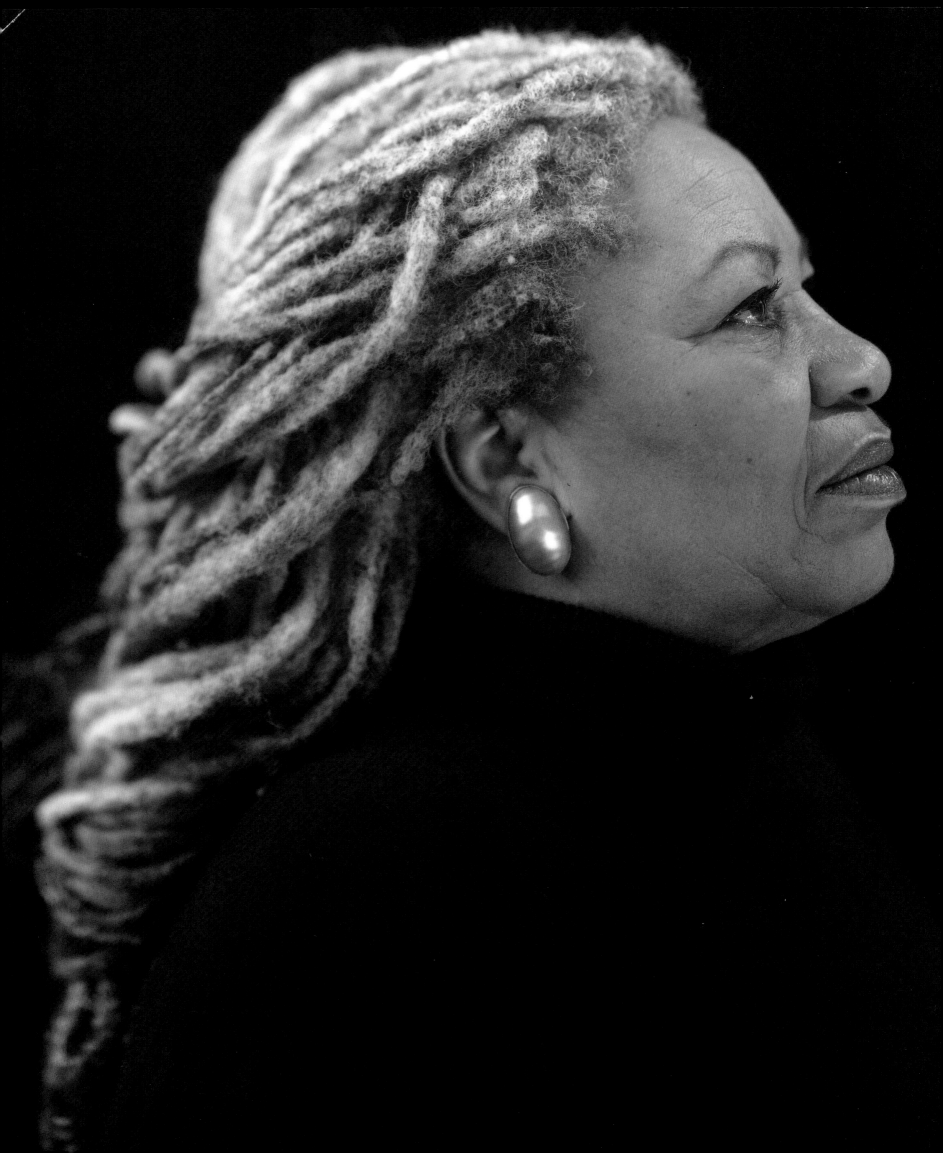

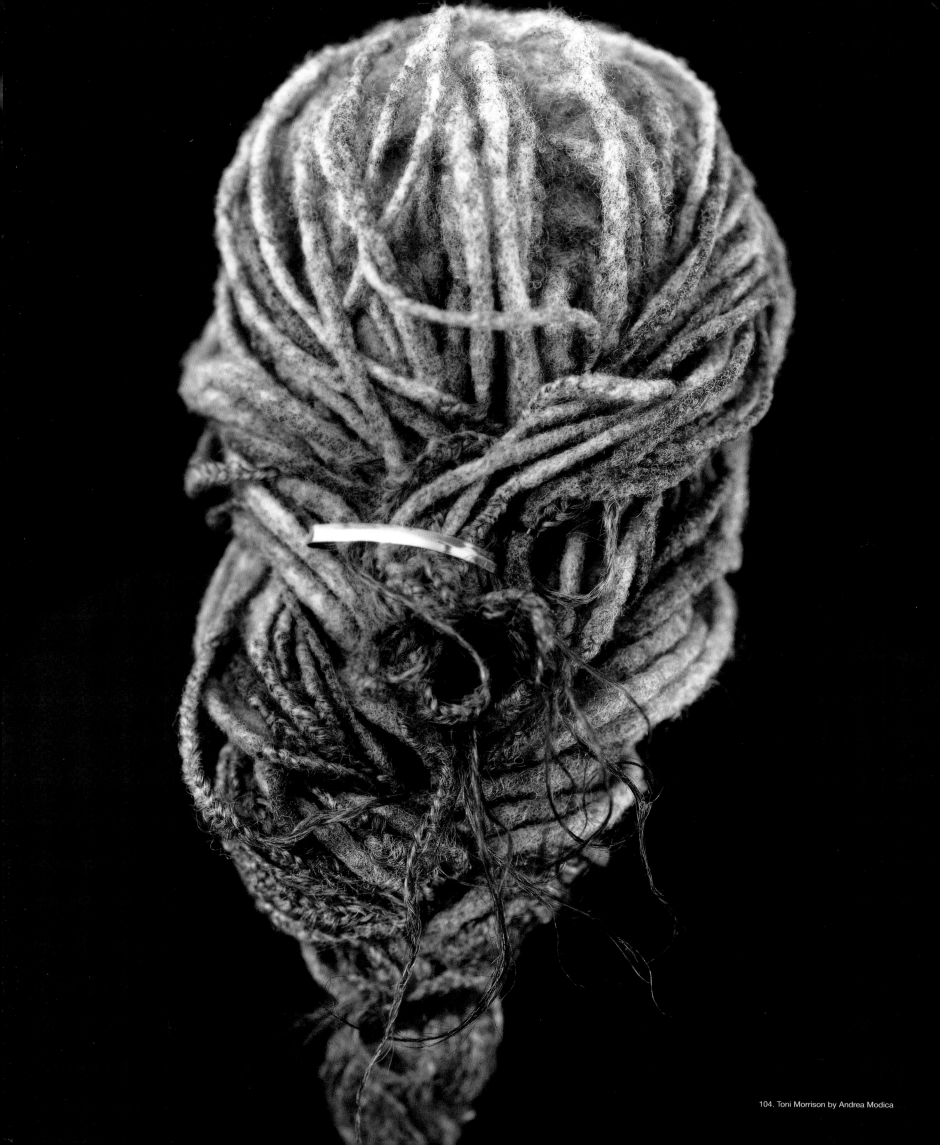

104. Toni Morrison by Andrea Modica

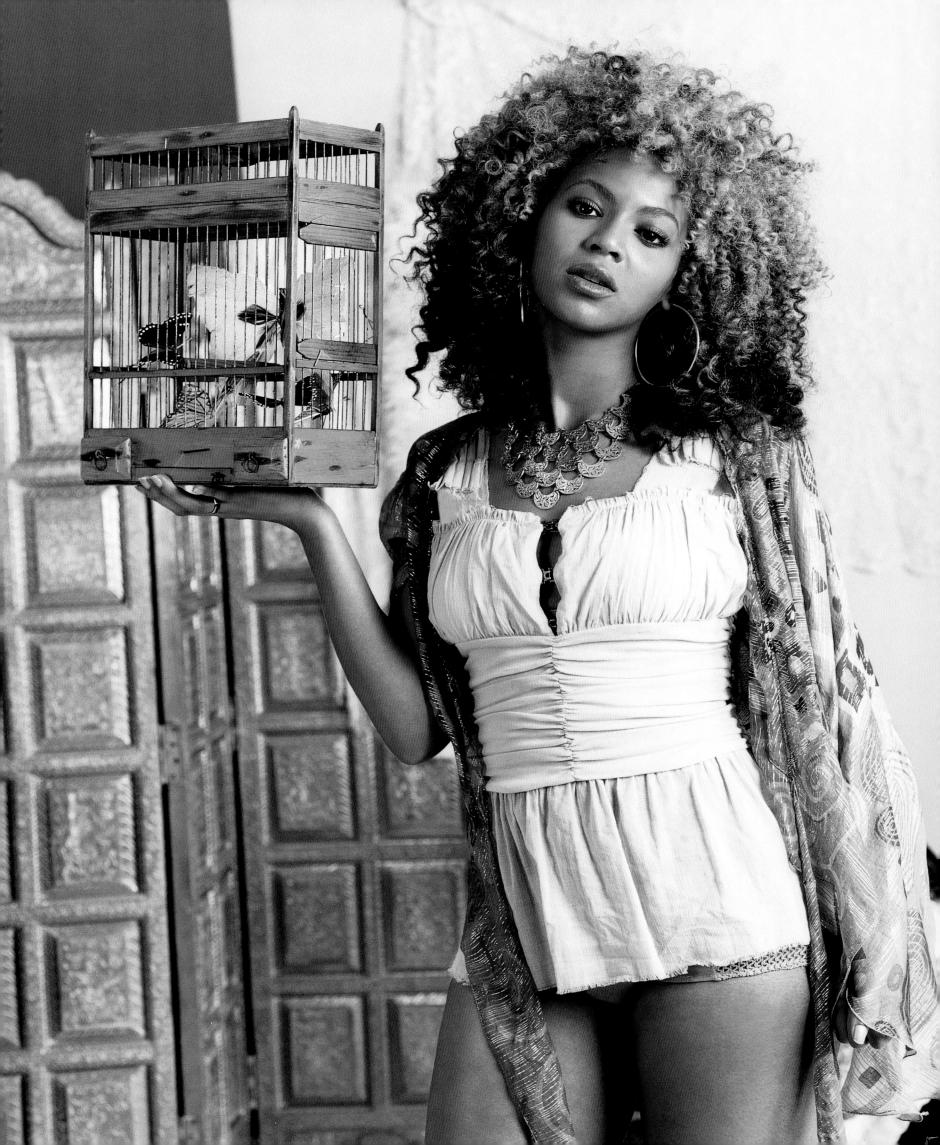

107. India.Arie by Gerald Forster

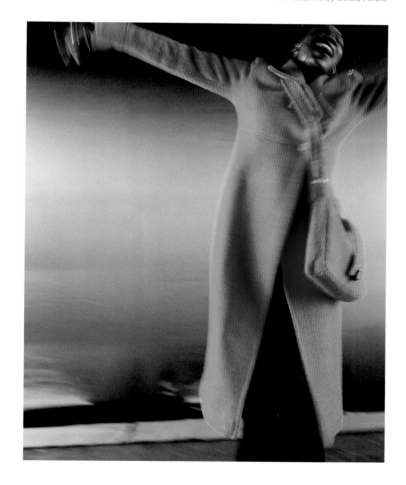

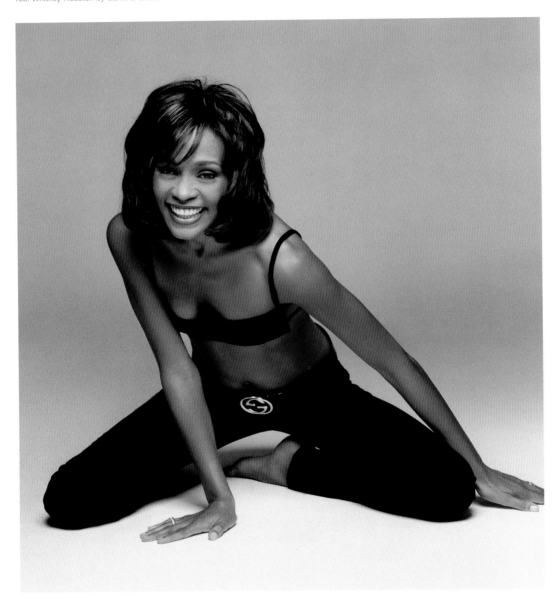

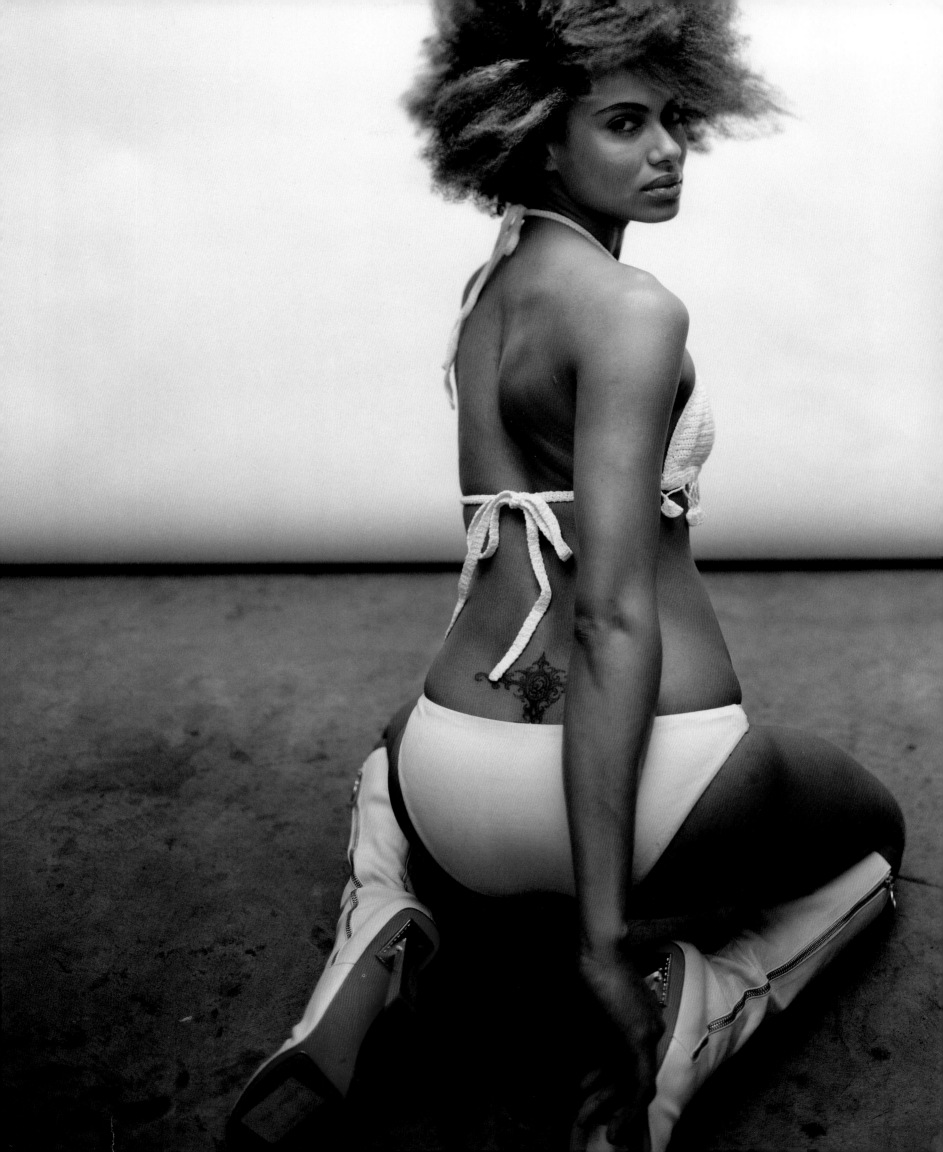

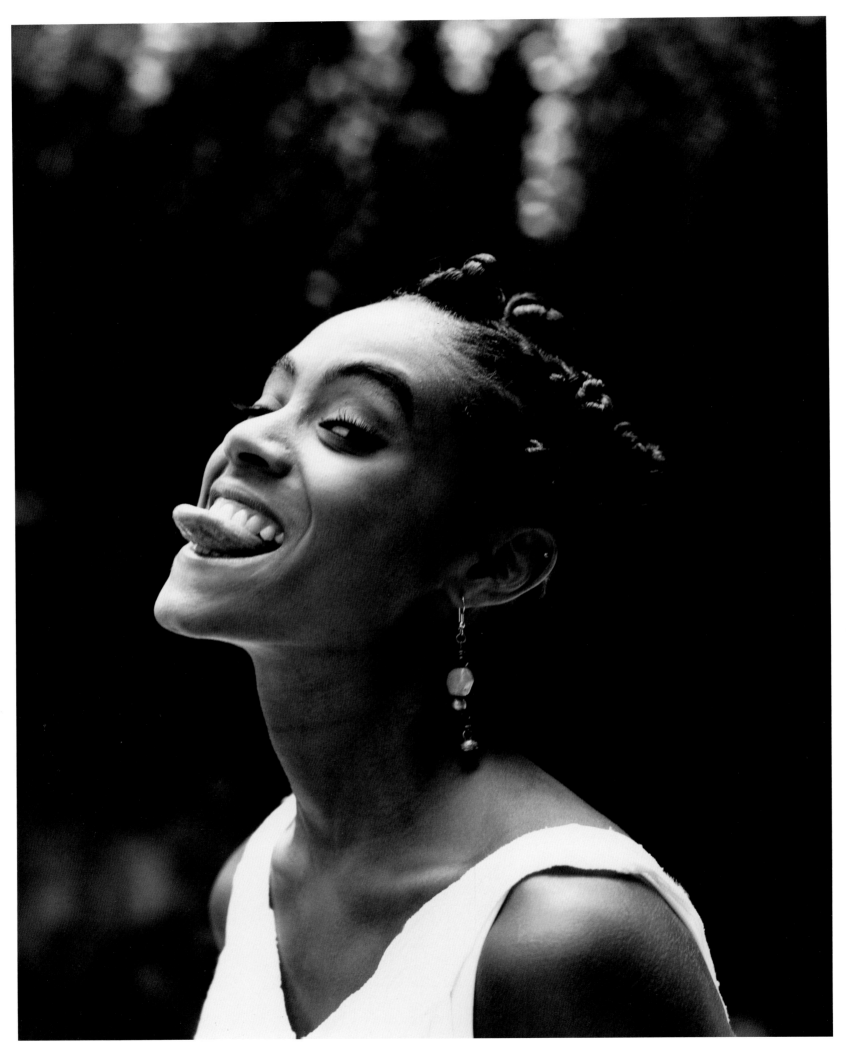

110. Jada Pinkett by Everard Williams

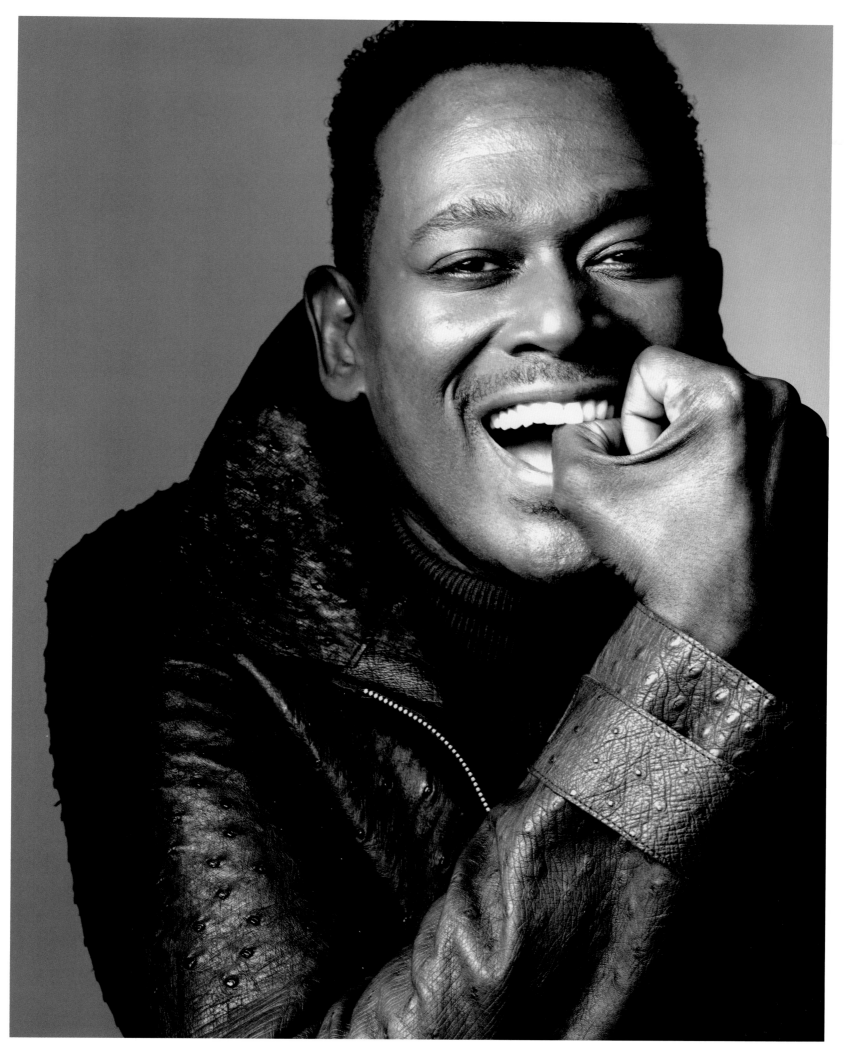

111. Luther Vandross by Albert Watson

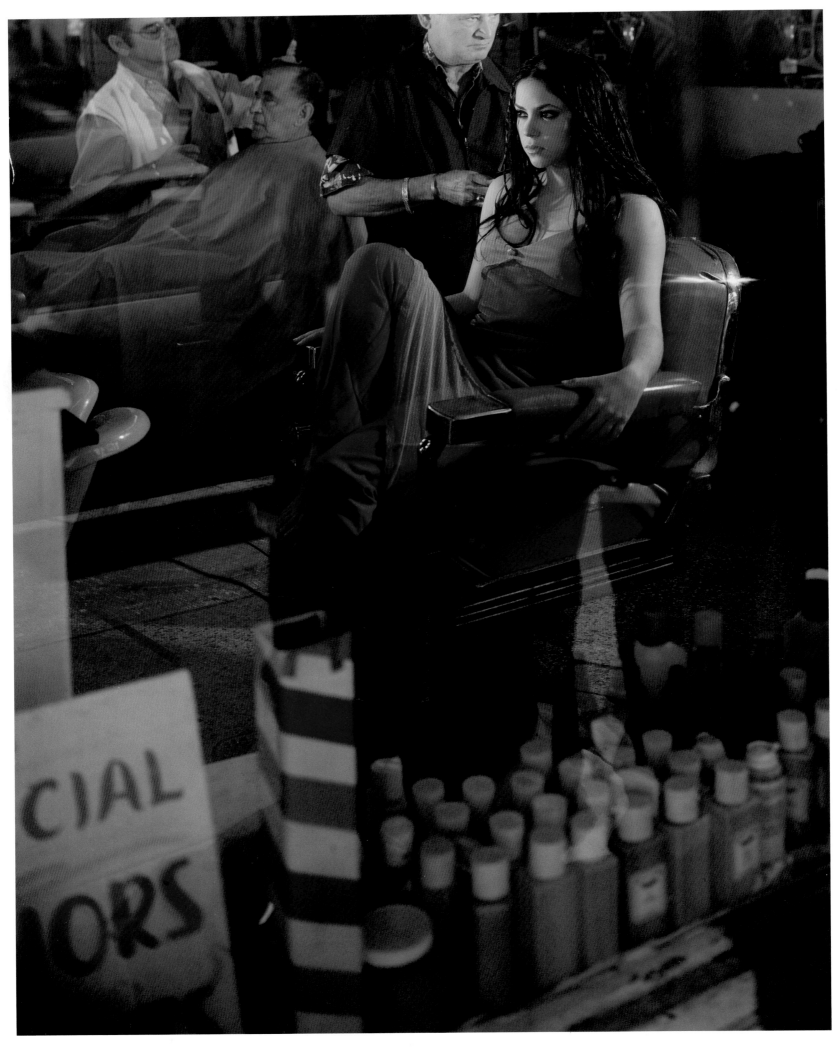

112. Shakira

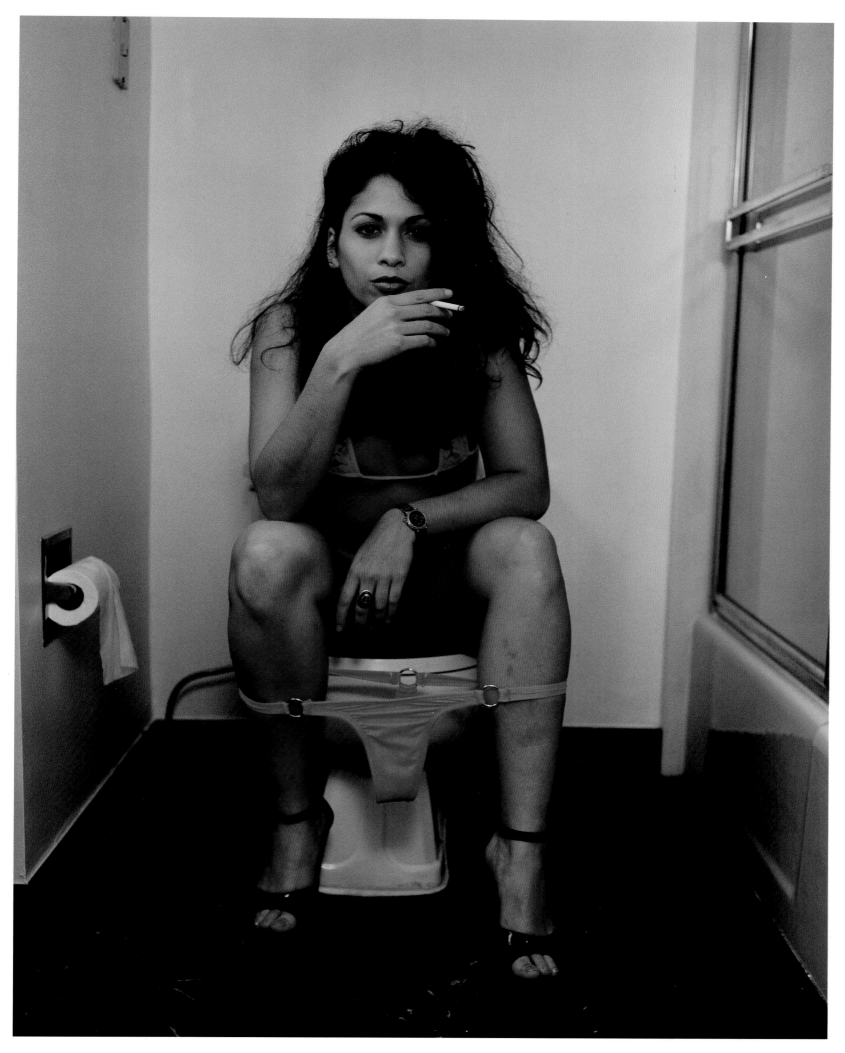

113. Lana Sands by Jeff Riedel

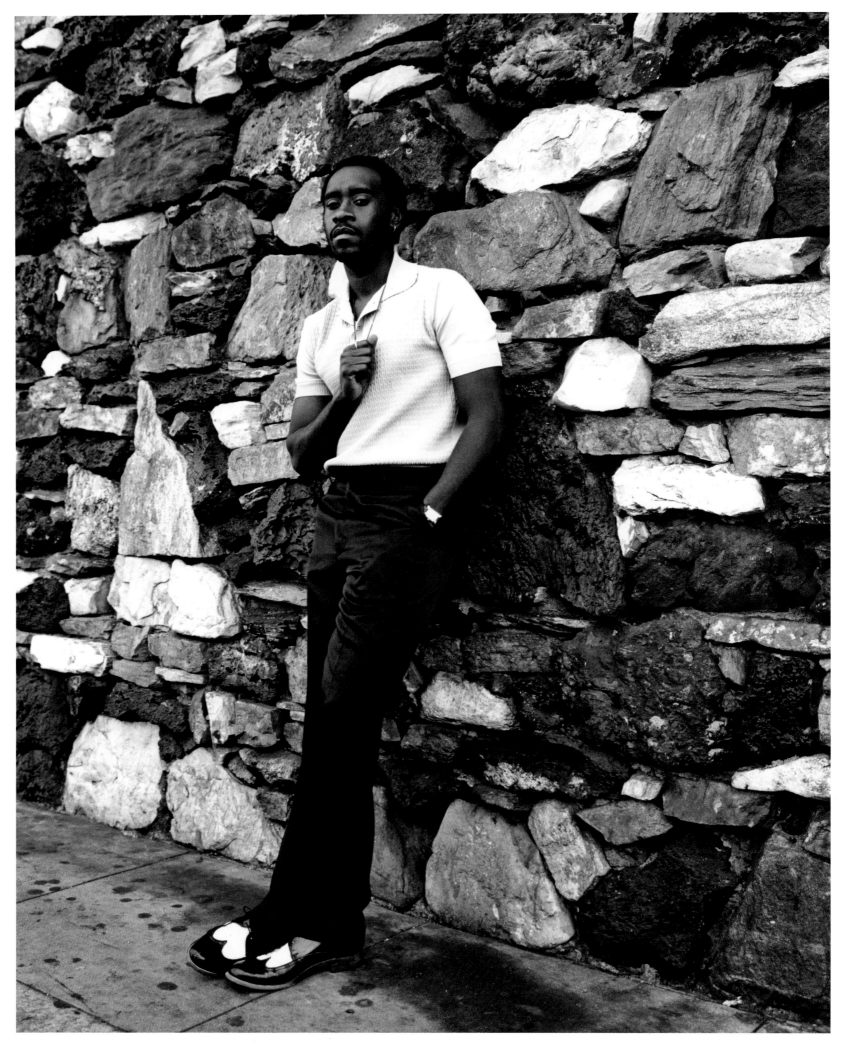

114. Don Cheadle by Melodie McDaniel

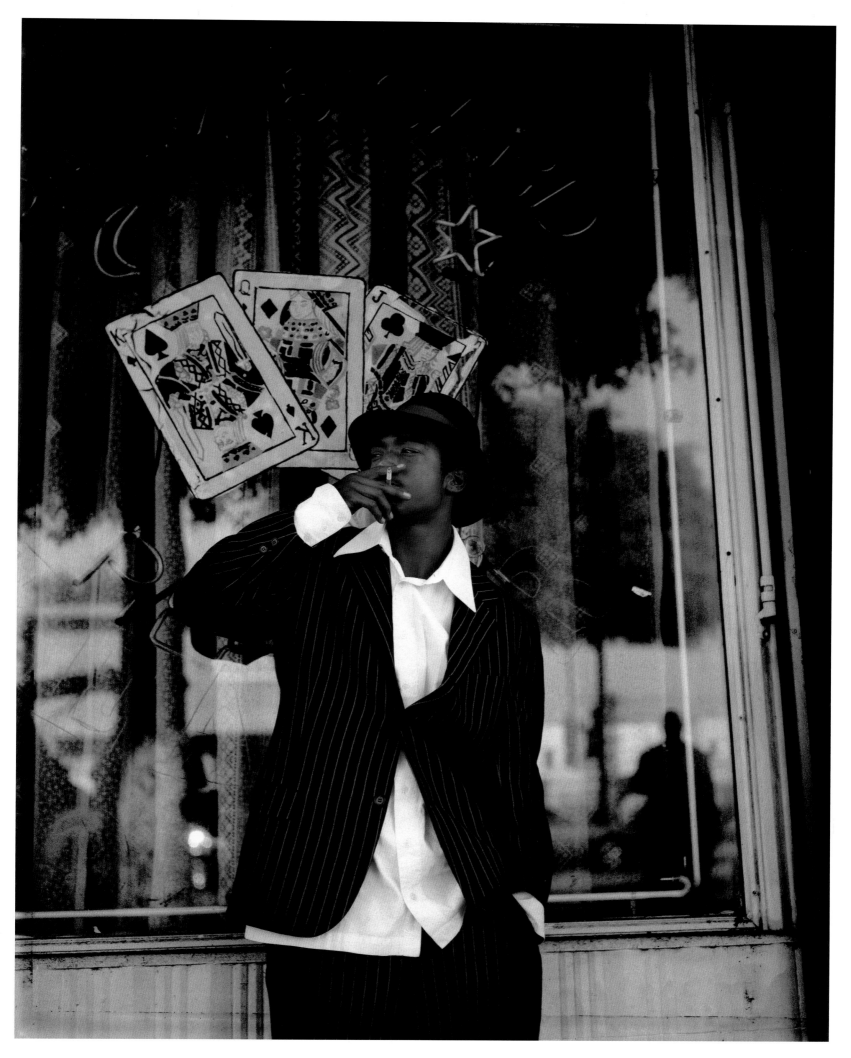

115. Ja Rule by Robert Maxwell

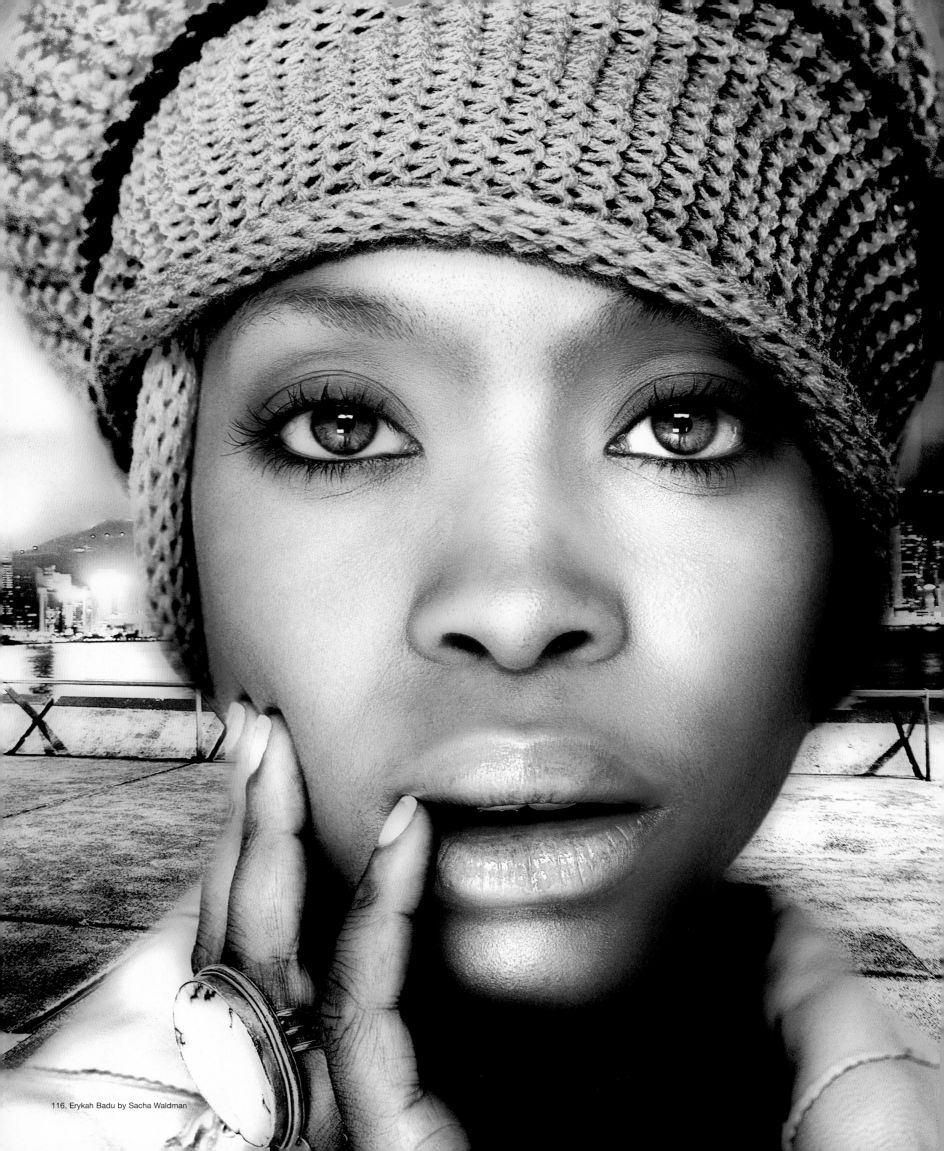

116. Erykah Badu by Sacha Waldman

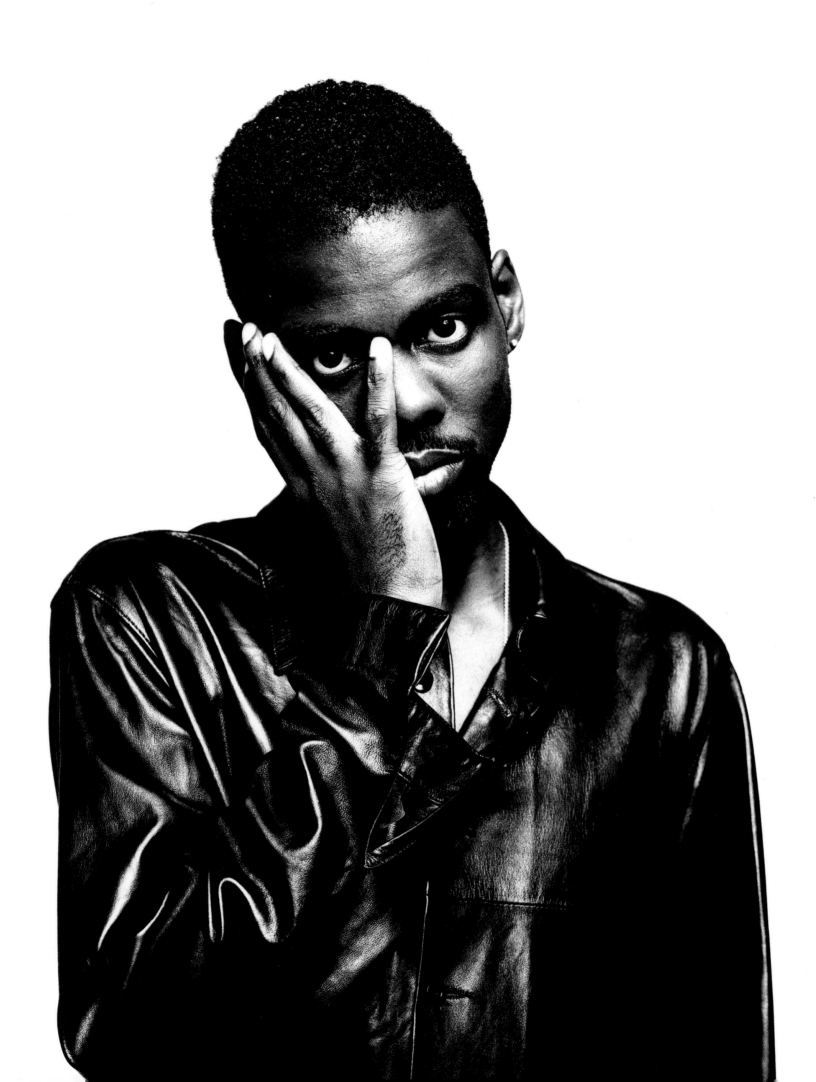

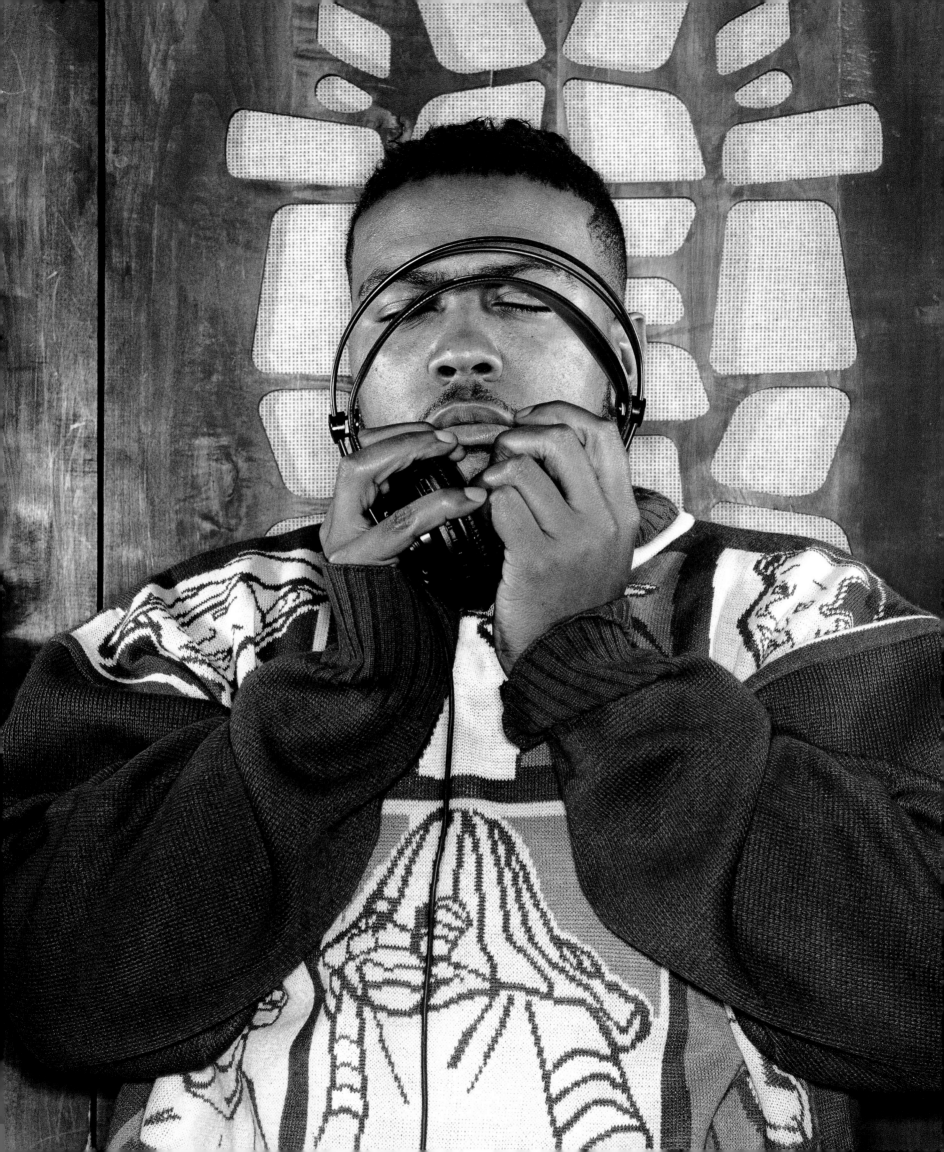

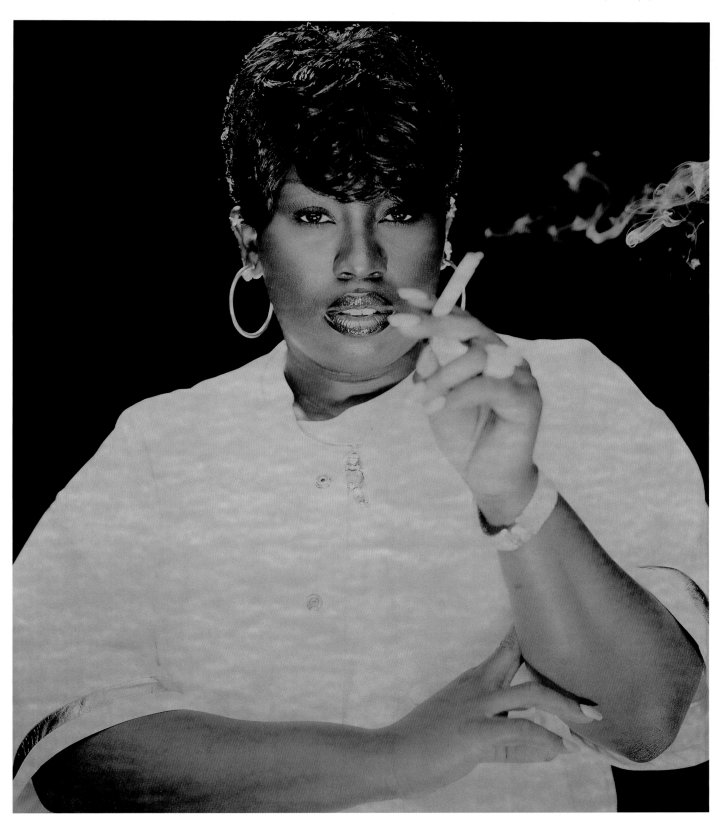

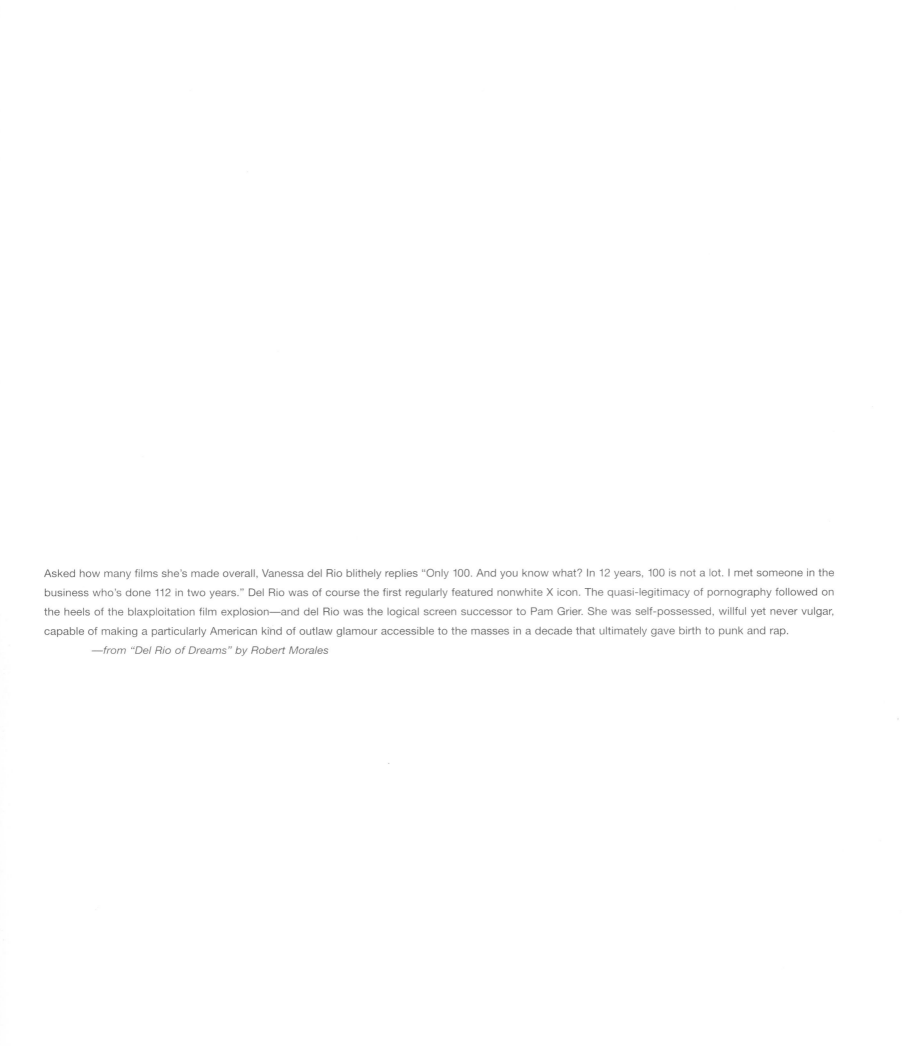

Asked how many films she's made overall, Vanessa del Rio blithely replies "Only 100. And you know what? In 12 years, 100 is not a lot. I met someone in the business who's done 112 in two years." Del Rio was of course the first regularly featured nonwhite X icon. The quasi-legitimacy of pornography followed on the heels of the blaxploitation film explosion—and del Rio was the logical screen successor to Pam Grier. She was self-possessed, willful yet never vulgar, capable of making a particularly American kind of outlaw glamour accessible to the masses in a decade that ultimately gave birth to punk and rap.

—*from "Del Rio of Dreams" by Robert Morales*

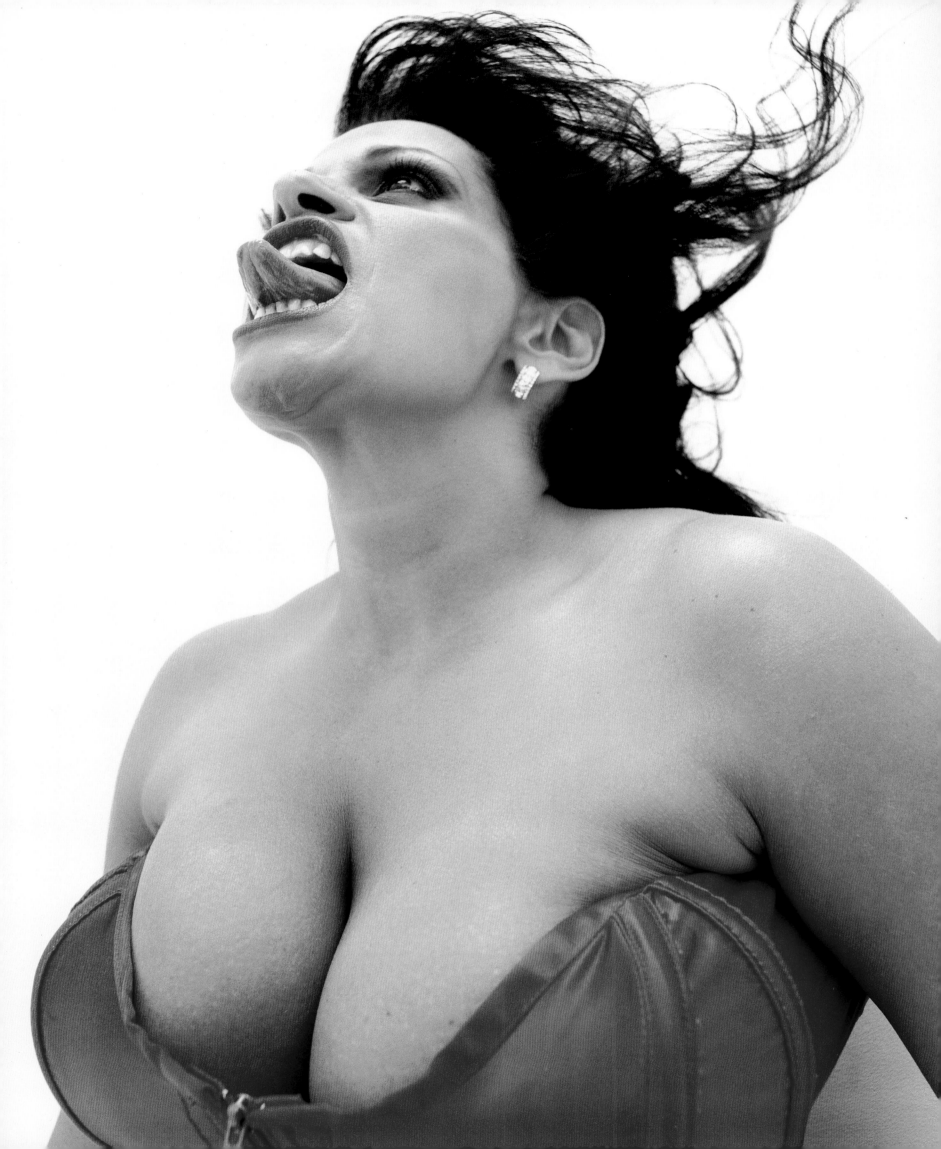

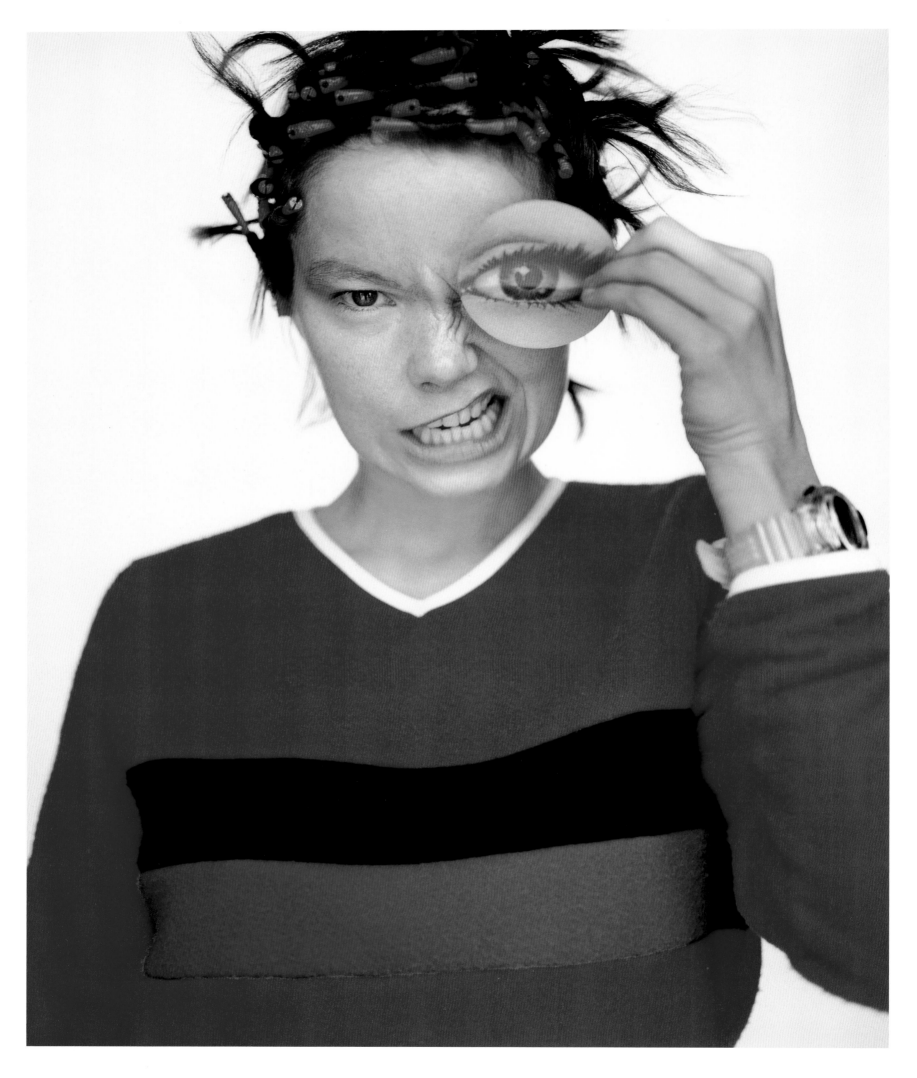

122. Björk by Barron Claiborne

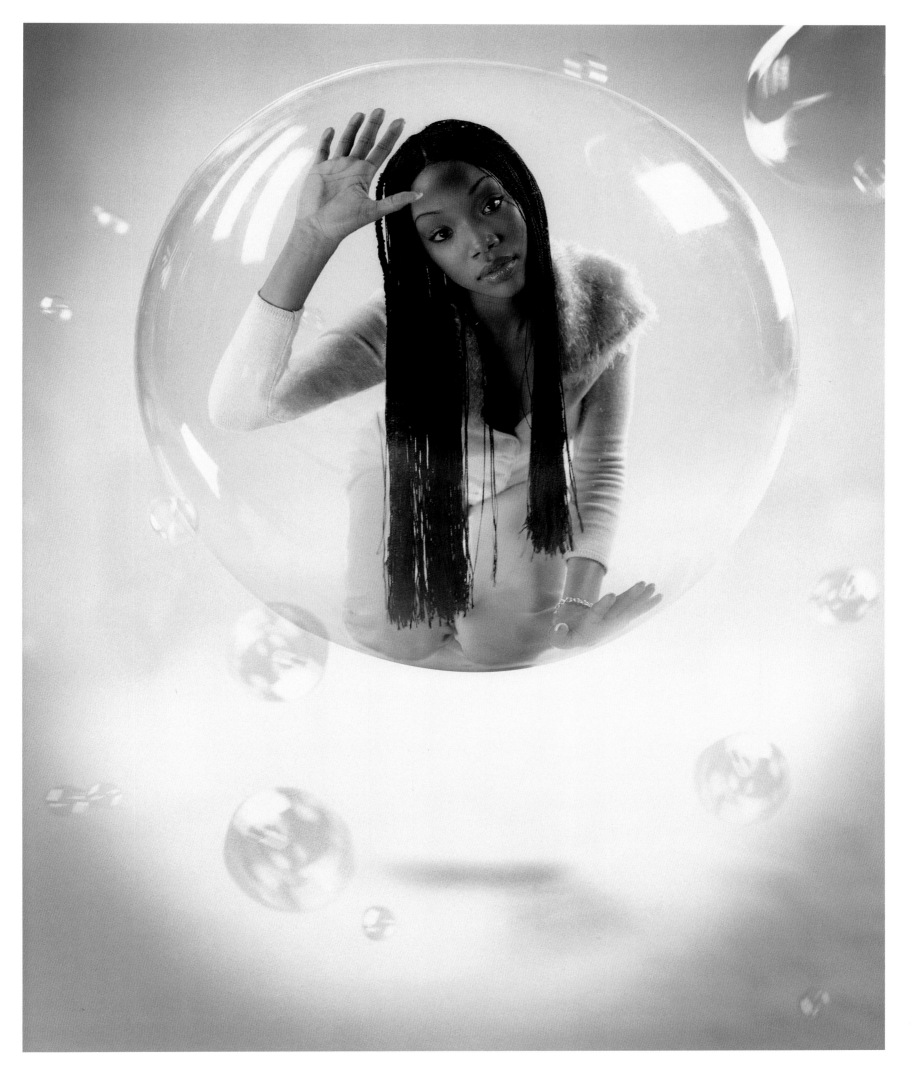

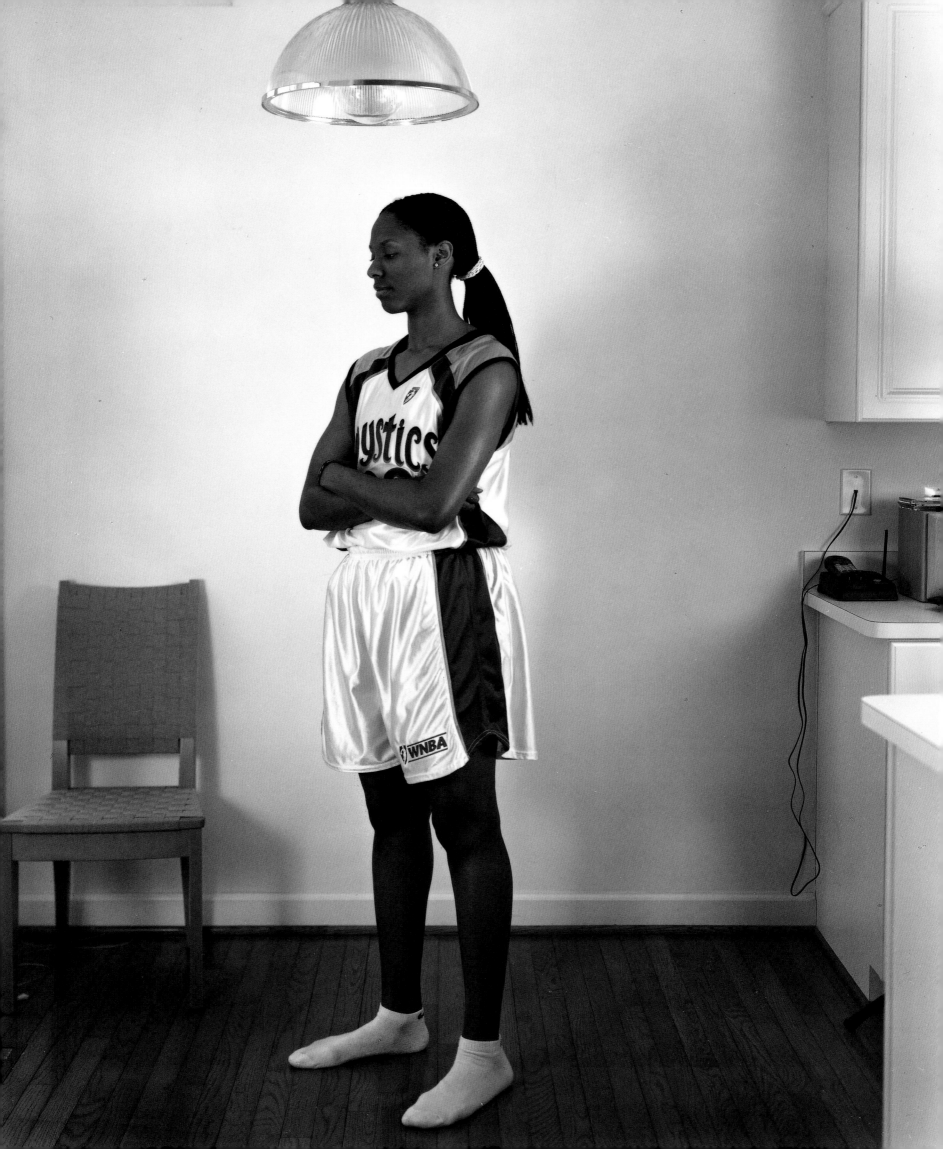

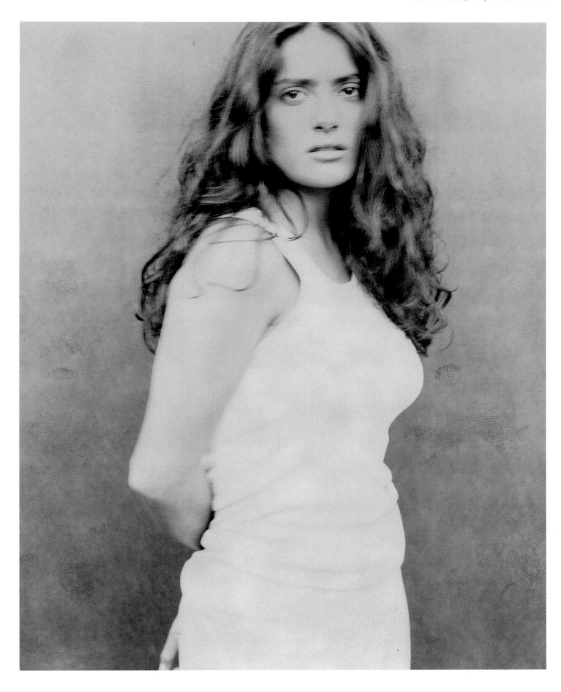

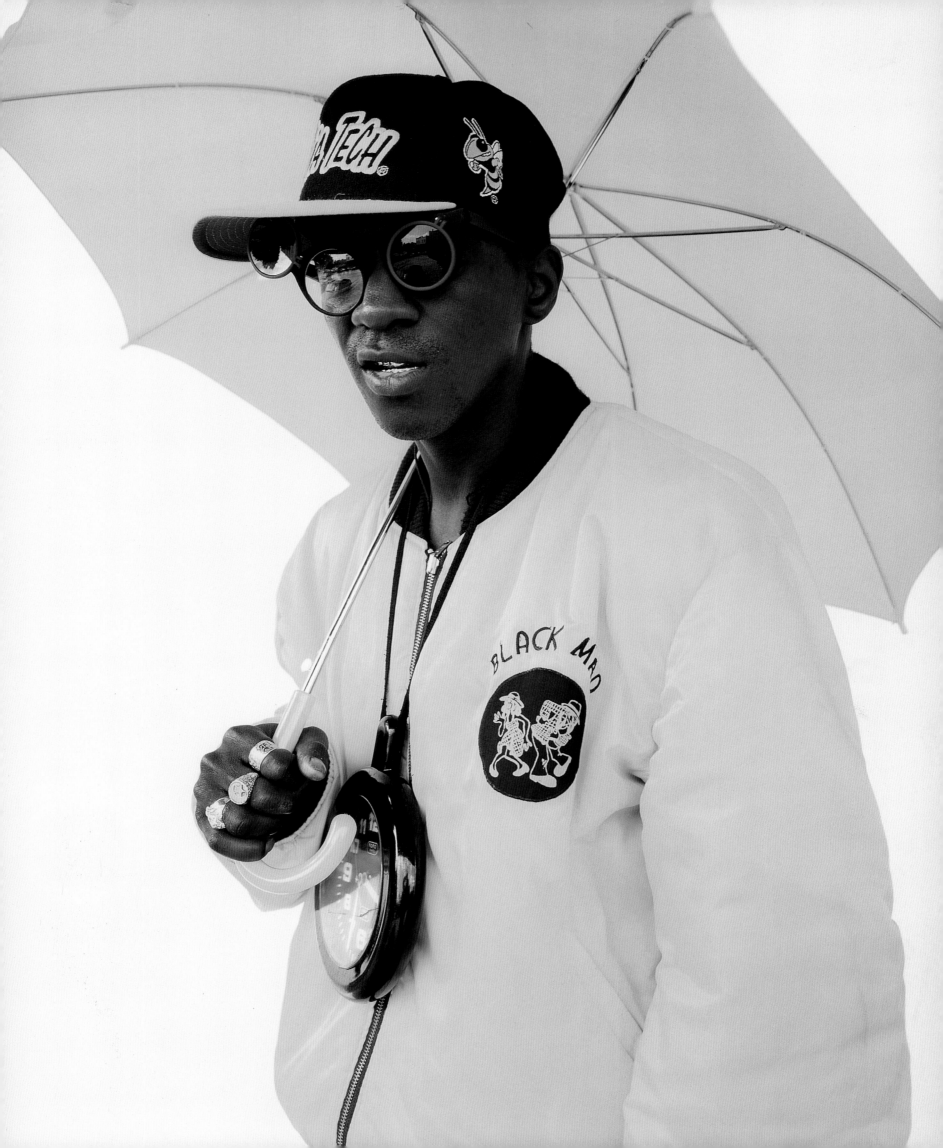

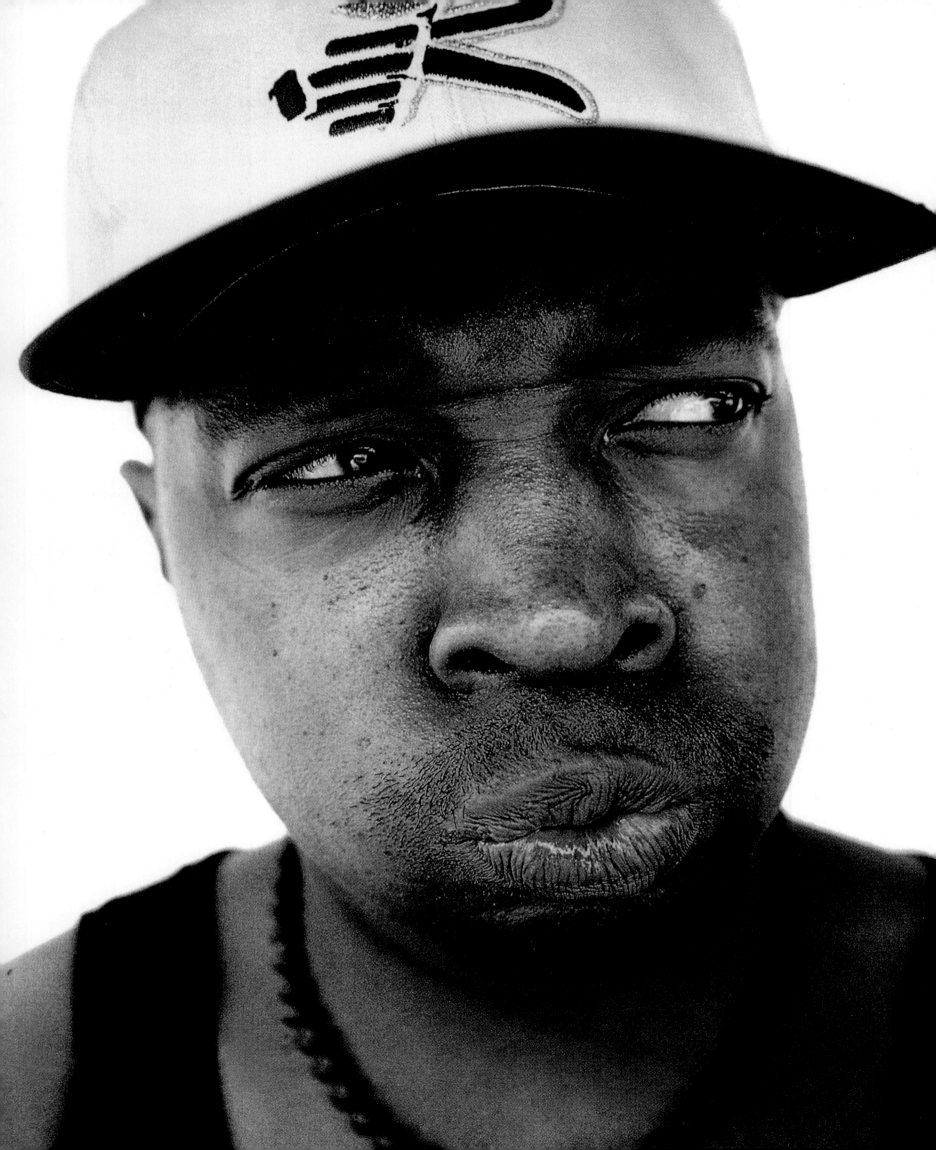

"You got so many kids that's into black music, but don't know nothin' about black music because they de-emphasize music history. And we can't judge nobody's blackness. I remember when white people were wearing African medallions, black people were getting mad. If white people know more about black facts than us, that just means we got to step up."
—*Chuck D*

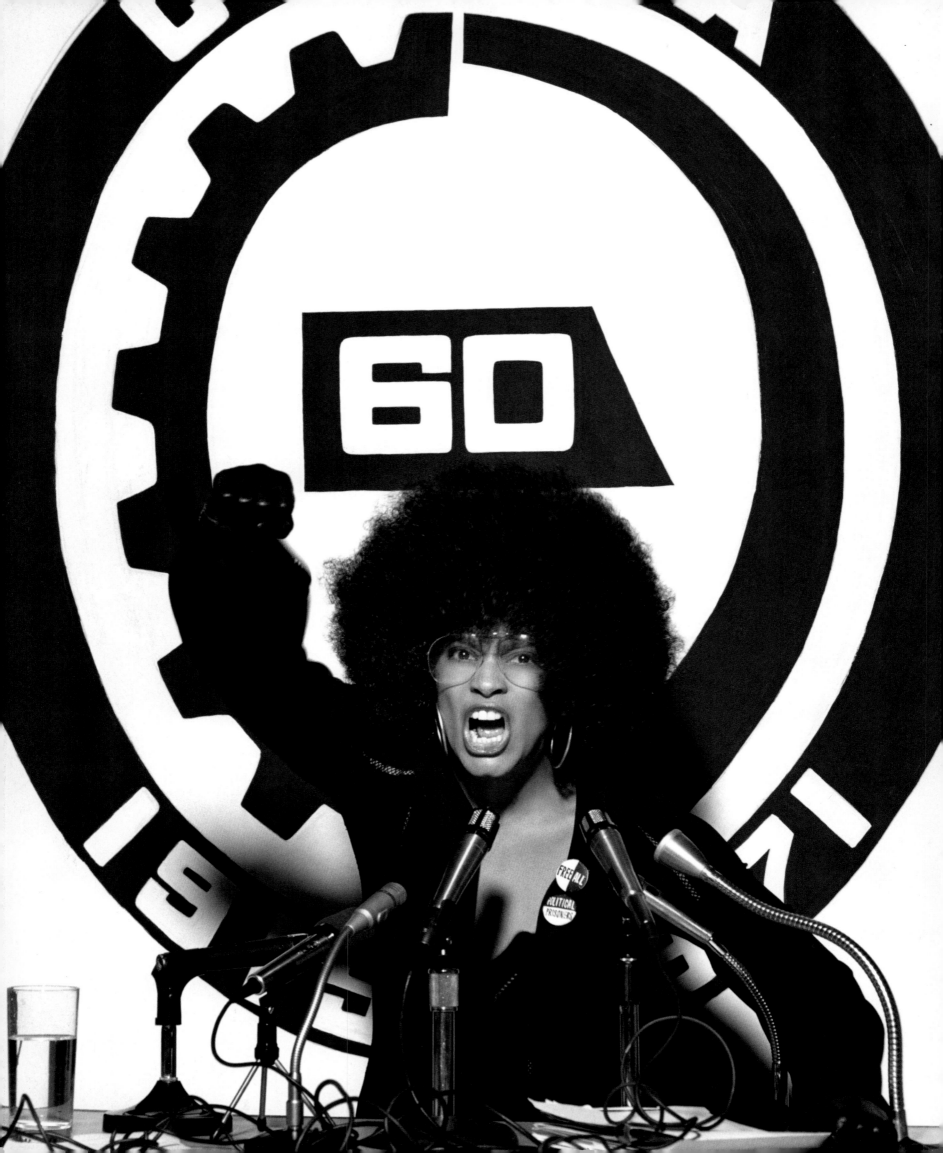

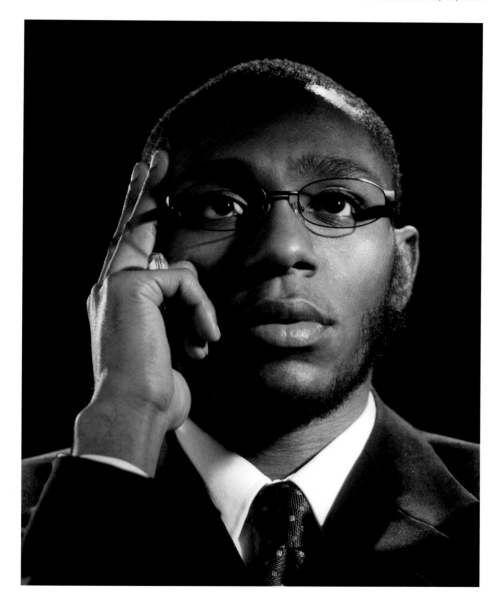

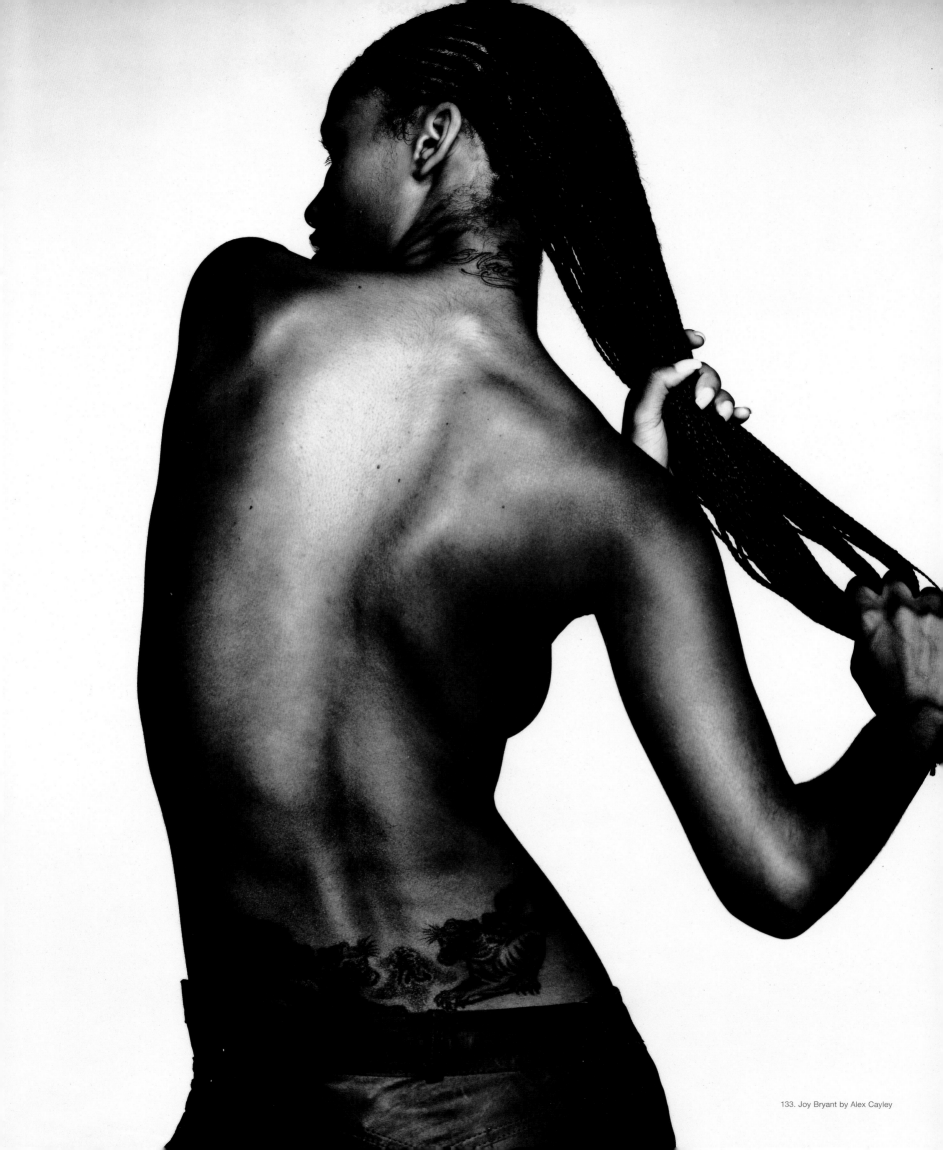

133. Joy Bryant by Alex Cayley

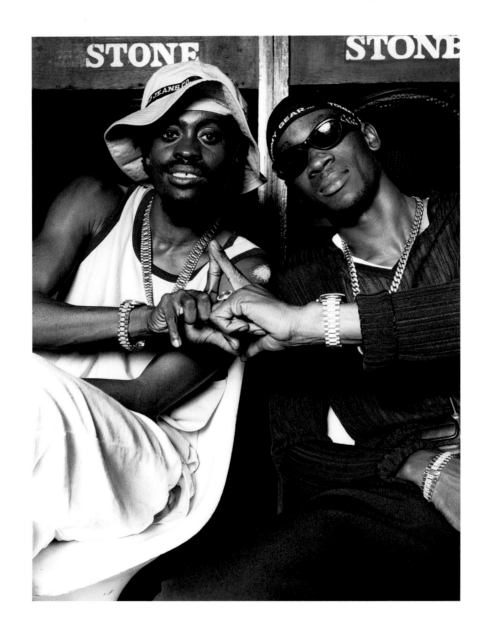

134. Beenie Man and Bounty Killer by Walter Chin

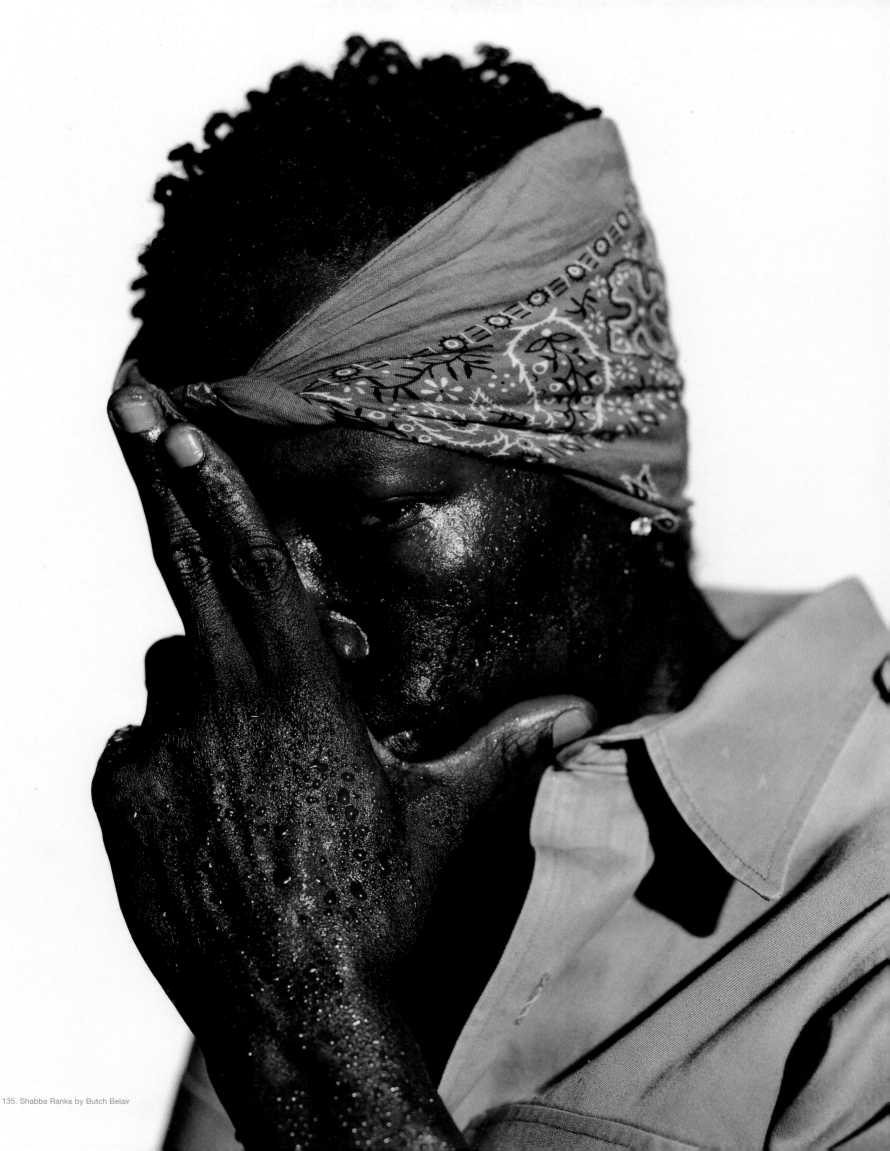

135. Shabba Ranks by Butch Belair

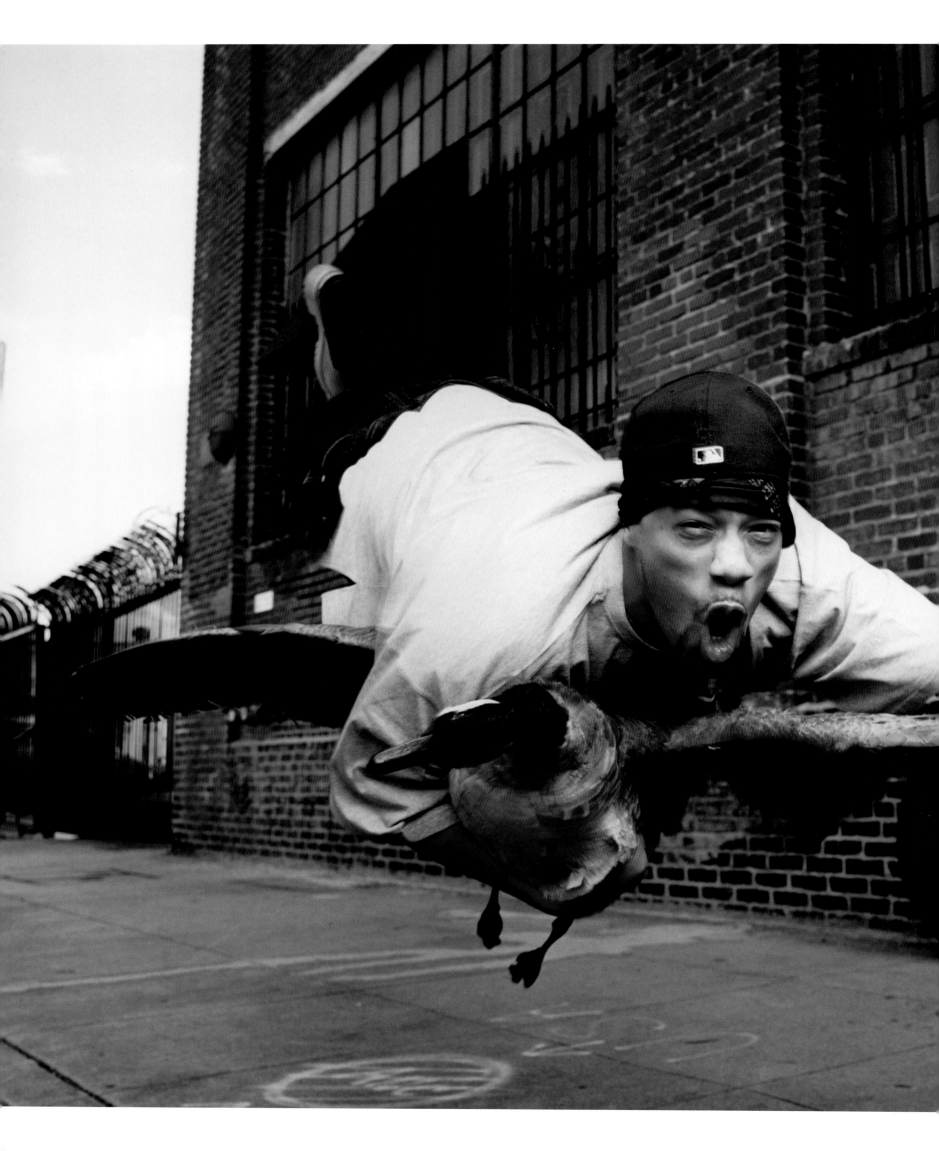

136. Redman by Dean Karr

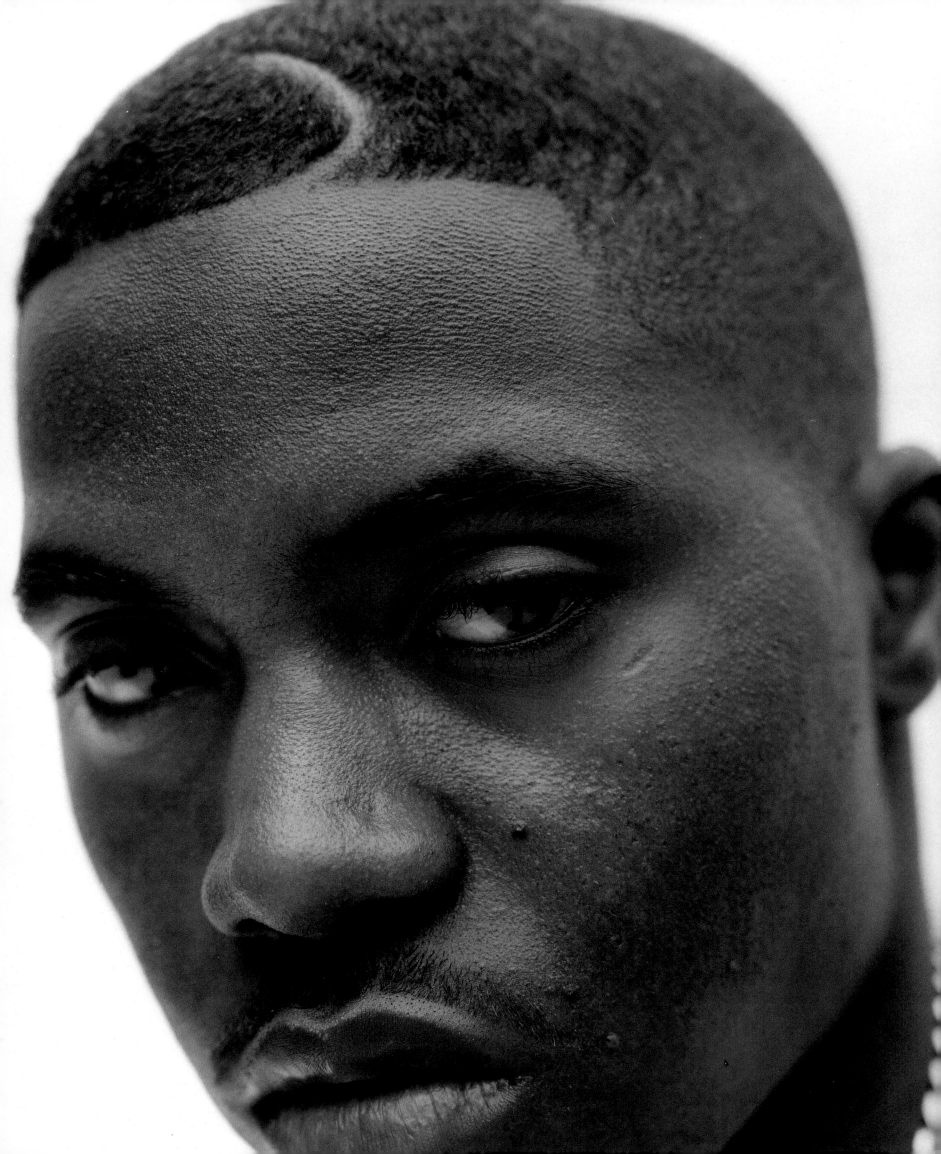

Although Nas dropped out of school in the eighth grade his verses are beginning to be studied in university classrooms alongside the poetry of T.S. Eliiot. Where some freestyle purists pride themselves on never picking up a pen, Nasty Nas has always been explicity a writer as well as a vocalist. From his first album—"writing in my book of rhymes all the words pass the margins"—to his most recent, on which he can be heard flipping through his spiral notebooks in the vocal booth, he's always made it clear that "It Was Written."

—*from "Of Love And War" by Rob Kenner*

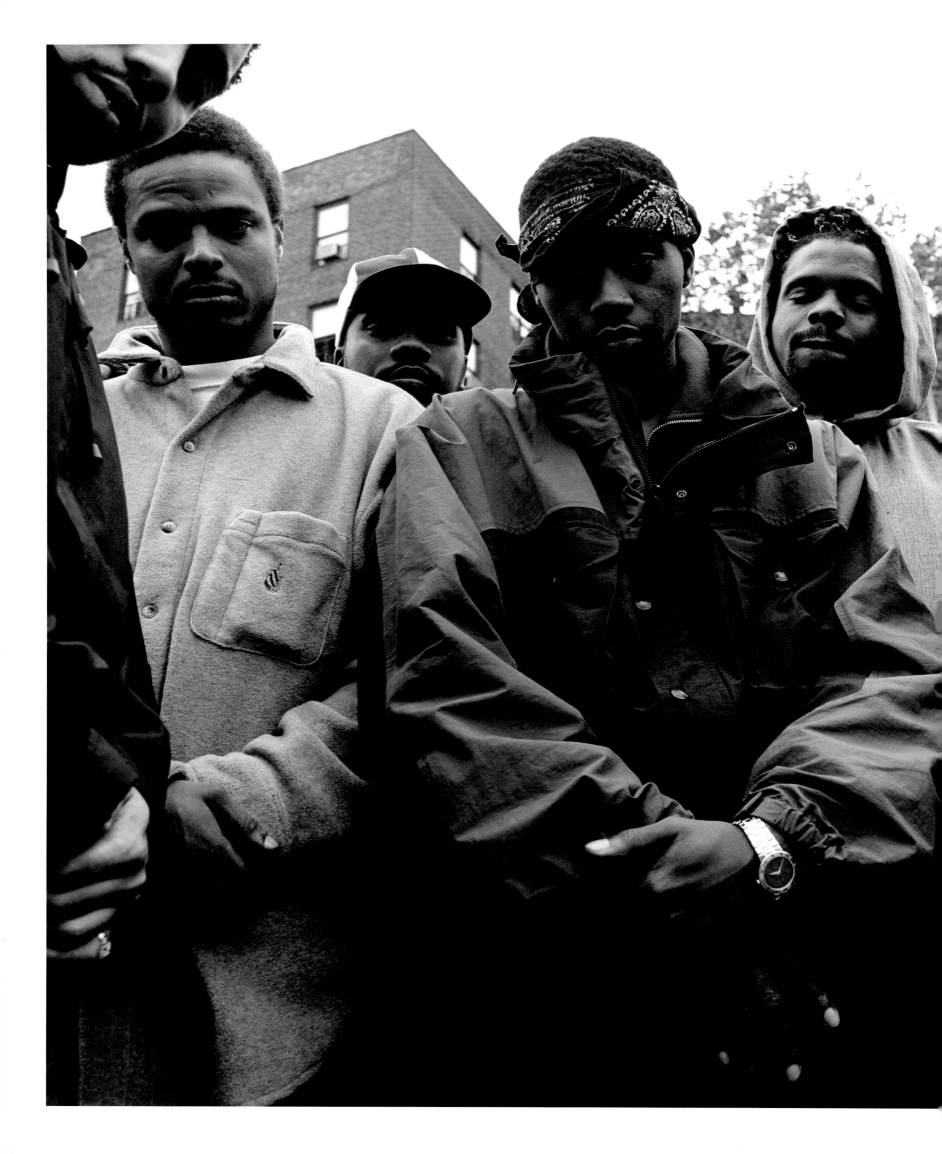

140. Nas and Crew by Andrew Williams

Free to blur the line 'twixt the blasphemous and the holy, nailed between the church and state, her body lay crossed. Did she—could she—belong to the host of hosts? Or to Dollar Man, who seemed somehow more omnipotent? And then there is the laying on of hands, be they the tiny palms of her children resting warm on her work-sore thighs or the damp palms of aroused men holding money, searching her body for where to put it, and how to feel her.

—*from "Southern Comfort" by Karen R. Good*

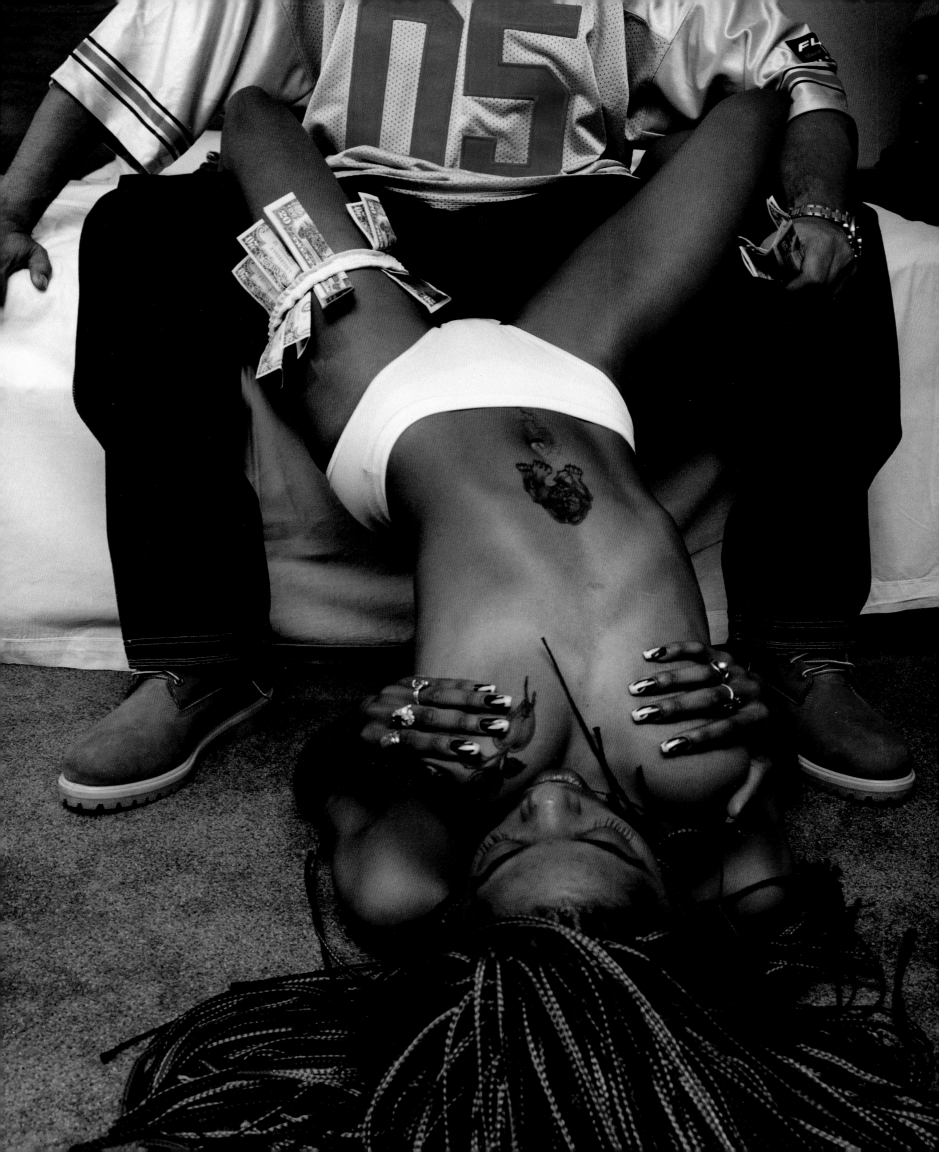

145. Hair Wars by Larry Fink

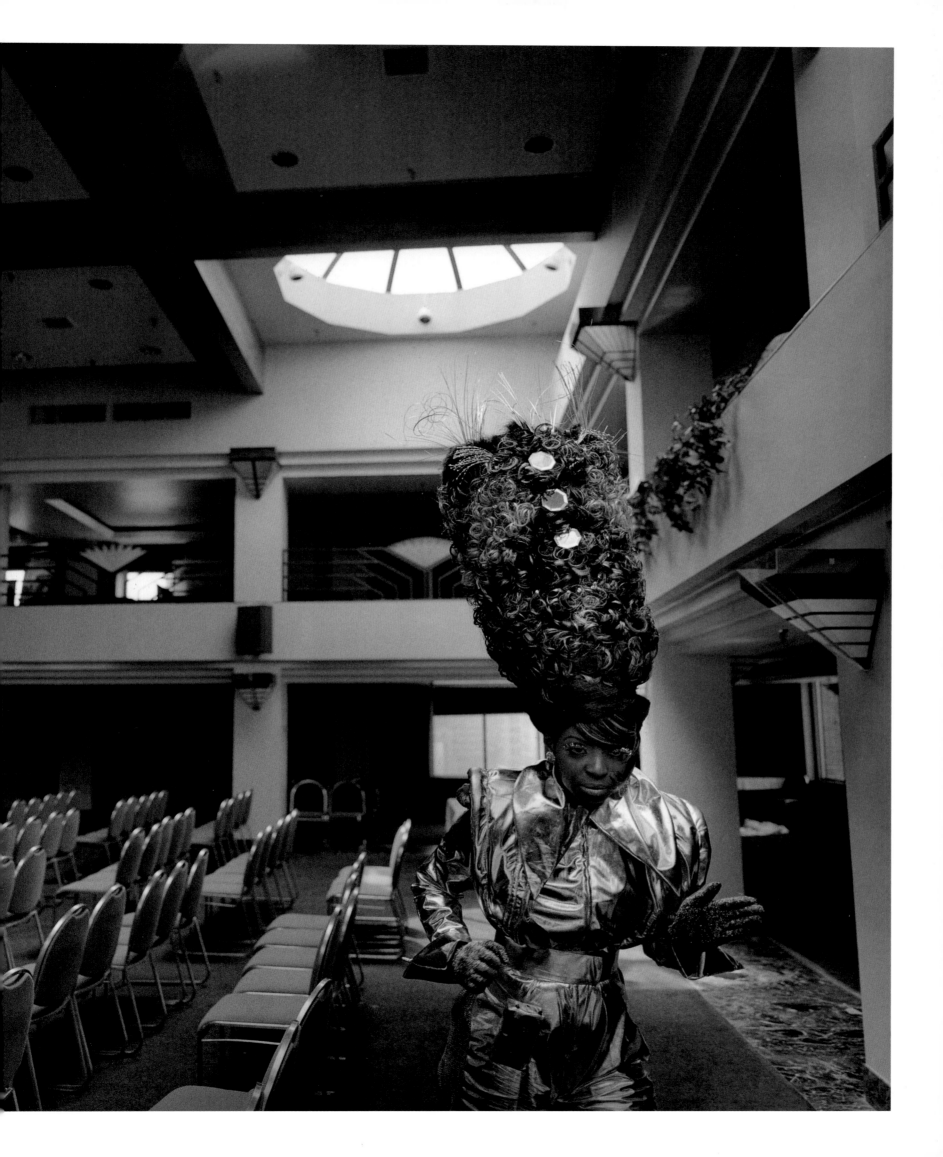

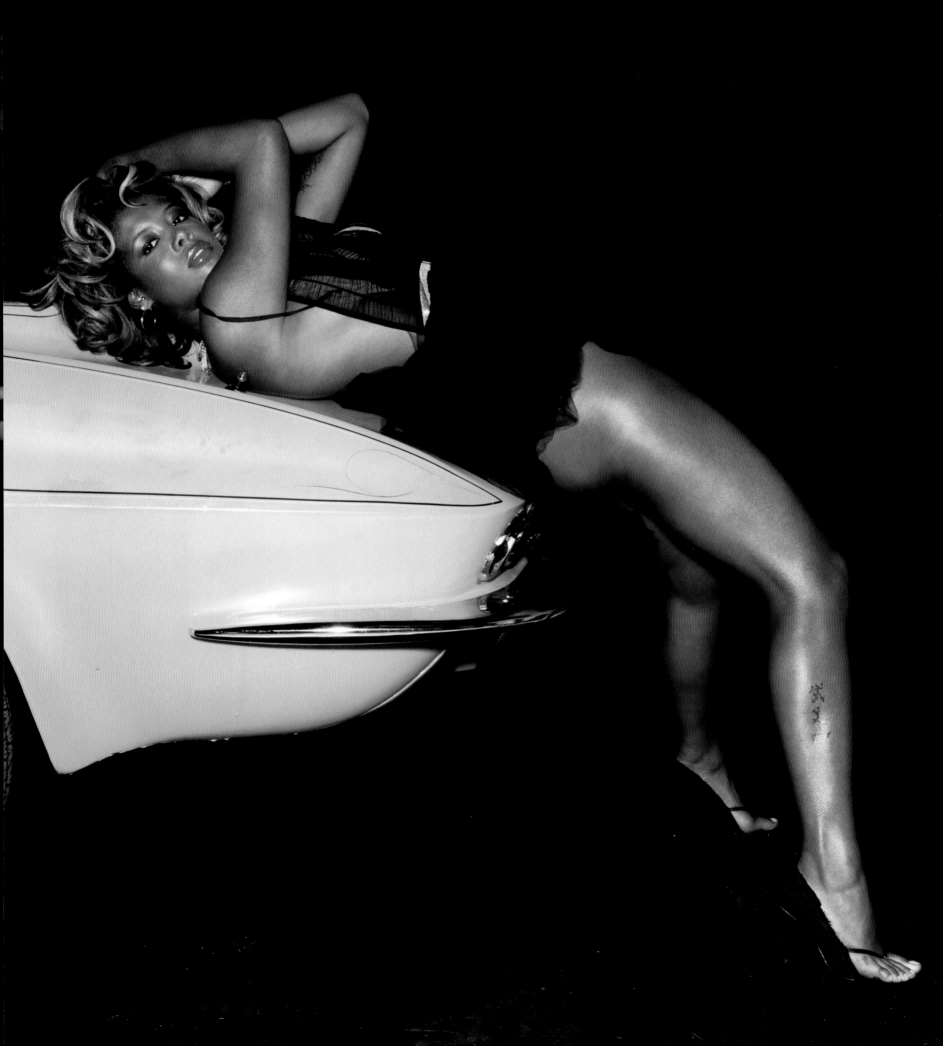

146. Kelis by Alex Cayley

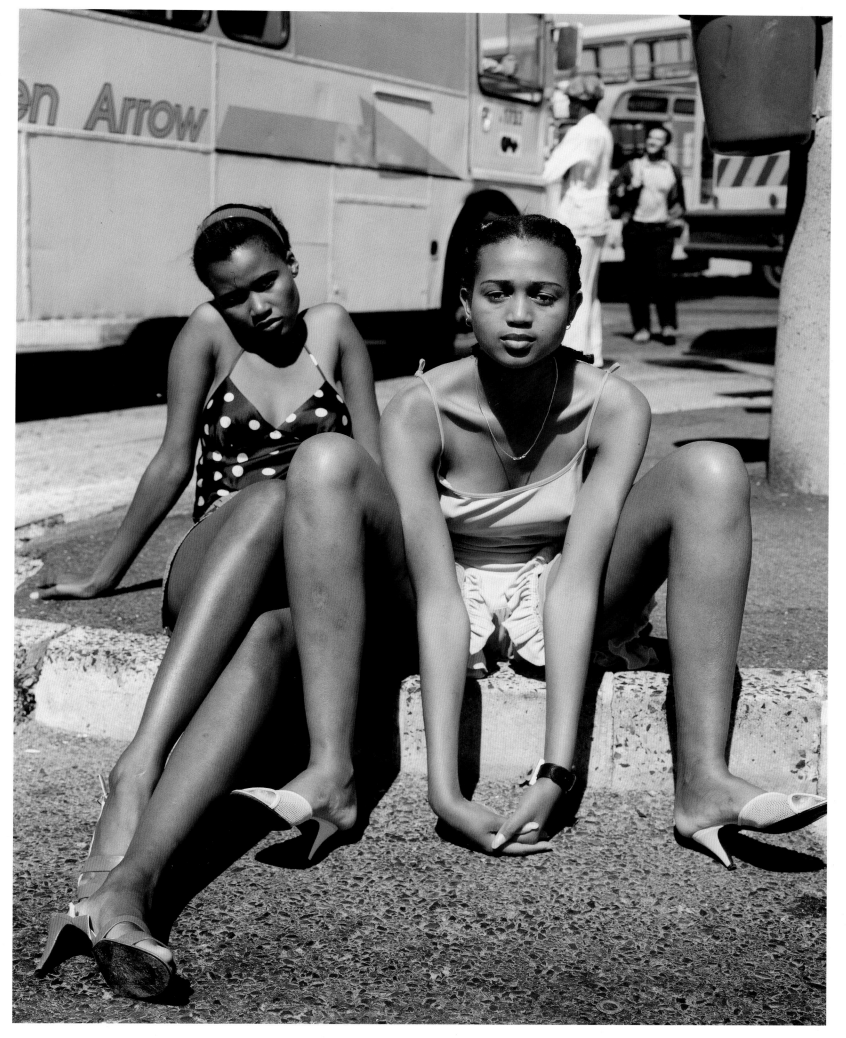

147. Cape Town by Dana Lixenberg

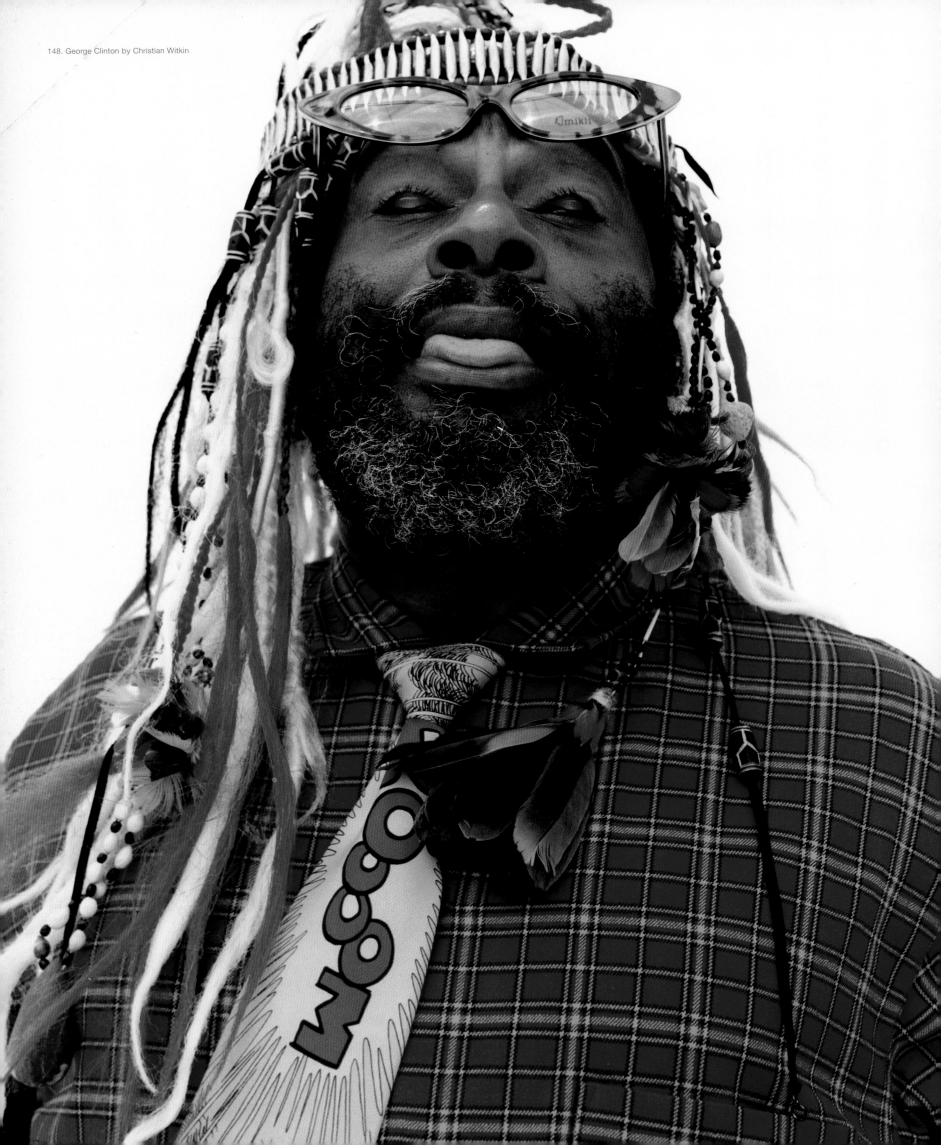

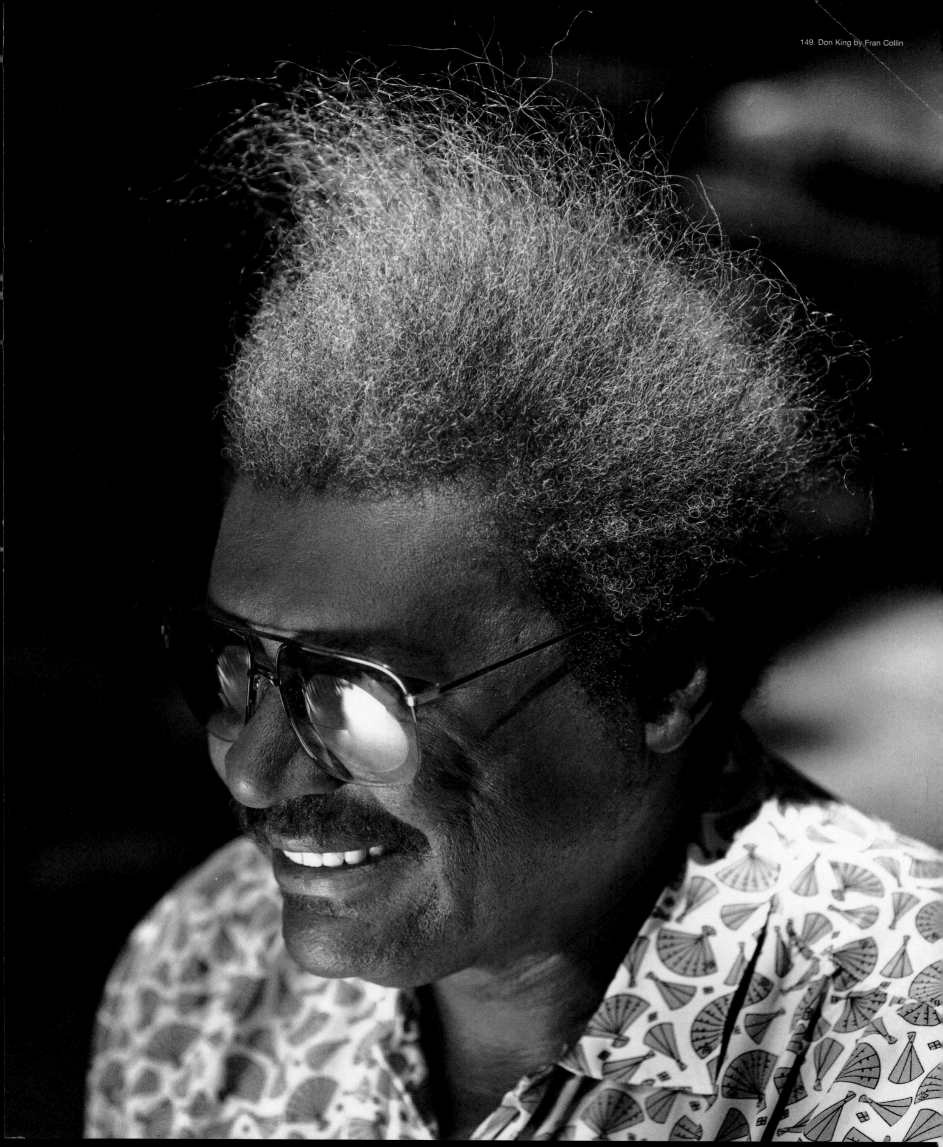

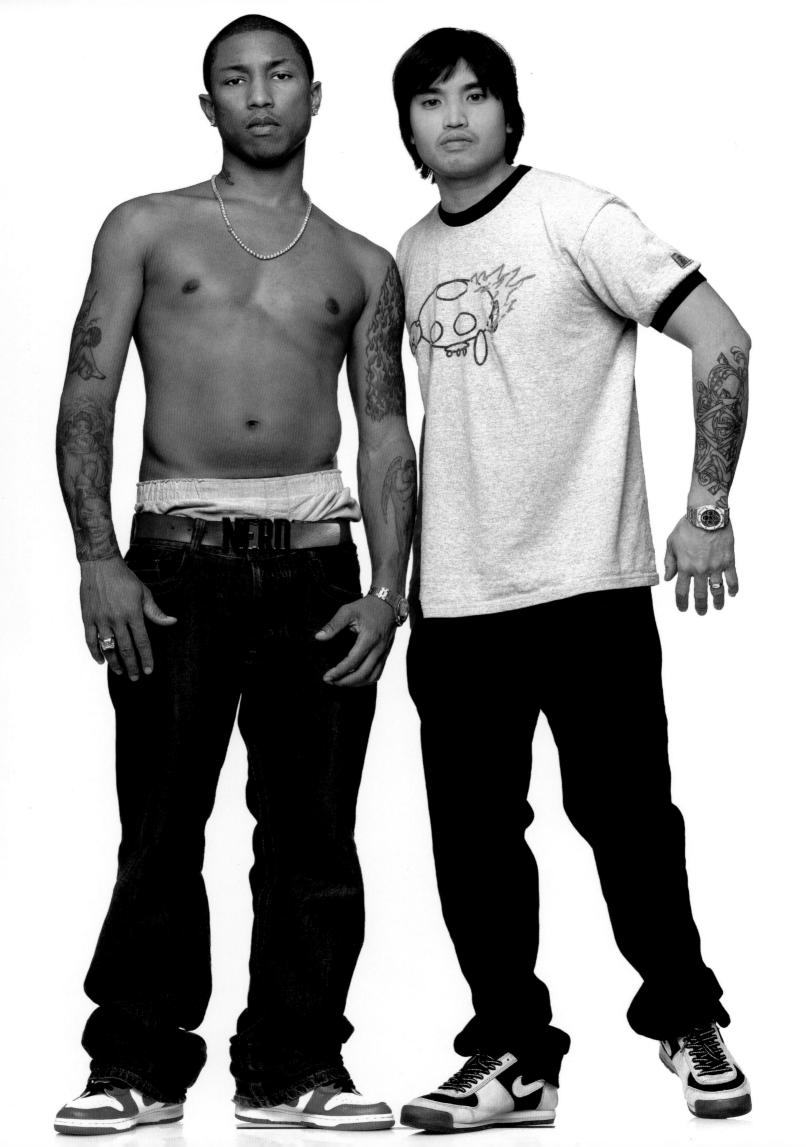

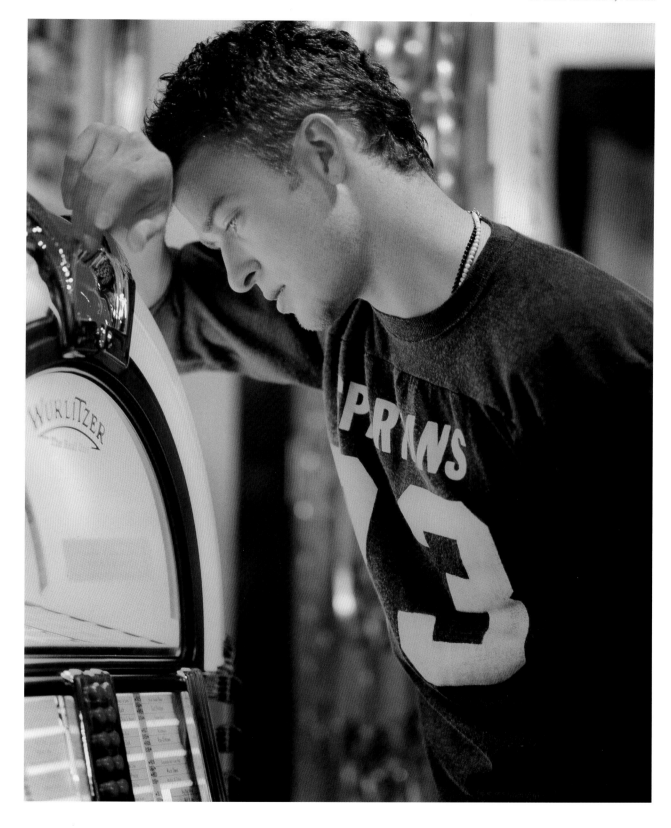

"We get criticized for the way we talk. People say, 'Oh, y'all country this and country that.' We don't worry about it since they're going to say what they're going to say. The thing is, the rap game is 20-plus years old. Everybody done rapped about cars, about girls. Everybody done rapped about money, about the struggle, about uplifting the race… alla that. The whole thing now is about having personality and charisma. It's not what you say, but how you say it."

—Nelly

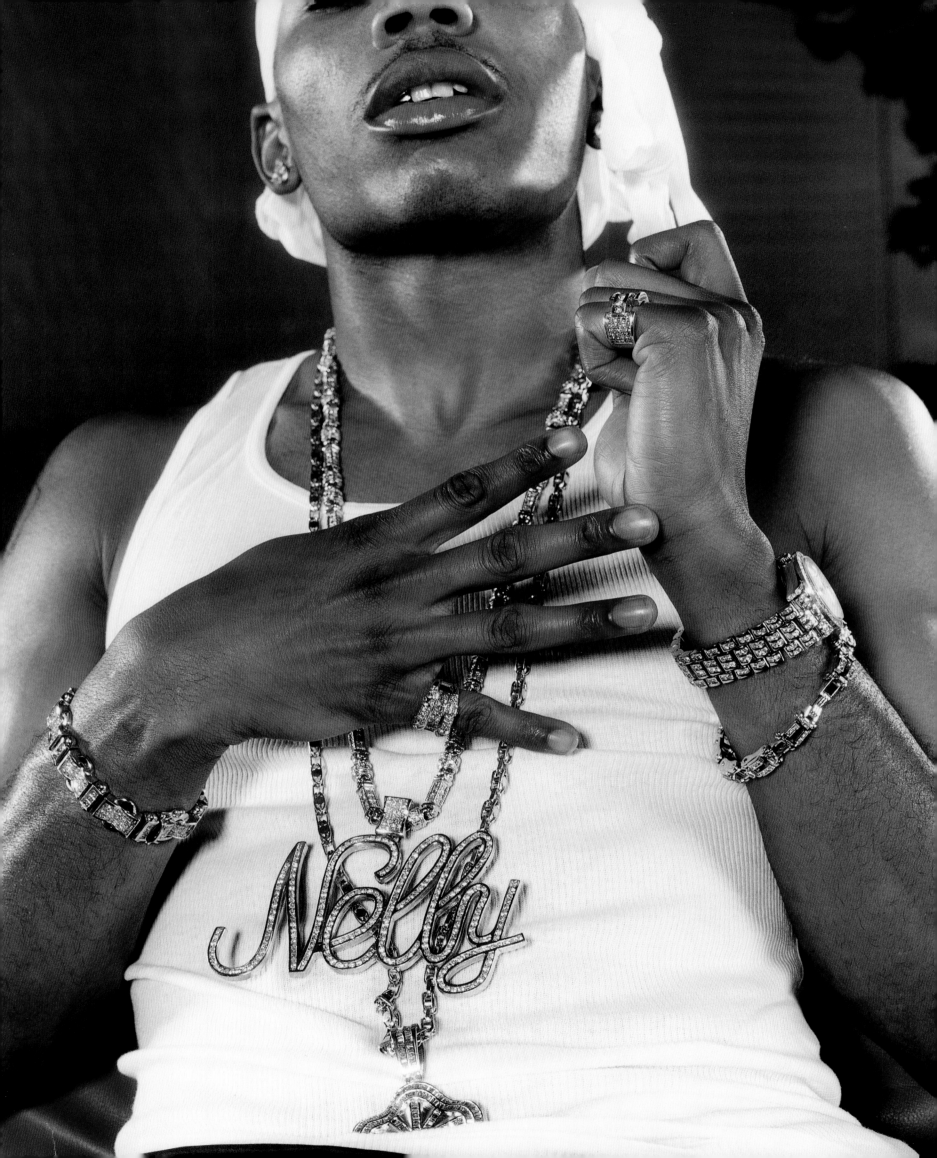

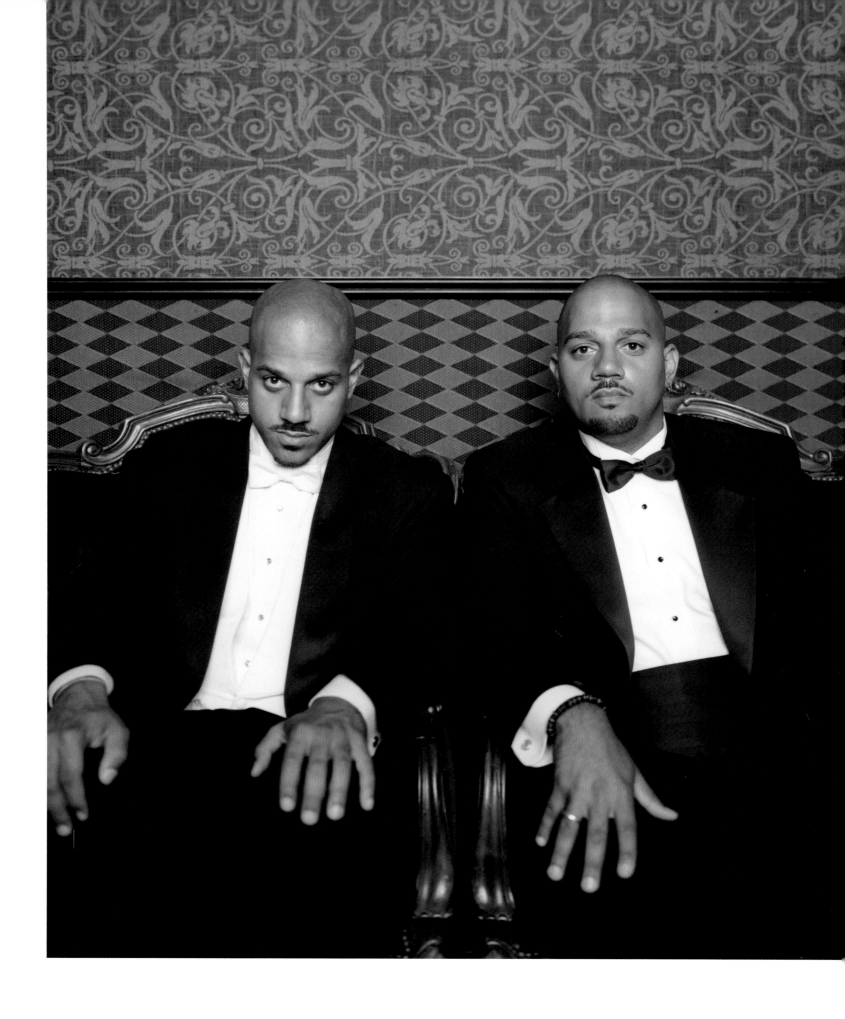

154. The Hughes Brothers by Barron Claiborne

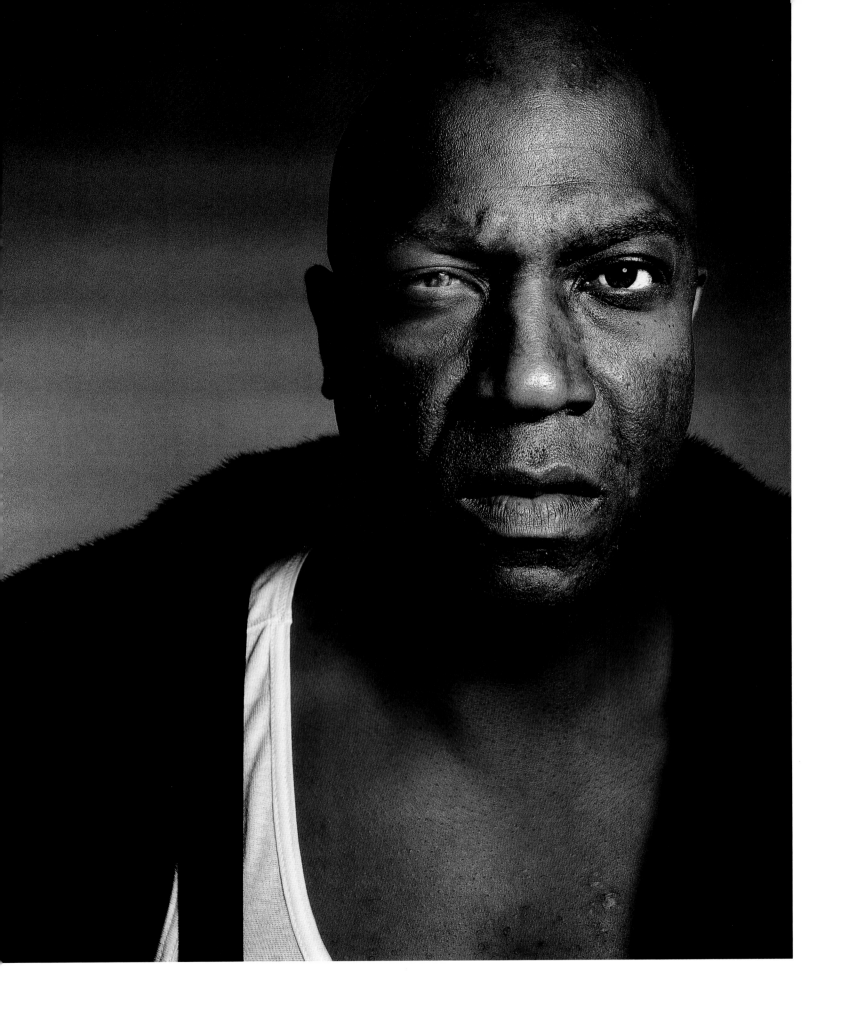

157. Teddy Riley by Dana Lixenberg

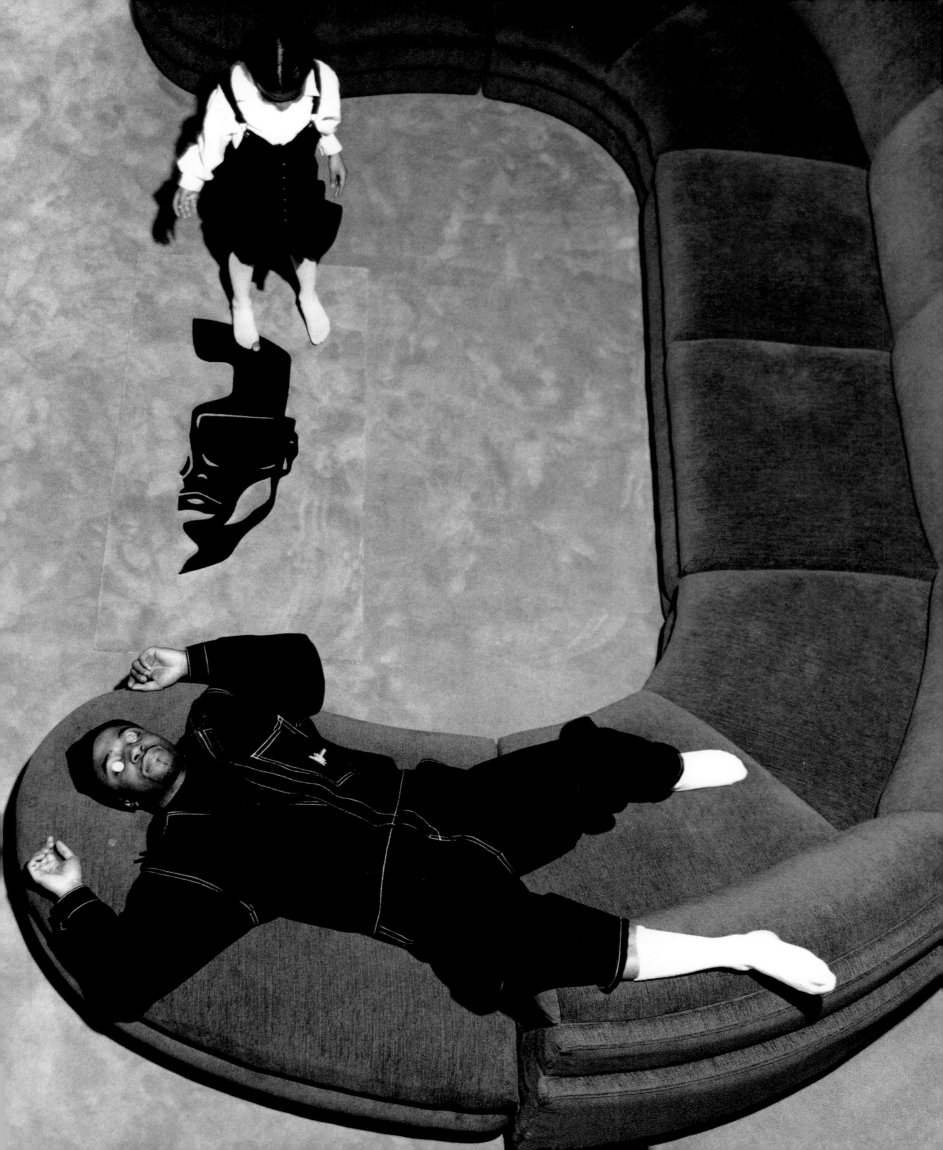

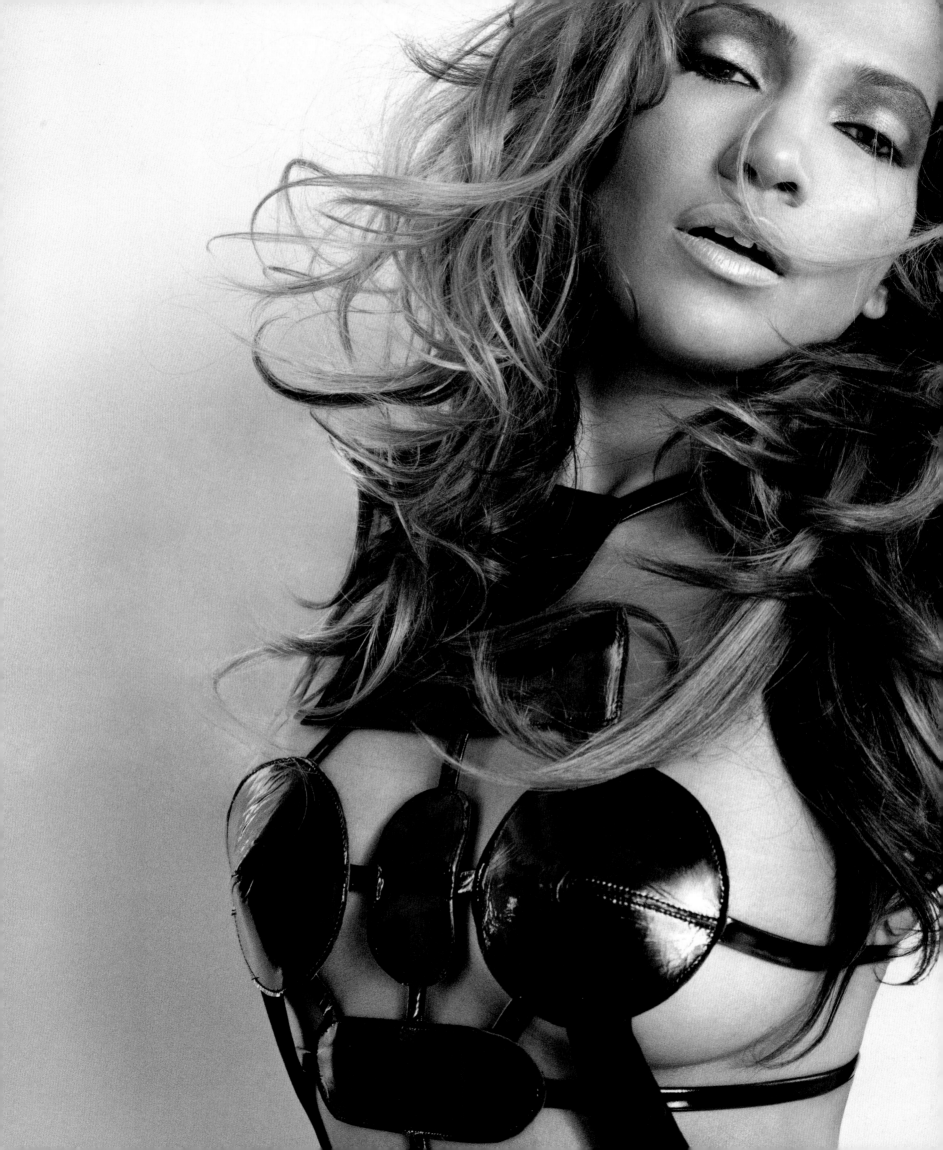

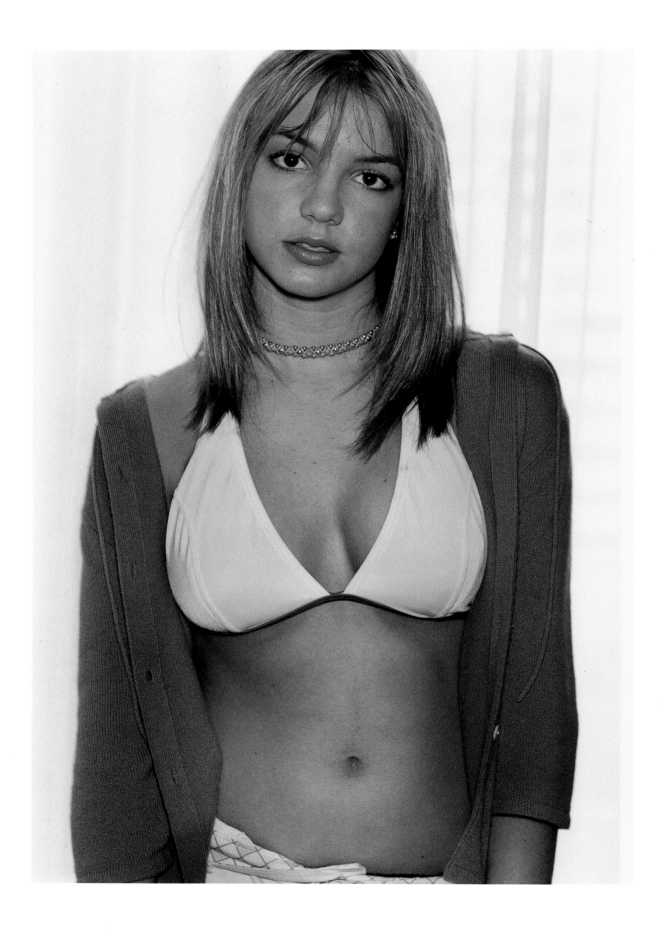

160. Britney Spears by Brian Walsh

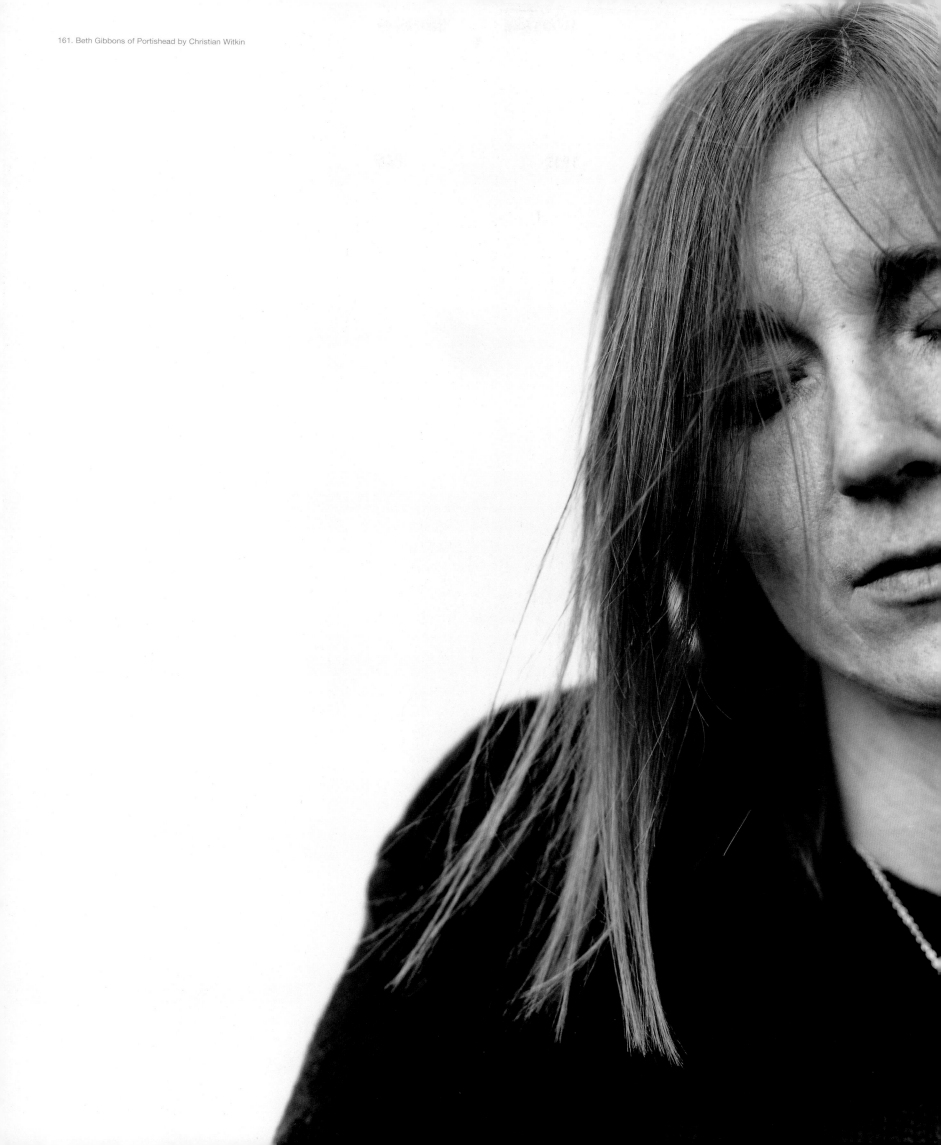

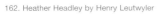

162. Heather Headley by Henry Leutwyler

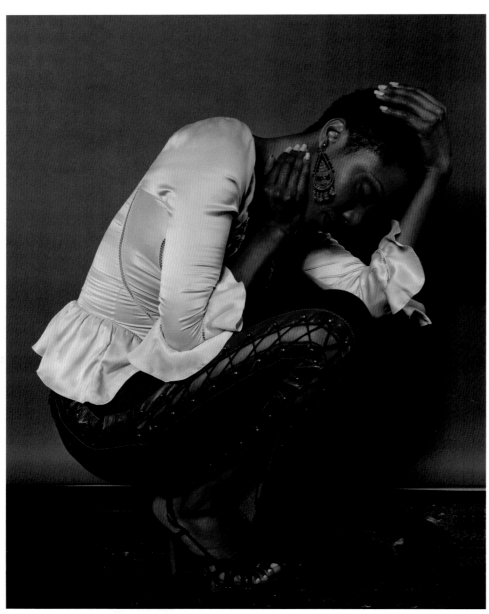

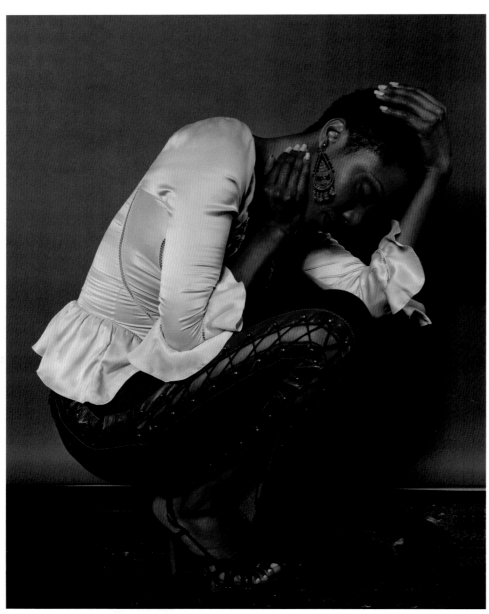

163. Destiny's Child by Vincent Skeltis

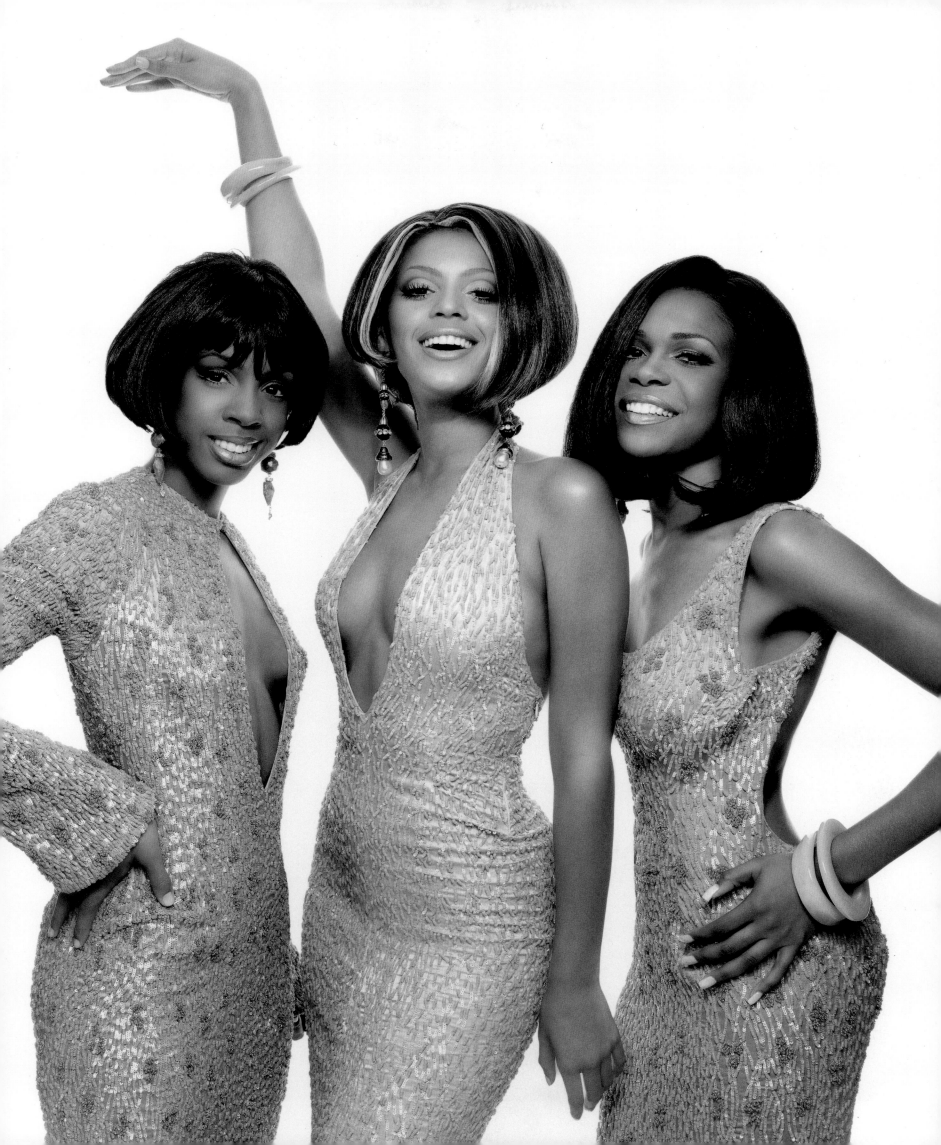

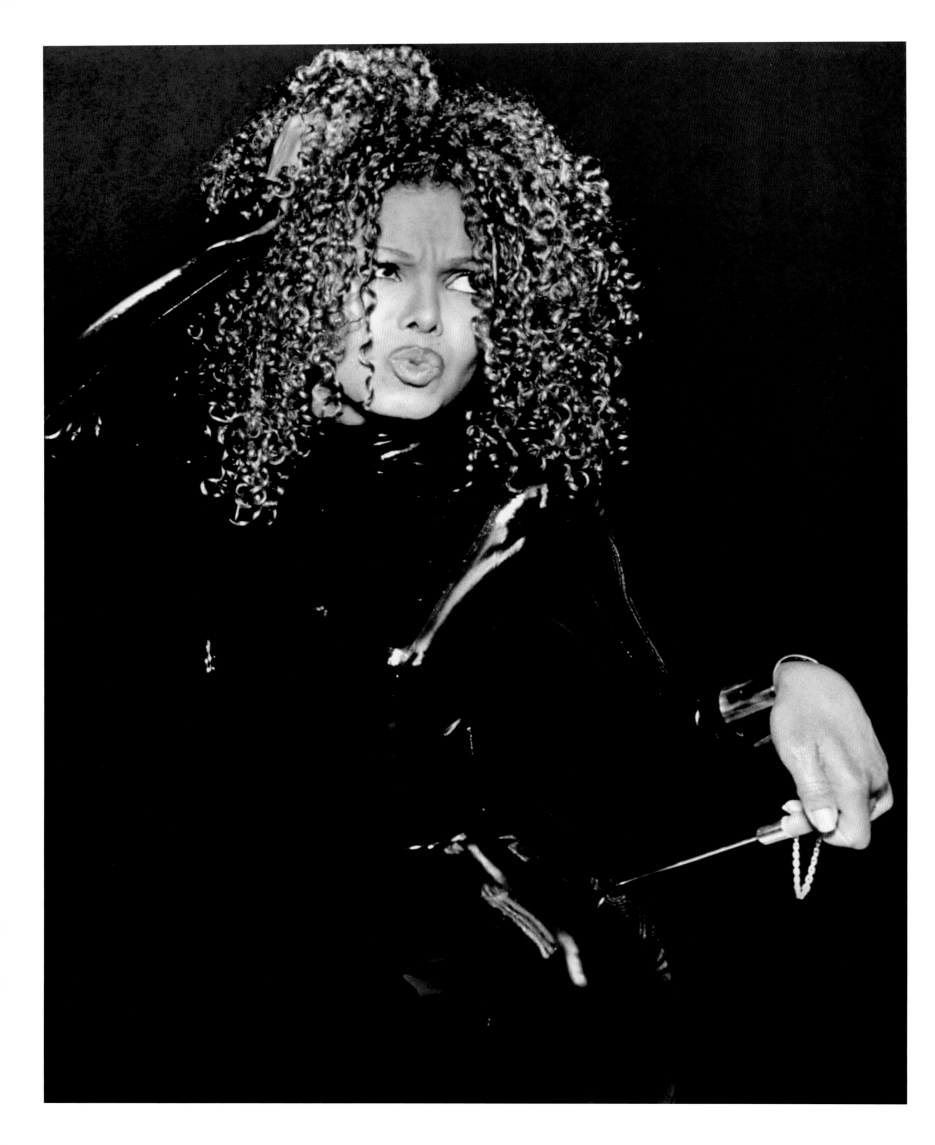

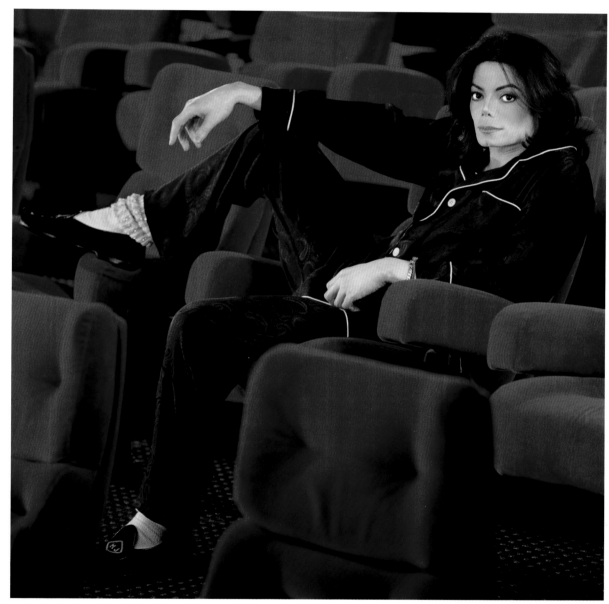

165. Michael Jackson by Jonathan Exley

167. Sarita Choudhury by Catalina Gonzalez

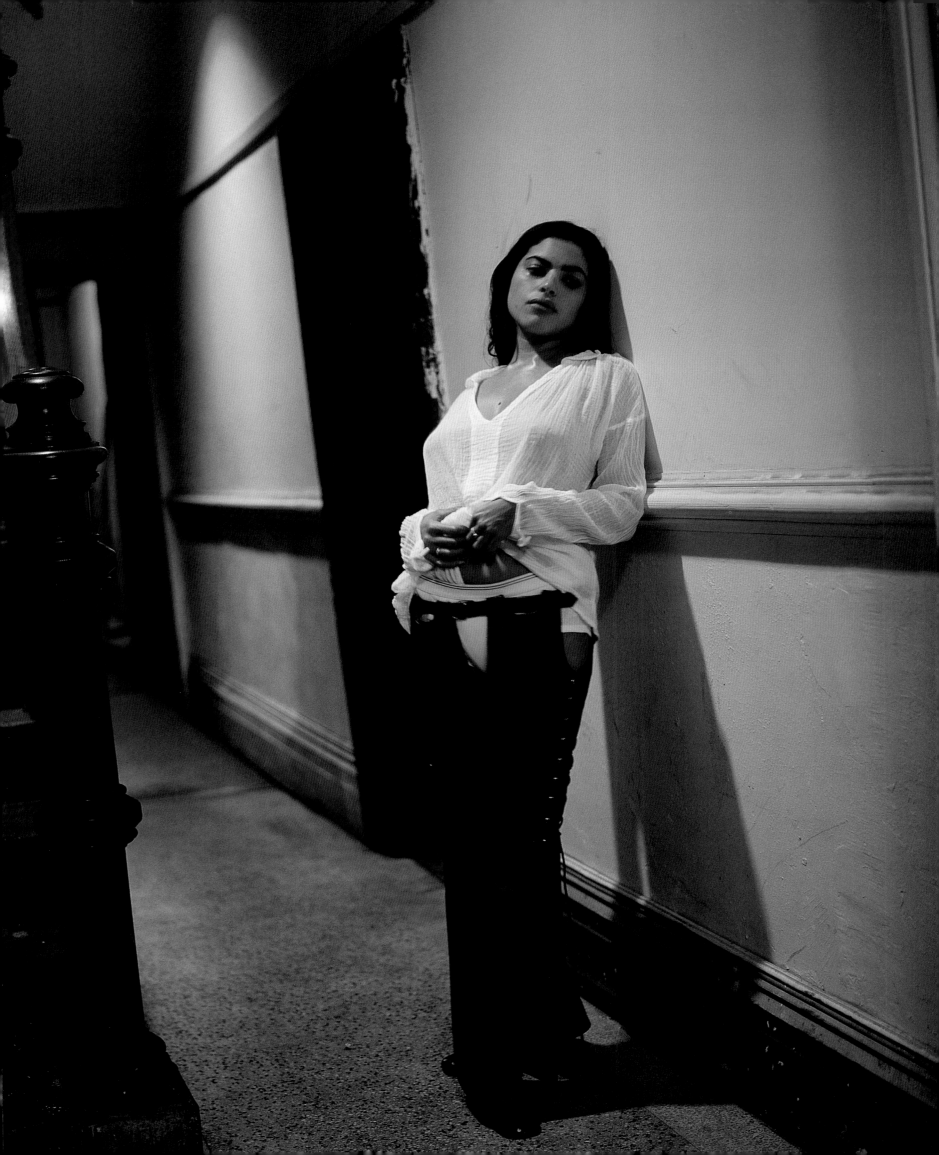

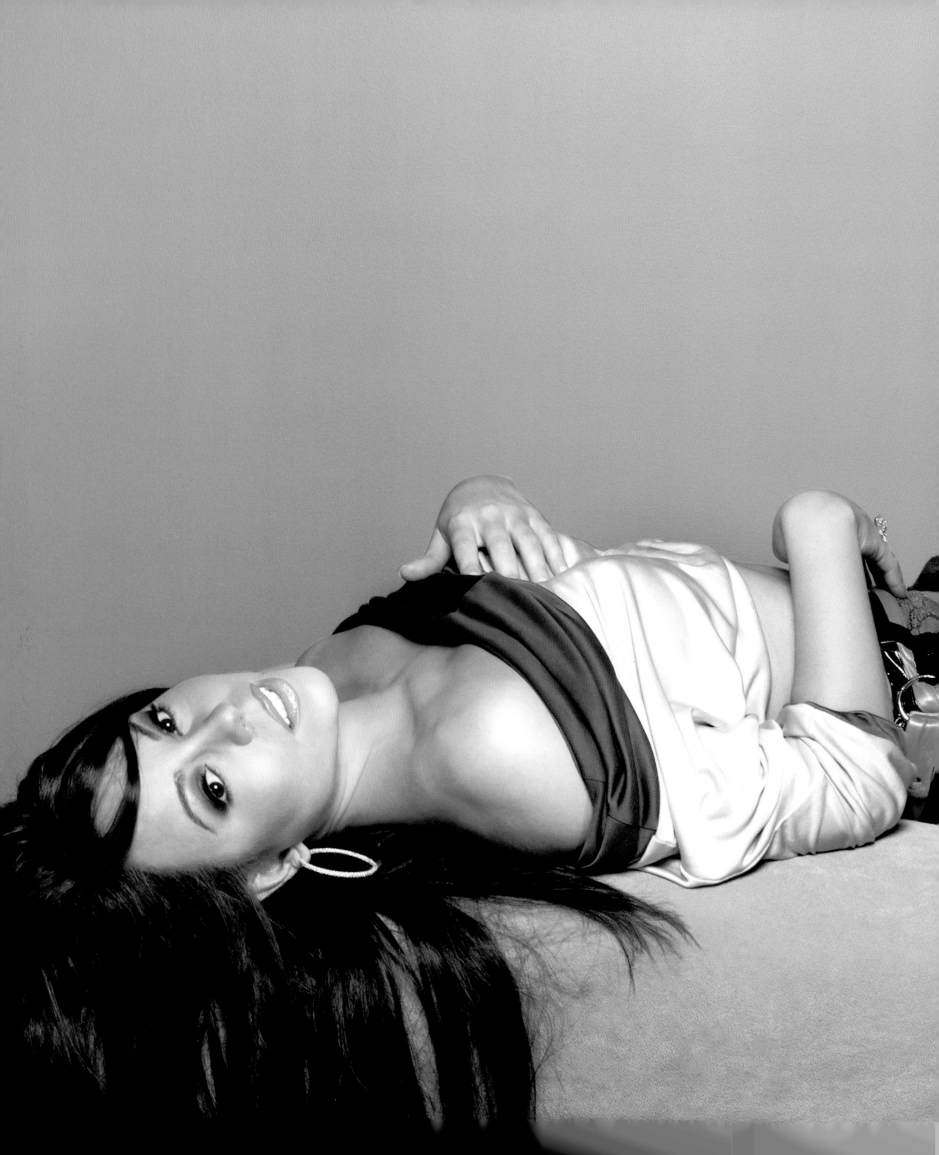

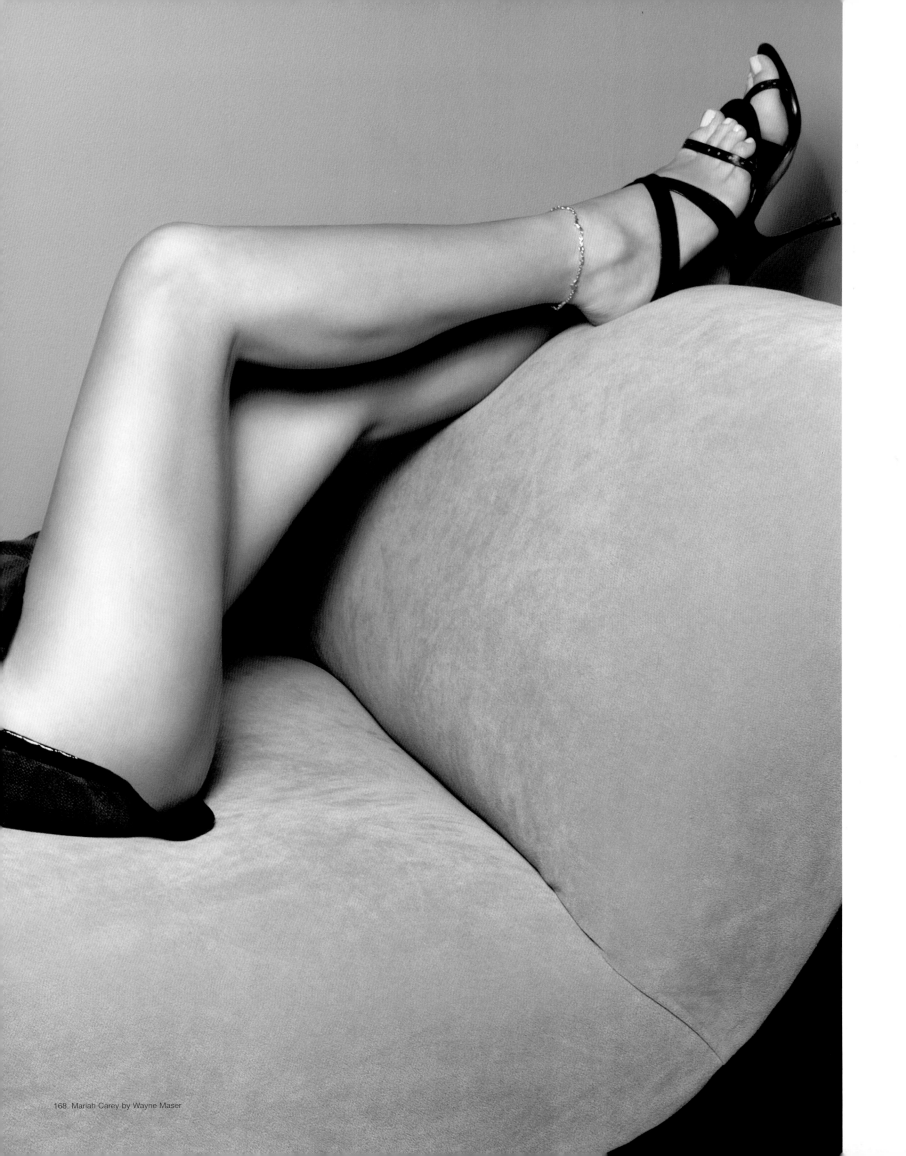

168. Mariah Carey by Wayne Maser

171. Madonna by Melodie McDaniel

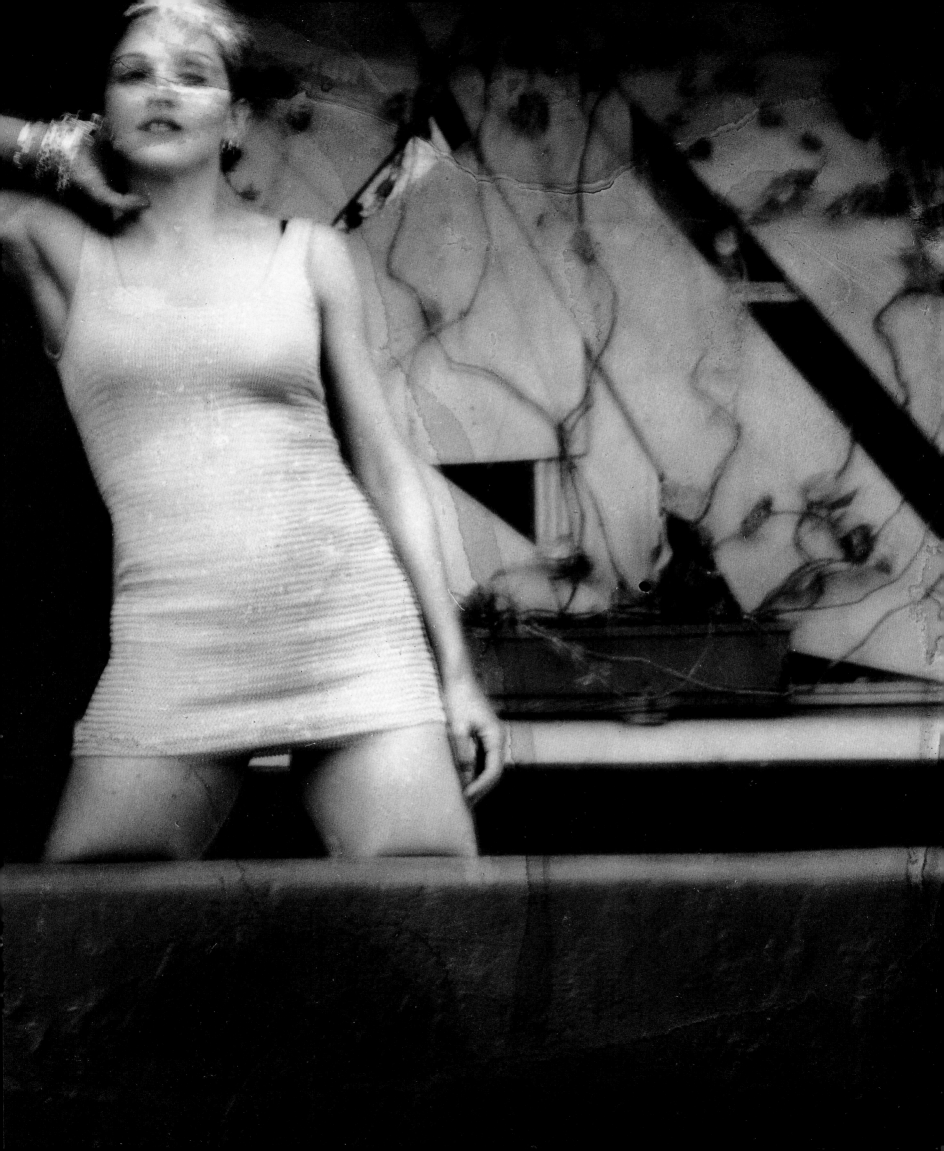

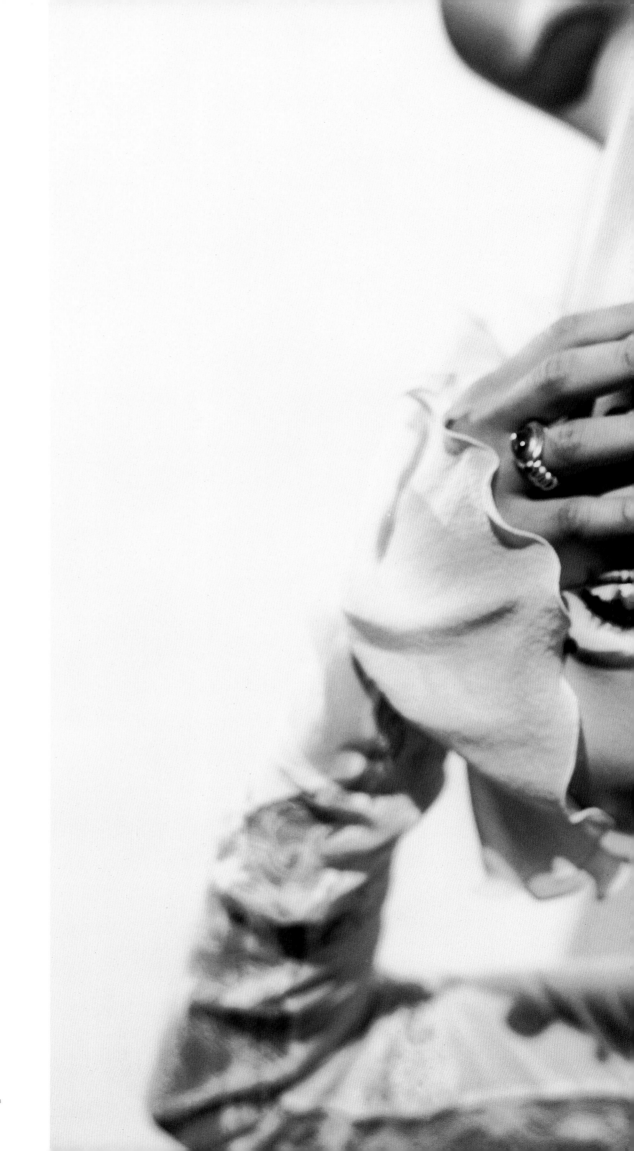

173. Rosie Perez by Cleo Sullivan

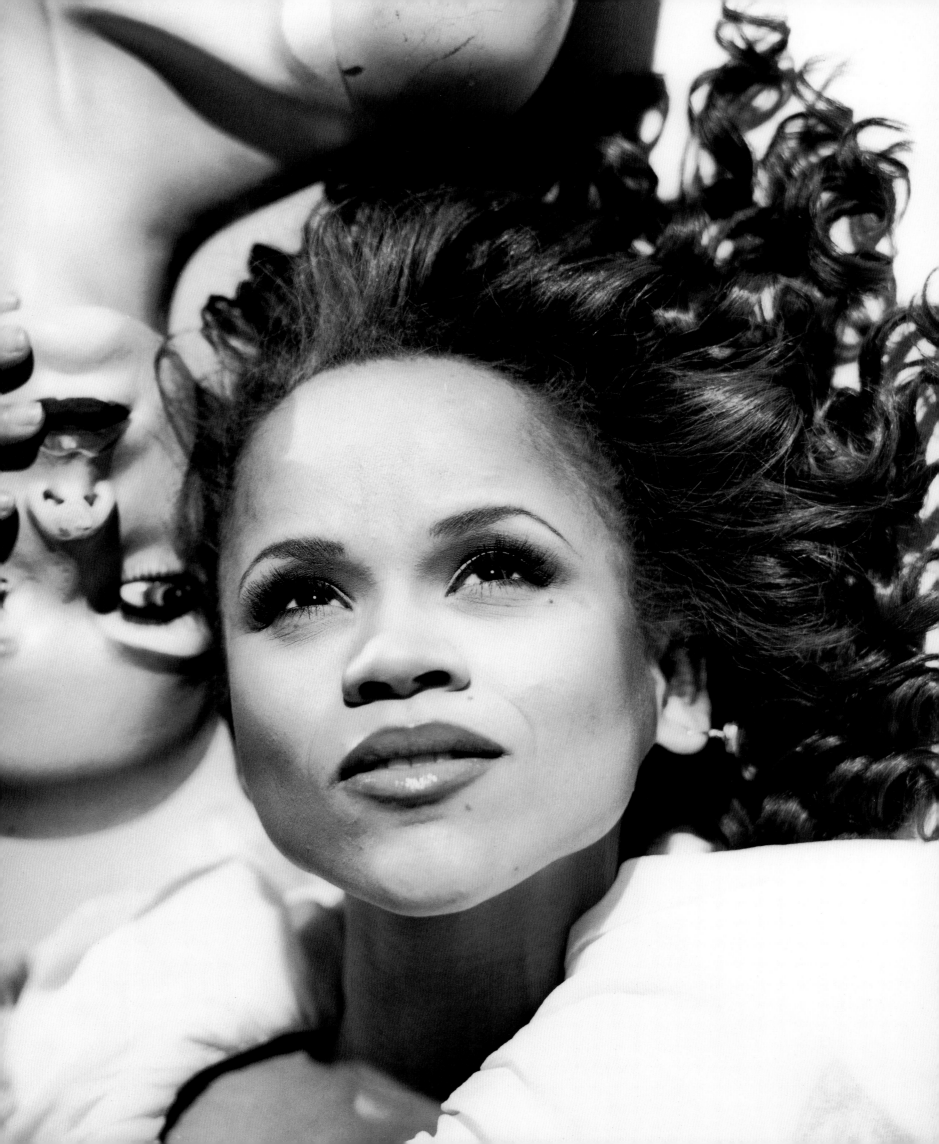

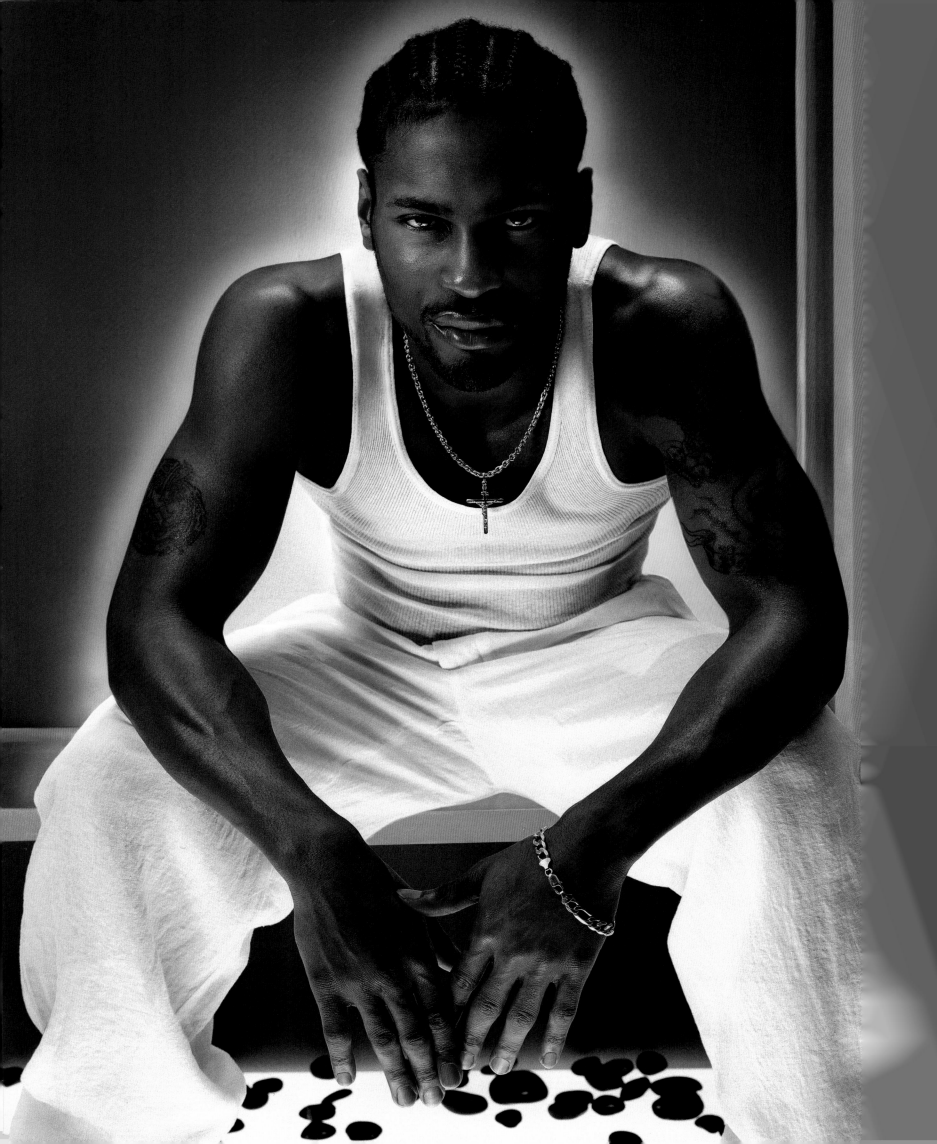

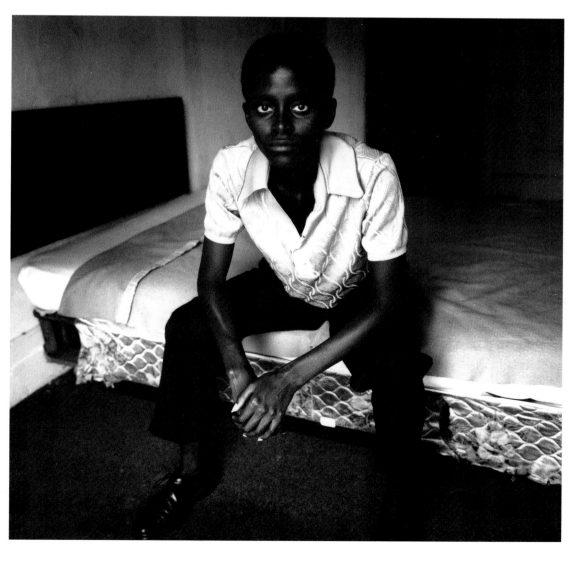

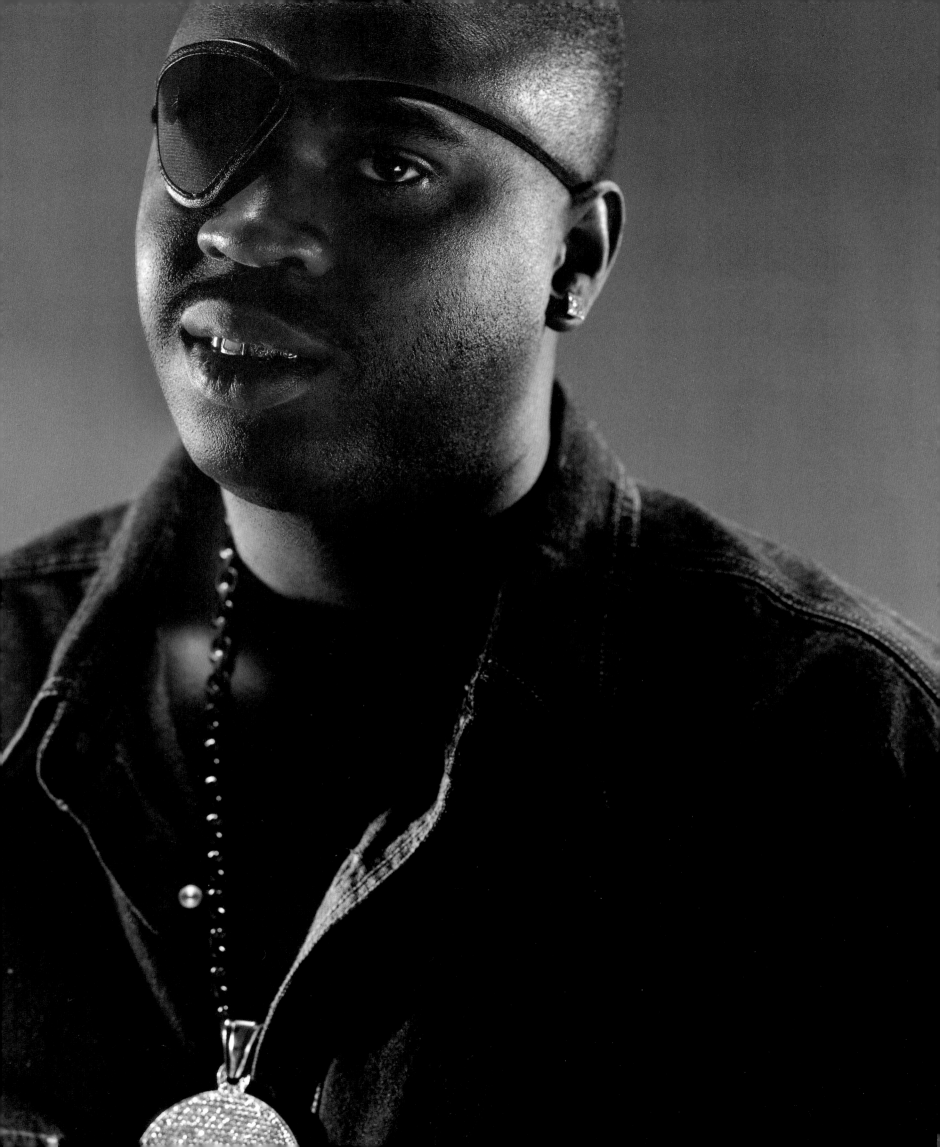

"People didn't sleep on the *Fugees*. They slept on the two brothers. They said she should go solo. There are always those who will try and divide a situation, but this isn't a group that was *put* together. We've known each other a long time. I've known Lauryn since she was in the eighth grade."

—*Pras*

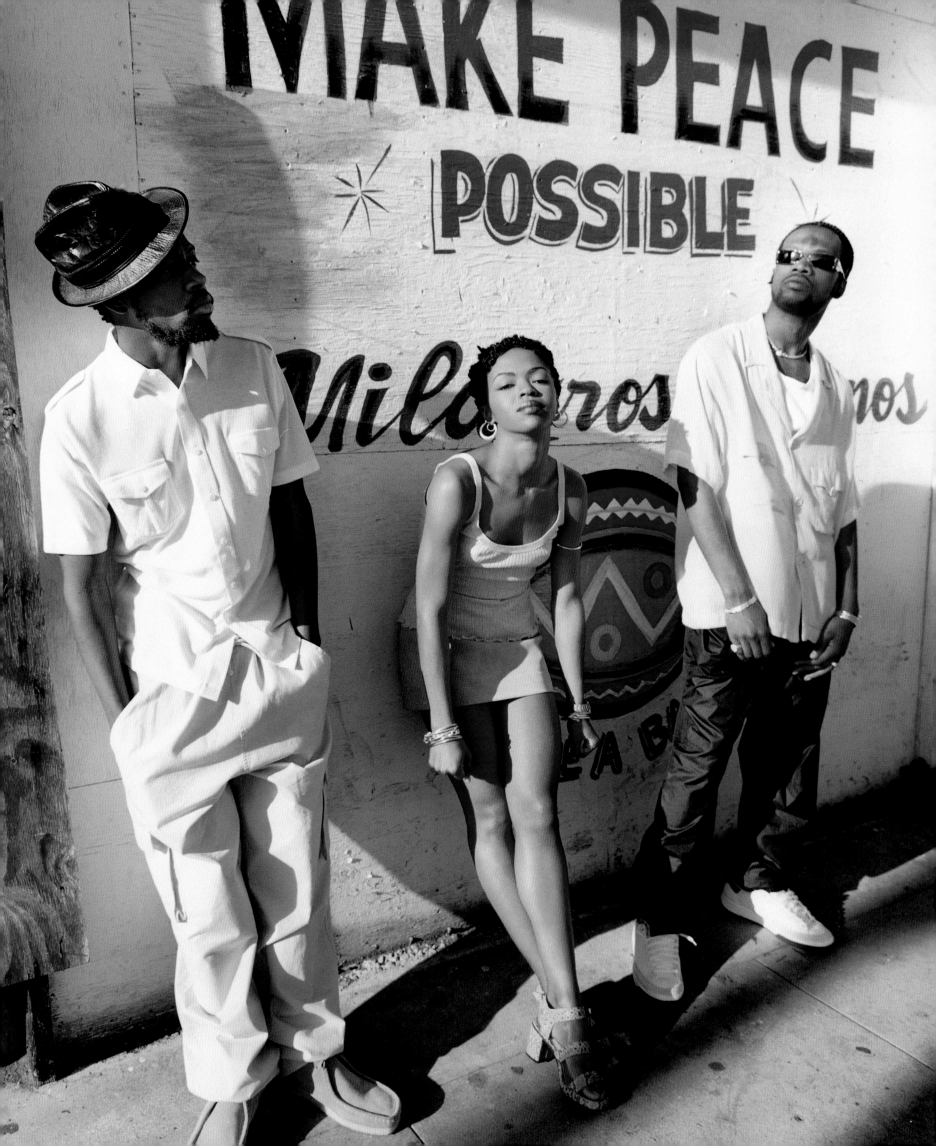

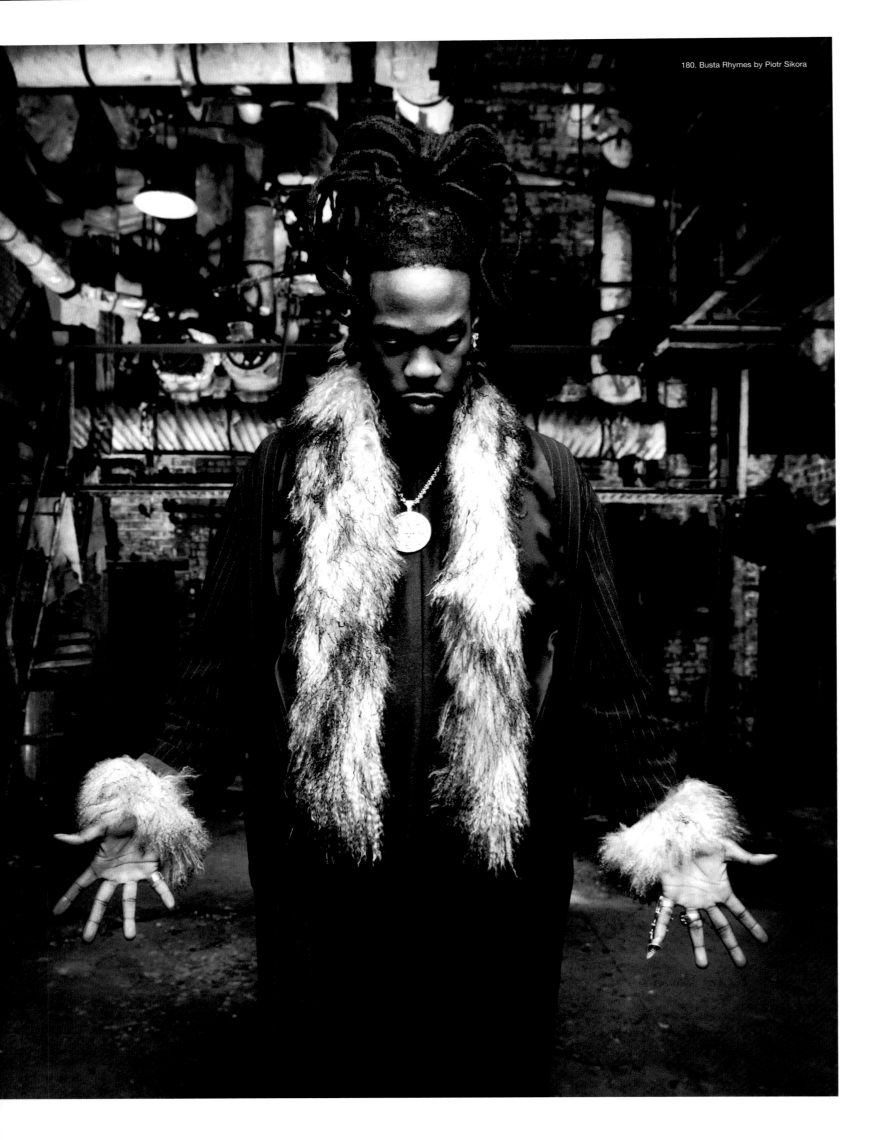

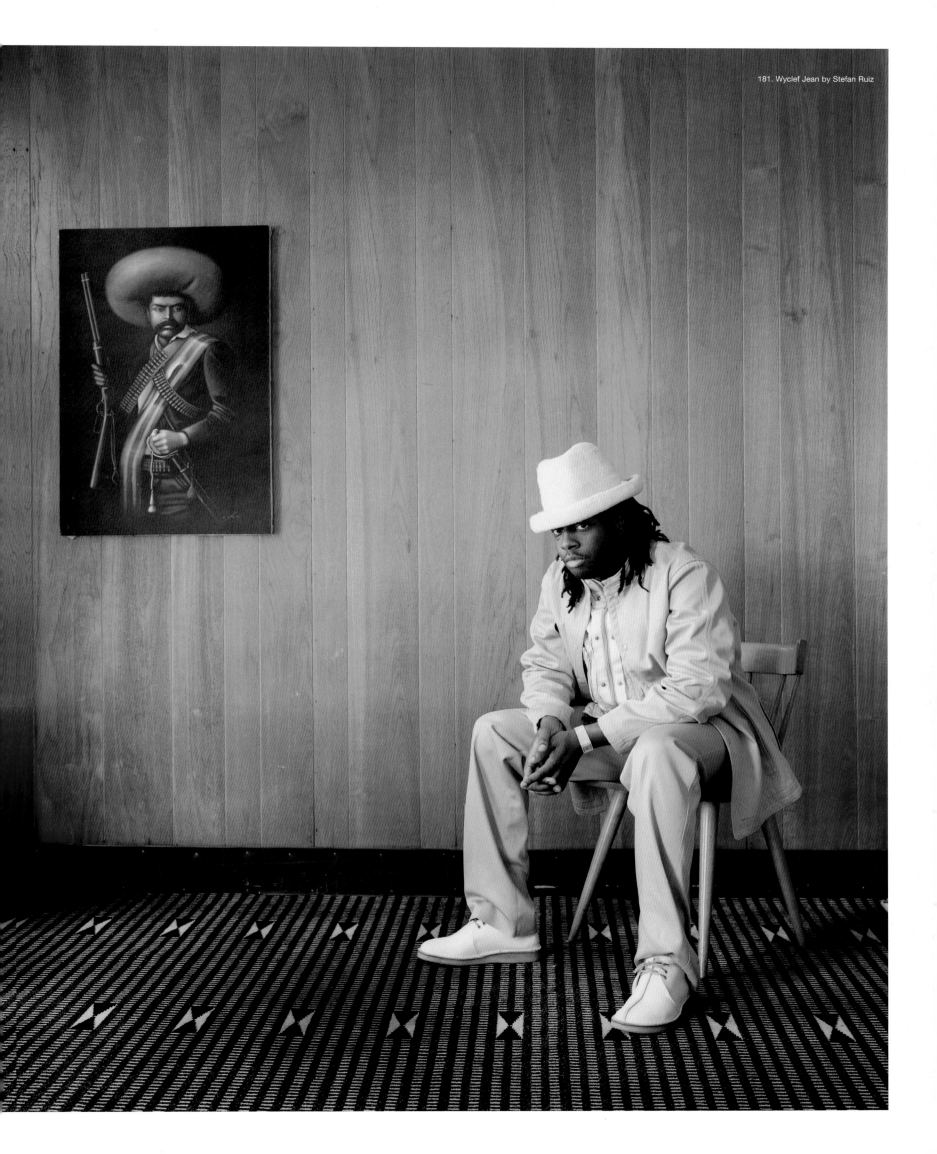

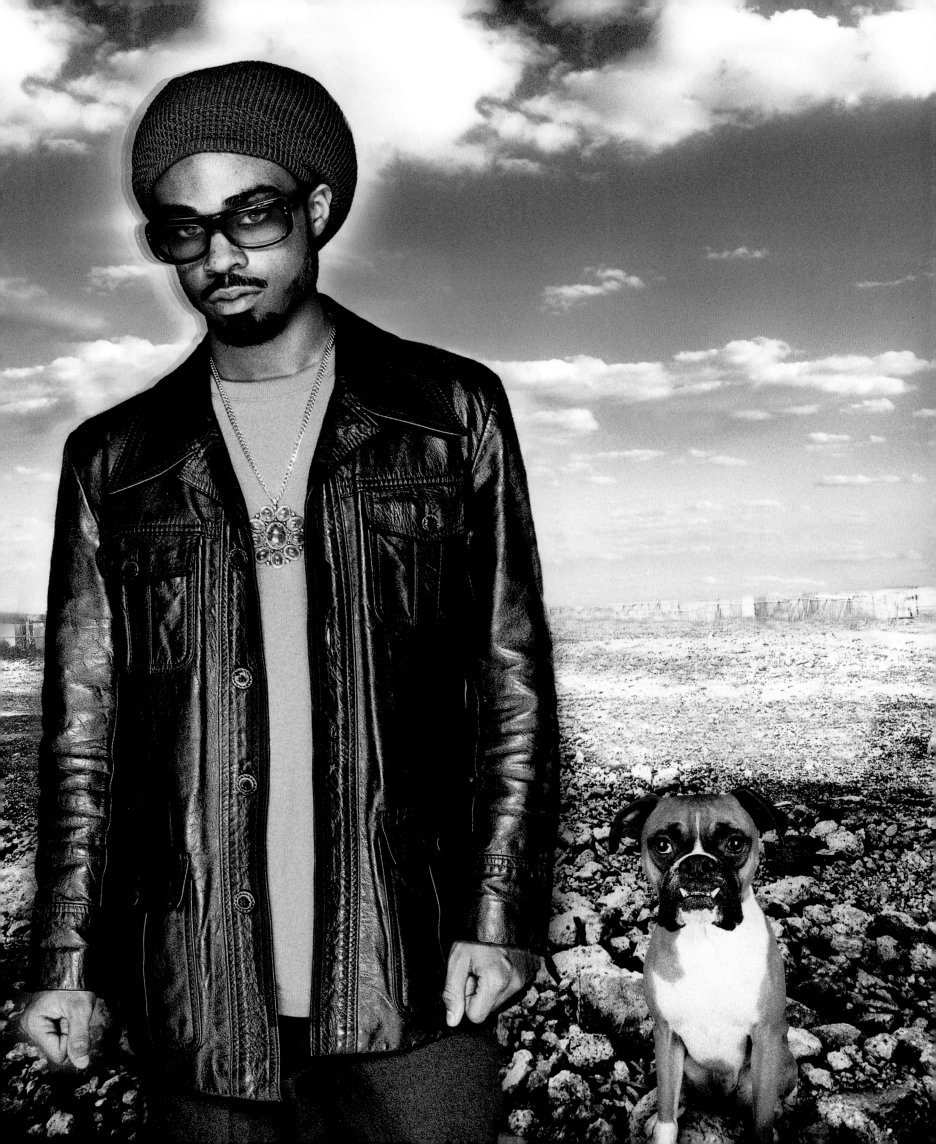

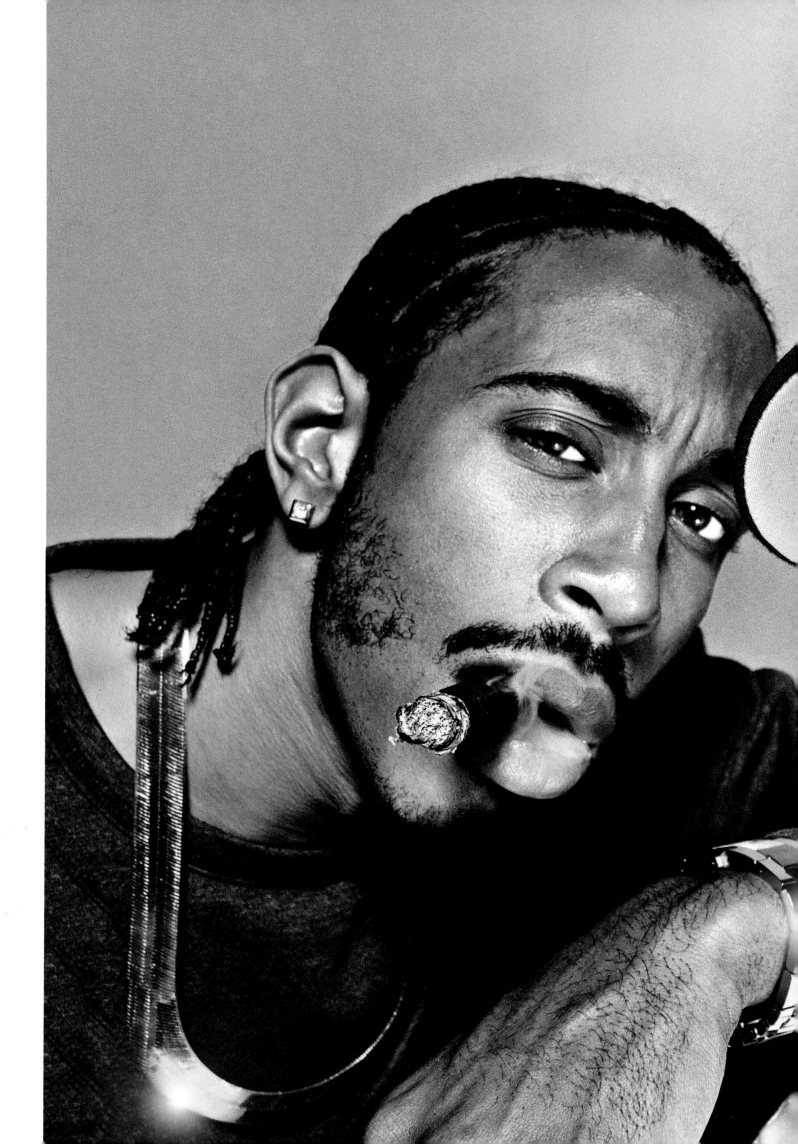

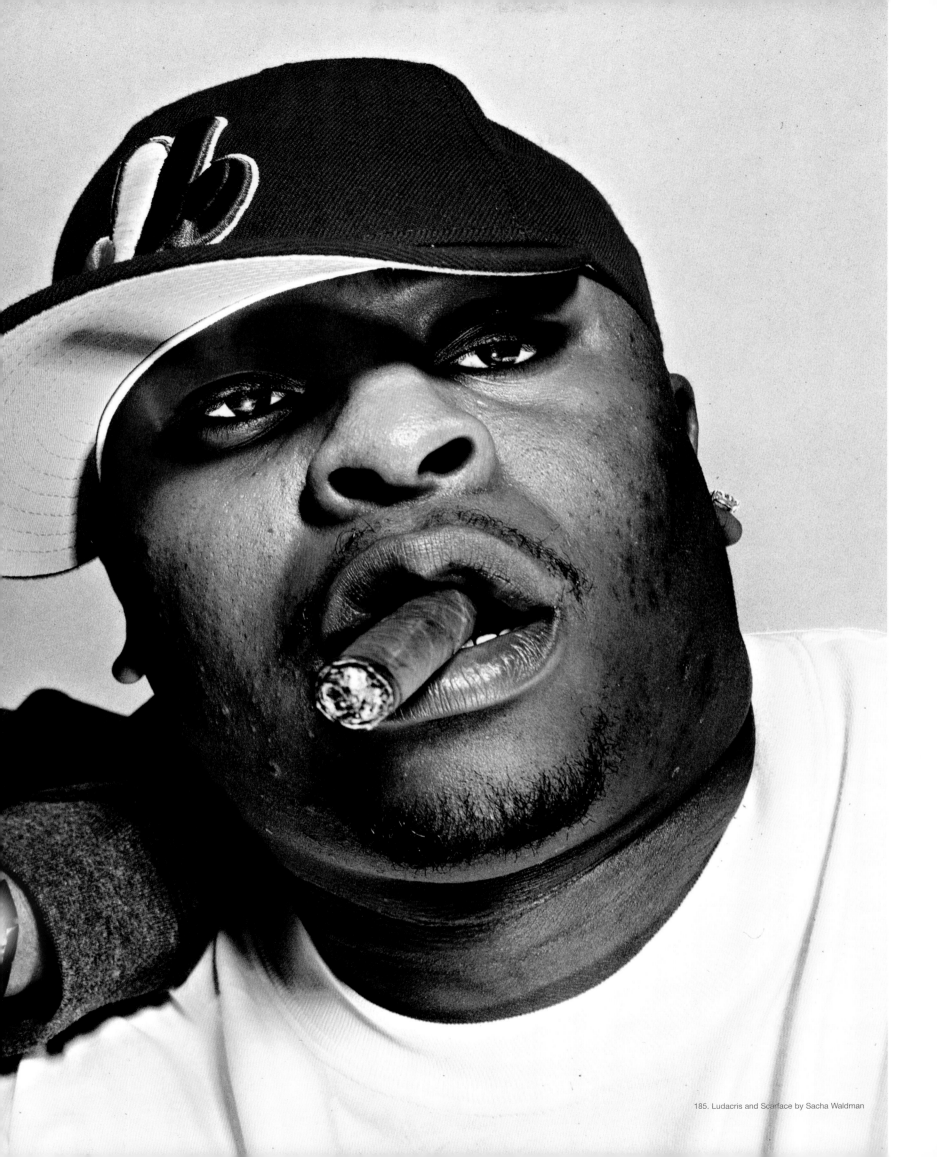

185. Ludacris and Scarface by Sacha Waldman

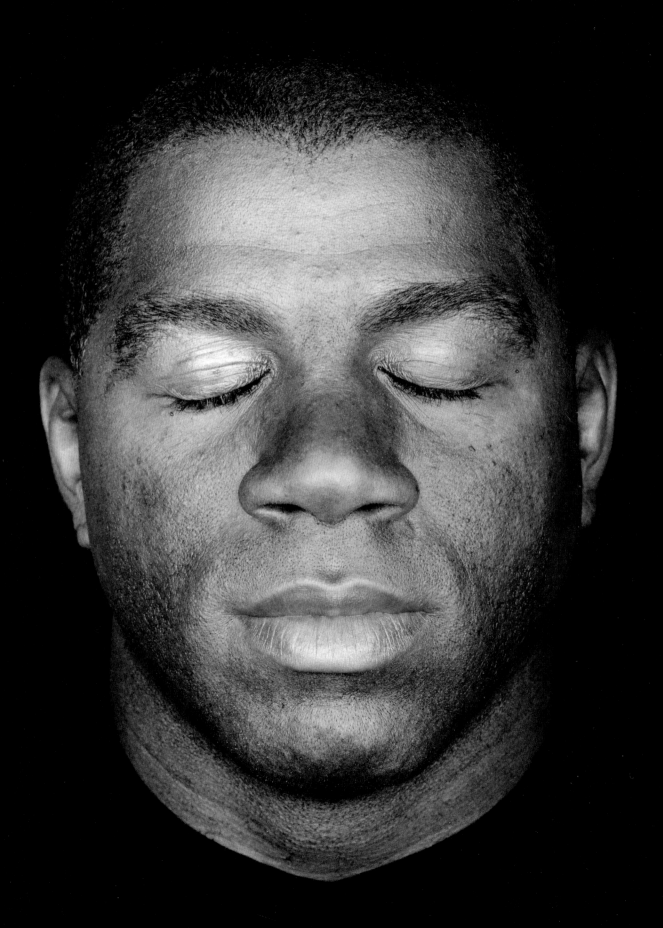

186. Magic Johnson by Dan Winters

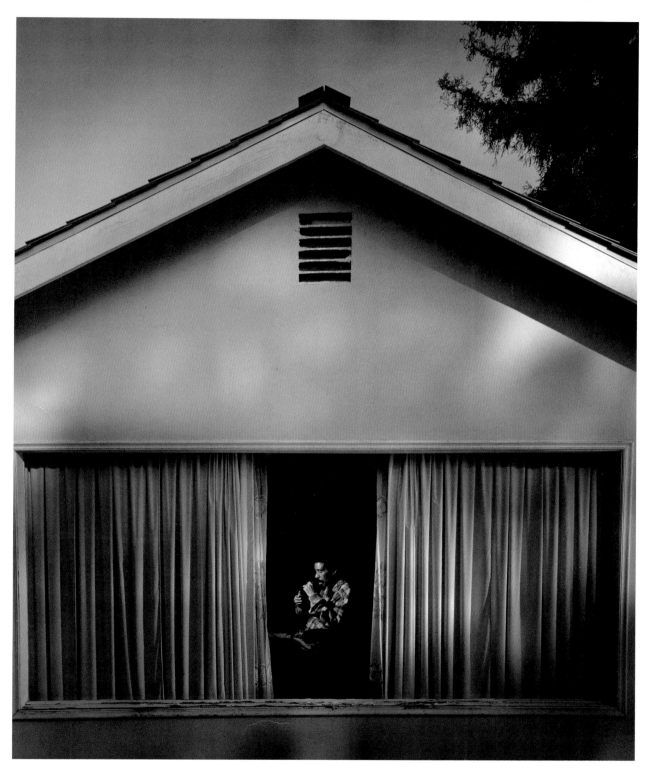

188. Tupac Shakur by Shawn Mortensen

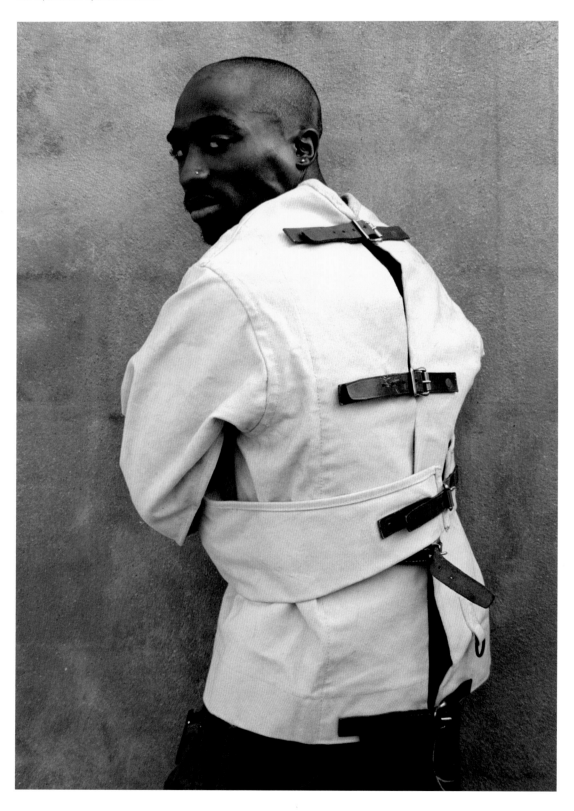

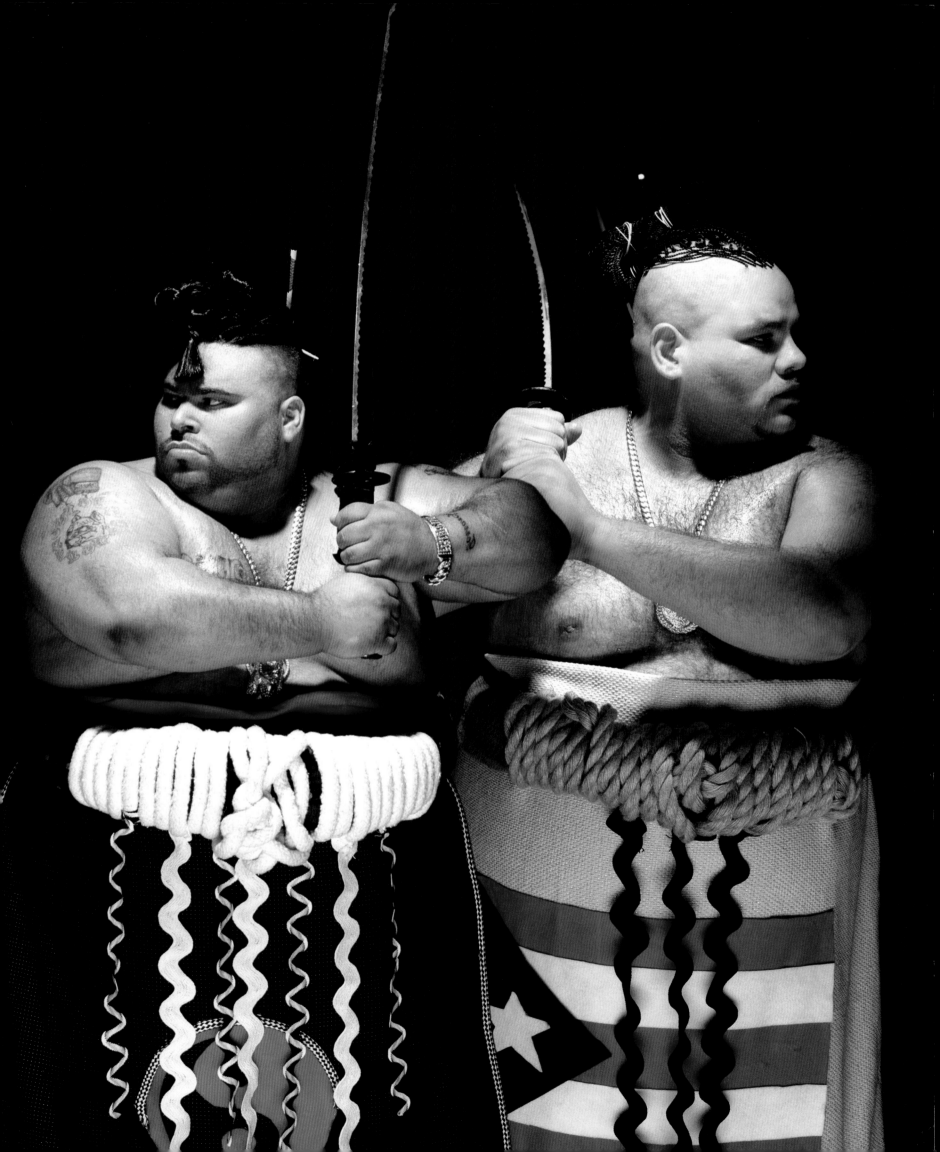

191. TLC by Seb Janiak

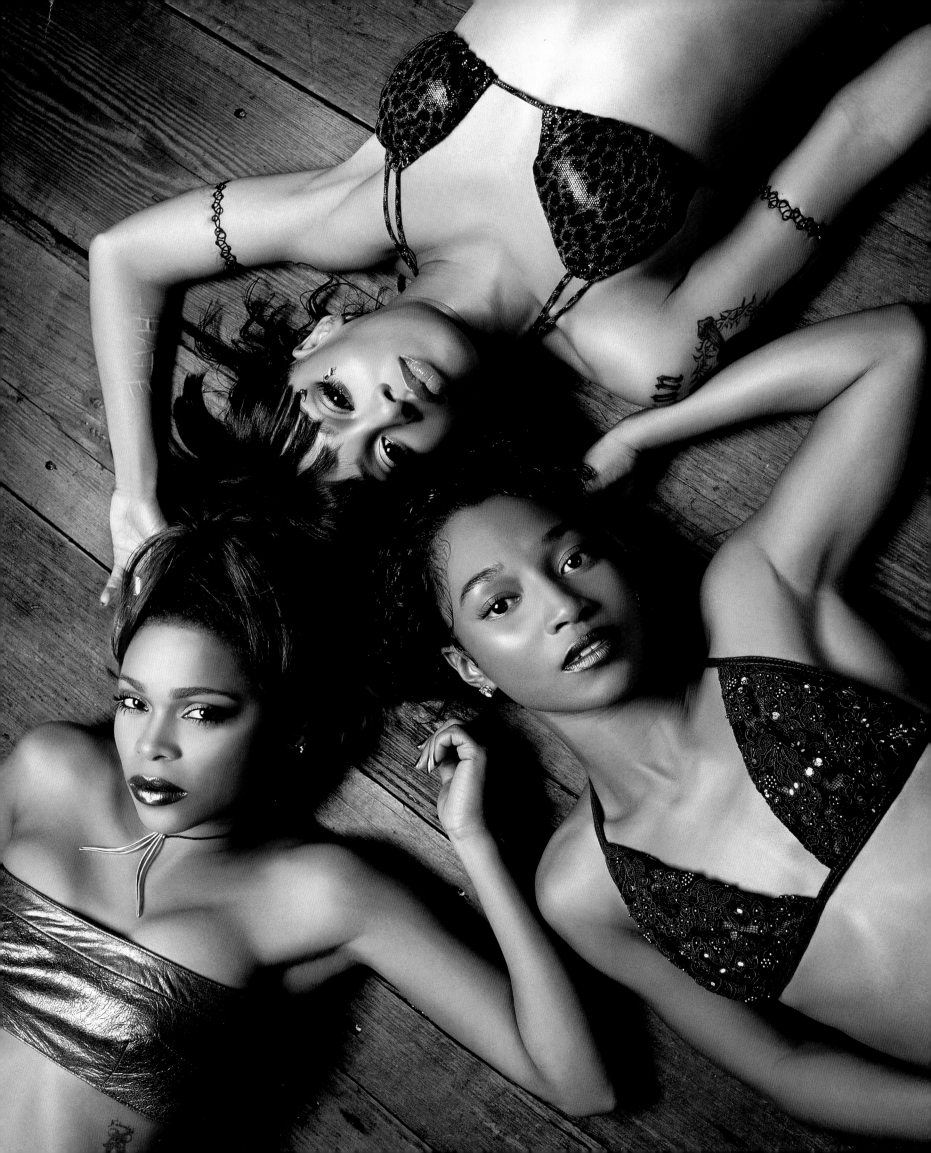

"The hardest thing about being in TLC is accepting the fact that I am Left Eye. I try to go out and be Lisa and it just won't work. I have to act a certain way, according to what people expect. It's not like I can be in Kroger's and have an argument with my man and not be on the news. So I have to separate the two, know that there is a difference between Left Eye and Lisa."

—Lisa "Left Eye" Lopes

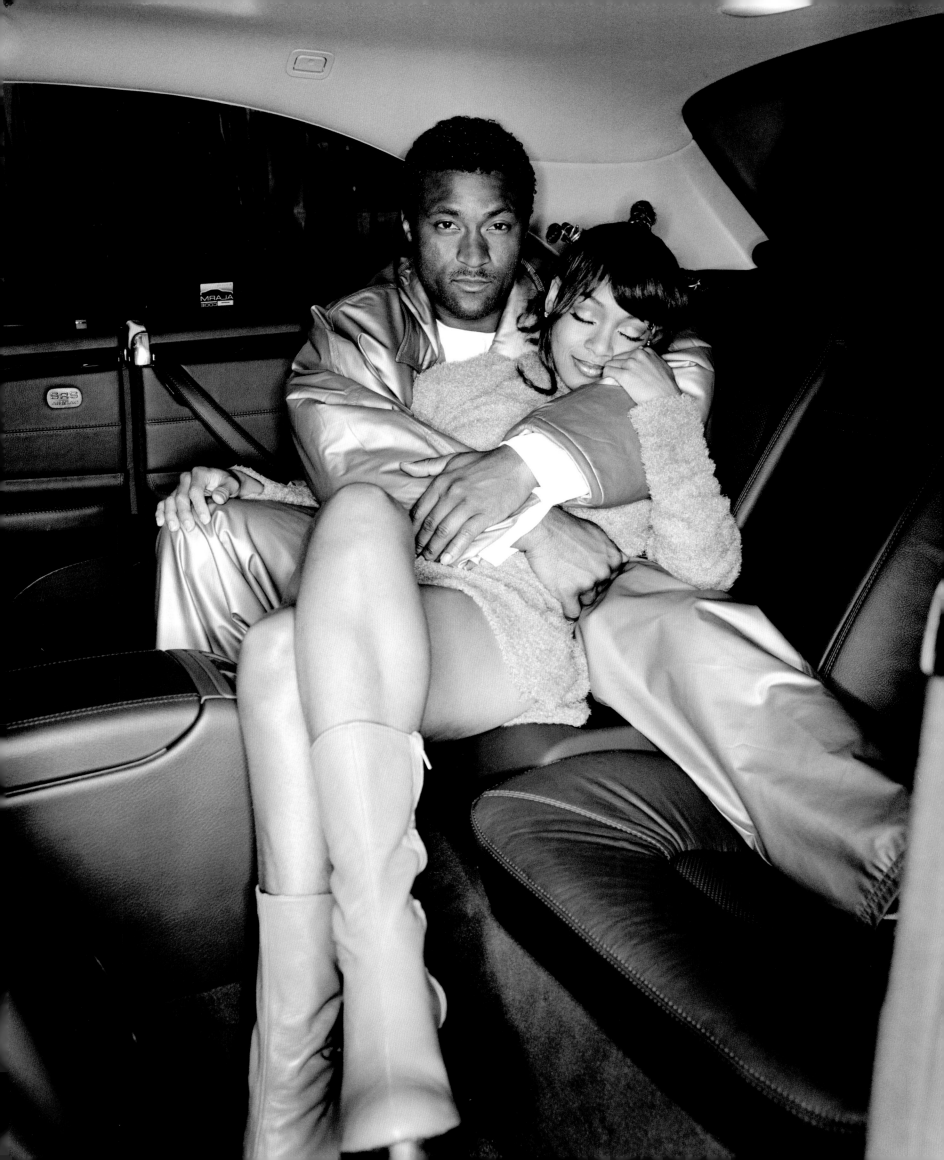

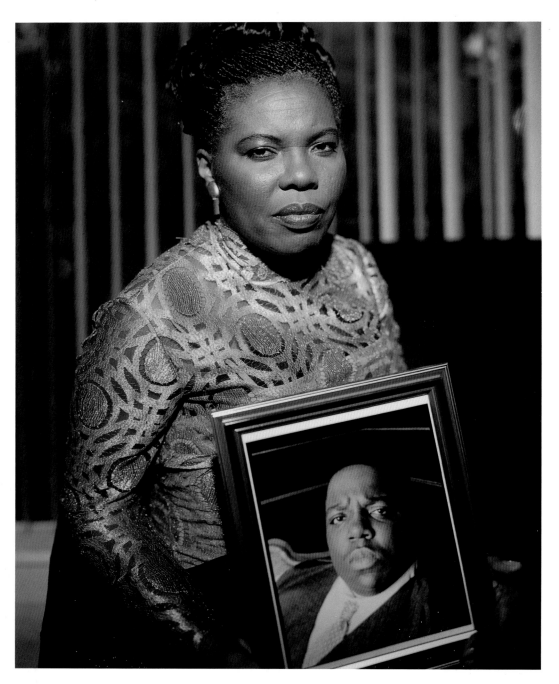

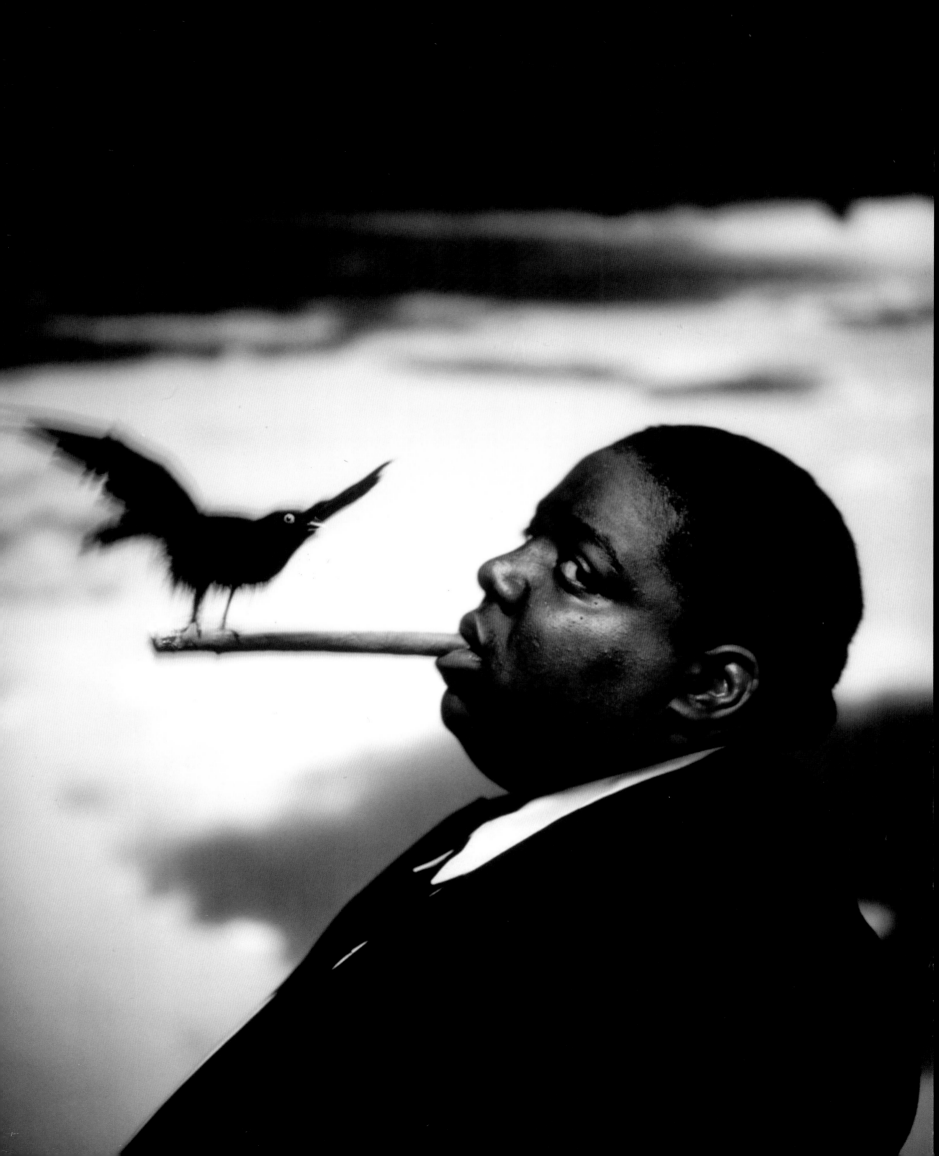

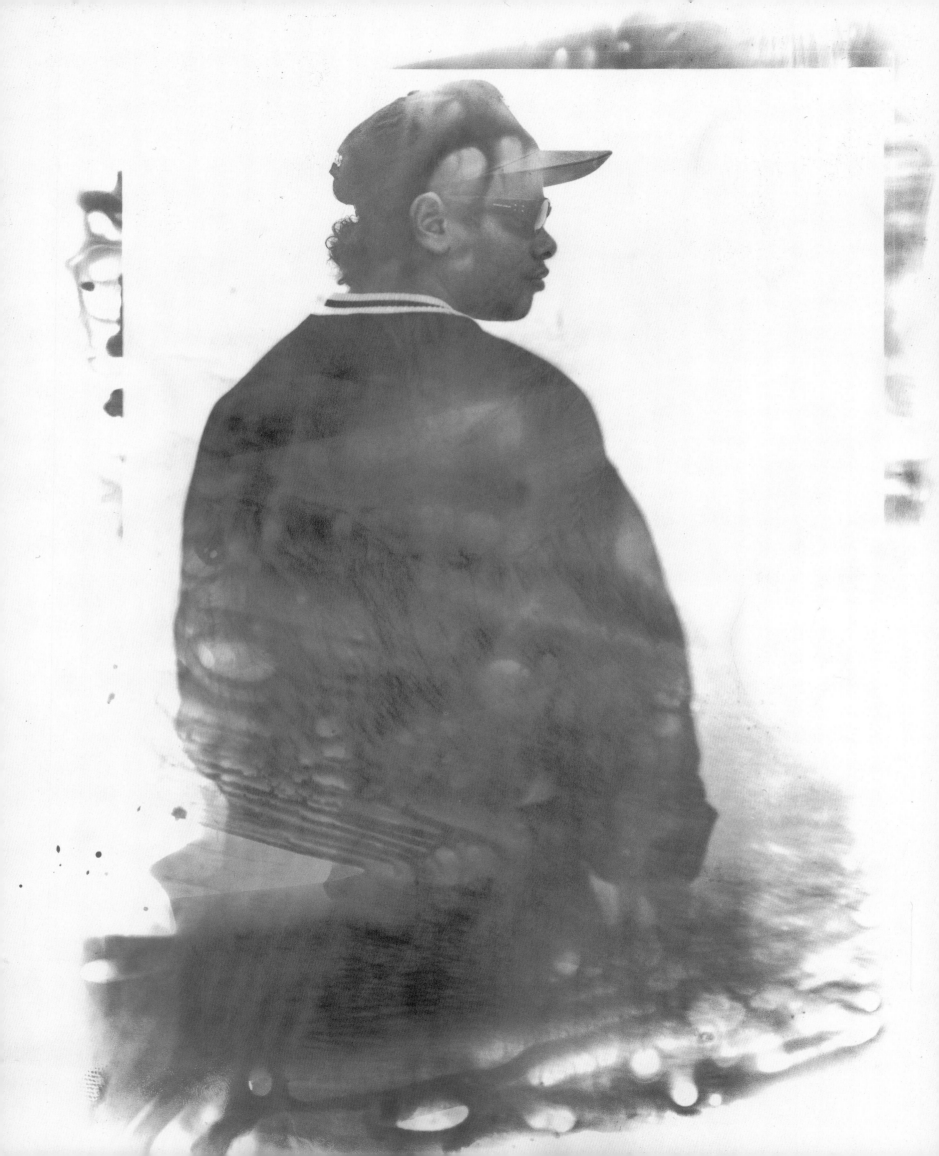

"This thing is real and it doesn't discriminate. It affects everyone."

—*Eazy-E*

What could be better than the combination of Quincy Jones, New York City, hip hop, publishing, and the backing of Time Inc.? Nothing. Thank you.

"We're starting a magazine and it doesn't even have a name yet," said Jonathan Van Meter. "Do you want to help?" Yes. Thank you.

Ten years later, while laying out this book, it became clear that VIBE had made a difference; changed the perceptions, stayed focused, and allowed a phenomenon to take place. From the first cover photograph of Treach by Albert Watson to powerful portraits by Dan Winters, Christian Witkin, Dana Lixenberg, Melodie McDaniel, Dah Len, Barron Claiborne, Ruven Afanador, David LaChapelle, and Sacha Waldman, VIBE's photography has never lost its course: provocative and truthful portraits of a culture that's once again changing the face of music. All the great photographers in this book, the hard work of the editors and art directors, and of course George Pitts' patient and persistent eye, are what make VIBE a visual reference for what's "now." The best music magazine, ever.

And me? I made some friends for life. Thank you.

—*Gary Koepke, founding Creative Director*

Cover .001

50 Cent by Christian Witkin, May 2003

"50 was a very calm, likable, smart guy," said Witkin. "It was a delight to work with him. Forget what you heard. He's not just another thug rapper."

Buju Banton by Christian Witkin, Oct 1993

"One has to understand I-and-I culture," Buju told Joan Morgan. Hence the details of Witkins' fist portrait— ring, scratches, and vestigial sixth finger.

002. .003

Navajo Gangstas by Dana Lixenberg, Dec 1996

"The young Navajos speed over the land in a dark-eyed car," wrote VIBE's Kathy Dobie, "scattering jackrabbits, speakers pulsing, 'Bang bang to the brain, it's another native tongue.' As cold as history, as tough and unsentimental." She might also have been describing Lixenberg's shot of this posse on the Navajo reservation, which is beautiful against all odds.

004. .005

Biv 10 Pee Wee All Stars by Jonathan Mannion, Dec 1998

"This was shot in Harlem," Mannion recalls. "We were out all afternoon in the sunshine, and then it started to rain. Everybody had their best gear on and nobody could get it wet, so they were rushing into a trailer. I was like, Yo, they're little kids. They need to be out having fun. The kids were all crazy happy. We went running through the streets causing havoc."

006. .007

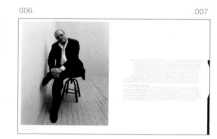

Quincy Jones by Christian Witkin, Nov 2001

"I came up with some bad people man," VIBE's founder told Editor-in-Chief Emil Wilbekin in his second cover story with the magazine. "Awesome, earth-shattering individuals. Frank Sinatra, Louis Armstrong, Nat King Cole and stuff like that... Sarah Vaughn, Ella Fitzgerald, Dinah Washington... The quality is so high it's ridiculous. I'm never going to settle for less."

008. .009

Aaliyah by Robert Maxwell, Dec 1996

When she was 11 years old, Aaliyah (which means "most exalted one" in Arabic) sang with Gladys Knight in Las Vegas. At 22 she died in a tragic plane crash. She was 17 when this portrait was shot on the beach in California, two years after the annulment of her marriage to R. Kelly. "When I'm in the studio I have to have the lights off," she said. "I'm very shy."

016. .017

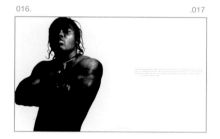

Treach by Albert Watson, Fall 1992

Back when "O.P.P." gave way to "Hip Hop Hooray" and Naughty By Nature was the hottest thing to come out of New Jersey since Queen Latifah, a new magazine ran this striking portrait of Treach on the cover of its 1992 test issue. The mag was almost called *Volume*, but Scott Poulson-Bryant's new name (VIBE) and Gary Koepke's last-minute logo design stuck.

018. .019

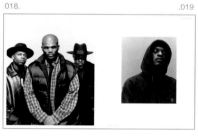

Run-D.M.C. by Piotr Sikora, Dec 1999; Rakim by Christian Witkin, Dec 1997

Ever since their debut in 1983, Run-D.M.C. became the indispensible group in hip hop's worldwide takeover. Their sonic and spiritual anchor was DJ Jam Master Jay (left), who was gunned down senselessly on Halloween, 2002. As Rakim, rap's most revered lyricist, once rhymed: "Goddamn that DJ made my day!"

020. .021

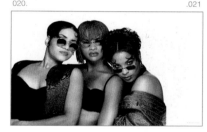

Salt-N-Pepa by Albert Watson, Feb 1994

"We're feminists to a degree," said Cheryl "Salt" James (left), who recorded her first song with Sandy "Pepa" Denton (center) in 1985. Dee Dee Roper a.k.a. DJ Spinderella joined the group later. "We believe in women shaping their own destinies," Salt said. "Carry yourself like a queen and you will draw a king." Watson's regal portrait could make a king wanna shoop.

022. .023

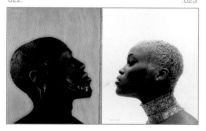

Wesley Snipes by Dan Winters, Oct 1993; Eve by Christian Witkin, Feb 2000

"I want to be an African man," Wesley Snipes told Danyel Smith in 1993. "We have always been part of the universe." Winters' portrait evokes the earth itself. "He's very sculptural," the photographer observes, "and he has an incredible melon." As for Eve, Witkin found the Ruff Ryders' first lady "classical and gorgeous."

024. .025

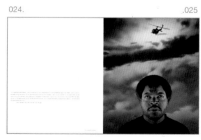

Ice Cube by Dan Winters, Mar 1994

Graphic clarity and lack of sentimentality are the hallmarks of Winters' photographs. He grew up raising pigs, cows, and bees in Ventura County, California, and now he brings a particular stylized spin to portraiture by his rendering of meaningful locations. Here he plays on the police helicopter motif of Cube's 1991 screen debut, *Boyz N The Hood*.

026. .027

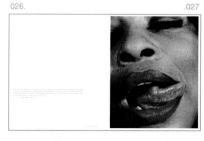

Chaka Khan by Alastair Thain, Nov 1993

Thain's monumental study of Chaka's vocal instrument serves as a visual counterpoint to "Better Days," Hilton Als' wistful prose portrait of the diva whose tongue shaped such sonic miracles as "Sweet Thing" and "Ain't Nobody." Nor did Chaka hold her tongue when asked to assess another singer's rendition of her song "I'm Every Woman"—she hated it.

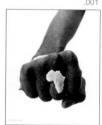

028. .029

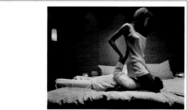

Freaknik by Alex Tehrani, Oct 1998

"There was something lovely about the exhibitionism," says Tehrani, who documented Atlanta's annual black-college bacchanal, which he saw as "a celebration of sexual energy." But not everybody was celebrating. "It's a man's paradise and a woman's hell," said 22-year-old Qiya, vowing not to return. "Brothas grab girls' butts or simply jump them."

030. .031

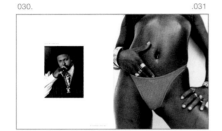

Suge Knight by Jonathan Mannion, Oct 2001; Pimper's Paradise by Christian Witkin, Dec 1993

Shot during Mike Tyson's 30th birthday party, Mannion's definitive portrait captures the intensity of the Death Row Records CEO's legendary presence. Witkin's severe study of a prostitute in Negril, Jamaica, was part of his first assignment for any magazine. "It wasn't easy," he says. "But I'll never forget it."

032. .033

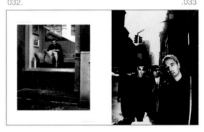

John Leguizamo by Butch Belair, Nov 1993; The Beastie Boys by Pierre Winther, May 1994

Men in Manhattan: John Leguizamo reads the *Times* in a Village window at age 29, not long after he played Johnny Blanco opposite Al Pacino in *Carlito's Way*. Hepcat entrepreneurs Mike D, Adrock, and Adam Yauch roll up lower Broadway just before the release of the Beastie's fourth album, *Ill Communication*.

034. .035

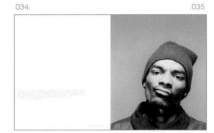

Snoop Doggy Dogg by Dan Winters, Sep 1993

Before his first album, *Doggystyle*, debuted at the top of the pop charts and before he faced murder charges in court, Snoop appeared on VIBE's first cover when the monthly offically launched in 1993. This Dan Winters portrait, first shot for VIBE, later turned up in Snoop's CD booklet and on the cover of *Newsweek* for a story called "When is Rap 2 Violent?"

036. .037

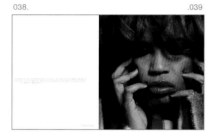

Lenny Kravitz by Robert Maxwell, Mar 2001

The man who sang "Let Love Rule" put his words into action during this unforgettable fashion shoot. The young lady is 20-year-old Adriana Lima, the Brazilian beauty famous for her Victoria's Secret and Guess! ads. Lenny and Adriana met at the VIBE shoot. They are now engaged. Who says you should never kiss on the first date?

038. .039

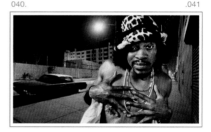

Macy Gray by Larry Sultan, Oct 2001

From his loaded portraits of suburban interiors to his photographs of actors killing time on the sets of porn movies, Sultan is a renowned art photographer with a talent for carefully observed situational portraiture. His smoldering study of the Dionysian R&B/pop star Macy Gray (who is actually a Sixties wild child in disguise) is no exception.

040. .041

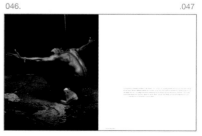

Andre 3000 of Outkast by Sacha Waldman, Dec 2000

"Outkast teaches us that our definition of revolution has evolved," wrote Rob Marriott in a VIBE cover story. "It is no longer isolationist. It is not simply male or ghettocentric or East Coast or angry or even urban. In fact, the revolution is expansive... Even our enemies have a part to play in the great social change that hip hop promised us."

042. .043

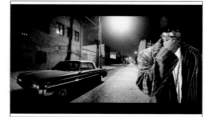

Big Boi of Outkast by Sacha Waldman, Dec 2000

Waldman's photographs are so detailed that the texture is almost palpable. The precise visual information suggests computer graphics, but the effects are used with enough restraint that his images still feel real. "The computer is an extension," he says. "It's a new tool we can use to create something interesting, not just another photograph of a celebrity."

044. .045

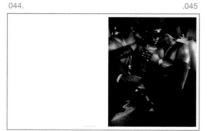

Ruff Endz by Marino Parisotto, Feb 2001

For the voyeuristic fashion spread "Bedtime Stories," sexy R&B acts like Sparkle, Monifa, Profyle, and Changing Faces modeled lingerie in a variety of steamy situations. Hottest by far was this ménage à trois in which Davinch and Chi from the duo Ruff Endz attend to one leather-gloved lady behind the tinted windows of a stretch limo. Talk about sex in the city.

046. .047

Puffy by Butch Belair, Sep 1993

"In its mad dash toward the finishing line of high capitalism, hip hop will need a hero," wrote Scott-Poulson Bryant in his prescient Puffy profile. "There he is, shirtless, the waistband of his Calvin Klein boxer briefs peeking perilously over the edge of his black shorts." Uptown's Andre Harrell fired him at press time, freeing Puff to build his own Bad Boy empire.

048. .049

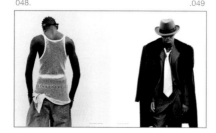

Buju Banton by Christian Witkin, Dec 1993; Puff Daddy by Piotr Sikora, Sep 1998

Essential rude boy flavor from Kingston, JA to NYC: Buju is the Voice of Jamaica with eyes in the back of his head. Puff Daddy is the Black Frank Sinatra. "I'm the one in the Rolls Royce with his hat turned," PD once explained. "Driving down Fifth Avenue, system booming. Walking' in Gucci, shuttin' it down."

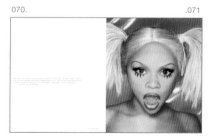

R. Kelly by Sacha Waldman, May 2002;
Winky by Walter Smith, Feb 1999

This was the last major photo shoot R. Kelly did before being arrested in June 2002 on child porn charges. And so the cover story that was supposed to celebrate his new album with Jay-Z became "Sex Lies and Videotape" part deux. On the other hand, NYC street bike legend Winky feels no need to hide his freaky side.

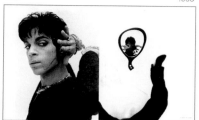

Prince by Dana Lixenberg, Aug 1994

Lixenberg traveled to Paris for this, her first VIBE cover shoot. "We got a call that he wasn't gonna make it," she says, "But then he came with his security and entourage. When it was time to shoot, he cleared the studio and put on his own music. I saw a mirror nearby and I started photographing his reflection in it and he saw what I was doing right away."

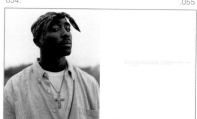

Tupac Shakur by Dana Lixenberg, Feb 1994

"We had to stay an extra day in Atlanta because he had a dentist treatment," recalls Lixenberg of Tupac's first VIBE shoot. "It was a bit drizzly. I found a location by the railroad tracks. It was a very low-key situation—no entourages. Nobody knew it would become such an iconic image. It's nice that people respond to this simple, undramatic approach."

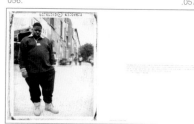

The Notorious B.I.G. by Catalina Gonzales, Aug 1994

Long before the Big Poppa era, when Versace shades and alligator loafers became Biggie's ghetto fabulous dress code, Gonzales caught the rising star Biggie Smalls a.k.a. The Notorious B.I.G. out on Fulton Street in his Brooklyn hardrock attire: Karl Kani sweatsuit and Timberland boots. Less than three years later both he and Tupac had been murdered.

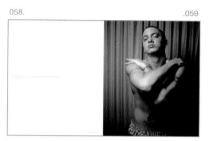

Eminem by John Peng, Feb 1999

Marshall Mathers' first VIBE shoot took place in a Hollywood hotel room in late 1998 while he was working on Dr. Dre's Chronic 2000. The 24-year-old wordslinger wasn't yet a household name, but his famous temper was already in effect: "I get offended when people say, 'So, being a white rapper... and growing up white... after being born white....' It's all I ever hear!"

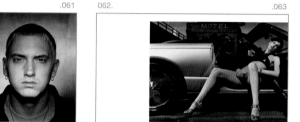

Dr. Dre by Dan Winters, Sep 2000;
Eminem by Dan Winters, Sep 2000

By the time Dre and Eminen's mugshots appeared together on the cover of VIBE's Juice issue, they had the rap biz on lockdown. "I've grown up a lot in the past two years," said Eminem. "Like Tupac," Dre observed, "Eminem has a lot of energy. A lot of spirit. A lot of talent. You've just got to be careful."

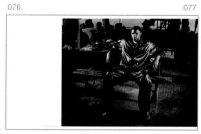

Whips and Bikinis by Xevi, June 2001

What could be sexier than a couple of hot chicks in metallic bikinis sprawled out the open door of an aqua Ford Thunderbird? "Girls, cars, and bikinis are such a *male* thing," says Xevi, a New York-based photographer and Barcelona native. "I thought it would be funny to have the girls making out. I try to support gay causes."

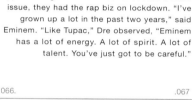

L.A. Stories by Dana Lixenberg, Nov 1993;
Brick City by Jonathan Mannion, Oct 1997

Lixenberg's first photos in VIBE were portraits of Los Angeles residents after the 1992 riots. What started as a personal project about gangs grew to encompass all the people living in the Imperial Courts projects in Watts. Mannion's study of Newark New Jersey street life exposed further paradoxes of human spirit.

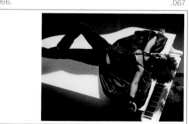

Alicia Keys by Michael Thompson, Sep 2002

By age 21, she had sold 8 million records and won 5 Grammy awards. But no matter how high she flies, Alicia always comes back to the keys. A piano student since age 7, she played Chopin's "Raindrop Prelude" at one recital and the audience went crazy. "It was gorgeous and spiritual," recalls her teacher, Margaret Pine. "It gave you goosebumps." So does this shot.

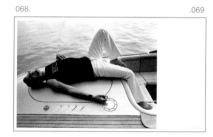

Ricky Martin by Arnaldo Anaya-Lucca, June 2001

Every detail was perfect for the Ricky Martin shoot in Miami—until somebody noticed a problem with the custom-made T-shirts: Boricua was spelled with a Q! Martin's trusty assistant simply ripped the studs off to make the Q into a C. "He was very Zenlike," says Emil Wilbekin, who styled the shoot, "the total opposite of his sex-bomb stage persona."

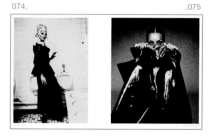

Lil' Kim by David LaChapelle, June 2000

"My pictures contain some degree of fantasy," says LaChapelle. "To me, that's always been a lot more interesting than reality." His edgy, award-winning work tends to be crazy, funny, and decidedly sexy. When he shot hip hop's "Queen Bee" for his first VIBE cover, he rendered her as a blow-up sex doll. Kim was adventurous enough to go with it.

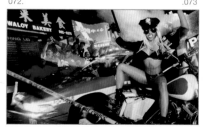

Lil' Kim by David LaChapelle, June 2000

Chinatown has always been a golden location for VIBE, and LaChapelle worked it like a Hollywood backdrop. Kim, who was quiet, self-contained, and sweet before the shot, morphed into a raunchy pinup cop, cheered on by legions of fans. "There are two sides to me," says Kim. "I can get ghetto red, but I can also be civilized enough to deal with the fabulous people."

RuPaul by Ellen von Unwerth, Mar 1994;
Vanessa Williams by Ruven Afanador, Dec 1994

Von Unwerth is a world-famous fashion photographer who specifically requested we use this humorous shot of RuPaul, though it was not the one that ran in the magazine. Afanador is a master of mystery. Hiding Vanessa Williams' beautiful face behind a chic raincoat has an understated yet theatrical effect.

Tracy McGrady by David Drebin, Dec 2002

The Orlando Magic's all-star shooting guard, who entered the NBA and made millions straight out of high school, was photographed at Disney World. Eschewing the Mickey and Goofy approach, Drebin found a bench where T-Mac could chill while a bunch of Japanese kids played soccer nearby. "He's as great of a guy as he is a ballplayer," Drebin says.

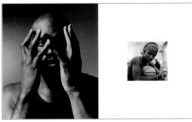

Shaquille O'Neal by George Holz, Feb 1994;
Stephon Marbury by Xavier Guardans, Nov 1994

The VIBE strategy when shooting athletes was not to hire sports photographers, but to find a newer way to photograph them. Holz has a passion for depicting the human body, which made him perfect for capturing Shaq. When we shot Marbury, he was a kid with his whole future ahead of him. Guardans' picture reflects that.

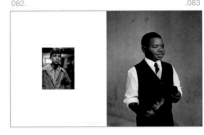

Minister Louis Farrakhan by Andrew Williams, Sep 1997;
Reverend Al Sharpton by Christian Witkin, Sep 2000

"Rage is a weakness," the Nation of Islam leader told Farai Chideya in a memorable Q&A, "but properly directed, it is a force that can propel a nation upward." Witkin's portrait of Sharpton was shot in Harlem at his National Action Network offices. "He looks a bit frazzled," says Witkin, "like he's internalizing his worries."

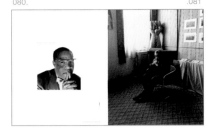

Moroccan Boy by Dana Lixenberg, May 1998;
Gary Coleman by Dan Winters, Oct 1998

Lixenberg went to shoot a fashion spread in Tangier, the city in Morocco that inspired the Bogart movie *Casablanca*. Most of the models she used were local residents, like this boy who smoked his cigarette with Bogie's cool. When VIBE ran a Gary Coleman Q&A, Winters jumped at the chance to shoot the former child star.

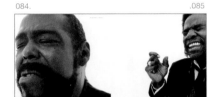

Barry White by Christian Witkin, Feb 1995
Al Green by Dana Lixenberg, June 1996;

Two master soul singers in midsong: Witkin is a big Barry White fan, and his respect shows in the picture. When she shot Al Green, Lixenberg mentioned her favorite song of his, "Simply Beautiful." Green effortlessly let the song emerge, bringing chills. The moment that is captured here was unnerving in its purity.

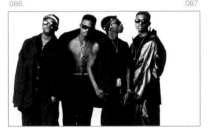

Jodeci by Albert Watson, Dec 1993

"Don't nobody mack like Jodeci," Dalvin DeGrate (second from left) told Danyel Smith after a rehearsal at the Apollo Theater. "I don't think of Jodeci as no boy group or no harmonizing group," added his brother DeVante (right). "I think of us as a black rock'n'roll band." Watson remembers them as perfect gentlemen: "Jodeci were a delight."

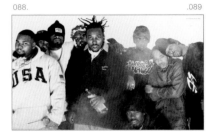

Wu-Tang Clan by Norman Watson, June 1995

Bönz Malone's Wu profile "Deep Space Nine" was made all the more memorable by Watson's masterful group portrait, one of the few pictures to show all nine original members, all being themselves. In the photo studio they were wild, unruly, and funny. In short, they were dream subjects—thoroughly alive, however difficult it was to capture all their vibrancy.

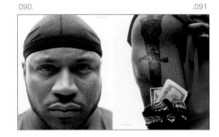

LL Cool J by Christian Witkin, Oct 2000

"It's rare that you have a subject who's aware of the light," says Witkin. "But LL was. He kept pumping up the volume on his new album and blew out the speakers in the studio." Witkin has an interest in exploring details: hands, feet, or in this case, a tattooed arm. "My style is very reductive," he says. "But it's not so simple. There has to be an emotional impact."

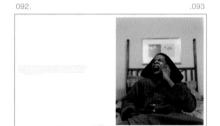

Jay-Z by Dana Lixenberg, Dec 1998

Inside Jay-Z's Manhattan hotel room, Lixenberg found the young rap mogul in a relaxed mood. "I was surprised that he had no entourage at the shoot," Lixenberg recalls. "He was just sitting on his bed watching TV and he yawned. I don't usually try to catch people in that sort of moment, but it kinda worked with the robe and the remote control."

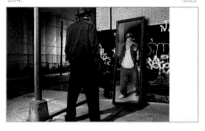

Jay-Z by Sacha Waldman, Jan 2003

Waldman has been known to stretch the boundaries of reality in his pictures, but this surreal image sprang from the mind of Jay-Z. "That was his concept," says the photographer. "He wanted to show himself looking in a mirror to show different sides of who he is—like the street guy and the pimp. I love working with people who will take a good idea and go with it."

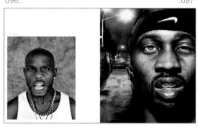

DMX by Jonathan Mannion, Oct 2001;
The RZA by Sacha Waldman, Mar 2001

"I fought against that growling picture for a long time," says Jonathan Mannion, who's shot album covers for DMX. But he has come to appreciate the image. "You can't direct that. It's the dog himself, revealing his true character. That shot is raw." Ditto for Waldman's noir portrait of RZA, teeth sparkling in the streetlights.

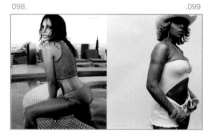

Toni Braxton by Tony Duran, March 2002;
Mary J. Blige by Christian Witkin, Julne 2001

Duran's pictures of Toni Braxton are some of the sexiest shots ever taken of her, including her semi-nude VIBE cover. Toni liked them so much she used some for her album. Wiktin captured Mary J. Blige rocking the urban cowgirl look with attitude to spare. She has graced VIBE's cover more times than any other artist.

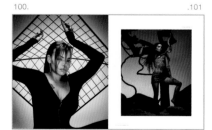

Faith Evans by Christopher Kolk, Dec 2001;
Lisa Bonet by Dah Len, June 2000

Kolk's elegant, mysterious picture of Faith turns her into a siren or an alluring spider woman, a true femme fatale. Dah Len has a great appreciation for Lisa Bonet's fearlessness in going from *The Cosby Show* to *Angel Heart*. He created this spare, evocative desert setting with his customarily brilliant color sense.

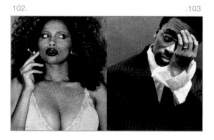

Lisa Nicole Carson by Tony Ward, Dec 1998;
Spike Lee by Barron Claiborne, June 1994

Tony Ward excels at photographing super-sexy women with a strong graphic kick. This shot of Lisa Nicole Carson is an effortlessly erotic out-take. Claiborne practices aesthetics with a capital A, and Spike—uncharacteristically dressed like a dandy—exhibits a sly humor normally reserved for his film work.

Toni Morrison by Andrea Modica, May 1998

This shoot was a labor of love. Modica is an art photographer—a mature woman with deep-seated humanity. Toni Morrison wanted to see her work before she agreed to sit. Modica approached the shoot gently, and with a desire to do something memorable, which she did. Morrison's stunnning mane of dreadlocks can be seen as a metaphor for the writer's art.

Beyonce Knowles by Kayt Jones, Oct 2002; India.Arie by Gerald Forster, Apr 2001

This cerebral yet sensual portrait of Beyonce was taken by Jones, a young English woman with a fresh inventive attitude. The picture works whether or not you get the Maya Angelou reference. Forster shoots inside white cloth tents so his subjects feel safe to reveal their true spirits. Witness India.Arie.

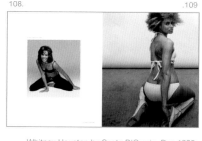

Whitney Houston by Sante D'Orazio, Dec 1995; Shakara by Christian Witkin, June 2000

"That was a beautiful day," George Pitts recalls of Whitney's cover shoot. "Her most disarming quality is how down home and funky she is. She was kind and friendly to everybody." After Shakara made a splash in *Sports Illustrated*'s Swimsuit Issue, Witkin shot her for VIBE. "She's even sexier in person," he admits.

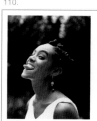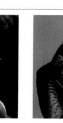

Jada Pinkett by Everard Williams, Aug 1994; Luther Vandross by Albert Watson, Sept 2001

This picture was taken three years before Jada married the Fresh Prince. You can see the playful rapport Williams had with the actress. Watson was the man to do Luther Vandross justice and show him as the icon he always will be. As the greatest R&B singer of his generation, he warranted a great portrait.

Shakira, May 1999; Lana Sands by Jeff Riedel, May 1997

Sometime before she became a blonde bomb-shell and conquered the Western world, Gabriel García Márquez's favorite Colombian pop star sat for a VIBE photographer. When the brainy porn star Lana Sands came to the VIBE offices, she was received like Elizabeth Taylor. Even sitting down, she is striking.

Don Cheadle by Melodie McDaniel, Mar 1996; Ja Rule by Robert Maxwell, Dec 2000

McDaniel's pictures exude a kind of funky, alternative cool. She was a perfect match for Don Cheadle, who's a thinking man's actor. The overriding impression in Maxwell's work is its timeless beauty. He persuaded Ja Rule to abandon the thug look in favor of a smart pinstripe suit—and he wears it well.

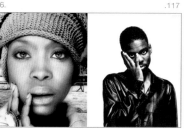

Erykah Badu by Sacha Waldman, Sep 2000; Chris Rock by Piotr Sikora, Nov 1999

Erykah Badu's eyes go on and on in Waldman's breathtaking outtake. When Chris Rock was guest editor for one issue of VIBE, he put himself on the cover as a presidential candidate. This was after *Vanity Fair* dressed him up in clown paint. Like many comedians, Rock is far more complex than people realize.

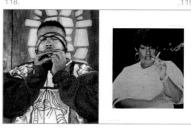

Timbaland by Erin Patrice O'Brien, Apr 2001; Missy Elliot by Lyle Ashton Harris, Sep 2000

Great hip-hop producers can be stars just like the artists, but it's no easy task to render a sonic visionary like Timbaland, who seems to be listening to some inner music in O'Brien's picture. Timbaland's most brilliant collaborator, Missy Elliott, has always been glamorous, a fact underscored by Harris' portrait.

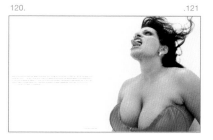

Vanessa del Rio by Christian Witkin, Jan 1996

While preparing to photograph this icon of the porn industry, Wiktin borrowed a few of her X-rated videos. "I was a bit intimidated after I saw the movies," he says. "But she was actually very nice in person, and willing to do anything within reason." The article on del Rio elicited several thousand letters, more than any other VIBE story at that time.

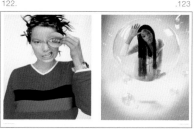

Björk by Barron Claiborne, Dec 1996; Brandy by Cleo Sullivan, Apr 1998

Björk has a beautiful playful nature open to creative experiment and she breathed humility, sweetness, and curiosity during this shoot. Here is yet another striking outtake in which Claiborne really caught her impish eccentricity. Sullivan's picture of Brandy in her (pop) bubble also inhabits a world of imagination.

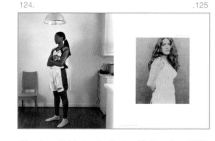

Chamique Holdsclaw by Andrea Modica, June 2001; Salma Hayek by Robert Maxwell, Mar 1996

Shooting the basketball star in socks and uniform in her kitchen gives this picture a sense of suprise. Yet it's a dignified and almost private portrait with an unforced classiness. Maxwell considers his shot of Salma Hayek, taken five years before her Oscar nomination, one of his most beautiful pictures.

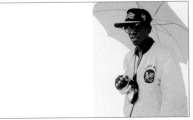

Flavor Flav by Geoffroy de Boismenu, Sep 1994

"While many people still view Flavor as a court jester," wrote Kevin Powell in "The Sound And The Fury," his Public Enemy cover story, "they don't realize how vital he is to PE's success." de Boismenu was an early VIBE discovery. His relaxed portrait captures Flav's street-smart dandyism. This photo wasn't published back in 1994, but it wasn't forgotten either.

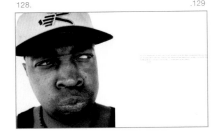

Chuck D by Geoffroy de Boismenu, Sep 1994

If this isn't the definitive image of Public Enemy's front man, it does literally look like the music. "I got so much trouble on my mind," Chuck rhymes in "Welcome to the Terrordome" and that's how he looks in this shot taken around the release of PE's scathing album *Muse Sick-N-Hour Mess Age*. The record was slept on, but PE still "Refuse to lose."

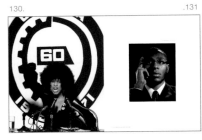

Cynda Williams by Albert Watson, Mar 1994;
Mos Def by Guy Aroch, May 2000

Hilton Als conceived the idea of an actress portraying Angela Davis. It was an ambitious idea to interpret history with fashion credits. Davis herself later commented on the story in a book of essays. Aroch returned to the Black Power fashion theme when VIBE cast the multi-talented Mos Def as Malcolm X—another coup.

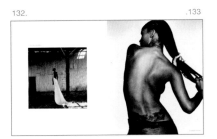

High Cotton by Ruven Afanador, May 1993;
Joy Bryant by Alex Cayley, Jan 2003

The most masterful photograph from a sublime shoot that elegantly tapped into the painful history of cotton and slavery in the Deep South. The picture has a beautifully realized stillness. Cayley's shot of the actress and model Joy Bryant is a great art photo that taps into traditions within the African aesthetic.

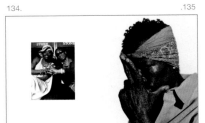

Beenie Man & Bounty Killer by Walter Chin, Apr 1998;
Shabba Ranks by Butch Belair, Oct 1994

Dancehall stars have always been a part of the VIBE universe, and no picture packs more star power than Chin's historic double portrait of perennial rivals Beenie and Bounty in a peaceful moment. It was Shabba who first served notice that the hardcore sound of Kingston Jamaica was going global. Belair shows him as raw as ever.

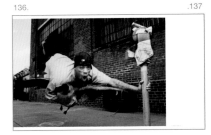

Redman by Dean Karr, May 2001

Karr's fantastic action picture comes out of the old film-making tradition where you use smoke and mirrors—aided by Redman's manically comic persona—to make magic. The goose was stuffed, the wind was real, and the rope that suspended Redman above the sidewalk was retouched out later. Everybody should do more pictures like this.

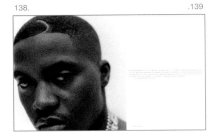

Nas by Christian Witkin, Feb 2001

One of the few photos that captures Nas as a dashing young thug. The haircut is beautifully photographed in a way that really blows up ghetto style. This is the 'do worn by most black men from age 5 to 90, with a part cut in by electric clippers. When Nas sports it, he gives props to a certain tradition in the sphere of black grooming.

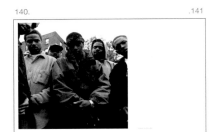

Nas & Crew by Andrew Williams, Dec 1995

The British born Williams did stellar work under precarious conditions in the legendary/notorious Queensbridge housing projects. This somber, dignified picture shows a much younger Nas among residents of his neighborhood. These individuals came together to represent a particular place, making sure everybody knows the Bridge is far from over.

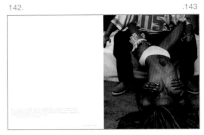

Atlanta Stripper by Marc Baptiste, May 1999

This is one of many pictures VIBE has run over the years that express over-the-top sexuality in a vivid, nonjudgmental way. The female model is an experienced stripper; the male model is Editor-In-Chief Emil Wilbekin. Baptiste turned in a first-class picture, though its artistry can sometimes be taken for granted because of the sexiness of its content.

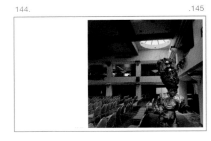

Hair Wars by Larry Fink, Mar 1998

A funny, surreal picture of a great Detroit-based competition for the most extravagant and well-wrought hairstyle. This "Funky Robot" was delightfully bizarre in a monumental way. Fink is a groundbreaking art photographer who seems to have had a great time with this assignment. His Hair Wars story won a number of major photography awards.

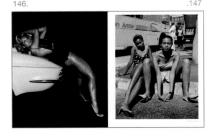

Kelis by Alex Cayley, Apr 2002;
Cape Town by Dana Lixenberg, Mar 1995

Cayley's dynamite portrait of Kelis has an ele-gance that makes it more than just a sexed-up shot. One can look at it a long long time. Lixenberg went to South Africa and, true to form, enlisted real women as fashion models. They could've been on a curb in Brooklyn, but something about the women is distinctly African.

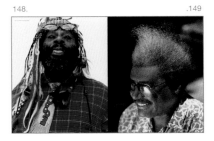

George Clinton by Christian Witkin, Nov 1993;
Don King by Fran Collin, Sep 1996

Clinton made the cover of VIBE at a time when Dre was sampling his beats and he was more current than ever. He changed R&B forever, making it as radical as Led zeppelin made hard rock. He may have popularized the term, but he did not have a monopoly on funk itself, as demonstrated by Collin's portrait of Mr. King.

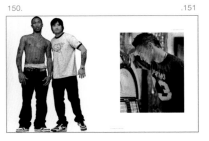

The Neptunes by Albert Watson, Sep 2003;
Justin Timberlake by Phil Knott, Feb 2003

The year just passed may well be remembered as the Revenge of the Nerds. Pharrell Williams and Chad Hugo, the production duo known as the Neptunes, have dominated the charts with their distinctive sound and quirky sex appeal. Boy-band refugee Justin Timberlake enlisted them for his (in)credible R&B album, *Justified*.

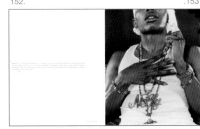

Nelly by Anthony Mandler, Dec 2001

Mandler's award-winning portrait of Nelly relies on the perfect elimination of information. It's an arty image of a cool young rapper on his way to super-stardom. The radically cropped composition emphasizes the delicacy of his body language. You don't even need to see his face; the jewelry says it all. This picture is all about artifice on both sides of the camera.

154. .155

156. .157

158. .159

160. .161

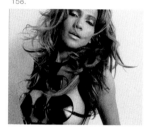

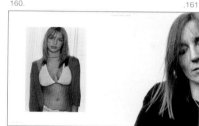

The Hughes Brothers by Barron Claiborne, Nov 2001;
Tiny Lister by Sacha Waldman, Dec 2000

Albert and Allen Hughes became famous for their film *Menace II Society*, but by the time Claiborne photographed them, they were directing Johnny Depp in the Edwardian thriller *From Hell*. Waldman calls this heroic shot of the legendary B-movie heavy Tiny Lister "as powerful a portrait as I'll ever do."

Teddy Riley by Dana Lixenberg, June 1994

Here's one of those moments that only gets captured when a photographer is absolutely alert to the activity in the moment. Lixenberg's aerial view of Riley's Virginia living room is made all the more sweet by the entrance of his daughter. The coins he laid over his eyes add an air of mystery. It's a picture that's hard to forget and hard to describe.

Jennifer Lopez by Tony Duran, July 2003

Inside Tony Duran's garage in Bel Air, one of the biggest stars on earth gives you Barbarella by way of the Bronx in a Roland Mouret dress straight off the Paris runway. "She and Tony don't talk when they shoot," says Emil Wilbekin, who produced VIBE's J-Lo cover. "They're very intuitive. She's incredible in front of the camera, totally in character. You just watch her like a movie."

Britney Spears by Brian Walsh, June 1999;
Beth Gibbons by Christian Witkin, June 1999

What can one say about Britney that this picture doesn't say? Walsh shows us a teen pre-phenomenon. She looks a bit like a deer in the headlights juxtaposed against a heavier cult icon, Beth Gibbons of the band Portishead, the natural successor to Annie Lennox. Herewith, two women joined by their blond locks.

162. .163

164. .165

166. .167

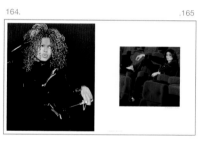

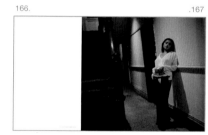

Heather Headley by Henry Leutwyler, Dec 2002;
Destiny's Child by Vincent Skeltis, Feb 2001

Leutwyler delivers a glamorous picture of Heather Headley, a Broadway musical actor photographed on the occasion of her first R&B album. It was Emil Wilbekin's idea to cast Destiny's Child, the 21st century's reigning girl group, as the Supremes. To judge by Skeltis' fabulous picture, the girls were into it.

Janet Jackson by Ellen von Unwerth, Nov 1997;
Michael Jackson by Jonathan Exley, Mar 2002

The Queen and King of Pop are both very clever readers of the media. Von Unwerth's kinky picture of Janet complemented the record she was putting out at the time, *The Velvet Rope*. Michael opted for a more conservative look, posing in Neverland's private movie room for Exley, his preferred photographer.

Sarita Choudhury by Catalina Gonzalez, Mar 1994

Here is a sensitive atmospheric portrait of a beautiful young actress enjoying the flush of her indie fame. She had already been in *Mississippi Masala* and was heading for *Kama Sutra*. Gonzales' use of shadow and mood in this outtake was ahead of the curve in '94. Color pictures were more brightly and evenly lit at the time. Shadows were considered mistakes.

168. .169

170. .171

172. .173

174. .175

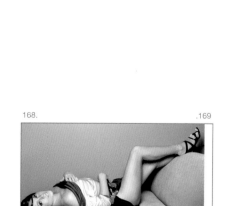

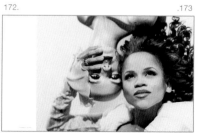

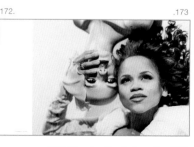

Mariah Carey by Wayne Maser, Mar 2003

It's no insult to call Maser's splendid reclining Mariah portrait a "Cheesecake shot." He's shown her like an old-school screen beauty, reminiscent of voluptuous 1950s sex symbols like Jayne Mansfield or Mamie Van Dorn. Buxom, curvaceous and archly innocent, Mariah has always carried herself like a glamour queen. We've got nothing but love for her.

Madonna by Melodie McDaniel, June 1994

This outtake from a never-published cover story was one of the more ethereal and straight-up sexy photos taken of Madonna that day in Miami. McDaniel is a visionary photographer who brings an element of the fantastic to a reality-based aesthetic. It enhances the magic that you don't know who it is right away; you just sort of discover it's *that* girl.

Rosie Perez by Cleo Sullivan, Dec 1993

Sullivan's Perez portrait says that girls are playful. Left to their own devices, they may conspire to do fun things that wouldn't occur to a man shooting a woman. Women working together often come up with something with greater lightness and wit. The mannequin is one of Cleo's metaphoric signatures. It's also a way to distract the subject from posing.

D'Angelo by Dah Len, Oct 1995;
Ebony by Melodie McDaniel, Dec 1993

Dah Len did a great job capturing D'Angelo's sensuality and infused the picture with his beautiful sensitivity to color. There's an obvious similarity of body language in McDaniel's portrait of Ebony, a 21-year-old female college student in a fashion story exploring androgyny. It's one of those odd photographic coincidences.

176. .177

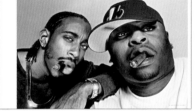

Slick Rick by Marc Baptiste, Aug 1999

Slick Rick is a hip hop pioneer who was always deserving of a first-class visual treatment. He gets it in Baptiste's picture, which strips away the layers of gold chains in search of the man who once said, "Performing in front of a lot of people changed the way people looked at me. I was just somebody who could be passed on the street."

178. .179

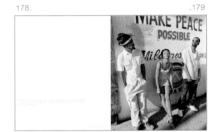

The Fugees by Melodie McDaniel, June 1996

Here's McDaniel again with one of the most unconventional covers in VIBE's history, but also one of the most beautiful. Conventional magazine wisdom is not to shoot a group outdoors against a patterned wall. This is almost an art photo of a great band who are not trying strenuously to get your attention. They draw you in by subtle body language and Lauryn's allure.

180. .181

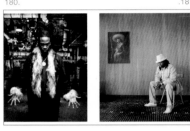

Busta Rhymes by Piotr Sikora, March 1999; Wyclef Jean by Stefan Ruiz, Sep 2000

Sikora cast Busta as a post-apocalyptic warlord, which feels just right for this over-the-top artist in all his finery. Ruiz's Wyclef picture is a deceptively simple picture, very European in its understated conception. It's extremely witty in its own dry way (check the hat echo). Like Wyclef himself, this one's a classic.

182. .183

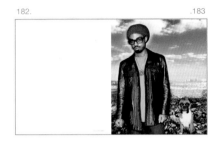

Bilal by Sacha Waldman, Oct 2000

Anybody waiting on Bilal's remake of "Where My Dogs At?" may be disappointed. "That's not really his dog," admits Waldman, who applied a bit of digital wizardry to this surreal image of the delicate-voiced soul singer. "I just had the dog and subconsciously I thought it worked with the shot." Something on the pooch's face is eerily reminiscent of the singer's expression.

184. .185

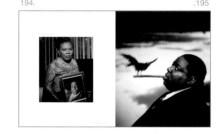

Ludacris & Scarface by Sacha Waldman, Nov 2001

Waldman's smoking image of Atlanta's lacivious Ludacris and Houston's infamous Scarface of Geto Boyz fame puts the Dirty South all up in your face. This picture proves beyond a doubt that the power of Waldman's photography does not depend on high-tech tricks. Here he's after an exaggerated realism that portrays these master rappers as full-time Big Willies.

186. .187

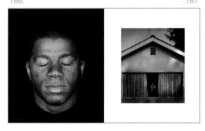

Magic Johnson by Dan Winters, June 1998; Richard Pryor by Dan Winters, Aug 1995

Here are two evocative pictures of American legends who persist in the face of physical hardship. Winters' stark simplicity makes these images cut like a knife to the jugular. Showing Magic with his closed eyes defies death as he has seemed to defy HIV. And the sight of Pryor contained in a suburban house is wrenching.

188. .189

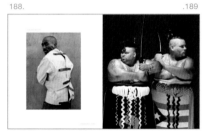

Tupac Shakur by Shawn Mortensen, Feb 1994; Big Pun & Fat Joe by Piotr Sikora, Aug 1998

After Shakur's tragic demise, Mortensen's shot of him in a straitjacket is even more disturbing. Sikora's sumo vision of the late Big Pun and his mentor Fat Joe was playful, but now seems stately. "I was like, Yo that nigga Pun just too big," Joe once said. But when Pun rhymed, Joe knew he was phenomenal. We did too.

190. .191

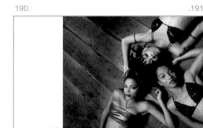

TLC by Seb Janiak, May 1999.

At the end of this session with the French photographer Janiak, a definitive group shot had not yet been accomplished. George Pitts suggested that TLC be shot against the pretty hardwood floor they'd been walking on all day. Their last cover image together spoke to a sort of unity. On a closer look, you might notice the enigmatic scar scratched into Left Eye's arm.

192. .193

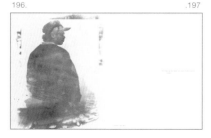

Lisa Lopes & Andre Rison by Chris Cuffaro, Sep 2001

Photographing romantic couples isn't something we're often asked to do, but it's always a pleasure to try. Cuffaro was able to take an especially touching picture of Lisa and Andre's love for each other, despite their public fights. He got every detail just right from the lighting to the feel of the car seats to the warmth of their embrace, now so bittersweet.

194. .195

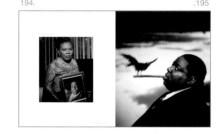

Voletta Wallace by Barron Claiborne, Mar 1998; Notorious B.I.G by Guy Aroch, Sep 1996.

Claiborne's sensitive picture of Mrs. Wallace was taken around the one-year anniversary of her son Christopher's murder. Six years later she still leads the effort to catch his killer. Aroch's picture of Wallace (a.k.a. B.I.G.) as Hitchcock is another Wilbekin brainstorm. It's still a witty picture, but hard to laugh at now.

196. .197

Eazy-E by Everard Williams, June 1995

Williams' portrait of the N.W.A founder—who pioneered what Carter Harris called "nutsack nihilism" in his memorable essay "Eternal Gangsta"—was shot not long before Eazy announced he was dying of AIDS. The angle of the picture gives it an elegaic quaiity that's enhanced by artistic printing techniques to convey the sense of loss more poignantly.

.208

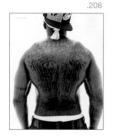

50 Cent by Christian Witkin, May 2003

Guess whose back? A sculptural treatment of the body is a recurring theme in VIBE photos, from Treach up to 50 Cent. May your back get no more holes!

For VIBE:

President: Kenard Gibbs
Editorial Director: Rob Kenner
Director of Photography: George Pitts
Photo Editor: Dora Somosi
Photo Assistant: Cynthia Edorh
Design: Gary Koepke for Modernista!
Associate Designers: Maria A. Becco and
Shannon McGlothin for Modernista!

For Harry N. Abrams, Inc., Publishers:
Project Manager: Deborah Aaronson
Design Coordinator: Brankica Kovrlija
Production Manager: Maria Pia Gramaglia

LIBRARY OF CONGRESS CATALOGING-IN-PUBLICATION DATA

VX: 10 Years of VIBE Photography with a foreword by Quincy Jones.
 p.cm.
ISBN 0-8109-4546-0
1. Hip-hop–Pictorial works. 2. Rap (Music)–Pictorial works. I. VIBE.

ML3531.V8 2003
782.421649'022'2–dc21

2003003829

Printed and bound in Singapore
10 9 8 7 6 5 4 3 2 1

Harry N. Abrams, Inc.
100 Fifth Avenue
New York, N.Y. 10011
www.abramsbooks.com

Abrams is a subsidiary of
 LA MARTINIÈRE
G R O U P E

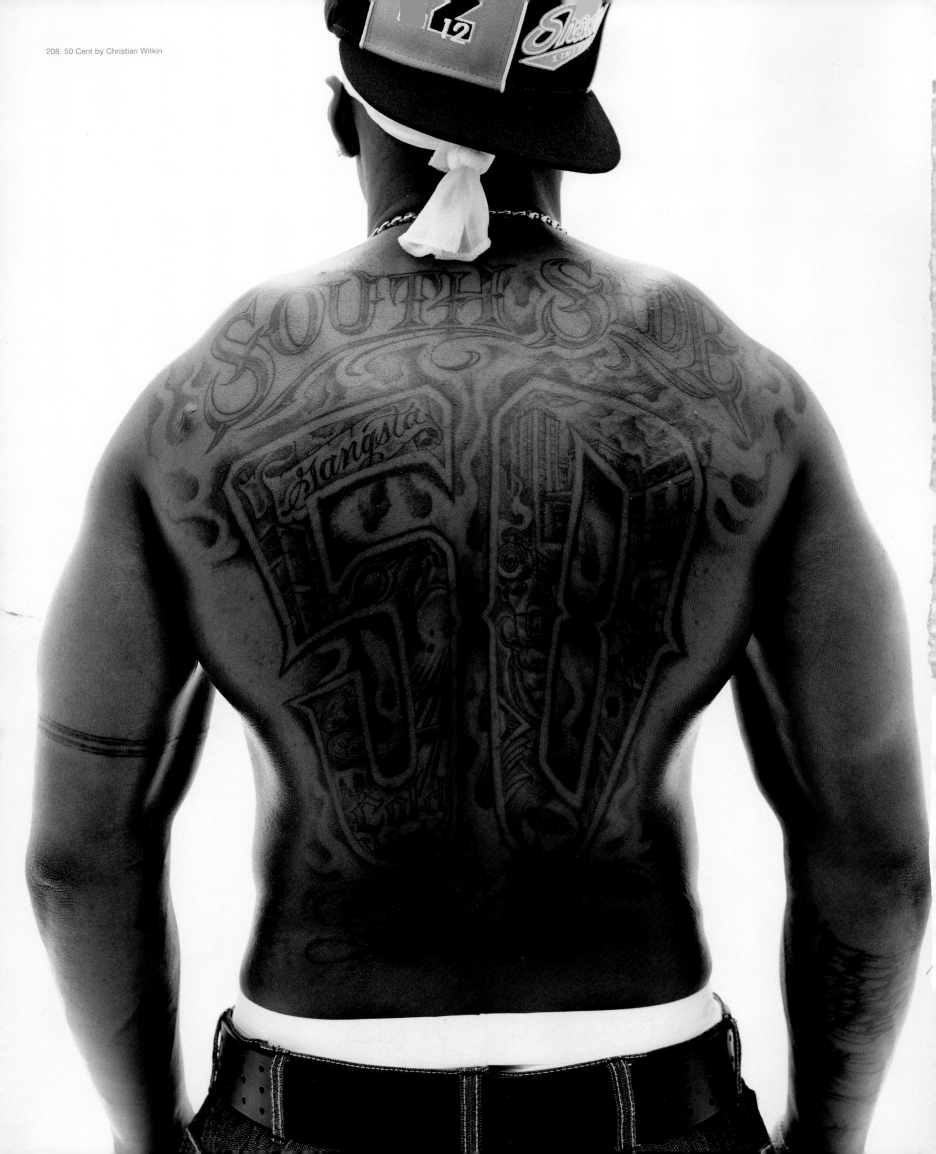